Charles G. Martignette – Louis K. Meisel

# GIL ELVGREN

## *All his glamorous American pin-ups*

**TASCHEN**

HONG KONG  KÖLN  LONDON  LOS ANGELES  MADRID  PARIS  TOKYO

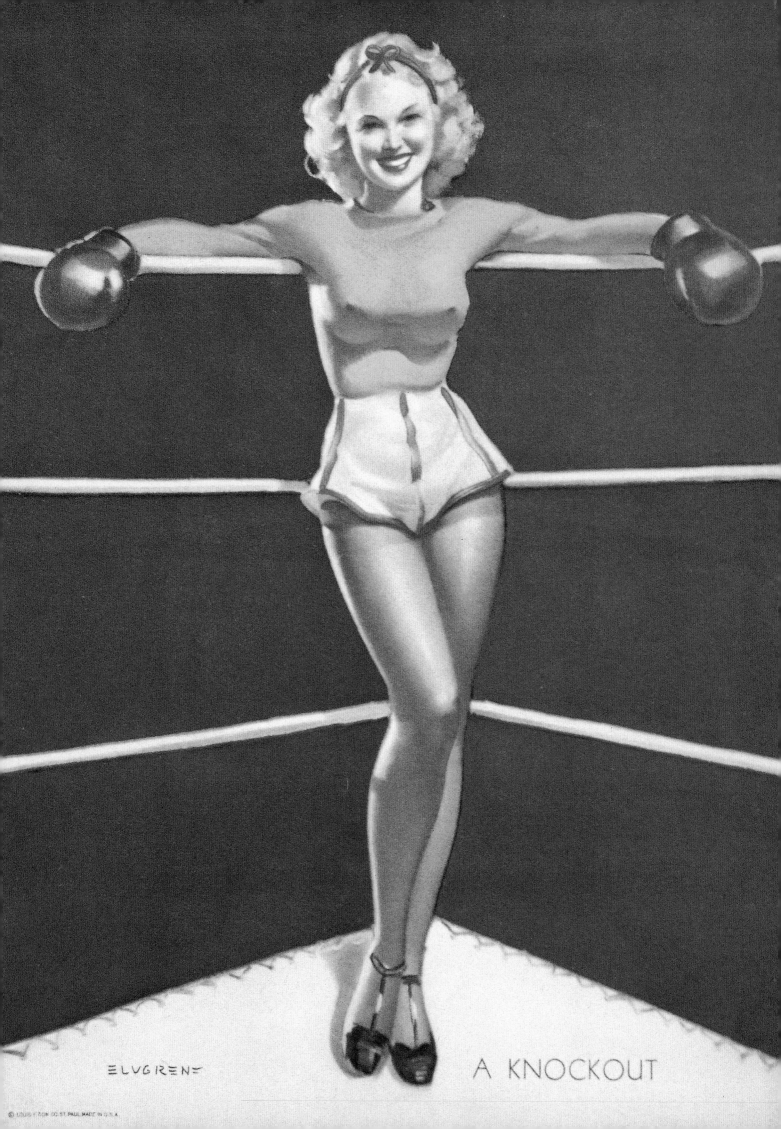

ELVGREN                                    A KNOCKOUT

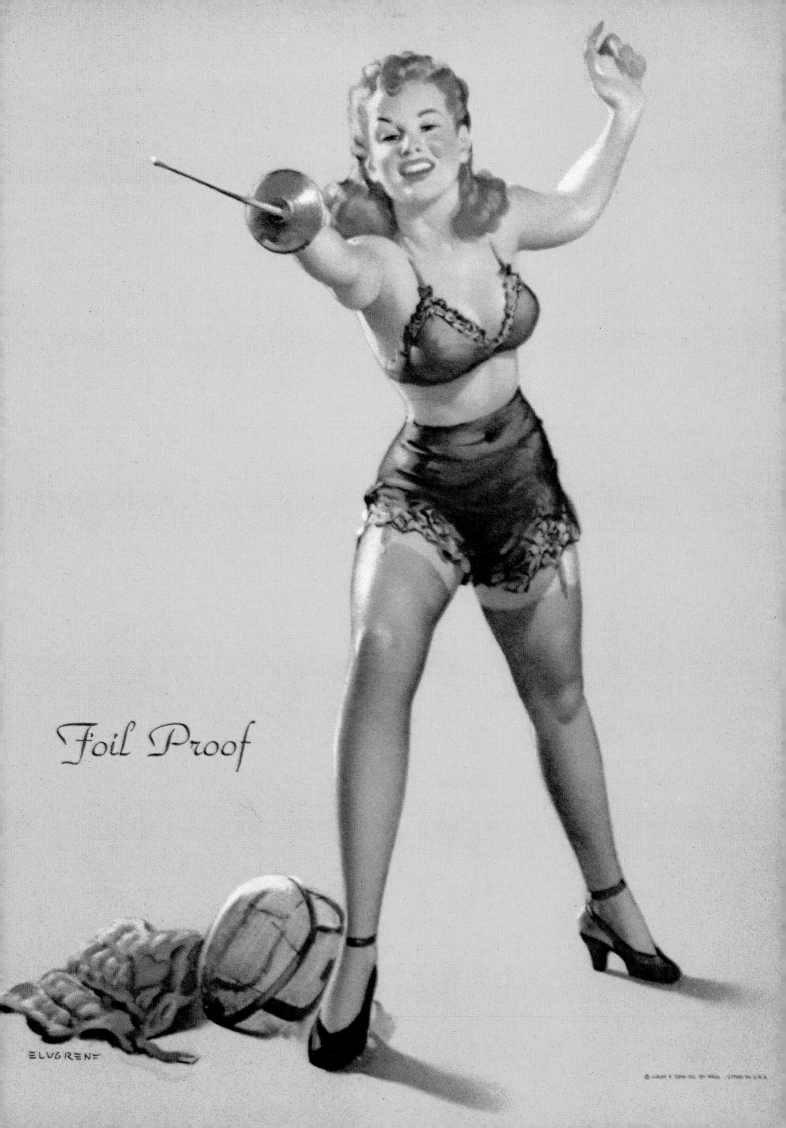

Foil Proof

ELVGREN

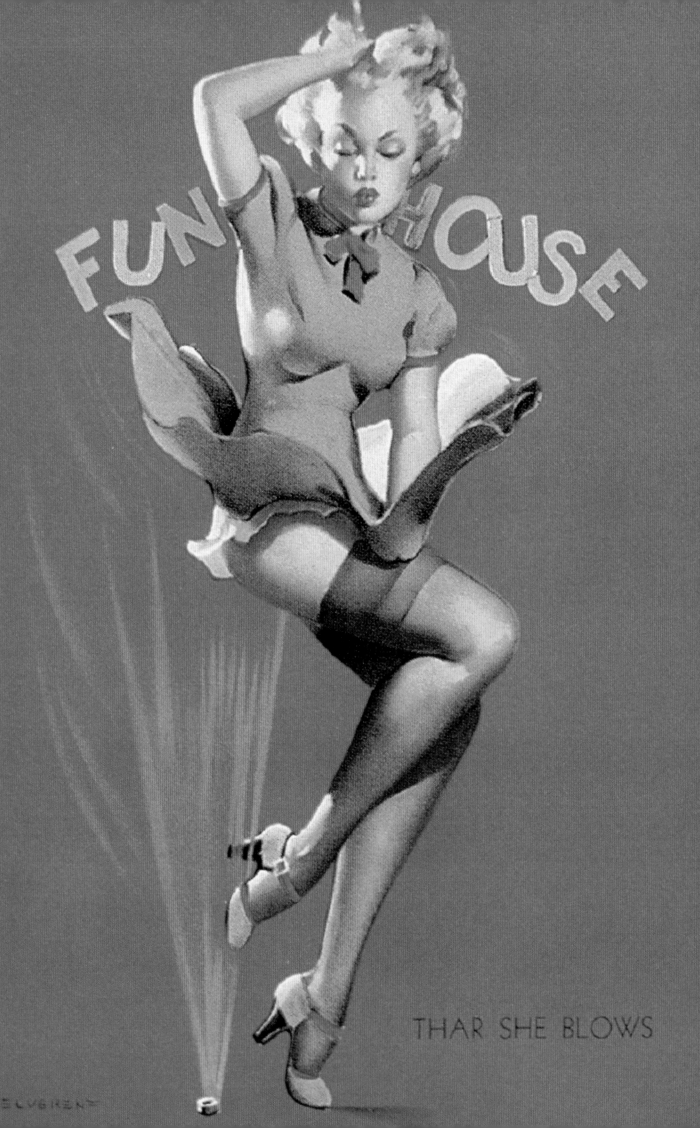

FUN HOUSE

THAR SHE BLOWS

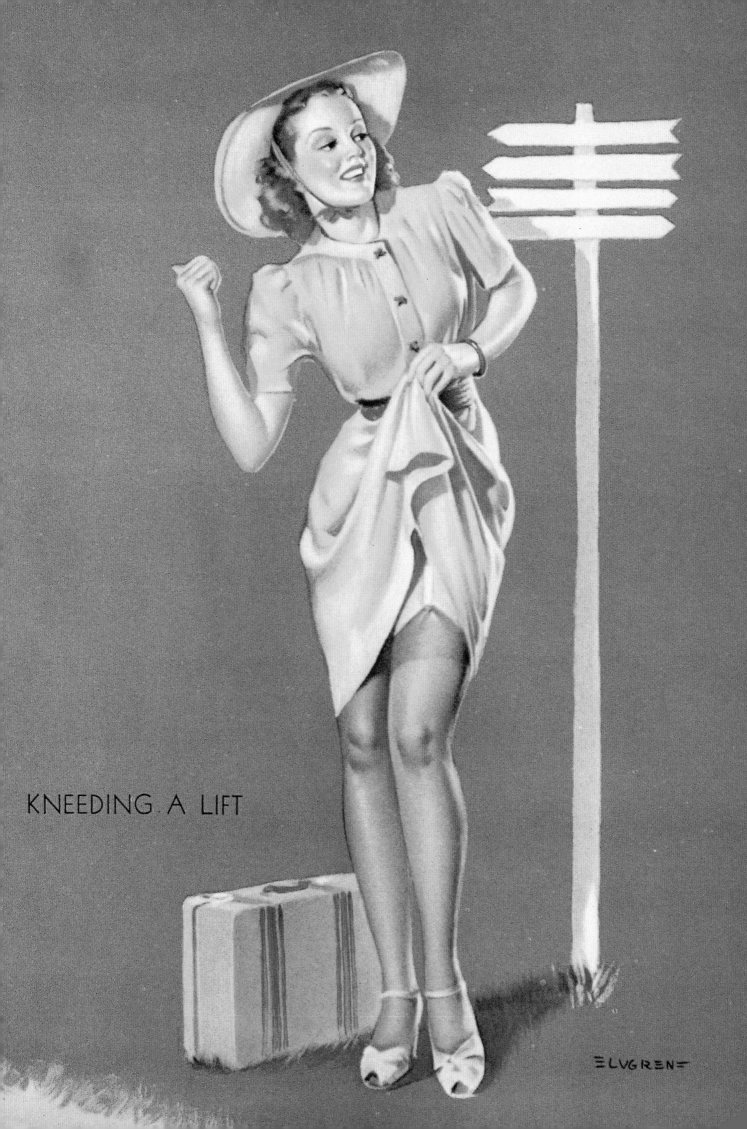

KNEEDING A LIFT

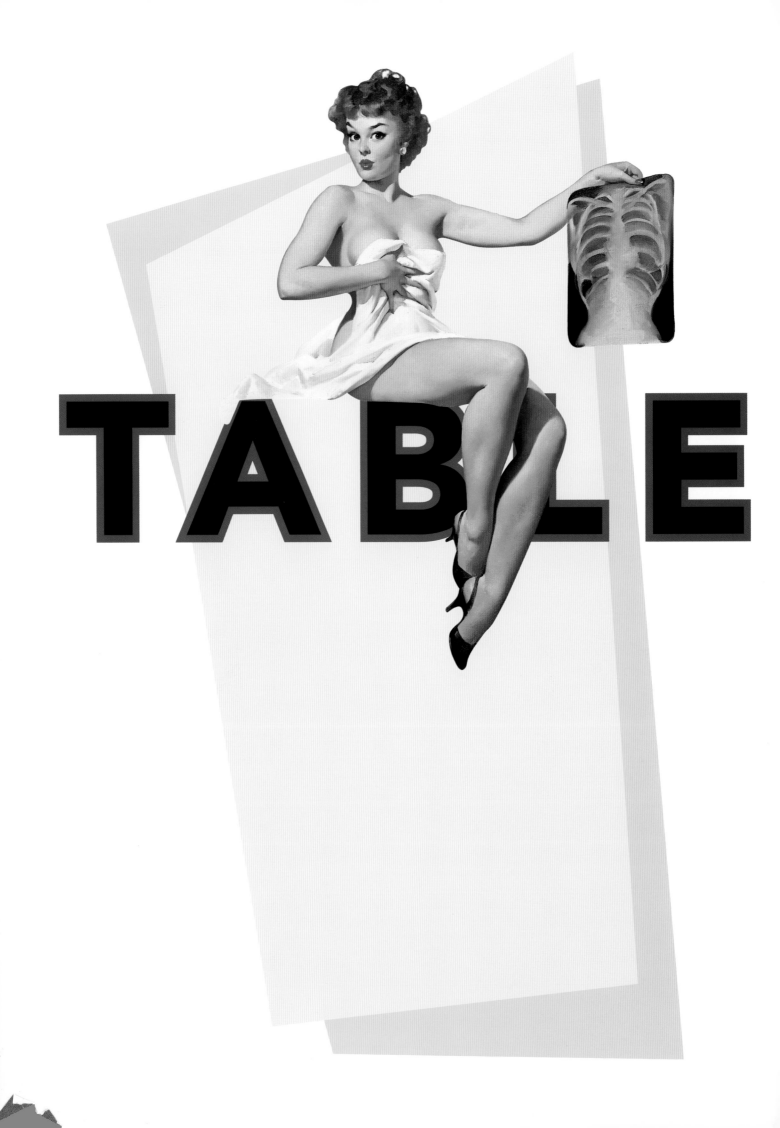

TABLE

# OF contents

# Why an ELVGREN MONOGRAPH?

Louis K. Meisel

**1** He was the best pin-up artist in the history of American illustration.

**2** His talent was prolific enough and important enough to justify a major book.

**3** His influence, both as an artist and a teacher, was extensive.

**4** Since the publication of The Great American Pin-Up, the demand for more of his work has been overwhelming.

**5** A promise was made to the artist by our friend Art Amsie that such a book would be published.

**1.** I believe it can be safely stated without fear of contradiction that Gil Elvgren was, and remains, the best pin-up artist the world has ever known. Approximately a quarter of a million people worldwide have already become familiar with the works of all 77 artists of this genre through the book *The Great American Pin-Up*, by Charles Martignette and myself. If they were asked to vote for the top artist, I am certain that Elvgren would receive a clear majority.

**2.** Between the mid-1930s and 1972, Elvgren produced over 500 paintings of beautiful girls and women. Almost all of them are oil on canvas and fully developed, finished works of art. In their quality, even the earliest works would rate an "A", and as the decades progressed, they just kept getting better and better. Elvgren continually surpassed himself, always improving in ideas, composition, color and technique.

**3.** Over the years, Elvgren's influence was felt by dozens of younger artists who were apprenticed to him, studied his work or otherwise sought to emulate "the master". He influenced not only artists working in the pin-up tradition and other illustrators, but also the Pop artist Mel Ramos (figs. 1 and 2, p. 10). The Photo-realist painter John Kacere likewise knew Elvgren and also derived personal inspiration from him (fig. 6, p. 11). Kacere says, "When I asked Gil if I could work in his studio, he told me he thought I should pursue a career as a fine artist, not an illustrator or pin-up painter."

**4.** After *The Great American Pin-Up* was published, we received an overwhelming response to Elvgren, including frequent requests to see more of his work. It has always been our intention to honor this great artist, and the outpouring of admiration only spurred us on.

**5.** Art Amsie, a friend of both Charles and mine, was close to Elvgren for many years. Our personal link with Elvgren, Art not only helped introduce us to Elvgren's work but also provided us with his paintings. Art was also a friend of the great American pin-up model Betty Page, whom he photographed in the 1950s (fig. 3, p. 10). In the 1960s and 1970s he owned a gallery called "The Girl Whirl", which was the only one devoted to pin-up art at that time. As Elvgren was dying of cancer, Art promised to use all his efforts to see that an Elvgren book would be published someday, since this had been Elvgren's dream. When I met Art many years ago, I told him that, with his assistance, I would take responsibility for that promise. This volume, then, is the fulfilment of a promise – to Gil, to Art, and to the world.

It has taken about ten years to assemble these images, which I believe constitute close to 98 per cent of all the pin-up and glamour paintings produced by the artist. I began with and was greatly assisted by the lists and copyright office information amassed by Art Amsie, who contributed his valuable personal knowledge as well. I was also provided with lists of titles and descriptions compiled by both Earl Beecher and Michael Stapleton.

Other first-hand information came from interviews with Joyce Ballantyne, one of Elvgren's artist colleagues, and from models Myrna Hansen and Janet Rae. I met Myrna Hansen, who posed for many Elvgrens including *Sitting Pretty* (figs. 4 and 5, p.11), at Glamourcon in Los Angeles. Janet Rae, the daughter of Elvgren's neighbors, posed for many of his best paintings, including *Inside Story*, *Well Built*, *Puppy Love* and *Sheer Comfort*; she was interviewed at length by our friend Marianne Phillips. Marianne is a dealer in pin-up collectibles, but, more importantly, she has spent years documenting the careers of pin-up artists and their work. She is a fountain of information on Zoë Mozert, Joyce Ballantyne and of course Gil Elvgren, and we are grateful to her for sharing this information with us.

Of course, the most important source of information and materials was Brown & Bigelow, the greatest calendar-publishing company I know. Teresa Roussin, the company's archivist and licensing coordinator, provided documents, histories, photographs, answers to limitless questions, permissions, encouragement and overall support. With the unceasing demand for ever more Elvgren pictures, we look forward to seeing many more reprints and licensing of these paintings from the Brown & Bigelow archives.

We present the story of the artist's life first, followed by the full spectrum of his oeuvre. Unlike artists whose work was done primarily to be shown and sold in galleries – and was therefore accurately dated, titled and documented – Elvgren produced work that was intended for reproduction. Thus, a painting completed in 1948, for instance, could be copyrighted in 1949 or 1950, but not appear in print until 1951 or later. Since Elvgren's paintings are rarely dated, we can give only approximate dates, based on style, model, situation, copyright date and the date of the products on which the images appeared. Much of the time, such clues have allowed us to determine an exact year, and our approximations are seldom more than a year or two off. Within the individual chapters, Elvgren's illustrations are presented in a roughly chronological order. The illustrations are organized in the following sections: the Louis F. Dow years (1937 to 1944); three chapters of work for Brown & Bigelow: the 1940s, the 1950s, and 1960 to 1972; and, finally, the advertising work, including the NAPA and Sylvania images (also for Brown & Bigelow), which were generally done a year before the date on the calendars, plus miscellaneous works dated as best we could. Titles were a problem. While Elvgren may have suggested titles from time to time, most were made up by copywriters working for the calendar and publishing companies. Sometimes a painting would be copyrighted under one title and published with this title as a calendar. Later it could be reproduced as a notepad with a different title, and then as a blotter with yet another. When a single title appears in a caption herein, it is either the copyrighted title or the only one we have found for it (some paintings have acquired titles by general usage among collectors). Secondary titles and all other titles are included in parentheses after the main title.

Virtually all Elvgren's work for Brown & Bigelow was oil on canvas, measuring 30 x 24" (76 x 61 cm). The Louis F. Dow paintings measure 28 x 22" (71 x 56 cm).

We have endeavored to use the best possible source for each illustration. Unfortunately, this is sometimes only a poor Xerox of a bad photograph of an old calendar. For the most part, however, we managed to track down better sources. In about two hundred cases, we were able to photograph the paintings themselves, most of which we own or have owned. As time goes on and more and more originals turn up, we hope our readers will be willing to help us complete our archives by bringing any new discoveries to our attention.

Louis K. Meisel with Susan and Ari,
New York
© Logo Studios

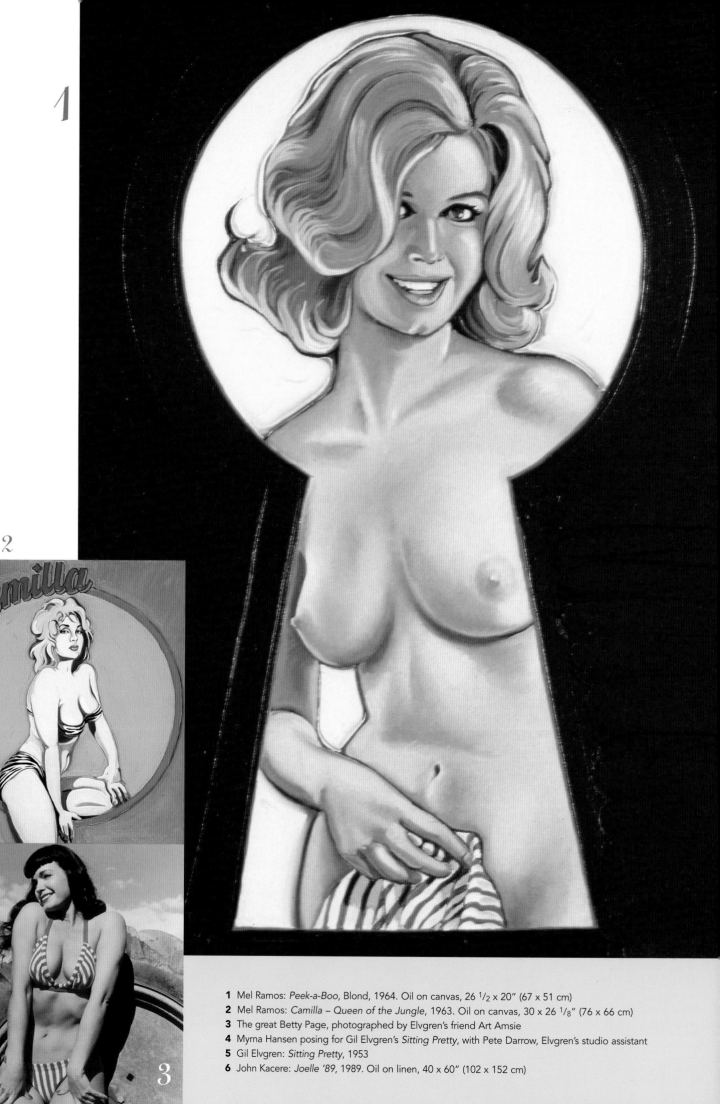

1 Mel Ramos: *Peek-a-Boo*, Blond, 1964. Oil on canvas, 26 1/2 x 20" (67 x 51 cm)
2 Mel Ramos: *Camilla – Queen of the Jungle*, 1963. Oil on canvas, 30 x 26 1/8" (76 x 66 cm)
3 The great Betty Page, photographed by Elvgren's friend Art Amsie
4 Myrna Hansen posing for Gil Elvgren's *Sitting Pretty*, with Pete Darrow, Elvgren's studio assistant
5 Gil Elvgren: *Sitting Pretty*, 1953
6 John Kacere: *Joelle '89*, 1989. Oil on linen, 40 x 60" (102 x 152 cm)

4+5

6

# The art and life of

# GIL ELV

Charles G. Martignette

Gil Elvgren (1914–1980) was the most important pin-up and glamour artist of the twentieth century. During his professional career, which began in the mid-1930s and lasted more than forty years, he established himself as the clear favorite of pin-up art collectors and fans worldwide. Although most of his work was created for commercial use, it has been increasingly recognized as "fine" art by many private collectors, dealers, galleries and museums. And indeed, though Elvgren has been considered mainly a pin-up and glamour artist for the last half-century, in reality he deserves recognition as a classical American illustrator whose career encompassed many different fields of commercial art. He was always a master in portraying feminine beauty, but his output was by no means confined to the calendar pin-up industry.

Thus, part of Elvgren's fame is undoubtedly due to his now legendary series of pin-ups painted over a period of nearly thirty years for Brown & Bigelow, calendar publishers of St. Paul, Minnesota. However, his twenty-five-year stint on advertising work for Coca-Cola helped to establish him as one of the great illustrators in this field as well. While the Coca-Cola artwork included some typical "Elvgren Girl" pin-ups, most of it depicted typical American families, children and teenagers – ordinary people doing everyday things. During World War II and the Korean War, Elvgren even painted military scenes for Coca-Cola. Like his famous Brown & Bigelow pin-ups, the Coca-Cola images eventually became acknowledged icons of American life. Elvgren's Coca-Cola subjects portrayed the American dream of a secure, comfortable lifestyle, but his well-known illustrations for magazine stories often captured timeless scenes that reflected the hopes, fears and joys of their readers. These publishing assignments were commissioned during the 1940s and 1950s by a host of mainstream American magazines, including *McCall's*, *Cosmopolitan*, *Good Housekeeping* and *Woman's Home Companion*.

In the field of advertising, alongside his Coca-Cola work, he contributed to campaigns for prominent American companies and products such as Orange Crush, Schlitz Beer, Sealy Mattress, General Electric, Sylvania, and Napa Auto Parts. With his work for Brown & Bigelow, the Coca-Cola and other national advertising assignments and his magazine work, Elvgren was much in demand as an artist, his time booked up more than a year ahead of his output.

Elvgren stood out not just for his painting and advertising graphics. He was also a notable professional photographer, wielding the camera with the same dexterity as he wielded his brush. And his amazing energy and talent did not stop there, since he was a respected, even revered, teacher of students who often went on to become famous artists in their own right – thanks, in no small measure, to Elvgren's personal instruction and encouragement.

Long before he attended his first art class in 1933, Elvgren had been impressed by the early "pretty girl" illustrators, among whom were names such as Charles Dana Gibson, Howard Chandler Christy, Harrison Fisher and James Montgomery Flagg. Their "glamour and romance" successors – McClelland Barclay, Haddon H. Sundblom, Andrew Loomis, Charles E. Chambers and Pruett Carter – had also left their mark on the young artist.

Early on, Elvgren had begun to tear out of magazines those covers or individual pages bearing illustrations by artists he admired or who interested him, and this became something of a ritual with him. As the tear sheets piled up week after week, month after month, they eventually formed a very comprehensive collection that would later influence both his painting technique and his approach to particular commissions.

To fully appreciate the significance of Gil Elvgren's art and accomplishments, it seems appropriate to start by reviewing briefly the two groups of artists whose influence is evident at the outset of his career. Subsequently, other artists who inspired him during his career will be introduced as we progress chronologically through his life and art. Mention will also be made of the artists who tried to imitate his style. Some of these were former students, others were friends, while many more never met him but knew his work from collecting their own tear sheets, just as he had done. By thus explaining the context in which Elvgren's work was created, we shall arrive at an informative, fully rounded – and, we hope, entertaining – picture of Gil Elvgren as a man and as an artist who was the Norman Rockwell of the pin-up and glamour genre of American illustration.

For many art historians, Felix Octavius Carr Darley (1822–1888) was the first American illustrator of note. He had a prolific career, working both for book publishers (illustrating works by leading writers of the day such as Poe, Hawthorne and Longfellow) and on magazines, and as a regular contributor to *Harper's Weekly*. More significantly, Darley was the first American illustrator to successfully challenge the dominance of the English and European schools of illustration over American commercial art.

In 1853, the year that Darley became a member of the National Academy, Howard Pyle was born in Wilmington, Delaware; twenty-five years later, he would emerge as the true father of American illustration. Not only an enormously productive artist, Pyle also wrote many famous books and stories and was, moreover, the founder of the Brandywine School, whose influence on American illustration art would endure for about a century. Almost all twentieth-century illustrators (including Elvgren) who worked in a painterly style were directly influenced by the teachings of Pyle (1853–1911) and his best students, Harvey T. Dunn (1884–1952) and Frank Schoonover (1877–1972).

Elvgren shared his admiration for the Brandywine School's philosophy of painting with Norman Rockwell (1894–1978). The two men first became acquainted in 1947, when they both attended a Brown & Bigelow Managers' Convention in St. Paul (fig. 7, p. 15), and a friendship developed. Elvgren and Rockwell were two of a kind: both had the knack of portraying real people in totally believable situations. The difference was that Rockwell had the choice of an almost unlimited array of subjects for his paintings, whereas Elvgren seemingly had less freedom in his pin-up assignments. Yet Rockwell soon took the opportunity to tell Elvgren what the latter had already often heard from other artists – that he admired his work and envied him for his job of painting the world's most beautiful women. Their meeting marked the beginning of a long association, which even led eventually to their sharing artistic secrets during their annual encounters.

The development of glamour illustration in the twentieth century was the consequence of an earlier general growth in commercial art as printing techniques continued to evolve and improve. In the late nineteenth century, the output of commercial art had expanded rapidly to keep pace with the voracious demand for illustrations in the new weekly and monthly periodicals and magazines. One of the first lessons that publishers learned was that magazines would sell better with illustrations, both on the covers and inside. The technical advances coincided with a population boom in the United States, which further fueled the demand for periodicals and newspapers and thus for quality artwork as well.

Within ten years of Pyle's first published illustration, the American public was introduced to the first real pin-up. This idealized All-American creation, blending the "girl-next-door" with the "girl-of-your-dreams", was called into life in Boston about 1887 by the pen of Charles Dana Gibson (1867–1944). Quickly becoming the sweetheart of America, the Gibson Girl was depicted primarily in pen-and-ink drawings. Her picture appeared in all the early periodicals, including *Scribner's*, *Century* and *Harper's Weekly*. Her success was so overwhelming that Gibson Girl drawings were soon seen on the front covers and as two-page centerfolds in such popular magazines as *Life* and *Collier's*. The single female of the early drawings developed into a group of females, then a man and a woman or mixed groups. The male figure, known as the Gibson Man, was enthusiastically taken up by the admirers of the Gibson Girl.

By 1900 the Gibson Girl (and the Gibson Man) had attained unprecedented international popularity. The image of the Gibson Girl was seen almost everywhere throughout the United States and Europe. Gibson's drawings were published and reproduced as prints, lithos, calendars, centerfolds and magazine covers as well as on numerous advertising specialty products such as playing cards, notepads, ink blotters and ladies' fans. Even wallpaper, fine china, jewelry boxes and umbrellas carried the pictures. Between 1898 and 1900, *Harper's* and *Scribner's* published a total of five hard-cover, oversize artbooks containing collections of Gibson's drawings. The last of these, entitled *A Widow and Her Friends*, bore a drawing on its front cover that the artist called the epitome of the Gibson Girl (fig. 9, p. 15).

The Gibson Girl enchanted more than one generation of Americans. Though she had her beginning in the early Art Nouveau period, she was still going strong in the Roaring Twenties as a flapper jitterbugging and dancing the Charleston in speakeasies. Gibson updated the style and manner of his drawings, and the fashions in them (fig. 12, p. 15), to win over a new audience during the Art Deco era (1920–1930).

Next on the scene was the celebrated Christy Girl. Created by Howard Chandler Christy (1873–1952), she soon enjoyed a widespread popularity that came close to equaling that of the Gibson Girl. The Christy Man logically followed, since the artist painted so many romantic boy-girl scenes.

Christy began his career with front cover assignments for the leading magazines (fig. 8, p. 15), then followed with book illustrations (fig. 10, p. 15). Even famous novels such as James Fenimore Cooper's *Last of the Mohicans* were illustrated with scenes featuring the Christy Girl. Christy lived in and maintained a studio at the Hotel des Artistes in New York. On the walls of the hotel restaurant, he painted a landmark series of sensual nudes that still draw people from all over the world. In 1921, at the peak of his career, he retired from commercial illustration to concentrate on portrait painting. His most famous commission, a portrait of the aviator Amelia Earhart, was completed in 1932 as an oil on canvas (fig. 11, p. 15) and later published by *Town & Country* as the front cover of their February 1, 1933, issue. It was the only exception to Christy's decision in 1921 not to make commercial use of his work. Exhibited in Christy's show entitled "Portraits of Celebrities" at the Baltimore Museum of Art in January 1936, the painting hung between portraits of Will Rogers and William Randolph Hearst. Shortly afterward, it disappeared and has resurfaced only recently; this lost treasure is thus reproduced here for the first time in more than sixty years.

Another member of the select group of glamour illustrators whose creations bear their name was Harrison Fisher (1875–1934). His Fisher Girl, rivaling those of Gibson and Christy, first appeared in *Puck* about 1898. During the 1910s and 1920s, Fisher had the prestigious assignment of painting all the front covers for *Cosmopolitan* (fig. 13, p. 16). Eventually, like Christy, he decided to restrict himself to portraits. In fact, this became a pattern among future generations of illustrators: having achieved the highest level of success in the commercial field, advertising artists longed for acceptance in the field of "fine" art. Portrait work seemed the best route to the recognition they sought from museums, critics and the fine-art community. Unfortunately, by the time their commercial careers had ended, many of them were no longer at the peak of their artistic or physical capabilities.

Gil Elvgren studied the work of these early classic glamour artists closely, since the Gibson-Christy-Fisher clan had created the basis from which all later glamour (and pin-up) art developed. Another early artist whom Elvgren emulated was John Henry Hintermeister (1870–1945). Although much of his art focused on Americana themes, he did produce a number of sensual pin-up and glamour paintings for calendar publication (fig. 14, p. 16).

The last of the great early American illustrators who influenced both Gil Elvgren and Norman Rockwell was J. C. (Joseph Christian) Leyendecker (1874–1951). Rockwell worshiped Leyendecker and

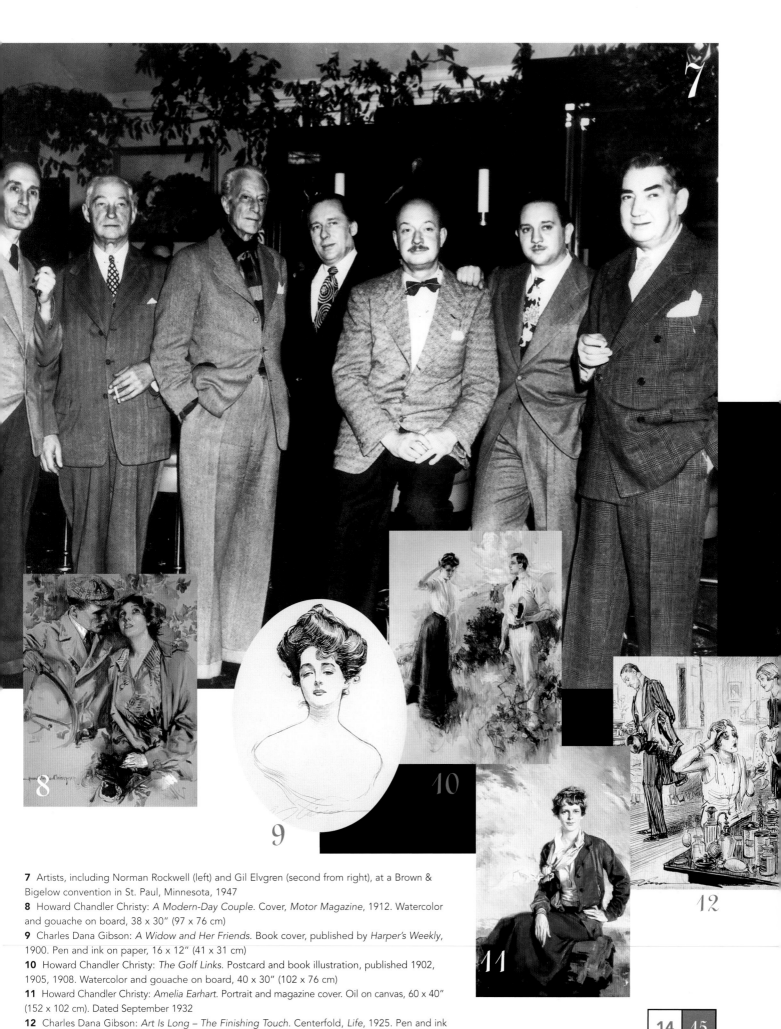

**7** Artists, including Norman Rockwell (left) and Gil Elvgren (second from right), at a Brown & Bigelow convention in St. Paul, Minnesota, 1947

**8** Howard Chandler Christy: *A Modern-Day Couple*. Cover, *Motor Magazine*, 1912. Watercolor and gouache on board, 38 x 30" (97 x 76 cm)

**9** Charles Dana Gibson: *A Widow and Her Friends*. Book cover, published by *Harper's Weekly*, 1900. Pen and ink on paper, 16 x 12" (41 x 31 cm)

**10** Howard Chandler Christy: *The Golf Links*. Postcard and book illustration, published 1902, 1905, 1908. Watercolor and gouache on board, 40 x 30" (102 x 76 cm)

**11** Howard Chandler Christy: *Amelia Earhart*. Portrait and magazine cover. Oil on canvas, 60 x 40" (152 x 102 cm). Dated September 1932

**12** Charles Dana Gibson: *Art Is Long – The Finishing Touch*. Centerfold, *Life*, 1925. Pen and ink on paper, 15 x 12" (38 x 31 cm)

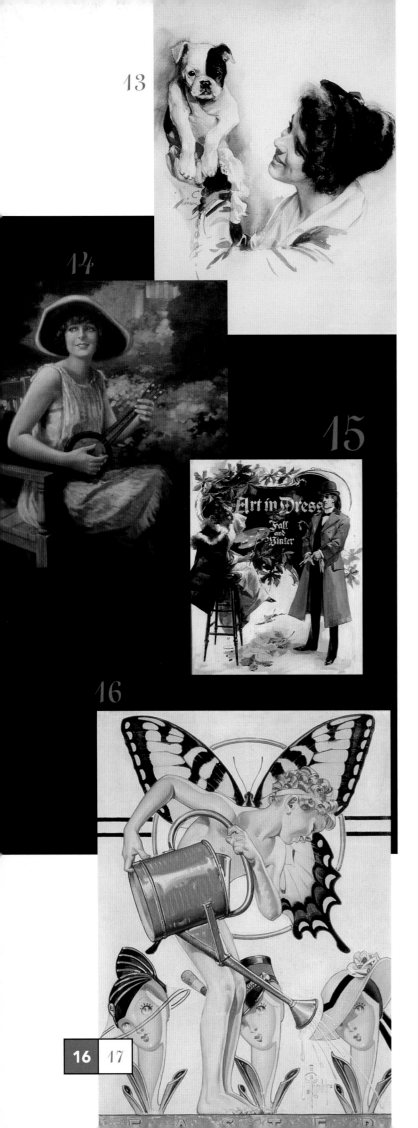

in his autobiography called him his greatest idol, mentor and source of inspiration. Rockwell would often go to downtown New Rochelle in the early evening just to watch Leyendecker get off the train on his return from his Manhattan studio. Years later, when Rockwell's career had evolved into a success story similar to Leyendecker's, the two became friends. Elvgren's admiration for Leyendecker dated from the time Gil began to attend classes at the Chicago Academy of Art. From there, he would occasionally visit the Art Institute in order to see Leyendecker's early student drawings, which were in its permanent collection.

Leyendecker's career began to flourish about 1895 with a commission to create a front cover for a fashion catalogue. His painting for this commission, *Art in Dress – Fall and Winter* (fig. 15, p. 16), is a superb rare example of the incorporation of Art Nouveau design into a depiction of a young, beautiful and highly fashionable couple. By 1899 Leyendecker had published his first *Saturday Evening Post* cover, which was the beginning of an almost lifelong relationship between the artist and the Curtis Publishing Company. Of his more than three hundred *Post* covers, the greatest were painted during the mid- to late 1930s, being notable for their whimsical and capricious character (fig. 16, p. 16).

Leyendecker's most famous image, the Arrow Collar Shirt Man, was created as advertising for shirts made by the menswear outfitters Cluett Peabody during the 1920s and 1930s. So popular was the handsome model who appeared in these advertisements that every week hundreds of letters proposing marriage were received from women by the artist and the company's advertising agency. Although most of Leyendecker's advertising commissions were for men's fashions (fig. 19, p. 17), he always enjoyed including a beautiful girl in his work. His legendary ad series for Hart, Schaffner and Marx (fig. 17, p. 17) matched the Arrow Collar work, in both popularity with the public and success in sales.

What Elvgren and Rockwell so admired in Leyendecker's work were two primary skills virtually unmatched by any other artist or illustrator of the period. First, he had a unique way of incorporating the bare canvas into a painting so that it served both as a color in itself and as an element of the final composition. Many other illustrators attempted, without success, to copy this feature of his style. Second, Leyendecker was an exceptionally strong graphic designer, who constructed his pictures almost in the same way as an architect designs buildings. Again, it is difficult to find artists who equaled Leyendecker in this respect. Elvgren and Rockwell were among the more successful, although nearly every illustrator of the twentieth century tried.

Another member of the Gibson-Christy-Fisher club of glamour artists was James Montgomery Flagg (1877–1960). He painted many mainstream subjects, as did the others in the group, but the focus of his work was painting pictures of beautiful American women. Like Christy, Flagg was a darling of the media; both were often featured in newspaper and magazine articles, or in newsreels in movie theaters. Although he became legendary for his classic World War I recruiting poster (*Uncle Sam – I Want You*), his Flagg Girls had their own admirers, including Elvgren (the two met briefly in New York in the mid-1950s). Elvgren was most impressed with Flagg's command of the pen-and-ink medium, evident in his depiction of *Garbo and Friends* (fig. 18, p. 17). This illustration was used as the endpapers in Susan Meyer's book *James Montgomery Flagg* (Watson-Guptill, New York, 1974). Although Elvgren himself never worked in this medium, he nonetheless appreciated Flagg's (and Gibson's) talent for brilliant line drawings.

Many of the leading illustrators who directly influenced Elvgren as his career began to take shape in the late 1930s were students of Howard Pyle's Brandywine School. Chief among them was Harvey T. Dunn, Pyle's protégé and most accomplished student. Dunn also became an influential teacher who passed on his own form of Pyle's philosophy to hundreds of artists. Dean Cornwell

(1892–1960) was perhaps the most famous of Dunn's former students (fig. 20, p. 18), and his influence was so great on Elvgren's generation of artists that they called him the "Dean of Illustrators".

That Dunn was crucial to Elvgren's development is clear from the huge file of tear sheets of Dunn's work that he collected. Three inches thick, this contained mostly examples of Dunn's magazine story illustrations and advertising subjects. Also in the file was a fascinating *Time* magazine article dated June 9, 1941 about Dunn and one of his most famous paintings. The work depicted a sensuous (and, at that time, highly provocative) full frontal nude that Dunn had painted in 1939 (fig. 21, p. 18), and it was illustrated in the magazine by a photograph that also showed the artist standing proudly in front of his creation. The article related how, when Dunn's nude was exhibited in May 1941 at the Guild Artists Bureau in New York (in a show entitled "Sexhibition"), George Baker, the gallery's director, invited the public to vote in five categories: best company on a desert island; best company in a desert; best company; best; and Whew! The caption the magazine used revealed the results – "Four Bests and a Whew!". Dunn's painting had won in all five categories.

Finally, McClelland Barclay (1891–1943) was also a role model for Elvgren and his peers during the 1930s. His highly stylized Art Deco paintings portrayed the "beautiful people" of the period, with special emphasis on the women. One of his well-known series of ads for Lucky Strike Cigarettes featured Miss America of 1932 endorsing her favorite brand (fig. 22, p. 18). Barclay's powerful story illustrations for *Cosmopolitan* (fig. 23, p. 18) greatly impressed the young Elvgren; they were painted in a bold, brash style that utilized unusual perspectives in the composition. His work for Fisher Body (General Motors; fig. 24, p. 18) helped to cement his reputation. Unfortunately, Barclay died in World War II while painting battle scenes on a ship that was torpedoed.

With these various artistic influences fresh in our minds, we can now turn to the story of Gil Elvgren and his remarkable career.

In 1933, as the Great Depression held America captive in its grip, an idealistic nineteen-year-old eloped with his high school sweetheart. It was a cold day in St. Paul, Minnesota, but for Gillette A. Elvgren and Janet Cummins the air was rich with the sunshine of romance, excitement and future challenges. Elvgren knew a lot about cold days. He was born on one in 1914 (March 15) and experienced many more as he grew up in the Minneapolis/St. Paul area. His parents, Alex and Goldie Elvgren, owned a paint and wallpaper store in downtown St. Paul, and its neon sign spelt out the family surname in a script lettering very similar to their son's early artistic signature.

After leaving University High School, Elvgren wanted to be an architect. His parents had encouraged him in this, because they had already noted signs of his natural talent for drawing – from the time he was eight, he had occasionally been sent home from school for sketching in the margins of his schoolbooks. Elvgren went to the University of Minnesota to study architecture and design, but also took art courses at the Minneapolis Art Institute. It was there, during a summer class in 1933, that he decided that creating art suited him far more than designing buildings or parking lots.

In the fall of the same year, he made a second important decision, one that would enrich his life for the next thirty-three years: he would marry Janet Cummins. The couple waited almost two months before telling their families of the marriage, which added a special celebratory note to that year's Thanksgiving and Christmas holidays. In the New Year, the newlyweds moved to Chicago for the artistic opportunities it offered. New York might have been their first choice, but Chicago was closer to home and just the place to further Gil's art education. It was also smaller than New York and perhaps somewhat less threatening.

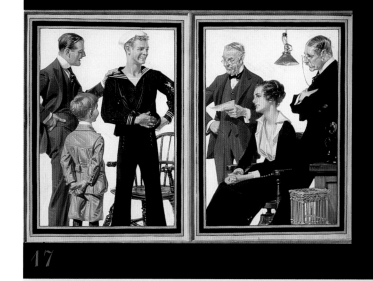

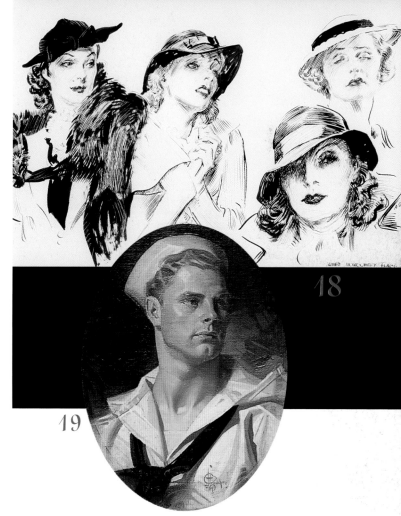

**13** Harrison Fisher: *Prize Winners*. Cover, *Cosmopolitan*, October 13, 1913. Watercolor and gouache, 21 x 9" (53 x 23 cm)

**14** John Henry Hintermeister: *A Beautiful Melody*. Calendar illustration, published 1915–1920. Oil on canvas, 28 x 22" (71 x 56 cm)

**15** J. C. Leyendecker: *Art in Dress – Fall and Winter*. Fashion catalogue cover, published September 1895. Gouache on heavy paper, 17 x 14" (43 x 36 cm)

**16** J. C. Leyendecker: *Easter*. Cover, *The Saturday Evening Post*, March 27, 1937. Oil on canvas, 28 x 22" (71 x 56 cm)

**17** J. C. Leyendecker: Fashion advertisement, Hart, Schaffner and Marx. Oil on canvas, 29 x 43" (74 x 109 cm)

**18** James Montgomery Flagg: *Garbo and Friends in Hollywood*. Magazine cover, published 1930. Pen and ink on board, 18 x 27" (46 x 69 cm)

**19** J. C. Leyendecker: Fashion advertisement, Kuppenheimer Clothing Co. Painted 1919; published 1920. Oil on canvas, 26 x 18" (66 x 46 cm)

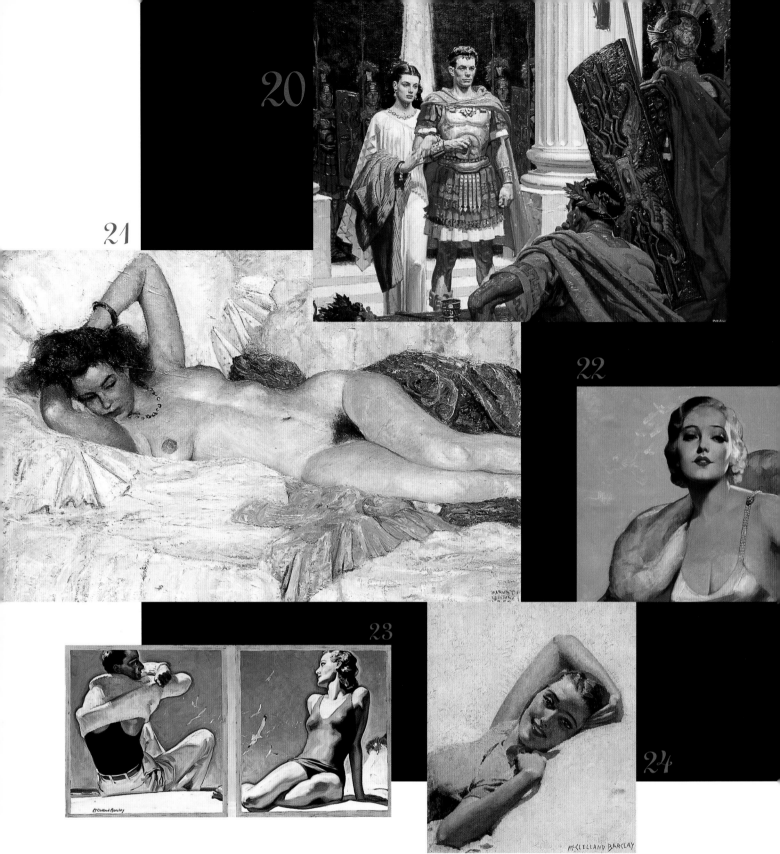

On arriving in Chicago, the young artist set about establishing himself. Ever a prudent man, he vowed to absorb and learn as much as possible as quickly as possible, so that he could start work as soon as possible. He enrolled at the prestigious American Academy of Art in downtown Chicago, where he struck up a close friendship with Bill Mosby, an accomplished artist and teacher who always remained proud of how Gil developed under his watchful eye. In an interview now in Brown & Bigelow's archives, Mosby recalled those days at the Institute:

Teaching art is like teaching mathematics or anything else. There are certain basic principles which anyone can learn. You

**20** Dean Cornwell: *Marcellus and Diana at the Trial.* Book illustration, *The Robe* by Lloyd C. Douglas. Published by Houghton Mifflin Co., 1941; *Life*, 1942
**21** Harvey T. Dunn: *Nude.* Painted 1939; *Time*, June 9, 1941. Oil on canvas, 28 x 40" (71 x 102 cm)
**22** McClelland Barclay: *Miss America*, 1932. Advertisement, Lucky Strike Cigarettes. Oil on board, 22 x 28" (56 x 71 cm)
**23** McClelland Barclay: *Lovers' Paradise.* Two-page illustration, *Cosmopolitan*, June 1932. Oil on canvas, 24 x 50" (61 x 127 cm)
**24** McClelland Barclay: Advertisement, General Motors Corp., published 1930. Oil on canvas, 22 x 18" (56 x 46 cm)

can teach anyone to draw and paint, but you can't make them an artist.

When Gil Elvgren came to the American Academy he had talent. Yes, but no more than most of the students who come here. The thing that set him apart from all the rest was a fierce determination to do one thing. So many of the students come here without a clearly defined idea of what they want to do. Gil, from the very first, knew exactly what he wanted. He wanted to be a good painter more than anything else. Into two years, he packed three and a half years of work. He had classes during the day; he went to night classes and classes during the summer. In the off-hours and on weekends he painted.

He was a good student and worked harder than anyone I have ever seen, took every course that could teach him anything about painting. We tried to tell him that it was not good to put all his eggs in one basket, that he should take some of the courses in advertising layout and lettering that would give him a more flexible background for commercial work. He admitted that there was logic in this and appreciated the interest in his welfare, but refused to have anything to do with [those subjects]. In the two years his progress was phenomenal. Without question he turned out to be one of the most successful of our alumni.

He is a fine painter; as a draftsman there are few who can equal him. He has amazing hands. They don't look like the hands of an artist. He's built like a football player, and a pencil is almost buried in that paw of his, but the touch he has and the subtle variations he is capable of can only be compared to the sensitive skill of a great surgeon.

Aside from his skill and ability, he is also one of the nicest guys in the business. He wears the same size hat today that he did before anyone had ever heard of Gil Elvgren.

In fact, Elvgren never took a break or stopped working from the moment he enrolled at the Institute until the day he graduated two years later – in almost half the normal time. His student paintings were so good that the school often used them to illustrate its catalogues and brochures. During his years at the Academy, Elvgren met a number of fellow artists who would become his friends for life. Some of them formed an informal network whose members would help one another professionally throughout their careers. They included Harold Anderson, Joyce Ballantyne, Al Buell, Thornton Utz and Coby Whitmore, who were later tremendously influenced by Elvgren's art. Even at this early stage of his development, his peers were struck by his artistry, by the way his hands worked magic on the canvas.

Yet at this point in his career, he had still to sell a single painting or receive a first commission. Gil might feel his time was approaching, but the Elvgrens struggled financially during their time in Chicago. Their reward was the tremendous progress Gil knew he was making.

In 1936 the Elvgrens decided to move back to St. Paul, where Gil proudly opened a studio. Fortunately, it was not long before he received his first paid commission: a front cover for a fashion catalogue, depicting a handsome young man decked out in a snazzy double-breasted jacket and summertime-cool white slacks (fig. 27, p. 20). The original artwork was executed in oil paint on illustration board and was unsigned, as the company's art director had specifically requested. No sooner had Elvgren delivered the artwork than the company's president called to congratulate him and to commission another half dozen catalogue covers. The young artist was on his way!

The next significant call followed within weeks. This time, it concerned a possible advertising commission for which Elvgren would have to present himself and his portfolio. The assignment, he learned, would be to paint a portrait of the Dionne Quintuplets, the French-Canadian sisters who had created a sensation in the American media. This was the break Elvgren had dreamed of but had not expected for several years. And, more than just the beautiful children, the commission had another decisive bonus – the client was Brown & Bigelow, the world's largest and most important calendar company. Elvgren's two Dionne Quintuplets paintings were published in calendars for 1937 (fig. 28, p. 20) and 1938 to enormous success. That Brown & Bigelow paid the quintuplets a total of $58,097.17 that year in royalties indicates how tremendously popular Elvgren's first two calendar pictures were. Needless to say, everyone at the company was happy with Elvgren. Starting his career by painting America's most famous, most loved and most admired young girls, he had become that rarity – an overnight commercial success.

Early in 1937, Elvgren was approached by Brown & Bigelow's biggest competitor, the Louis F. Dow Calendar Company, also located in St. Paul. Their art director wanted Elvgren to paint a series of pin-up girls, an assignment he eagerly accepted. The young artist could scarcely believe his good fortune: not only had he been lucky to get such tremendous "breaks" so soon after opening his first studio, but he would also now be painting beautiful girls and seeing his work widely reproduced in calendars. What Elvgren did not realize was that the Dow Company would reproduce his work in several additional formats, including notepads, ink blotters, mutoscope cards, matchbook covers and playing cards. They even produced specially designed booklets with an Elvgren pin-up on the cover and a dozen Elvgren prints inside measuring 8 x 10" (20 x 25 cm).

When Elvgren left Dow in 1944 to work for Brown & Bigelow, the company hired an artist to paint over certain areas of the pin-ups he had executed for them; in this way, Dow could use the images a second time without having to pay Elvgren any fees or royalties. Fortunately, the artist selected for this task, Vaughan Alden Bass, was very competent and approached the job with great respect for Elvgren's talent. Thus, Bass generally painted over only the clothing and/or the background of an Elvgren painting and left the face, hands and legs untouched. A good example of Bass's approach is the overpainted version of Elvgren's *A Perfect Pair* (see fig. 151, p. 64), which can be compared with the picture first published by Dow in a series of portraits, including a calendar, a twelve-print booklet, a mutoscope card and a matchbook cover (see fig. 152, p. 64).

In 1938 Elvgren received his first commissions for several life-size die-cut in-store display figures of both men and women. More than 6,500 of his almost lifesize pin-ups for Royal Crown Soda (figs. 25 and 26, p. 20) were distributed to grocery stores throughout the United States. His die-cut wall-unit displays portraying a grandfatherly type known as the Toasting Scotsman were designed for Frankfort Distilleries of Louisville, Kentucky, and produced by the Mattingly and Moore Company. The same year was also significant for Gil and Janet Elvgren for a quite different reason, since in 1938 they became the proud parents of their first child, Karen.

For the next two years, Elvgren remained busy with various advertising commissions, some magazine editorial work and of course his pin-ups for Louis F. Dow. With the fantastic success Gil was enjoying professionally and the added joy that their first child brought to their home life, the couple felt ready to consider how best to shape their future. Most of Elvgren's business was coming from Chicago and New York. There was no question in his mind that he could do even better if he were based in one of those two art centers. As they had once before, they selected Chicago, and the family of three prepared to move.

Shortly after his arrival in the Windy City in 1940, Elvgren secured a position at the noted Stevens/Gross Studio. There he met the man who would become his true mentor, Haddon H. Sundblom (1899–1976). Not only would the two men become the

best of friends, but Sundblom's influence on Elvgren's artistic development was enormous. The older artist was already something of an idol to Elvgren. The younger man had been assembling a file of tear sheets on Sundblom long before they met, and while most of the sheets were magazine story illustrations, the famous Coca-Cola ads (fig. 30, p. 21) also figured among them. (It was Sundblom who in due course introduced Elvgren to the Coca-Cola Company, as a result of which Elvgren's Coca-Cola ads appeared beside Sundblom's on newsstands, billboards and calendars.)

Sundblom and Howard Stevens had established the studio that developed into Stevens/Gross back in 1925, in association with their friend Edwin Henry. While Elvgren admired the painting styles of all three artists, it was Sundblom who impressed him most. When Elvgren arrived in Chicago, Sundblom was painting a national series of ads for the Cashmere Bouquet Soap Company (fig. 31, p. 21). Sundblom had done only a few pin-up and glamour paintings exclusively for that market, but they were real winners. Most of the time, he had used his own name and signature on his pin-ups (figs. 29 and 32, p. 21). However, if a pin-up subject was meant to be intentionally provocative (for instance, one in which the model is wearing lingerie or some kind of transparent material; fig. 33, p. 22), Sundblom would not sign the painting. In such cases, the publisher (almost always Louis F. Dow) would use a "slug" signature giving Sundblom's nom de plume, Showalter.

As their friendship developed, Sundblom introduced Elvgren to Andrew Loomis (1892–1959), who was also one of Elvgren's early heroes. Elvgren had admired Loomis for his glamour pin-ups (fig. 34, p. 22) as well as his prize-winning magazine story illustrations (fig. 35, p. 22), which were brilliantly designed and constructed. Loomis also taught at Elvgren's former school, the American Academy of Art, so it is likely they would have met anyway. In the event, as a result of meeting Loomis, in 1940 Elvgren agreed to teach night classes at the Academy that fall.

Earl Gross and Howard Stevens both agreed with Sundblom that Elvgren was the perfect candidate to take over much of the Coca-Cola advertising work that their studio was producing for the Atlanta-based company. The decision was a major milestone in Elvgren's career – it led to the first of a twenty-five-year series of advertising works for Coca-Cola that are now considered landmarks in the history of American illustration. Elvgren's first job was to paint an image for a die-cut in-store stand-up display for national distribution (fig. 36, p. 23). The enthusiastic response by Coca-Cola's art director and executives was the harbinger of things to come.

Having completed his first billboard painting for the Coca-Cola account (fig. 37, p. 23), Elvgren brought the artwork into his class at the Academy of Art to illuminate a facet of the advertising illustration business. He hoped to impress his students with the fact that this painting would soon be seen as a giant

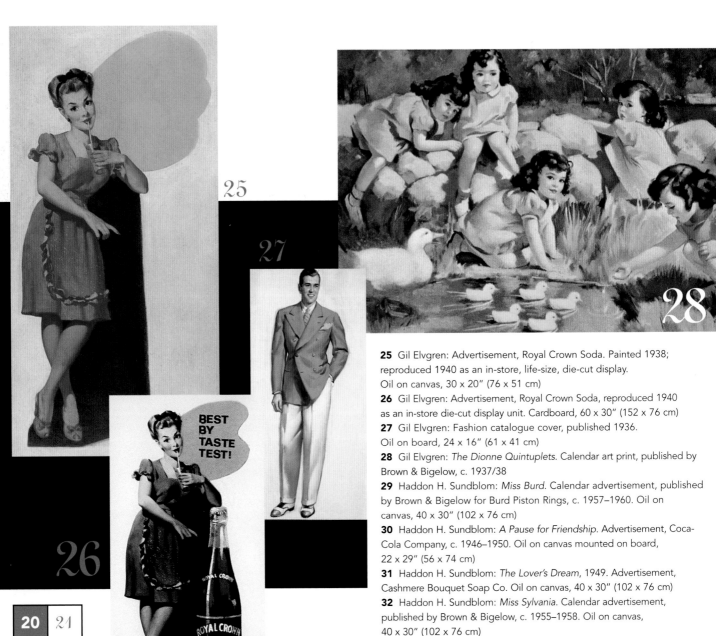

**25** Gil Elvgren: Advertisement, Royal Crown Soda. Painted 1938; reproduced 1940 as an in-store, life-size, die-cut display.
Oil on canvas, 30 x 20" (76 x 51 cm)
**26** Gil Elvgren: Advertisement, Royal Crown Soda, reproduced 1940 as an in-store die-cut display unit. Cardboard, 60 x 30" (152 x 76 cm)
**27** Gil Elvgren: Fashion catalogue cover, published 1936.
Oil on board, 24 x 16" (61 x 41 cm)
**28** Gil Elvgren: *The Dionne Quintuplets*. Calendar art print, published by Brown & Bigelow, c. 1937/38
**29** Haddon H. Sundblom: *Miss Burd*. Calendar advertisement, published by Brown & Bigelow for Burd Piston Rings, c. 1957–1960. Oil on canvas, 40 x 30" (102 x 76 cm)
**30** Haddon H. Sundblom: *A Pause for Friendship*. Advertisement, Coca-Cola Company, c. 1946–1950. Oil on canvas mounted on board, 22 x 29" (56 x 74 cm)
**31** Haddon H. Sundblom: *The Lover's Dream*, 1949. Advertisement, Cashmere Bouquet Soap Co. Oil on canvas, 40 x 30" (102 x 76 cm)
**32** Haddon H. Sundblom: *Miss Sylvania*. Calendar advertisement, published by Brown & Bigelow, c. 1955–1958. Oil on canvas, 40 x 30" (102 x 76 cm)

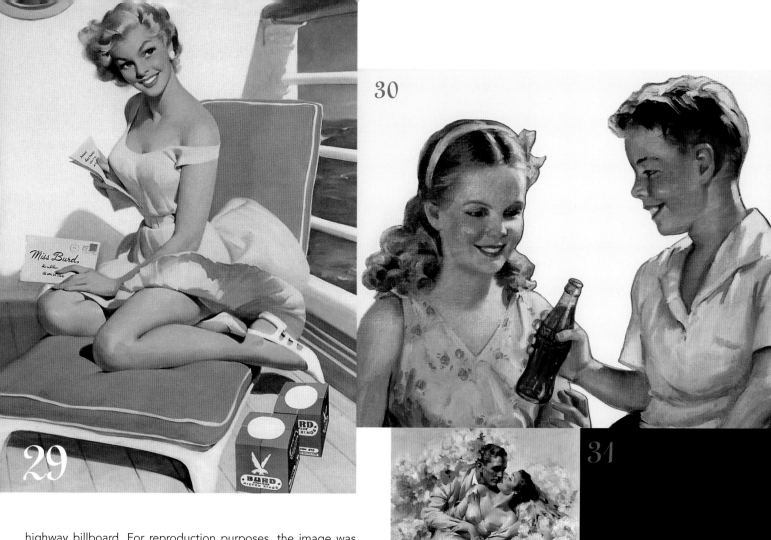

29

30

31

32

highway billboard. For reproduction purposes, the image was divided into twenty-four separate sections, which were each reproduced on a single sheet of paper; these were later reassembled or glued together to form the advertising sign. Elvgren was particularly proud of one painting of the Coca-Cola Girl that he created for a full-page national magazine ad and requested that the original artwork (fig. 38, p. 23) be returned to him, later giving it to his friend Al Buell.

Immediately after the bombing of Pearl Harbor, General Electric asked Elvgren to do some national advertising work for their War Effort campaign. His first ad painting for the company (fig. 44, p. 24), published in June 1942 as a full page in *Good Housekeeping* (fig. 45, p. 24), carried the caption "She Knows What Freedom Really Means" and depicted a proud Elvgren Girl dressed in an officer's uniform of the Red Cross Motor Corps. By the time the United States had become involved in the war, Elvgren had already had his pin-ups published and reproduced on millions of advertising specialty products and, of course, on calendars of all sizes and shapes. With the need to encourage the troops, the Louis F. Dow Company very smartly repackaged some of the special twelve-print Elvgren pin-up booklets (fig. 40, p. 24) so that they could be easily mailed without an envelope from the United States to GIs fighting abroad. These proved a smashing success.

On the home front also, Elvgren's pin-ups produced for Dow continued to enjoy great popularity, the calendar prints now often being used to raise money at bond rallies. Men and women alike could enjoy their spare time putting together a jigsaw puzzle featuring an Elvgren pin-up (fig. 41, p. 24). Elvgren's best-selling image at Louis F. Dow had been his *A Perfect Pair* (see fig. 151, p. 64), but close on its heels was *The High Sign* (fig. 42, p. 24). So successful was the latter that it was the second image that Dow asked Vaughan Alden Bass to overpaint (fig. 43, p. 24) during the war years.

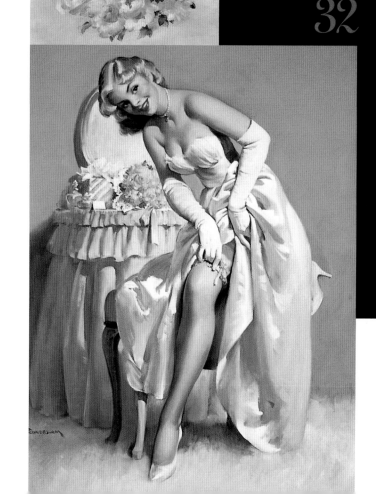

Newspapers and magazines of the period were filled with stories about the soldiers who were abroad fighting the war, for it would be hard to find an American who did not have a neighbor or loved one in the armed services. Often focusing on the morale of the troops, such stories would be illustrated with snapshots of the soldiers in their barracks or tents or perhaps even in a battlefield trench during a lull in the fighting. Quite often, one can spot Elvgren's Louis F. Dow pin-up prints and booklets hanging on a wall, glued to a knapsack, or clutched by a young, obviously lonely soldier. The only other pin-up artist whose work was so prominently featured in these stories was Alberto Vargas, who had *Esquire* magazine behind him. Elvgren's accomplishment is all the more amazing in that he had attained such popularity within five years of opening his first studio. No doubt his art had met with so strong a response from the American public because it offered escape from reality, and even solace, during the dark days of the war.

With the birth of Gil Jr. in 1942, the Elvgren family was expanding. Business was also growing. Later that year, Elvgren began a series of national advertising paintings for Four Roses, a blended-whiskey company that wanted its product to be shown in a recreational setting. The first piece published (fig. 46, p. 25) depicts a group of men enjoying their favorite tipple while on a deep-sea fishing trip. The second in the series was a scene of couples sharing drinks in front of a fireplace at a ski lodge. The original paintings in the Four Roses series, done on illustration board rather than canvas, were the first the artist had executed on this material since 1936.

Al Buell, a fellow illustrator and one of Elvgren's cronies in Chicago, was already working at the Stevens/Gross Studio when Elvgren arrived. I interviewed Buell several times in 1980 for a cover feature about the history of American pin-up and glamour art for *Antique Trader*. In the course of our conversations, he told me that Elvgren used to talk to him all the time about three artists whose magazine illustration work particularly interested him: they were Charles E. Chambers, Pruett Carter, and John LaGatta. Chambers (1883–1941; fig. 48, p. 25) had studied with George Bridgman (the father of modern anatomical drawing), whom Elvgren considered to be one of the greatest artists of the 1930s.

Carter (1891–1955) was one of the artists whose style Elvgren aimed to emulate. Buell said that Elvgren had hoped to study someday with Carter at the Grand Central School of Art (where Harvey Dunn also taught), but that the opportunity had never presented itself, since Elvgren's busy career never left him time. Carter was best known for his romantic illustrations for magazine stories (fig. 47, p. 25). Buell also sent me a tear sheet he had once borrowed from Elvgren's file on LaGatta (1894–1977), another important artist who specialized in romantic boy-girl scenes (fig. 49, p. 25). According to Buell, Elvgren regarded LaGatta as one of the best fine-art illustrators working in the commercial arena and especially admired his depiction of feminine beauty. Like his advertising work, LaGatta's magazine story illustrations were often designed to highlight the sensual aspects of beauty.

1943 was another banner year for Gil Elvgren. His schedule was booked solid with commissions, his children were growing, and Janet became pregnant with their third child. Louis F. Dow was aggressively marketing and promoting the pin-ups Gil had done for the company several years earlier. Life seemed pretty good to the talented, respected artist and happy family man. Yet what followed put all this in the shade.

It all began in 1944, when Elvgren was approached by Brown & Bigelow to come aboard as a staff artist. This invitation meant that his work would be in more or less direct competition with work by the company's other pin-up and glamour artists, who were the crème de la crème of the field. Rolf Armstrong, Earl Moran and Zoë Mozert had already established themselves as

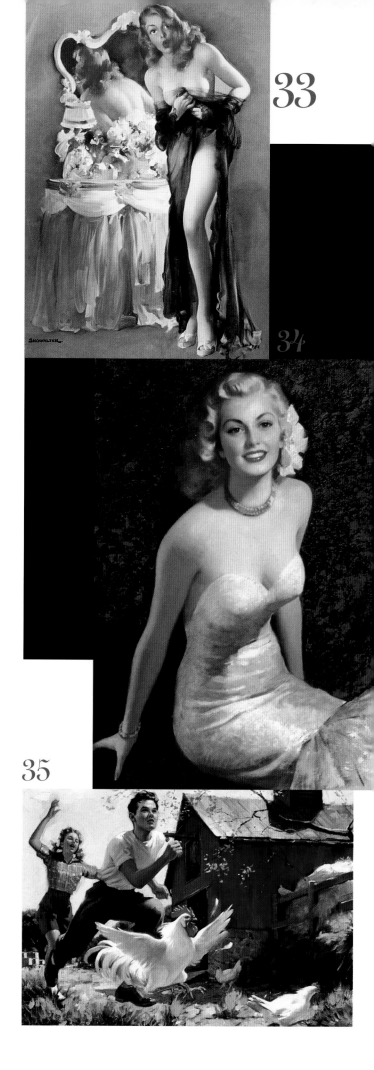

36

37

Now! *for* Coke

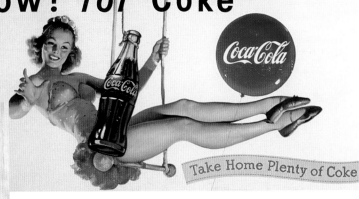

Take Home Plenty of Coke

**33** Haddon H. Sundblom: *Sheer Surprise*. Calendar, published by Louis F. Dow Company with a nom de plume signature, *Showalter*, c. 1958–1960. Oil on canvas, 30 x 22" (76 x 56 cm)
**34** Andrew Loomis: *A Real Knock-Out*. Calendar glamour pin-up, published by Brown & Bigelow. Oil on canvas, 34 x 24" (86 x 61 cm)
**35** Andrew Loomis: *The First Car*. Story illustration, *Ladies' Home Journal*, April 1952. Oil on canvas, 28 x 40" (71 x 102 cm)
**36** Gil Elvgren: *Have a Coke!* Advertising art, Coca-Cola Company, published c. 1937. Oil on canvas, 18 x 23" (46 x 58 cm). Reproduced as a die-cut window display
**37** Gil Elvgren: *The Pause that Refreshes*. Advertising art, Coca-Cola Company. Oil on board, 24 x 34" (61 x 86 cm). Reproduced as a 24-sheet billboard, c. 1945–1950
**38** Gil Elvgren: *Thirst Asks Nothing More*. Advertising art, Coca-Cola Company, c. 1950. Oil on canvas, 22 x 28" (56 x 71 cm)
**39** Gil Elvgren: *Take Home Plenty of Coke*. Advertising billboard, Coca-Cola Company

38

big money-makers for the publishing house, while Elvgren's only previous involvement with the company had been with the two Dionne Quintuplets calendars some years earlier.

While Elvgren was pondering whether to accept Brown & Bigelow's offer, Janet gave birth to their third child and second son, Drake. This new addition to the household had to be considered as Gil weighed the company's offer of a salary that averaged out at about $1,000 per painting, with an expected income of $24,000 the first year. A large sum of money in 1944, it meant that he would become one of the highest paid illustrators in America and certainly be in a unique position at Brown & Bigelow.

Before he committed himself to working exclusively for Brown & Bigelow, Elvgren accepted from the Philadelphia firm of Joseph C. Hoover and Sons his first (and only) commission to paint a glamour-girl subject. Because he did not want to create problems with Brown & Bigelow, he accepted the job on condition that Hoover would accept the canvas unsigned and not publish it as his work. Elvgren received $2,500 for the painting, which, at almost 40 x 30" (102 x 76 cm), was the largest pin-up he had ever created. His pin-ups for Louis F. Dow all measured 28 x 22" (71 x 56 cm), with the exception of *Help Wanted!* (see fig. 116, p. 52), which he painted in the odd size of 33 x 27" (84 x 69 cm).

Elvgren's 1945 painting for Hoover, entitled *Dream Girl* (see fig. 210, p. 90), became the biggest-selling "evening gown"

pin-up ever published by Hoover. It was kept in their Superior line for more than ten years, and in 1945 was also reproduced as an in-store display ad for the Campana Balm Home Dispenser Gift Package. After the rapid success of *Dream Girl*, Hoover's president approached Elvgren about doing a series of calendar paintings, but by that time he had decided to accept Brown & Bigelow's offer.

Elvgren's arrangement with Brown & Bigelow allowed him the freedom to continue doing story illustrations for magazines and advertising work for Coca-Cola. In fact, he could accept any other advertising assignments as long as there was no conflict with his Brown & Bigelow work. And so 1945 was a turning point in Elvgren's long career: the Brown & Bigelow deal marked the beginning of its most important phase, lasting until his retirement in 1972 and even afterward, as he continued to work on special assignments for the firm.

Charlie Ward, president of Brown & Bigelow and the man who had persuaded Elvgren to join the company, was a fun-loving, "live hard, play hard, enjoy life" kind of person. The two soon struck up a good relationship, and Ward told Elvgren he had plans to market the artist's name and work as they had never been marketed before. Keeping his promise, Ward introduced Elvgren to the company's sales staff and national clientele with all the fanfare such a star deserved. Elvgren's name and

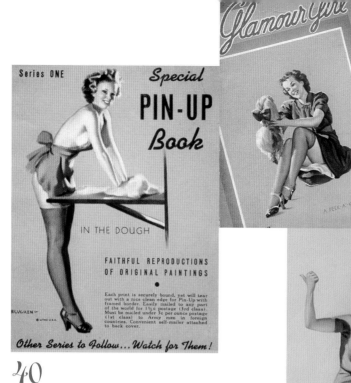

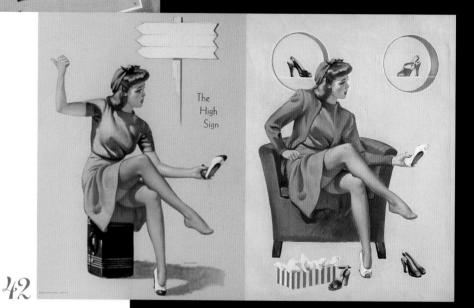

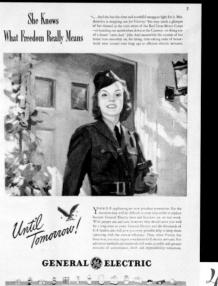

**40** Gil Elvgren: Special pin-up book, series one, published by Louis F. Dow Company, c. 1937
**41** Gil Elvgren: *A-Peek-a'-Knees*. Illustration on *Glamour Girl* picture puzzle, 1940
**42** Gil Elvgren: *The High Sign*. Published as a calendar, notepad, and art print by Louis F. Dow Company, 1937–1943
**43** Gil Elvgren: *A Cute Pair*. Calendar painting, published by Louis F. Dow Company, 1943. Oil on canvas, 28 x 22" (71 x 56 cm)
**44** Gil Elvgren: *She Knows What Freedom Really Means*. Advertising art, General Electric, *Good Housekeeping*, June 1942. Oil on canvas, 22 x 28" (56 x 71 cm)
**45** Gil Elvgren: Advertisement, General Electric, *Good Housekeeping*, June 1942

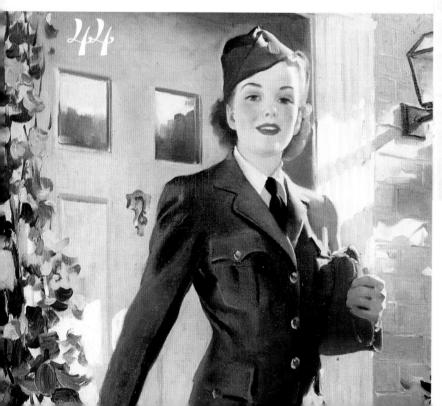

**46** Gil Elvgren: Advertisement, Four Roses Liquor, c. 1947. Oil on board, 16 x 14" (41 x 36 cm). Published as window and counter display
**47** Pruett Carter: Story illustration, *Excuse Me for Living* by Adelaide Gerstley, *The Saturday Evening Post*, c. 1950–1955. Oil on canvas board, 21 x 22" (53 x 56 cm)
**48** Charles E. Chambers: Story illustration, *The Saturday Evening Post*, c. 1937. Oil on canvas, 33 x 25" (84 x 64 cm)
**49** John LaGatta: Story illustration, *Cosmopolitan*, c. 1935. Oil on canvas, 27 x 28" (69 x 71 cm)

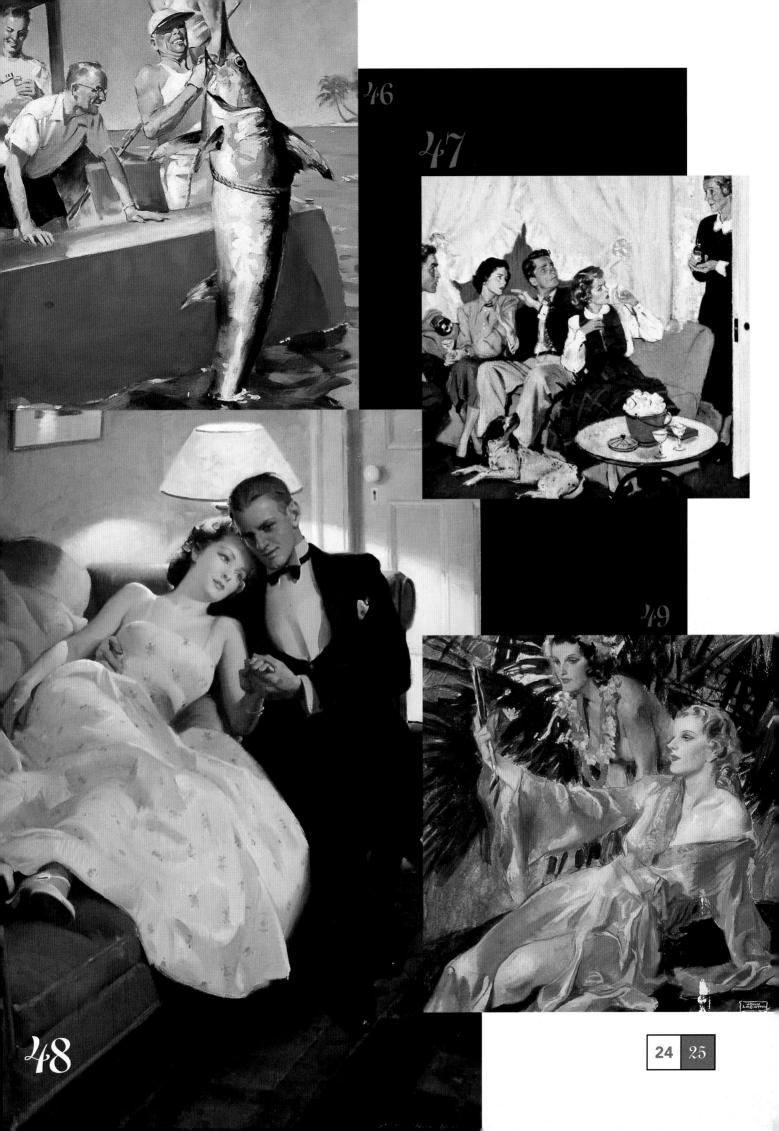

46

47

48

49

landmark style were immediately recognized when Ward described him as the artist responsible for the immensely popular Coca-Cola advertisements and roadside highway billboards.

Elvgren began his Brown & Bigelow pin-up series by selecting a larger, 30 x 24" (76 x 61 cm) canvas as the perfect format. This was considerably bigger than the 28 x 22" (71 x 53 cm) format he had used almost exclusively for the Dow pin-up series. Except for several special commissions on an even grander scale, almost all his subsequent Brown & Bigelow paintings would use the same format as his first canvas for the company.

During Elvgren's first month with Brown & Bigelow in 1945 (doing work for publication in 1946), word came down from the executive offices that Ward had specifically asked his new artist for a nude pin-up for the 1946 line. Enthusiastically accepting the assignment, since he wanted to please Ward by producing a best-selling calendar picture, Elvgren painted a work measuring 36 x 30" (91 x 76 cm), the largest nude he had ever done. *Gay Nymph* (fig. 238, p. 101) depicted a beautiful nude blonde basking on a beach in the purple-blue moonlight and surrounded by exquisite lilacs. The figure became so popular that Brown & Bigelow rushed out a special deck of playing cards carrying the image and packaged it with another deck bearing a nude painted by another of their leading artists, Zoë Mozert. The dual pack, named *Yeux Doux* and captioned "In the Modern Translation By Gil Elvgren – Zoë Mozert", was sold as a promotional item, with the client's name printed on the box cover. The packaging was of the highest quality, and the set made an impressive-looking gift for clients to give their customers at Christmas 1946.

The following year Ward again wanted another Elvgren nude, this time with the double set of cards featuring Elvgren's creations alone. *Vision of Beauty* (fig. 236, p. 100) was an instant hit, equaling the sales figures of *Gay Nymph*, which itself had set a record for Brown & Bigelow nudes. *Vision of Beauty* was a much more conservative, almost fine-art nude in an interior setting. The double-deck box carried the legend "Mais Oui by Gil Elvgren".

During his career at Brown & Bigelow, Elvgren was able to paint only one nude subject a year, and some years the company did not want any nudes at all for their forthcoming line. Since Elvgren enjoyed painting nudes, he would occasionally do them for his own pleasure. Only a few such oils are known to exist at present, among them a wonderful Asian model shown reclining on Elvgren's studio couch during a break in a painting session (fig. 52, p. 27). This painting was done on canvas board measuring 16 x 27" (41 x 69 cm) and dates from about 1947.

Another nude, which like the previous painting hung in Elvgren's studio, was painted in only two hours (fig. 54, p. 27). It shows one of Elvgren's regular models from the 1940s seated in a big, comfortable chair in his studio. Inscribed "Two-Hour Sketch" and signed "Elvgren", it was painted on canvas and measures 29 x 23" (74 x 58 cm). Executed sometime between 1940 and 1945, the work demonstrates Elvgren's extraordinary dexterity. Few artists could create an oil of this quality, with such impressionistic brilliance, in so short a time.

The March 1946 issue of *McCall's* contained Elvgren's first double-page story illustration. The painting (fig. 50, p. 26) was also noteworthy in depicting the first true Elvgren Man, pictured in a romantic pose with one of the most beautiful Elvgren Girls. As reproduced on the printed page (fig. 51, p. 26), the picture had spectacular results, but Elvgren had to disappoint all the top magazines that subsequently clamored for story illustrations. Unfortunately, there just were not enough hours in the day to accommodate even a small portion of the work he was being offered.

The first three pin-up subjects that Elvgren delivered to Brown & Bigelow in 1948 became the company's biggest sell-

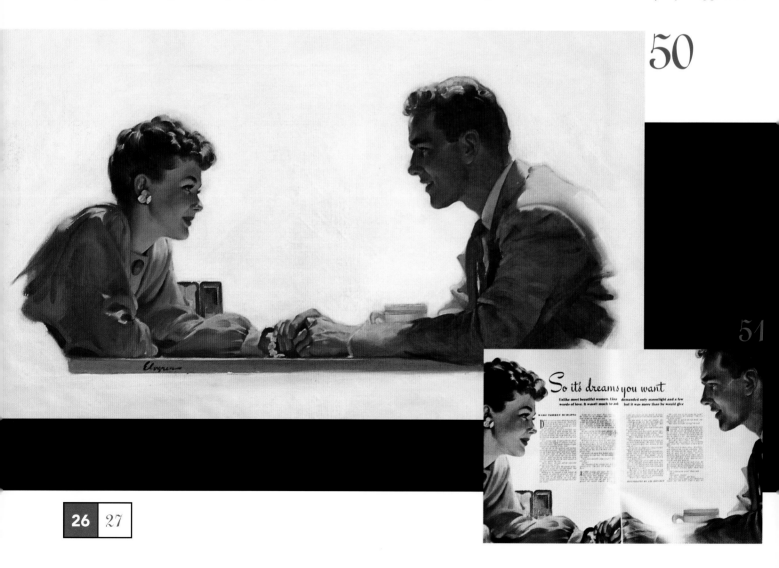

50

51

ers within a couple of weeks of their release. One of these, *He Thinks I'm Too Good to Be True* (fig. 190, p. 80), was the first of Elvgren's non-nude pin-ups to be published by Brown & Bigelow as a giant-size (30 x 20" [76 x 51 cm]), "hanger", or single-sheet, calendar print. This proved so popular that the image was rushed out as a deck of cards. In 1952, it reappeared as one of twelve pictures in a special issue called the *Ballyhoo Calendar*; Brown & Bigelow's art director Clair Fry selected it as the front cover for the envelope (fig. 53, p. 27). Beside the striking title was the caption "Limited Edition – 12 Enticing Eyefuls In Full Color!" Once again, an Elvgren product, the first of its kind for Brown & Bigelow, had generated a great deal of unexpected income for the publisher.

While Elvgren's nudes and pin-ups were enjoying such wide acclaim, a fellow artist whose career Elvgren had followed was also in the national spotlight. Albert Dorne (1904–1965) was the creator of a series of monthly ads for the popular 1015 Wurlitzer Juke Box (fig. 55, p. 27) that were published from 1946 as full pages in every leading American magazine. Elvgren kept a comprehensive file on these, since he felt their composition and handling of color were quite progressive for the time. Dorne was elected president of the Society of Illustrators and became founder-director of the Famous Artists Schools in Westport, Connecticut.

Between 1948 and 1949, Elvgren introduced another innovation to the advertising-specialty world in the form of an Elvgren Girl letter opener. The sculpture was in cream-colored plastic and packaged in a folding container. Clients could run their advertising message on a beach ball that the girl held over her head (fig. 59, p. 29). A special message on the packaging read: "Yes sir! When there's a job to be done, a service to perform, or a need to be met, we're ready for action. And when it's time for a smile, we like to erase those frown lines with something on the light side, for all work and no play makes Jack a dull boy. So … meet Ellen, the Eye Opener, a girl who'll appeal to your 'mail' instincts … as she opens your mail, let her serve to remind you of us. Treat her nice … she's a swell gal. Designed by Elvgren".

By the end of the decade, Elvgren was the most important artist Brown & Bigelow had under contract. In his short time with the company, he had painted a half dozen wildly successful images and created an innovative product that had never featured before in their line. With the vigorous assistance of the media, his art had now begun to reach a vast new national audience. In March 1948, *See* magazine published a five-page article called "Eye-Catching Calendars" on Elvgren and his work. Elvgren and his studio assistant, Ewen Lotten, were pictured positioning eighteen-year-old pin-up model Pat Varnum on a special set that Elvgren had built in his studio solely for the purpose of photographing this one model for one calendar-painting assignment.

The magazine *U.S. Camera* followed with a similar article in March 1949 focusing on Elvgren's calendar work and the process by which he created a pin-up painting. Titled "An Artist Lights a Model", it specifically discussed Elvgren's personal preferences with respect to studio lights when shooting a model for an assignment. Five months later, in August 1949, Elvgren found himself and his work the cover story in a third national magazine, called *Pix*. The story, "Legs Are Big Business", was subtitled "Calendar Artist Elvgren's Sexy Masterpieces Are Big Sellers" and featured the model Candy Montgomery, who posed for Elvgren's *Keeping Posted* (fig. 193, p. 81).

Thanks to the phenomenal success of Elvgren's pin-ups, Brown & Bigelow was harvesting a steady stream of new clients. By 1950, the firm had hundreds of new clients for advertising-specialty products bearing images by Elvgren. The artist himself was also being approached by new companies and major advertising agencies that wanted to commission him for

various commercial jobs. And, as before, there simply was not enough time to handle even a fraction of the work being offered. The companies for whom Elvgren did manage to fit in advertising work included Coca-Cola, Orange Crush, Schlitz, Red Top Beer, Ovaltine, Royal Crown Soda, Campana Balm, General Tire, Sealy Mattress, Serta Perfect Sleep, Napa Auto Parts, Ditzler Automotive Finishes, Frankfort Distilleries, Four Roses Blended Whisky, General Electric Appliance and Pangburn's Chocolates.

Faced with such demand for his work, in 1950 Elvgren considered opening his own studio staffed by illustrators he had studied with, artists who were once his own students, and talented aspiring illustrators. There were many such artists who

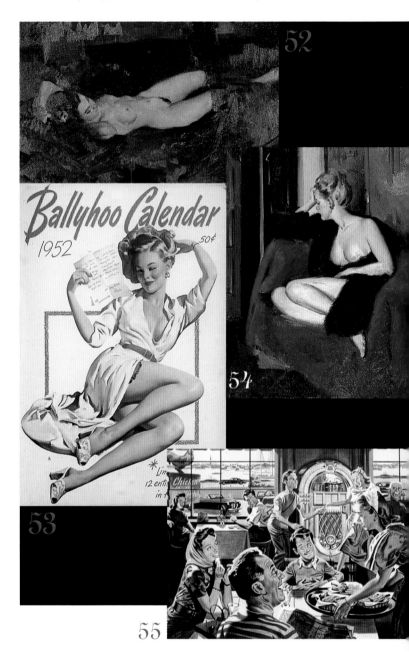

50  Gil Elvgren: Two-page story illustration, *So It's Dreams You Want* by Ware Torrey Budlong, *McCall's*, March 1946. Oil on canvas, 24 x 34" (61 x 86 cm)
51  Gil Elvgren: Two-page story illustration, *McCall's*, March 1946
52  Gil Elvgren: *Reclining Oriental Nude in Studio*, c. 1947.
Oil on canvas, 16 x 27" (41 x 69 cm)
53  Gil Elvgren: Envelope cover for *Ballyhoo Calendar*, published by Brown & Bigelow, 1953
54  Gil Elvgren: *Two-Hour Sketch*, c. 1940–1945. Oil on canvas, 29 x 23" (74 x 58 cm)
55  Al Dorne: Advertisement for Wurlitzer (Juke Box), *The Saturday Evening Post*, 1946. Oil on board, 16 x 20" (41 x 51 cm)

admired both Elvgren and what became known as Sundblom's Chicago School of "mayonnaise painting". The latter phrase was applied to Sundblom's and Elvgren's art because both achieved such a creamy, "smooth as silk" look in their paintings. However, after weighing the pros and cons, including all the headaches and responsibility of operating a larger-scale business, not to mention the loss of time to his own career, Elvgren let the idea drop.

America had emerged from the World War II years a new country. The "baby boomer" phenomenon was in full force, housing starts were at an all-time peak, and the illustration industry was entering the most productive decade of its history. Between 1950 and 1960, American illustration art experienced a golden age as the demand for editorial, advertising, book and calendar artwork reached record levels. Elvgren continued to keep an eye open for new ideas. As earlier in his career, there were artists whose work he especially followed and kept in his file of tear sheets for reference.

One such artist was Tom Lovell (1909–1997), who had the biggest folder in Elvgren's file cabinet. Nearly three inches thick, it was filled with almost every piece of illustration Lovell had ever had published. In the margin of one magazine love-story illustration, in which Lovell had depicted a pin-up-like subject (fig. 57, p. 28), Elvgren had written comments, along with a note to remind Al Buell to review this subject. In fact, in a kind of mutual admiration society, Elvgren and Lovell would call each other on the telephone to pass compliments back and forth.

Also distinguished by mutual respect was Elvgren's relationship with the illustrator Walter Baumhofer (1904–1985). Both worked for the art director of *McCall's* from 1946 into the mid-1950s. Elvgren admired Baumhofer's brilliant use of lighting to set the ideal mood for a scene from a story (fig. 56, p. 28). Like Sundblom, who often used light to render his story illustrations dramatic, Baumhofer was most successful in capturing the particular quality of a written scene in visual terms. Elvgren had followed Baumhofer's career since the 1930s, when the older artist had painted pulp magazine covers at Street and Smith alongside Robert G. Harris (born 1911). Harris painted in a slick, almost photorealistic, manner that many of his contemporaries admired. Elvgren drew Brown & Bigelow's attention to Harris, who was commissioned to do his only calendar pin-up for the company. Although executed as a glamour evening-dress subject (fig. 58, p. 29), the Harris calendar piece commanded much respect from Brown & Bigelow's staff artists and executives.

In a telephone interview a few years ago, Harris told me that he remembered how Elvgren was envied by most of his fellow illustrators, especially at the Society of Illustrators in New York. For them, Elvgren had a "dream career". He painted beautiful women every day of his life, while they had to regularly accept the often boring tasks required by their commissions.

From the mid-1940s to the mid-1950s, Elvgren was also inspired by the work of Walt Otto. Like Elvgren, Otto was a "mainstream" commercial illustrator as well as a pin-up and glamour artist. Both men had been educated in Chicago and started their careers there, and each enjoyed the other's work. Similarities to Elvgren's style can be seen in Otto's *Saturday Evening Post* cover of a skiing girl (fig. 60, p. 30) and in his advertising painting for Alka-Seltzer (fig. 63, p. 30).

Because of Elvgren's great popularity, Brown & Bigelow often used him for special promotions. Within the company, he spent much time with the national sales managers, since they and their regional salesmen were responsible for selling the new products every year. Out "on the road", he met the press, the other media and the public at various publicity events. As a result of his travels, Elvgren had the opportunity to meet many people, including a number of celebrities, some of whom be-

**56** Walter Baumhofer: Two-page magazine story illustration, c. 1950. Oil on canvas, 17 x 34" (43 x 86 cm)
**57** Tom Lovell: Two-page magazine story illustration, c. 1950. Oil on canvas, 24 x 36" (61 x 91 cm)
**58** Robert G. Harris: *The Right Number.* Calendar, published by Brown & Bigelow, c. 1950. Oil on canvas, 24 x 20" (61 x 51 cm)
**59** Gil Elvgren: *Ellen, the Eye-Opener.* Letter opener, manufactured by Brown & Bigelow, c. 1958–1960. Plastic, 10 x 1 3/4" (25 x 4 cm)

57

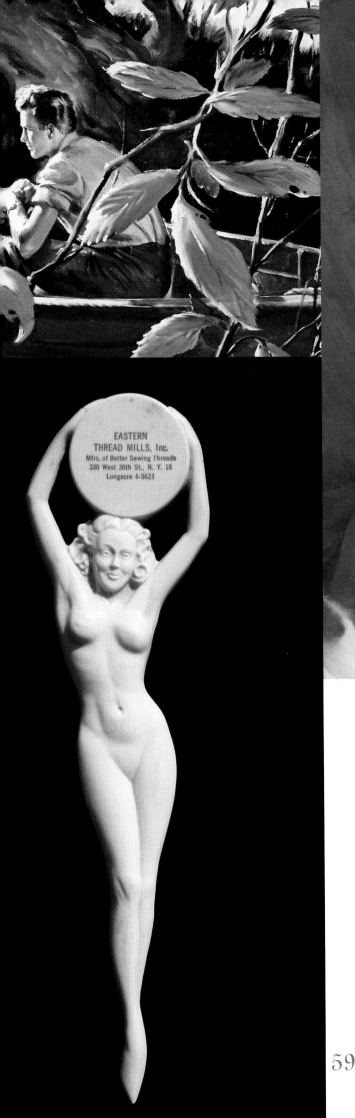

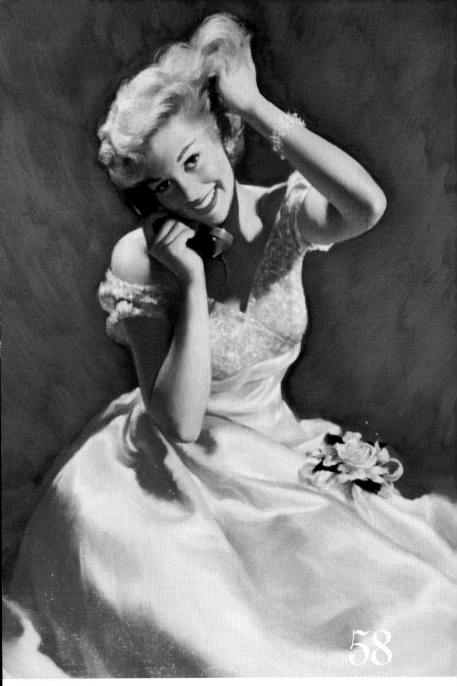

came close friends. One such was film star Harold Lloyd, who, about 1950, introduced Elvgren to 35mm stereo color photography. Already an avid photographer, Elvgren immersed himself in this new area of interest whenever he could find the time.

Lloyd valued Elvgren first and foremost as a friend rather than as a noted illustrator, but was nonetheless a fan of Elvgren's work, and about 1951 Elvgren gave him one of his best Brown & Bigelow nudes (fig. 251, p. 108). This was the first pin-up (and also the first nude) that Clair Fry asked Elvgren to create specifically for publication on playing cards. The result was *To Have*, an oil-on-board painting measuring 27 x 19" (69 x 48 cm). A second similar image was entitled *To Hold*. The resulting double deck of cards was manufactured with a special die-cut window flap that showed just the model's face. The copy inside the flap read: "Whether they be blondes, brunettes or redheads, gentlemen really prefer GIRLS … Especially those charmers painted by Gil Elvgren. And whatever preference you may have in the way of card games, we hope your pleasure will be heightened by the presence of these two lovelies." When the inside flap was removed, the full nude pin-up was revealed.

Elvgren could afford to give away his paintings because in 1951 his salary arrangements with Brown & Bigelow had changed.

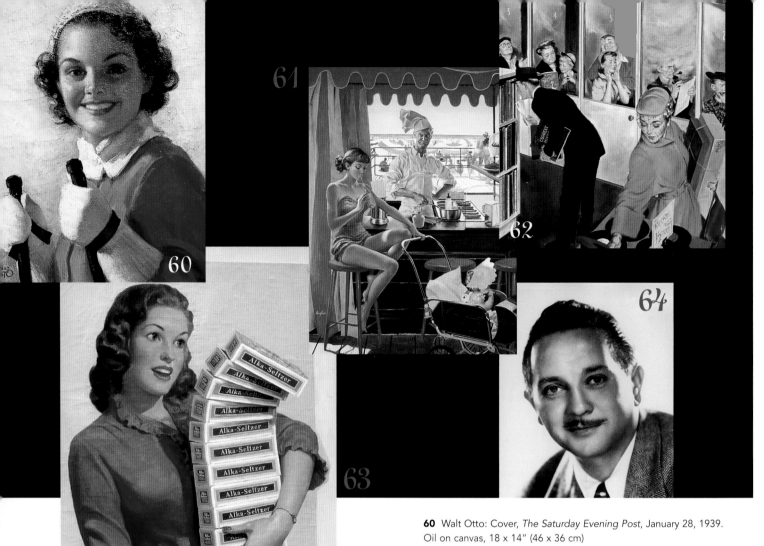

**60** Walt Otto: Cover, *The Saturday Evening Post*, January 28, 1939. Oil on canvas, 18 x 14" (46 x 36 cm)
**61** George Hughes: Cover, *The Saturday Evening Post*, August 28, 1954. Oil on Masonite, 31 x 25" (79 x 64 cm)
**62** Thornton Utz: Cover, *The Saturday Evening Post*, April 19, 1952. Oil on board, 19 x 18" (48 x 46 cm)
**63** Walt Otto: Advertisement, Alka-Seltzer, published as a display poster, c. 1950. Oil on canvas, 30 x 24" (76 x 61 cm)
**64** Gil Elvgren, c. 1950

From his previous rate of $1,000 per canvas, he was now paid approximately $2,500 per painting, with a projected yearly output of twenty-four subjects. With the supplementary income from fees for his magazine illustrations and numerous national advertising accounts, Elvgren was able to move his family from downtown Chicago to the suburb of Winnetka. As soon as they moved into their new home, Gil began building a studio in the attic. Fitted with overhead windows that allowed the northern light to flood his easel, the studio was completed within months. Elvgren's son Drake told me that his father initially worked alone in the studio, but soon hired a full-time assistant who helped light and photograph the models, built sets with various props to portray different subjects and prepared Elvgren's paints and tools. Having a studio located in his home enabled Elvgren to work more efficiently, since he thus eliminated commuting and other time-consuming intrusions on his day.

Getting ideas for new subjects was a constant problem. Like many other artists in the pin-up and glamour world, he often felt that every imaginable subject had already been done over and over. When he worked at the Stevens/Gross Studio with a dozen other fellow artists, Elvgren had regularly discussed ideas with them, and they in turn asked for advice from him. I remember Joyce Ballantyne telling me in a phone conversation around 1982 that she and Elvgren often traded ideas. She went on to say that it was the practice at the Studio for artists to help each other out in other ways as well: if someone was not feeling well or was under pressure from a client or a deadline to finish a painting, one of the others would take up a brush and finish the painting for the beleaguered colleague. At home, Elvgren did not have that luxury, although sometimes, when stuck for a creative thought, he would pick up the telephone and see what his artist friends might suggest.

Elvgren was also generous with ideas for friends like George Hughes, who painted more than 125 front covers for the magazine *The Saturday Evening Post*. Elvgren once told him about a scene he had witnessed at a beach, and Hughes developed the idea into a pin-up-like subject (fig. 61, p. 30) published as a *Post* cover on August 28, 1954. Elvgren came up with a similar suggestion for his close friend Thornton Utz (born 1914), who told me in an interview many years ago: "Gil was smart as a whip when it came to ideas. One day I was stuck for a new *Post* cover idea and Gil mentioned he had been in a record store the day before. He described all the people in each booth listening to the record they were thinking about purchasing and I took his thought and worked up some preliminary sketches. Eventually [April 19, 1952] the idea became a published *Post* cover" (fig. 62, p. 30).

In 1951, *Modern Man* magazine ran a feature story on Elvgren and used as a cover picture Elvgren photographing

model Candy Montgomery for the assignment, which would be entitled *Keeping Posted*. In the feature, Elvgren is referred to as "America's greatest painter of topical art." When asked what he thought of American women, Elvgren said they "are infinitely smarter today. They are more beautiful than ever before. They are more natural. They are not tying themselves in like they used to. And they are not looking like boys any more, thank God." He also told the magazine that "movies, TV, and magazines have had an enormous influence in changing old-fashioned standards. And calendar art has probably had more influence than any of these."

During the 1950s, *Figure Quarterly* magazine interviewed Clair Fry several times about Elvgren (fig. 64, p. 30). His perception of who Elvgren was and how he was in those days is quite informative:

First of all, Gil is one of the most able draftsmen and painters in the commercial field. That, actually, is only a small part of the story. There are many able draftsmen and painters who have never risen above complete obscurity. I suppose, considering the difference, it is like two men, each having a fine set of carpenter's tools, the tools being comparable in every respect; one of them has a clear-cut plan of the house he is going to build in his mind, while the other man with equally fine equipment, works without that clearly defined understanding of an objective.

Gil has excellent taste. That is a commodity hard to come by. Many artists with great ability never are accepted because line and pattern, excellent though they may be from the literal point of view, add up to an effect that is clumsy, dull, and lacking that peculiar essential which in real life makes one particular girl stand out in sharp contrast to the great average.

Gil also has wit. Not only in his situations having a humorous turn, but even more in the ingenuity and inventiveness shown in his color schemes, poses, gestures, and all that goes into a lively, exciting statement that captures universal attention. His work is sincere and very honest. The reaction to Gil's paintings is that here is a real girl. The carefully thought out gestures and expressions are done with such mastery that they convey the exact meaning Gil intended without the phoney quality that exists in such a vast percentage of commercial painting. Gil has his finger on the pulse of the current evaluation of feminine beauty. This is a most important factor. If you look at the pictures of pretty women from Rubens on, you find a distinct change in the yardstick of various eras as to what is and what isn't beauty. Gil knows exactly what the ingredients are to touch the fancy of that judgment at this moment. Maybe, when everything else has been said, that knowledge and the ability to translate it is the most important factor in Gil's outstanding success.

The recognition of his abilities, as described by Fry, meant that Elvgren's doorbell never stopped ringing. Callers ranged from those who implored him to do "just one job" to those who wanted him to do everything for their company or product. In the early 1950s, the Schmidt Lithograph Company of Chicago and San Francisco succeeded in hiring Elvgren to paint a number of "universal billboards" for their varied clients. These billboards were so called because they featured a format and images that could be easily adapted to sell almost any product. Most of these works consisted primarily of glamour heads, almost always without background props or settings, although the first two assignments Elvgren delivered were exceptions to that format. The first painting Elvgren executed for Schmidt was entitled *Poolside Fun* (fig. 65, p. 32). It depicted a beautiful Elvgren Girl drying her hair after a dip in the pool, while in the background a couple seated at the poolside is being served a beer by a butler. In the upper left corner, another Elvgren Girl stands

on a diving board about to take the plunge. The entire scene is held together by Elvgren's brilliant perspective and composition.

Elvgren's second job for Schmidt was a portrayal of a smiling beauty holding a tray of beer bottles (fig. 66, p. 32). The artist himself painted the title, *The Pick of the Picnic!*, directly onto the work. Most of Elvgren's work for Schmidt was executed on illustration board measuring approximately 15 x 30" (38 x 76 cm). In most cases, he used only the leftmost third of the board and kept the rest of the board blank for the advertising copy. These original paintings have sometimes been subsequently cut down in order to eliminate the blank area, when a collector wanted to frame just the painting; however, there are a few diehard collectors who insist on leaving the board as it was originally made.

In another version of *The Pick of the Picnic!* (fig. 67, p. 32), the bottles have been changed by mechanical overlay into a single quart bottle of A-1 Pilsner Beer. The Elvgren Girl pointing her finger and smiling (fig. 70, p. 33) was modeled by Myrna Hansen, who started working for Elvgren in 1951, when she was fifteen years old, and later became one of his favorites. Another painting, of a girl wearing a pearl necklace (see fig. 585, p. 238), was used in two different versions by Schmidt, the company having sold the same image to two separate businesses. Elvgren's paintings were similarly altered to suit a specific situation when they were reproduced in advertisements for Pangburn's Chocolates (figs. 68 and 69, p. 33).

During the 1950s and 1960s, Elvgren took great pleasure in following the careers of artists whose work he admired. Since he continued to accept magazine commissions for many years, some of these artists came from that field. His file on Jon Whitcomb (born 1906; fig. 71, p. 34) was massive and seems to have included almost every published illustration that Whitcomb did during his prolific career. Unlike Elvgren, Whitcomb worked mainly on illustration board but would, very occasionally, execute an oil on canvas for a magazine story illustration.

Another artist respected by every illustrator at work between the mid-1930s and the 1950s, including Elvgren, was Edwin Georgi (1896–1964). Utilizing iridescent pastel colors long before they were fashionable, Georgi developed a dramatic approach to color that became his trademark. Almost always focusing on beautiful women (and handsome men), his work was seen in all the leading American magazines (fig. 72, p. 34). Elvgren's appreciation for the talent of his peers underscores how generous and unpretentious a man he was.

After settling in the new house in Winnetka, sometime about 1953 Elvgren and his family went to Florida on vacation. Almost immediately upon arrival, the artist fell in love with this popular vacation spot. For one who had lived with snow and ice for so long, the clean blue sky, the tropical winds, and the swaying palm trees were just too good to be true. And, even though he had just set up a new life and home in Winnetka, he started to consider moving to the Golden State.

In January 1955, Charlie Ward called Elvgren to request a special painting of a nude that would be used for Brown & Bigelow's 1957 line as a one-sheet hanger. This format is a large – usually 20 x 30" or 22 x 28" (51 x 76 or 56 x 71 cm) – single-print calendar with the months either printed on it or attached to it in a pad. When Elvgren's sultry blonde nude was delivered to the company's headquarters, it was given the title *Golden Beauty* and then inventoried before being sent to Ward's office. To everyone's surprise, the painting then vanished. It is published for the first time here (fig. 252, p. 109). The story behind the disappearance is as follows: after keeping the painting in his home for a number of years, Ward gave it to Red Rudinski, chief of Brown & Bigelow's maintenance department and a longtime friend. The author of a book about safecracking techniques, Rudinski eventually came to owe a very big favor to a St. Paul

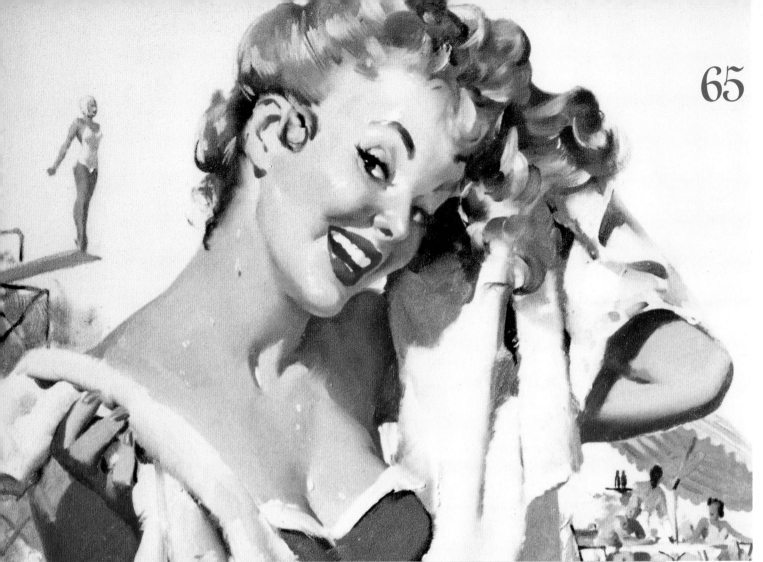

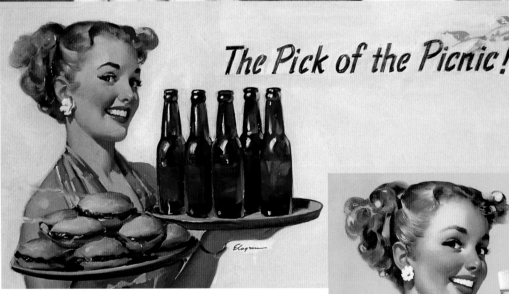

The Pick of the Picnic!

66

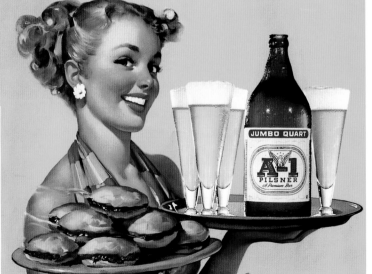

**65** Gil Elvgren: *Poolside Fun*. Universal billboard, Schmidt Lithograph Corp., c. 1950. Oil on board, 16 x 20" (41 x 51 cm)
**66** Gil Elvgren: *The Pick of the Picnic!* Universal billboard, Schmidt Lithograph Corp., c. 1950. Oil on board, 18 x 30" (46 x 76 cm)
**67** Gil Elvgren: Segment of universal billboard advertising A-1 Pilsner Beer – Jumbo Quart, Schmidt Lithograph Corp., c. 1950
**68/69** Gil Elvgren: *Check and Double Check* and *On Her Toes!* Used in advertisements for Pangburn's Chocolates
**70** Gil Elvgren: Cut-down universal billboard for Schmidt Lithograph Corp. Oil on board, 18 x 16" (46 x 41 cm)

67

PANGBURN'S *Milk and Honey* CHOCOLATES

*a Valentine* *she will never forget*

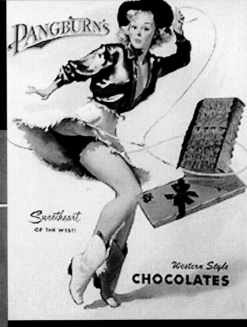

PANGBURN'S

*Sweetheart* OF THE WEST!

*Western Style* CHOCOLATES

68

69

70

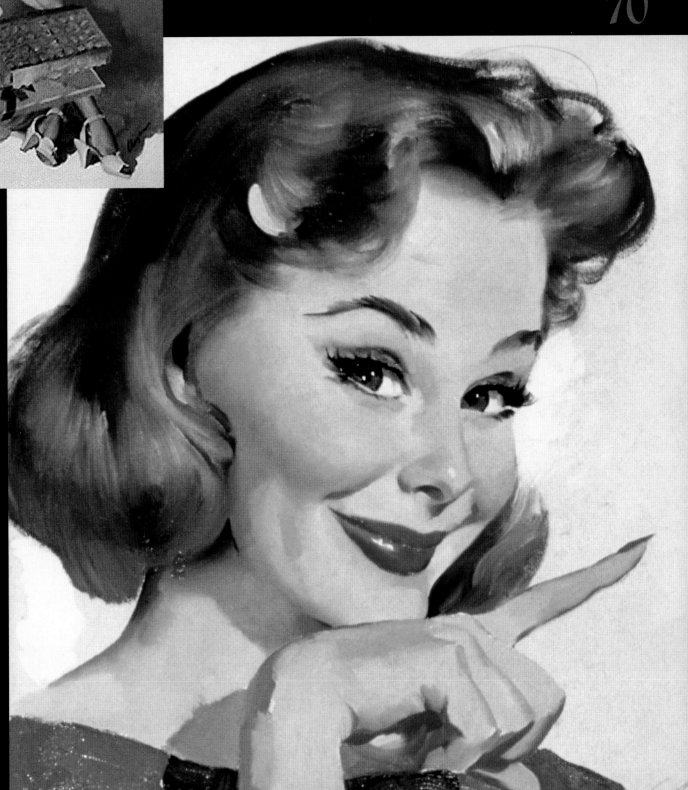

PANGBURN'S *Milk and Honey* CHOCOLATES

real-estate magnate and gave the painting to him for Christmas. For the next thirty years, the painting remained in the back office of the real-estate firm in downtown St. Paul, where it became something of a legend. Finally, it was acquired by an art collector in 1990 for a private collection.

Also in 1955, Elvgren attained a measure of pop cultural status when twelve of his best Brown & Bigelow pin-ups were reproduced on a revolving lampshade (fig. 75, p. 35). The shade hung on a spindle so that it turned as the heat escaped through vents located on its top. Manufactured by the Econolite Corporation, the unit was known as a motion or heat lamp. Since it was made from celluloid, the shade was extremely fragile and highly susceptible to burning from the heat of the lightbulb.

In 1954, one of Elvgren's favorite illustrators, Harold Anderson (1894–1973), was asked to do a calendar painting of the Coppertone Billboard Girl. Elvgren's friend Joyce Ballantyne had painted the original advertising 24-sheet billboard subject, *Don't Be a Paleface!* (fig. 73, p. 35), which eventually became a popular icon. Depicting a small dog pulling down a little girl's bathing suit, the painting helped to establish Ballantyne's reputation as a mainstream advertising illustrator, while making Coppertone one of the best-known products in the world. (Elvgren had first met Joyce Ballantyne at the American Academy of Art in Chicago, when he was teaching there. She was one of his students, but she soon became both his friend and his artistic peer.) Anderson's painting for the calendar commission was executed in a thick, rich, creamy Sundblom-Elvgren style: it won Elvgren's enthusiastic approval upon completion and was a runaway success upon its publication (fig. 74, p. 35).

In 1956, Elvgren finally convinced his family to make the big move down to Florida. This idea had been on his mind for almost four years, and the time seemed just right for a change of lifestyle and environment. Elvgren had many friends waiting for him in Florida. Joyce Ballantyne had been there for some time, as had such old friends as Arthur Sarnoff, Bill Doyle, and Elmore Brown. Especially gratifying to Gil was that two of his

and Janet's closest friends, Al Buell and Thornton Utz, lived there with their families. So, from the day of their arrival, they were in a sense actually more at home than they had been up North. In addition, the Illinois weather had not been conducive, for much of the year, for visiting and socializing, while in Florida just the opposite was true. Elvgren soon found that he liked everything about living in his new adopted state.

The Elvgrens found an ideal house on Siesta Key, and Gil built a fabulous split-level studio there. For the first four years, he had a studio apprentice named Bobby Toombs, who went on to become a recognized artist in his own right. In a telephone conversation I had with Toombs in 1980, he told me what a terrific teacher Elvgren had been. He said that Elvgren not only taught him the handling of paints and various shortcuts that would help when working to deadlines, but also showed him how to approach a given assignment in a properly thoughtful manner (a philosophy that reflected the teachings of Howard Pyle and Harvey Dunn). Toombs said, "Naturally the color values were a major part of the learning process, but with Gil Elvgren by your side, you felt as if you could do anything. He would pick up a brush and make it dance all over the canvas. It was like magic watching him paint, back in those good old days."

Once he was settled in Florida, Elvgren painted a great many portraits, but not for the reason that most semi-retired illustrators do. With no aspirations to "fine" art, Elvgren simply enjoyed the people he met in his new community in Siesta Key. Many of his models were famous or went on to become so after posing for him. Myrna Loy, Arlene Dahl, Donna Reed, Barbara Hale, and Kim Novak were just a few of Gil's models. In the 1950s and 1960s, it was a great career boost for an aspiring actress or starlet to have her likeness reproduced and published on a million Elvgren calendars. In fact, many Hollywood starlets rode the train each week between Los Angeles and St. Paul, home of Brown & Bigelow, just to present themselves for consideration as models for Elvgren or one of the other big names.

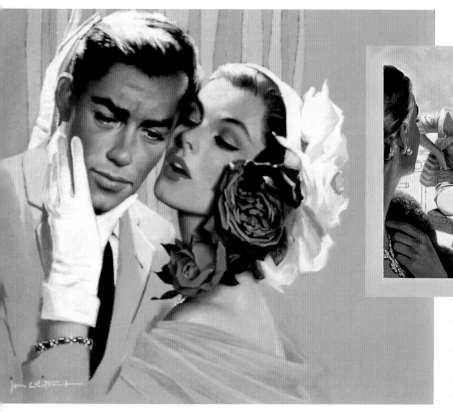

*72*

*71*

**71** Jon Whitcomb: Magazine story illustration, *I Think I Love You.* Oil on canvas, 16 x 20" (41 x 51 cm)

**72** Edwin Georgi: Story illustration, *A Date with Bo. Redbook*, June 1953. Oil on board, 27 x 22" (69 x 56 cm)

**73** Joyce Ballantyne: *Don't Be a Paleface!* Cardboard billboard display for Coppertone. Reproduced from 1950 to the present day

**74** Harold Anderson: *The Coppertone Girl.* Published as a calendar, c. 1955

**75** Revolving electric lamp, with twelve Elvgren pin-ups reproduced on the shade. Manufactured by the Econolite Corporation, c. 1955

Although most artists prepare preliminary drawings or sketches of a subject before tackling an oil, Elvgren did not normally do so. He did, however, sometimes ask his studio apprentice to execute such drawings if the latter was so inclined. On the occasions when Elvgren decided to do something special in a pin-up job, he would often make a study himself. Generally these were fairly small, measuring an average of 20 x 16" (51 x 41 cm). Once he did a fully finished preliminary drawing – for the pin-up entitled *Bear Facts* (or *Bearback Rider*; fig. 414, p. 172), one of his most famous Brown & Bigelow images. The drawing was almost the size of his oils at 28 x 22" (71 x 56 cm), just slightly smaller than the 30 x 24" (76 x 61 cm) of the finished oil paintings. This sensational study (see fig. 415, p. 172) was inscribed and given as a gift to "Toni". Its lower left corner reads, "To Toni – Who could have been my most favorite model! 'Hi Neighbor!' Gil Elvgren." Toni's identity is not known, but she may well have modeled for Elvgren, and specifically for some of his Schlitz advertising paintings, since that company's ad slogan was "Hi Neighbor!" It is also possible, but unlikely, that Toni was a next-door neighbor.

In choosing his models, Elvgren did not limit himself to the starlets and actresses mentioned earlier. In the 1940s, he was especially fond of Dayl Rodney and Pat Varnum, both in their late teens. From the mid-1950s, after the move to Florida, the model Myrna Hansen (who in 1954 became Miss USA) and his fifteen-year-old neighbor, Janet Rae, posed for him. In the 1960s, Rusty Allen and Marjorie Shuttleworth were favorites.

Elvgren was always searching for new themes and situations that could be worked out in his canvases. Although his fellow pin-up artists in Florida would often come up with suggestions, it was his family that he relied on most. Ever since the Chicago days, Gil had been in the habit of discussing ideas with his wife and children at dinnertime. The opportunity for all of them to kick ideas back and forth made for an entertaining way of sharing the night's meal.

Besides a special account for Napa Auto Parts at Brown & Bigelow every year, Elvgren was also asked to do one pin-up a year for both Ditzler and Sylvania. For the first two accounts, he had to submit an almost full-size (30 x 22" [76 x 56 cm]) color preliminary painting (fig. 551, p. 230); for Sylvania, a pencil study was required. Elvgren shared the Sylvania assignment with Bill Medcalf, the Ditzler project with Mayo Olmstead (born 1925). In an interview in 1990, Olmstead recalled meeting Elvgren in the early 1950s, when the younger artist was doing his first Brown & Bigelow assignments. He had been a fan of Elvgren's for years, and the idea of meeting and working with him at Brown & Bigelow had made him understandably nervous. According to Mayo:

Gil Elvgren was the nicest guy you'd ever want to meet. He couldn't do enough to help a fellow artist out. When I first went to Brown & Bigelow around 1950, Elvgren was already the star of the operation. Everyone respected his talent and ability, which was in a class by itself. I remember ever so vividly the way Gil helped me. My first assignment was to paint a Western cowgirl pin-up subject for a "hanger" calendar. I wasn't even sure how big my original should be, but Gil was right there helping me, suggesting I use the same size canvas as he used, 30 x 24" [76 x 61 cm], and I did, although I did my painting as a horizontal image [fig. 76, p. 37] because it was going to be reproduced larger than normal due to the enormous size of the "hangers". If it hadn't been for Gil Elvgren helping me and supporting me at Brown & Bigelow through that first job, you know, the cowgirl piece, and then through my next few assignments, I don't think I would have ever made it! He was a real "prized" individual, you know, like a one-of-a-kind original-gem human being! I have been grateful to Gil for all of his help, his friendship, and his artistic guidance ever since the day I first met him.

The Napa pin-ups that Elvgren did for Brown & Bigelow had to be more conservative than usual. To circumvent problems, Elvgren always submitted a fully finished preliminary study, executed in oil on illustration board, to the company, which would then present it to the Napa executives for approval. Only then would he paint the finished oil. In one of these studies (fig. 573, p. 235), the fish

75

73

74

COPPERTONE®
Get the Fastest Suntan Possible
...with MAXIMUM SUNBURN PROTECTION

DON'T BE A PALEFACE!

the woman has reeled in lies between her legs. After reviewing the study, the Napa executives asked Brown & Bigelow's art director, Buzz Peck, to ask Elvgren to move the fish to one side, and this is how it appears in the final version.

Haddon Sundblom's influence on Elvgren remained perceptible even at the height of his career. In turn, Sundblom's own paintings bore traces of various other artists' work – Howard Pyle, Harvey Dunn, John Singer Sargent, Anders Zorn, Robert Henri, J. C. Leyendecker and Pruett Carter – but the prime influence was that of Sorolla. Sorolla's sunlit glow pervades Sundblom's work and was passed on by him to Gil Elvgren and his circle. This "circle" was a group of artists with whom Elvgren had studied or whom he had taught in Chicago. It contained many who became close friends. What they had in common was that they had all studied and worked under the watchful eye of "Sunny", as they affectionately called Sundblom. Among them were Harry Anderson, Joyce Ballantyne, Al Buell, Matt Clark, Earl Gross, Ed Henry, Charles Kingham, Al Kortner, Al Moore, Walt Richards, James Schucker, Euclid Shook, Bob Skemp, Thornton Utz, Coby Whitmore and Jack Whitrup.

In Siesta Key, Elvgren met the famous writer John D. MacDonald, whom Drake Elvgren remembers as living directly across the water from his family. The men became great friends, spending hours playing chess and often attending the many parties in their community. Elvgren, who did not enjoy being in the limelight, would hide his shyness in social gatherings by sitting at any available piano and playing – anything to avoid making small talk. Occasionally, Elvgren and MacDonald were joined by the artist's other famous author buddy, MacKinlay Cantor.

The Elvgrens also continued to socialize regularly with the Buells and Utzes. Al Buell had worked for Brown & Bigelow for almost twenty-five years, starting like Elvgren by painting pin-ups, but eventually becoming responsible for the successful *Artist Sketch Pad*, a twelve-month calendar (fig. 77, p. 37). Utz mainly painted covers for *The Saturday Evening Post* and had various national advertising accounts, but like Elvgren and Buell, he enjoyed painting a beautiful woman whenever the opportunity presented itself. One of the works he executed in Florida is a painterly rendering of a pin-up by the seashore that captured perfectly the spirit of the time (fig. 79, p. 38).

Gil Elvgren lived life to the fullest. As an avid outdoorsman, he enjoyed hunting, fishing, trolling for pike in northern Minnesota and deep-sea fishing in Florida. Although he didn't care much for swimming in the ocean, he could regularly be found taking dips in his pool and relaxing at poolside. He also loved to race cars with his two sons. He owned two racing cars, and every year he would take his family to Sebring, Florida, to watch the twelve-hour Grand Prix of Endurance.

Another activity Elvgren enjoyed with his sons involved his lifelong passion for collecting fine vintage weapons, especially pistols and rifles. He had been introduced to guns and weaponry at the age of four, when at a war bond rally in 1918 his father had hoisted him onto his shoulders so that Gil could see a display of guns in a store window. At ten, he received his first gun as a birthday gift from his Dad. After that, he began collecting them and eventually became a sharpshooter, winning numerous competitions throughout his lifetime. He even built a fifty-foot shooting range in the basement of his house in Winnetka. By the time he moved to Florida, he had more than one hundred valuable examples of firearms, which he kept in three glass-enclosed wall cases. Elvgren was a member of the Sarasota Gun Club and also the Sarasota Rifle and Pistol Association. He taught firearms courses for the Chicago Police Department, the Air Patrol, the Civil Defense and the Coast Guard.

Over the years, Elvgren had probably a dozen or so helpers in the studio, most of whom were talented artists who aspired to achieve greatness by developing their own talents with the instruction and advice of the artist they admired the most. Bobby Toombs, for example, took over Elvgren's Brown & Bigelow Napa account once Gil decided he had had enough of deadlines. There were also numerous students Elvgren had taught back in Chicago who saw their careers take off after their time under the master's guidance. Harry Ekman, who had studied with Elvgren in 1953 in Chicago, eventually launched his own successful career in the pin-up and glamour-art field.

When he wasn't painting pin-ups in Florida, Elvgren was busy working on his magazine illustration commissions, although he was always turning down manuscripts simply because he didn't have the time to do the work. The art directors at the magazines he worked for (*McCall's, Cosmopolitan, Redbook, Woman's Home Companion* and *The Saturday Evening Post*) regularly agreed to wait as long as a year to be able to book a job with Elvgren.

In 1963, Elvgren was honored with the publication of a unique deck of playing cards entitled *American Beauties* (or sometimes *Top Hat*). Licensed by Brown & Bigelow, this deck was the first ever to contain reproductions of 53 different Elvgren pin-up images, as compared to previous decks which illustrated merely one Elvgren Girl. Elvgren was the only Brown & Bigelow artist ever to be so honored; the only other pin-up artist to have a 53-image deck produced was Alberto Vargas. The Elvgren deck far surpassed the Vargas deck in every respect, and it proved a huge success. Elvgren's pictures are narrative, entertaining and lively, whereas Vargas's lacked backgrounds, situations and any substantial life.

In the midst of all this great success, a terrible sadness engulfed the Elvgren home in 1966 as Janet died of cancer. After her death, Elvgren immersed himself even more in his work. Throughout the 1960s his popularity remained undiminished, both at Brown & Bigelow and with the American public. He had reached the point in his career, after thirty years of painting, when he was relaxed enough not to worry about anything except creating the best possible image for any work. The result was that his 1960s pin-ups were the best conceived, best painted, and best-looking works he ever did. Refreshing and magnetic, these Elvgren Girls captured the viewer's attention with their sex appeal. They were red-blooded All-American glamour girls, and their popular success had the sales force of Brown & Bigelow in seventh heaven. Every business in America seemed to be clamoring for Elvgren Girls on the Brown & Bigelow calendars they gave to their Christmas customers. It was the best time in Elvgren's career, marred only by his sorrow over the death of his wife. As time went on, he eventually began to spend time with Marjorie Shuttleworth, one of his models in Sarasota.

Charlie Ward had a cabin cruiser that he often used to entertain Brown & Bigelow's clients during the summer months in St. Paul. Elvgren had been on the boat many times, and when Ward needed a painting of the craft, it was Elvgren who obliged (fig. 78, p. 38). Later, in Sarasota, a Mr Regal asked Elvgren to do a similar painting of his almost identical vessel. Elvgren's nautical subjects turned out to be as superb as everything else he painted.

Gil Elvgren's ability to capture the spirit of American feminine beauty was unsurpassed. His pin-ups were pictures of real girls in real, everyday situations. Sometimes they were a bit exaggerated, but they always worked. Painting with thirty-two colors on his palette, he mostly used canvas measuring 30 x 24" (76 x 61 cm) placed on a large wooden easel. While painting, Elvgren usually sat in a chair on wheels, so he could move about and look at the work in progress from every angle. A mirror on the wall behind him enabled him to see the painting over his shoulder. During the years in Winnetka and for several years after they moved to Florida, young Drake prepared his father's painting materials each day.

When Elvgren was asked what feature of a model most interested him, he replied, "A gal with highly mobile facial features

capable of a wide range of expressions is the real jewel. The face is the personality." The model was the all-important factor in making a painting strong. He preferred young models (fifteen to twenty years old) just starting their careers, because at that point they have a freshness and spontaneity that are often lost after they gain experience and poise. He valued models who were enthusiastic and interested, but said that they were very hard to find. When asked about his techniques, he explained the distinctive "touches" he added to every painting – how he built up the bust, lengthened the legs, pinched in the waist, gave the body warmer and more attractive curves, worked over the facial features and expression, added just a little more of a tip and tilt to the nose, made the mouth fuller and more sensuous and the eyes a bit larger. He ended by saying that he liked to create the feeling that, underneath all the surface charms, there was a delicious warmth of mischief behind the model's eyes.

Elvgren always planned each painting carefully. Beginning with an idea, he would develop the visual situation and then select the appropriate model for that specific setting. Next he would decide on the wardrobe, the background for his studio set, the props and the lighting. Even the model's hairstyle was a significant factor: since it could take up to two years for a painting to be published, the girl's hair had to be done in a style that would not date easily. Finally, Elvgren photographed the scene with a 2 1/4 Rollei, after which he could begin to paint.

The distinguishing mark of Elvgren's pin-ups compared with those of his contemporaries is that the Elvgren Girls looked like real people. It seems that, at any moment, the girl might step out of the painting and say good morning or offer the viewer a cup of coffee, a drink or an invitation to some not-so-innocent fun. Elvgren Girls had personality and zest; they were lively, friendly beauties brimming with enthusiasm. They were sweet-faced, but also generously endowed by nature. They could

76 Mayo Olmstead: *Still a Baby at Heart*. One-page hanger calendar, published by Brown & Bigelow, c. 1950. Oil on canvas, 24 x 30" (61 x 76 cm)
77 Al Buell: *Top Date*. Calendar, published by Brown & Bigelow, 1962. Oil on canvas, 30 x 24" (76 x 61 cm)

**78**

**79**

easily kindle a twinkle in anyone's eye and often had one in their own. For more than thirty years, from the 1940s through the 1960s, they epitomized the All-American Girl.

In the early days of Elvgren's career, the Girls were called "goose-pimpling streamliners" and "fancy dancy armfuls". They danced their way out of the Depression and into World War II, then accompanied America's soldiers into the Korean War. And always, in wartime, they gave soldiers spirit and hope and reminded them of their girls back home. The American girls Elvgren painted had box-office appeal. Armed with a charming, friendly smile, they captured the affections of many men and women during the golden age of the American pin-up.

During his career at Brown & Bigelow, Gil Elvgren had two main signatures, which differed in size but not style. His early signature (1945–1957) was about half the width and height of his later signature (1958–1972), which was much bolder and more prominent. The larger signature clearly relates to his growing reputation. By 1958, Elvgren had become a living legend in the field of commercial illustration. Although Vargas and Petty were also respected by their peers, Elvgren was particularly

emulated by all the working commercial artists of the period. Hundreds of illustrators longed to be able to paint girls as Elvgren did.

Elvgren never participated in the lucrative market for paperback-novel cover art, which exploded during the 1950s and 1960s. However, his tear-sheet file (which the author acquired from the artist D. H. Rust many years after Elvgren's death) indicated that he followed the genre closely, and that his favorite artists were James Avati (born 1912) and James Bama (born 1926), two leaders in the field. Avati painted extremely sensual subjects while Bama enjoyed tremendous success with photorealistic renderings of subjects with an up-to-date but slightly fantastic character. Ed Balcourt, who managed the careers of Bama and Ron Lesser among others, told me in an interview in Florida that the leading paperback artists often discussed Elvgren's art when they met in New York at publishing functions. Elvgren was thus acknowledged not only in his own field, but also by artists working in related fields.

As a result of this admiration, and because his own skills had developed to such a great extent, by 1958 Elvgren felt extremely contented with both his talent and his success. Painting with

increasing ease and confidence, he created his greatest and most sophisticated pin-ups in the last stage of his career (fig. 80, p. 39). As this book reveals, Elvgren's early work is much tighter than his later paintings, which are structurally more relaxed and apparently less academic. In reality, the masterly style of the later paintings evokes that of John Singer Sargent. Elvgren had essentially attained total mastery of his craft, both in his conceptual approach and in his painting technique.

Gil Elvgren – a man who had spent much of his life enriching the lives of others – succumbed to cancer on February 29, 1980, at the age of sixty-five. In his studio, on Featherbed Lane in Siesta Key, Drake found his father's last painting – brilliant, even in its unfinished state. And published here for the first time (fig. 81, p. 39). The art historians of the twenty-first century will not fail to recognize the importance of both Gil Elvgren's contribution to twentieth-century American art and his influence upon it.

80

Charles G. Martignette

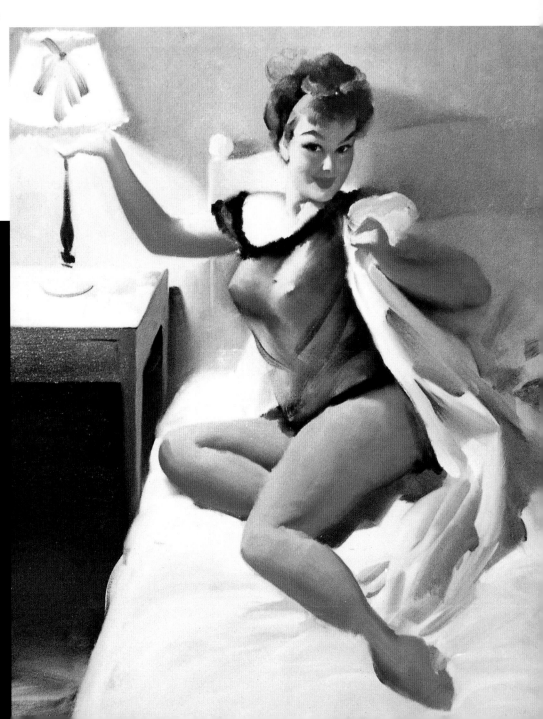

84

# The Louis F. DOW Years

# 1937-1944

83

82

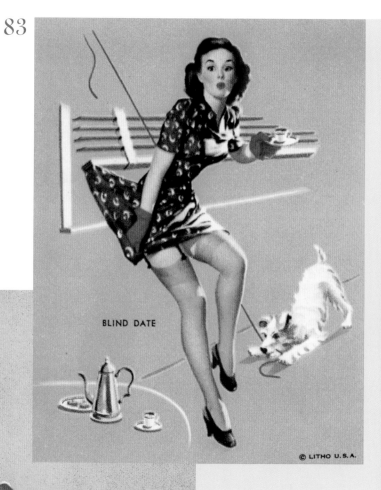

BLIND DATE

© LITHO U.S.A.

*Going Up*

ELVGREN

| JANUARY • 1946 | | | | | | |
|---|---|---|---|---|---|---|
| S | M | T | W | T | F | S |
| - | - | 1 | 2 | 3 | 4 | 5 |
| 6 | 7 | 8 | 9 | 10 | 11 | 12 |
| 13 | 14 | 15 | 16 | 17 | 18 | 19 |
| 20 | 21 | 22 | 23 | 24 | 25 | 26 |
| 27 | 28 | 29 | 30 | 31 | - | - |

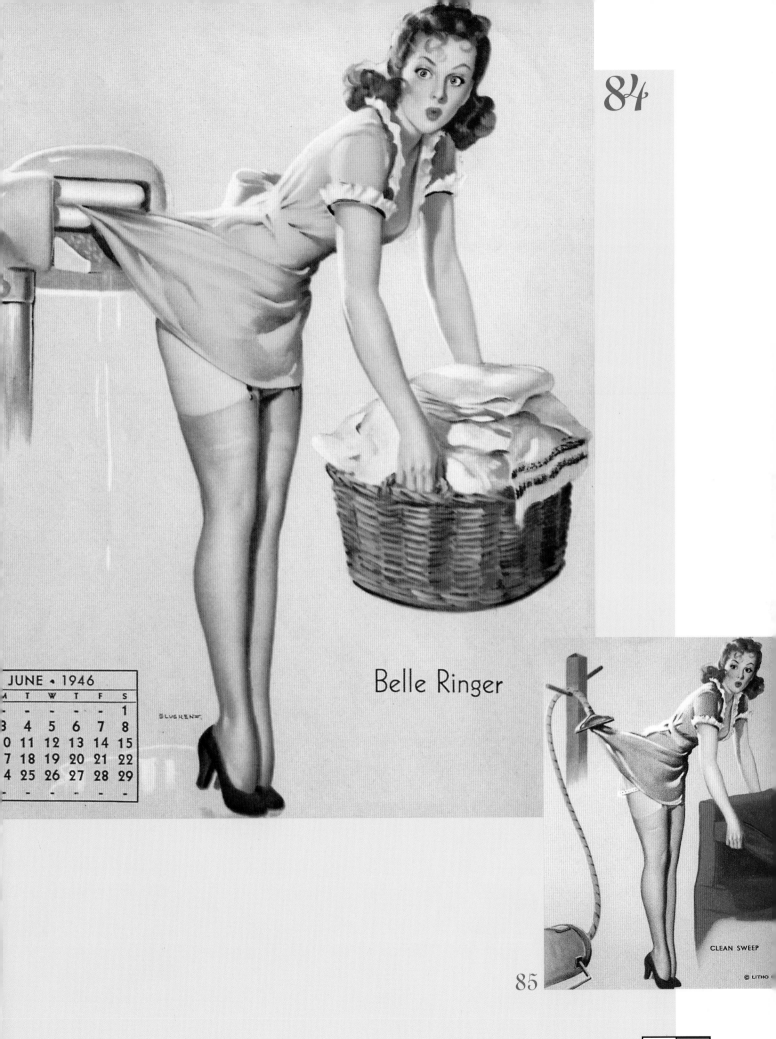

84

JUNE • 1946

| M | T | W | T | F | S |
|---|---|---|---|---|---|
| | | | | | 1 |
| 3 | 4 | 5 | 6 | 7 | 8 |
| 0 | 11 | 12 | 13 | 14 | 15 |
| 7 | 18 | 19 | 20 | 21 | 22 |
| 4 | 25 | 26 | 27 | 28 | 29 |

Belle Ringer

85

CLEAN SWEEP

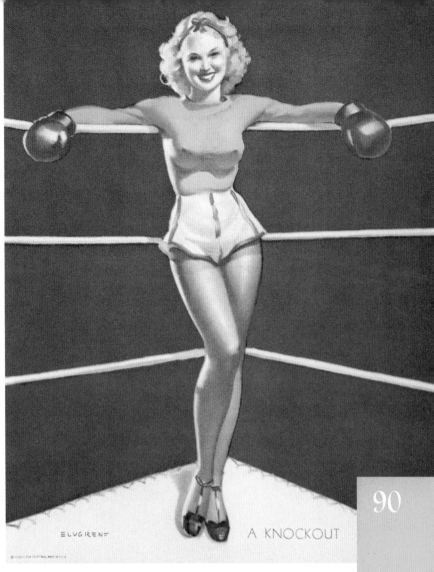

A KNOCKOUT

SURE SHOT

87

86

90

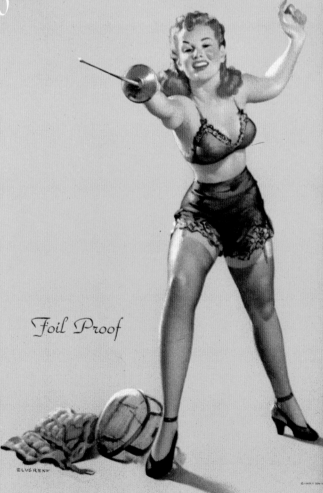

Foil Proof

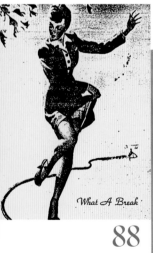

What A Break

88

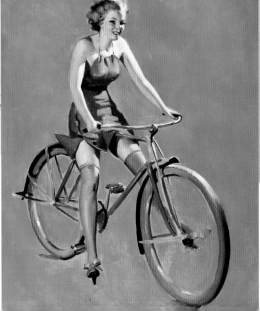

89

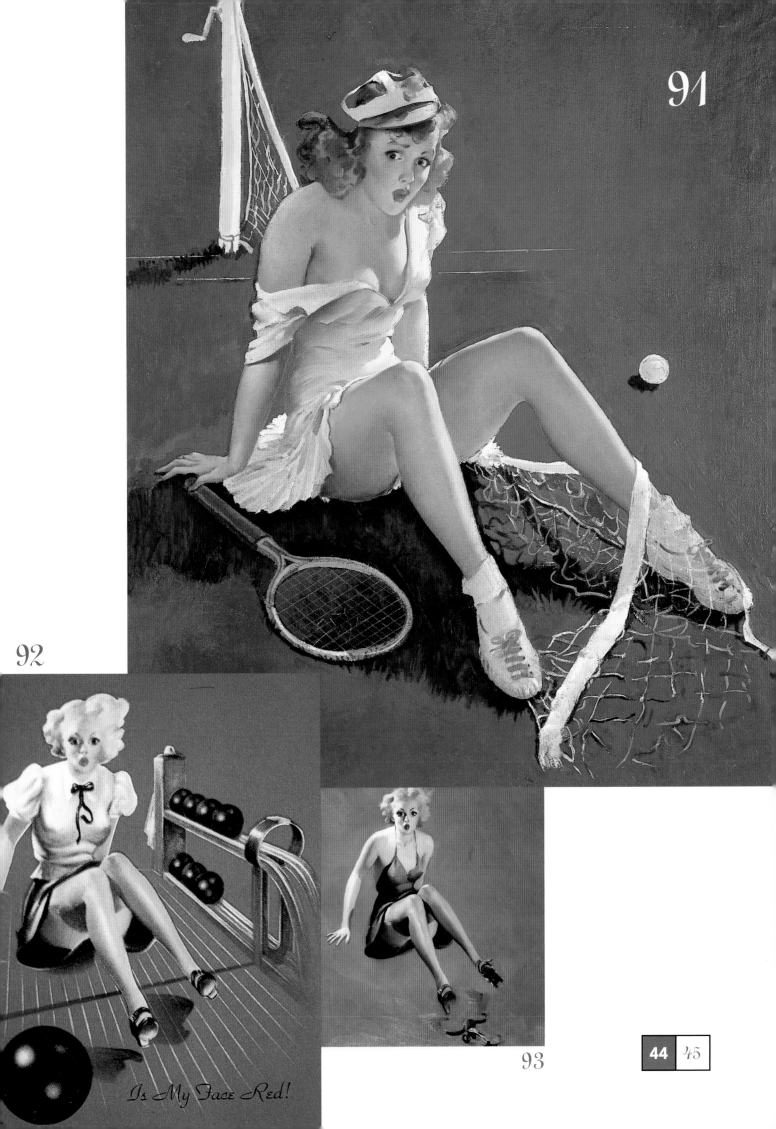

91

92

93

*Is My Face Red!*

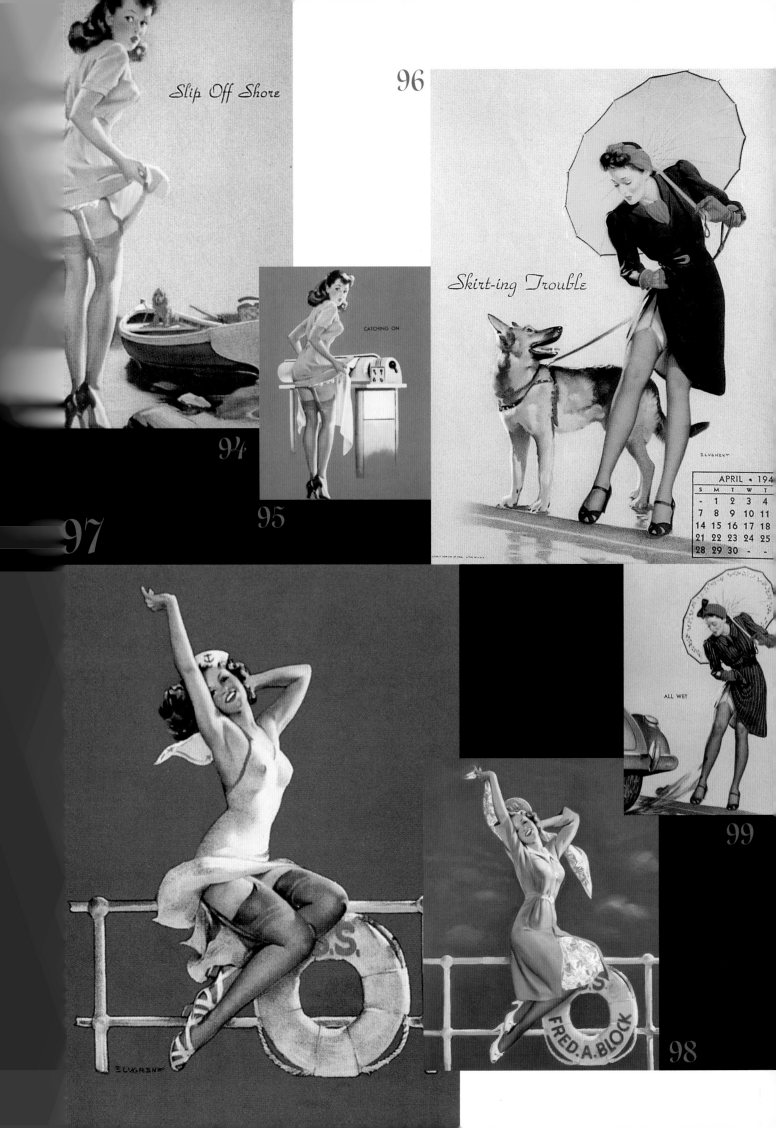

Slip Off Shore

96

Skirt-ing Trouble

CATCHING ON

94

95

APRIL · 194

| S | M | T | W | T | | |
|---|---|---|---|---|---|---|
| - | 1 | 2 | 3 | 4 | | |
| 7 | 8 | 9 | 10 | 11 | | |
| 14 | 15 | 16 | 17 | 18 | | |
| 21 | 22 | 23 | 24 | 25 | | |
| 28 | 29 | 30 | - | - | | |

97

ALL WET

99

FRED. A. BLOCK

98

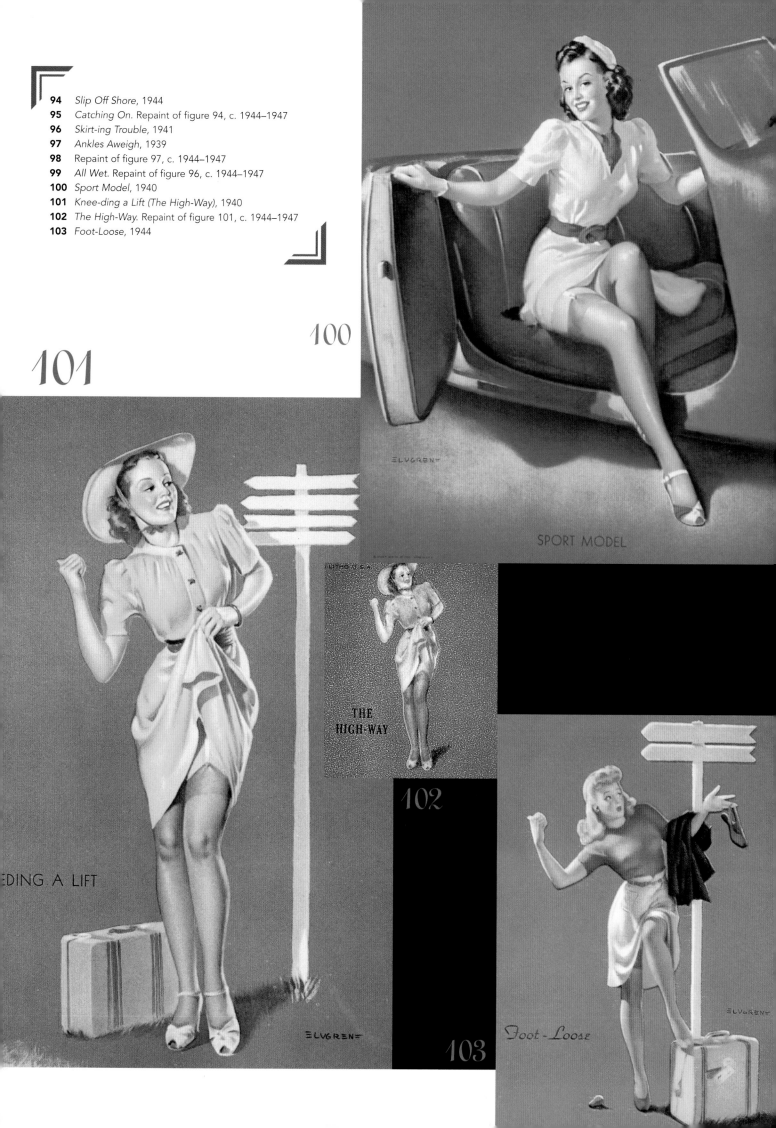

100

101

SPORT MODEL

THE
HIGH-WAY

EDING A LIFT

102

103

Foot-Loose

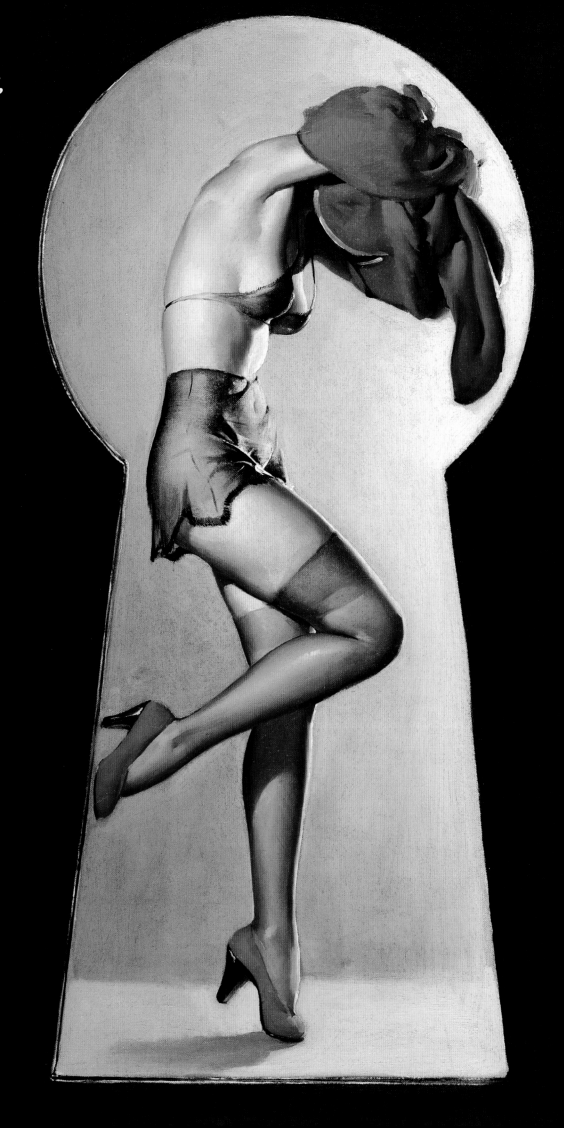

105

DOUBLE EXPOSURE

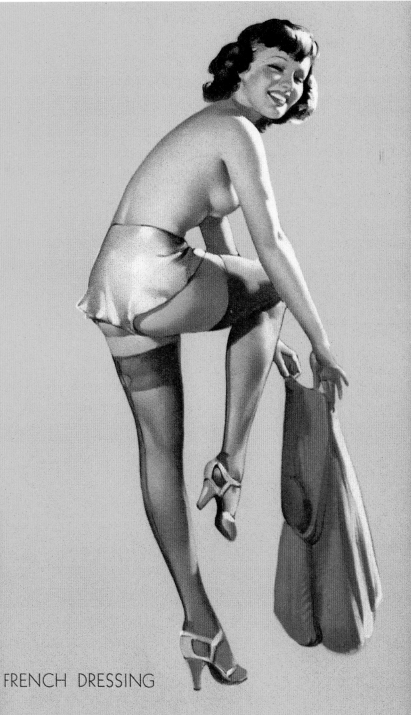

FRENCH DRESSING

106

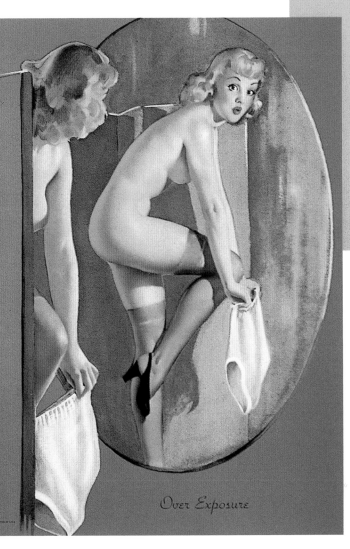

Over Exposure

107

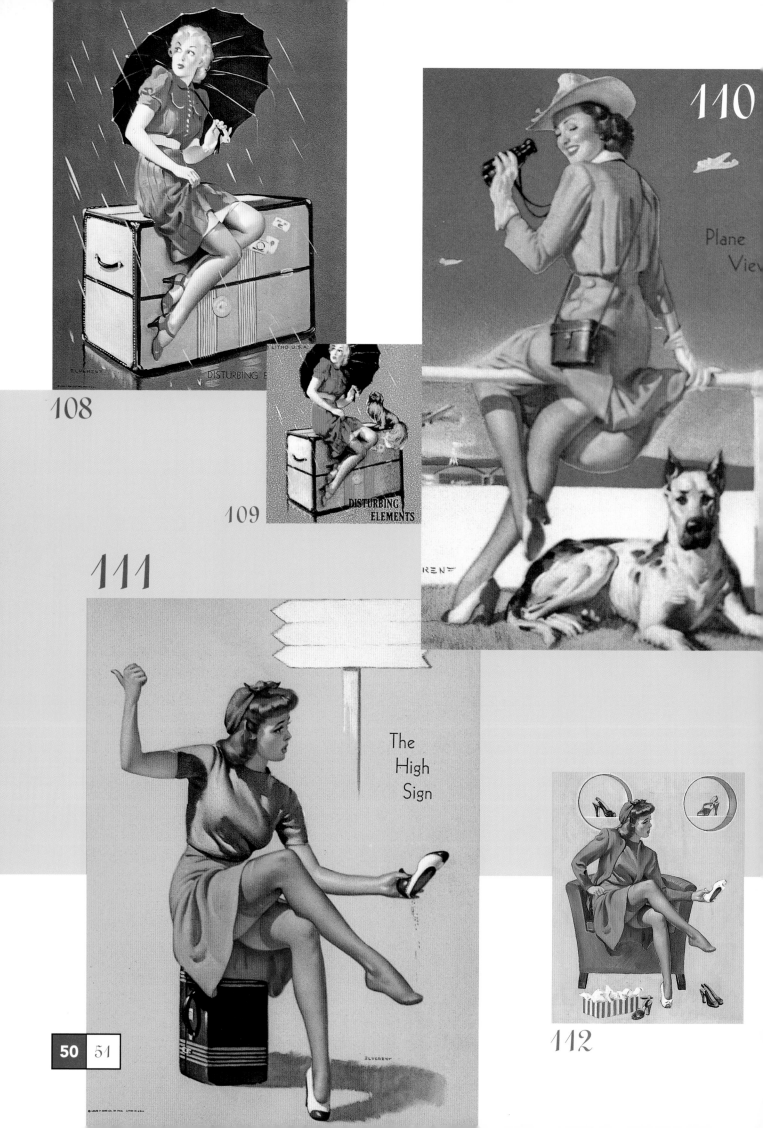

108

109 DISTURBING ELEMENTS

110 Plane View

111 The High Sign

112

**113**

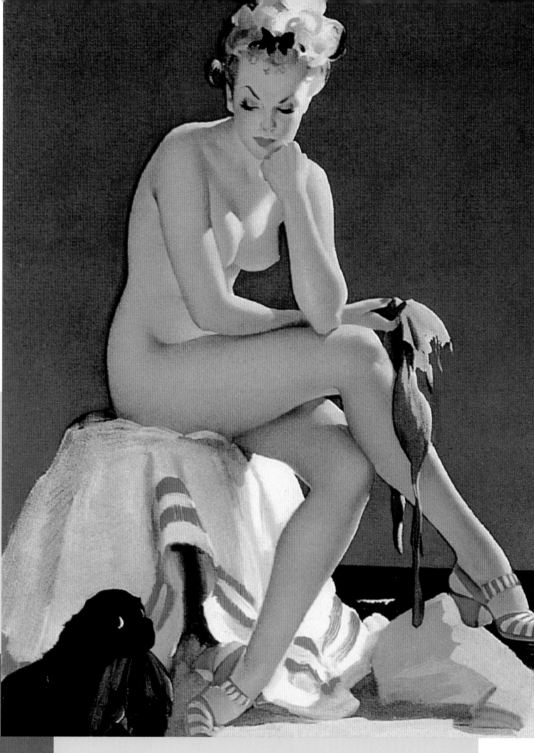

DUMB PLUCK

**114**

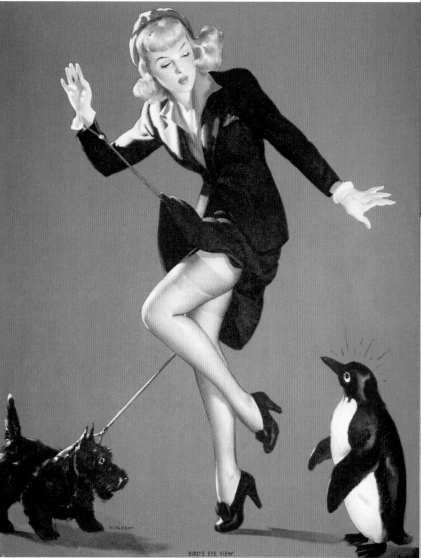

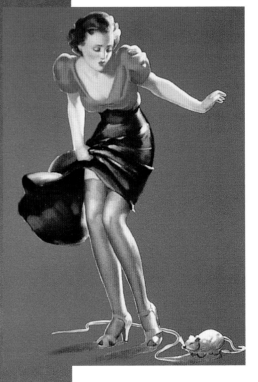

A PLEASING DISCOVERY

YOUR ADVERTISEMENT
IN THREE OR FOUR LINES
WILL BE PRINTED IN THIS SPACE

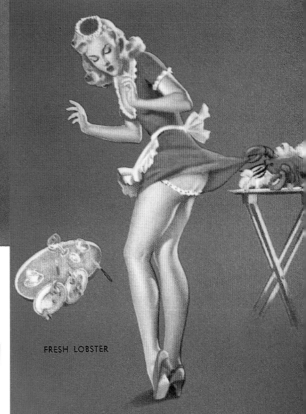

FRESH LOBSTER

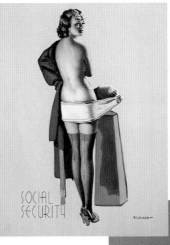

SOCIAL
SECURITY

ELVGREN

123

PALETTE-ABLE

ELVGREN

124

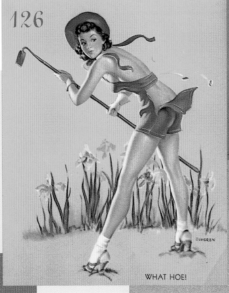

FIGURES DON'T LIE

ELVGREN

122

125

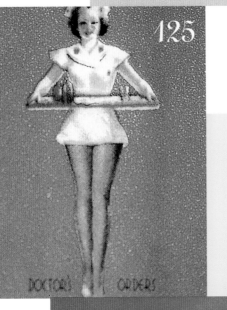

DOCTOR'S ORDERS

126

WHAT HOE!

ELVGREN

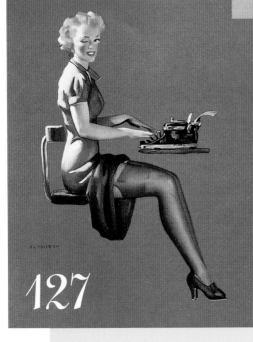

ELVGREN

127

128

ELVGREN

IN THE DOUG

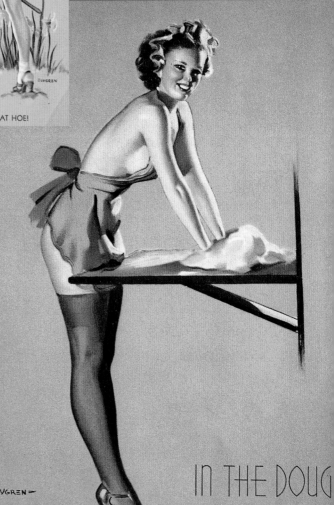

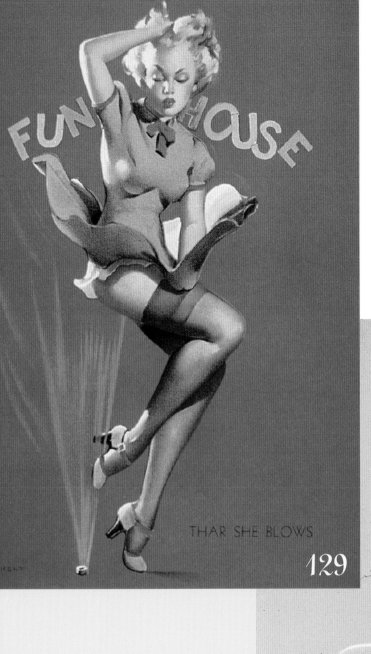

FUN HOUSE

THAR SHE BLOWS

129

130

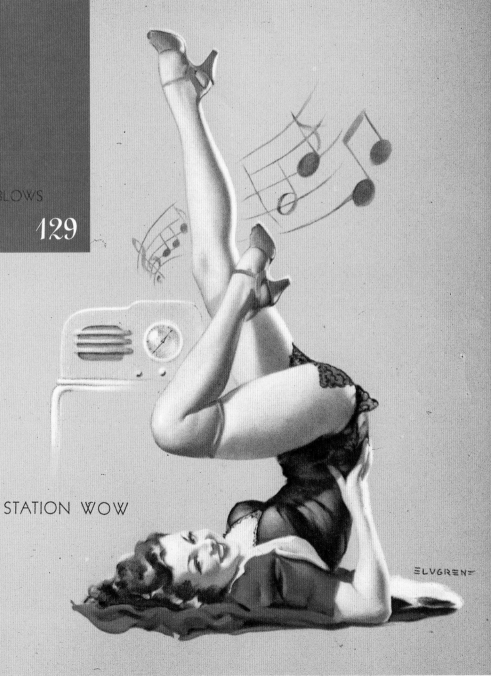

STATION WOW

131

SITTING PRETTY

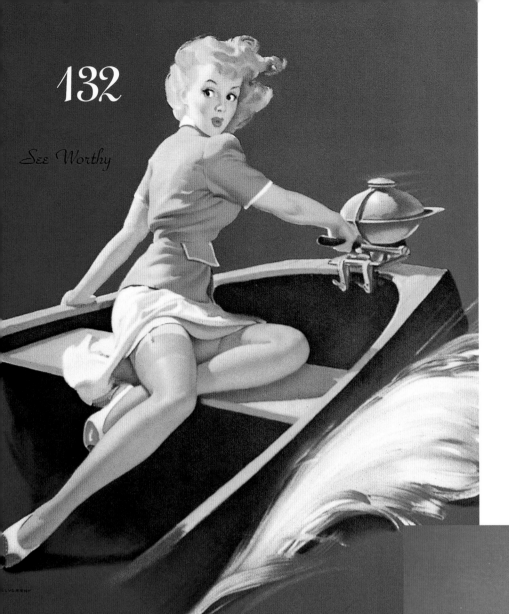

**132**

*See Worthy*

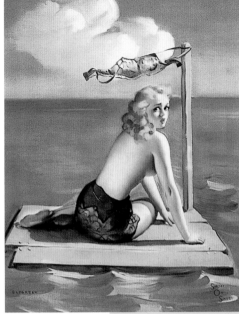

**133**

**132** *See Worthy*, 1944
**133** *Short on Sails*, 1939
**134** *Catch On*, 1941
**135** *Catchy Number.* Repaint of figure 134, c. 1944–1947
**136** *Tail Wind*, undated
**137** *Caught in the Draft (What's Up)*, undated
**138** *Up in the Air.* Repaint of figure 137, c. 1944–1947

*Catch On*

**134**

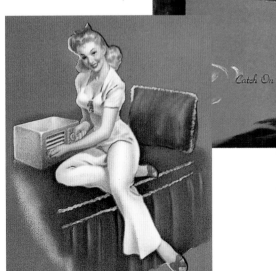

CATCHY NUMBER

**135**

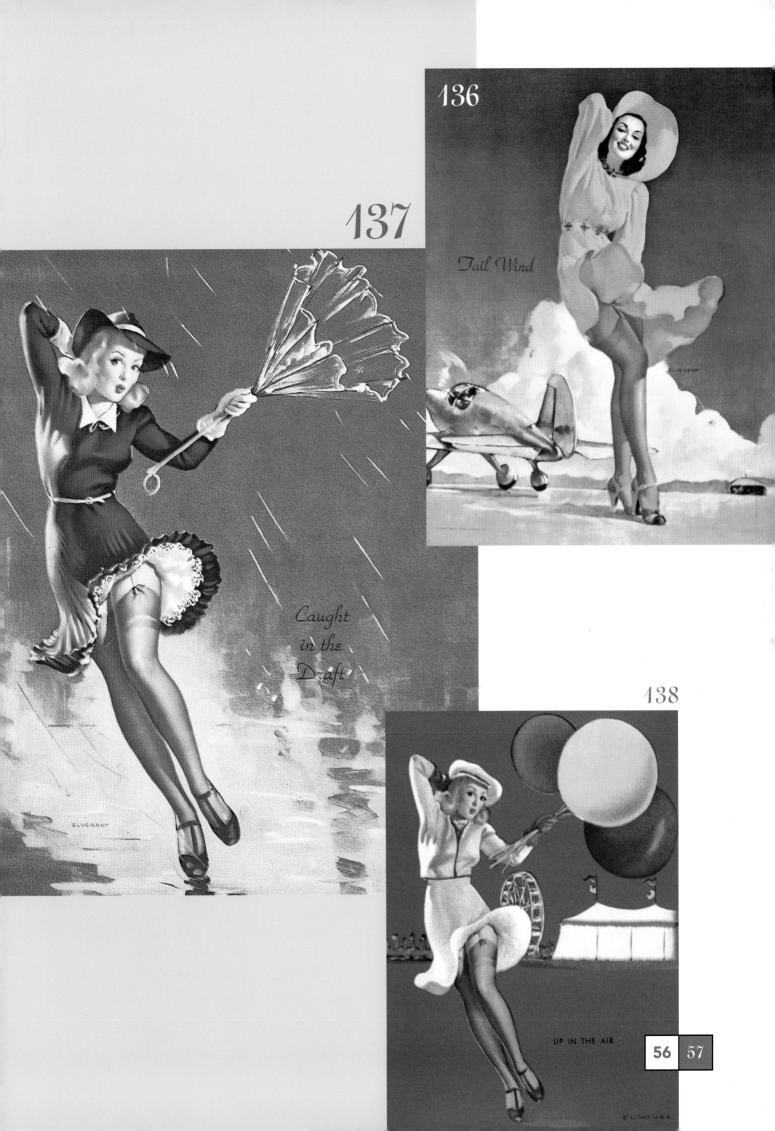

**137**

*Caught in the Draft*

**136**

*Tail Wind*

**138**

UP IN THE AIR

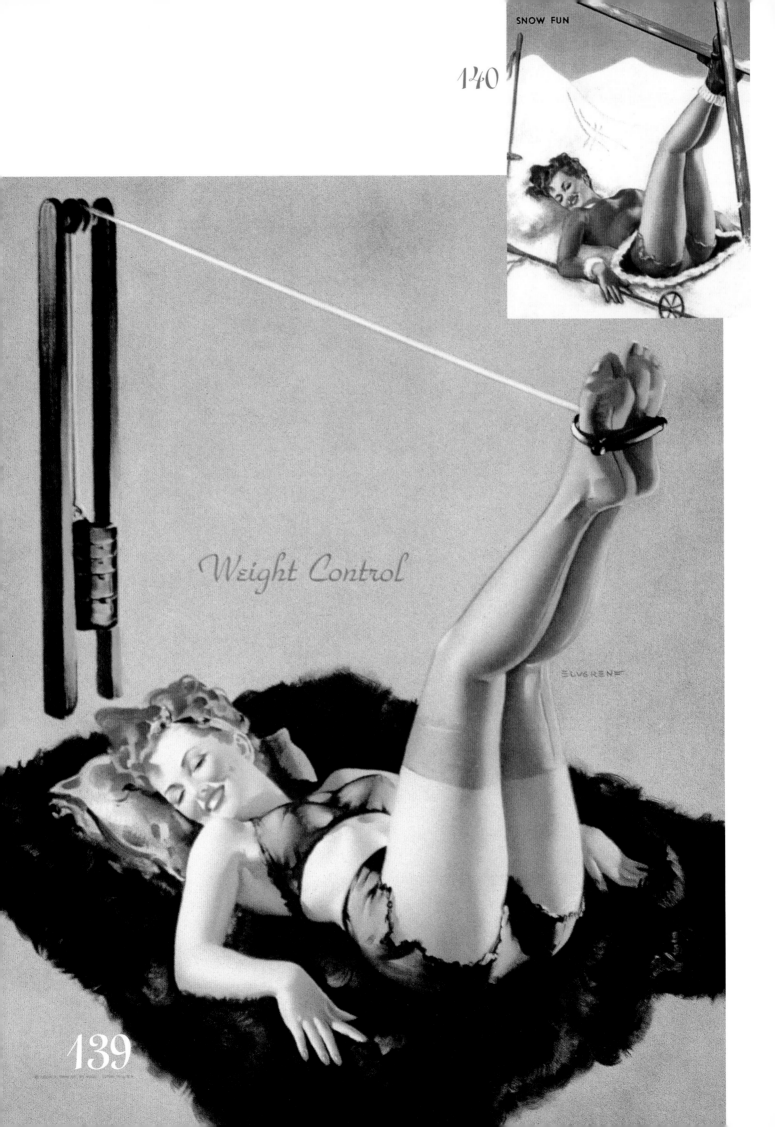

SNOW FUN

140

Weight Control

ELVGREN

139

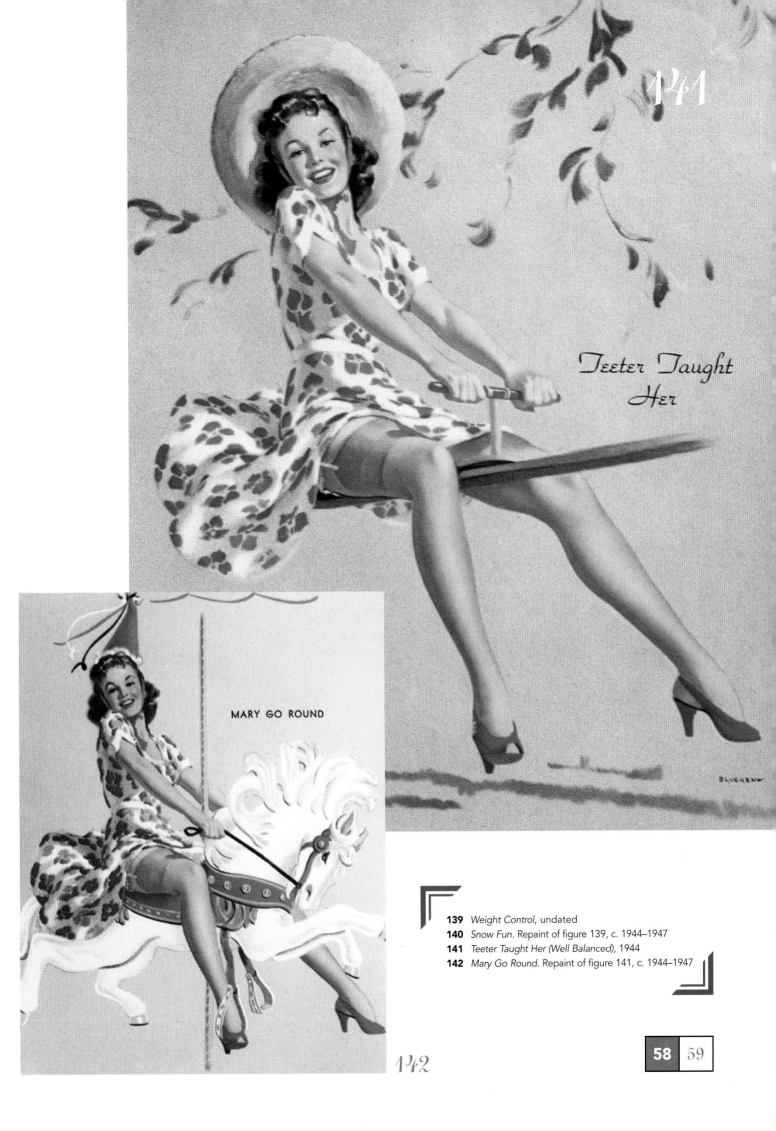

Teeter Taught
Her

MARY GO ROUND

**139** *Weight Control*, undated
**140** *Snow Fun*. Repaint of figure 139, c. 1944–1947
**141** *Teeter Taught Her (Well Balanced)*, 1944
**142** *Mary Go Round*. Repaint of figure 141, c. 1944–1947

141

142

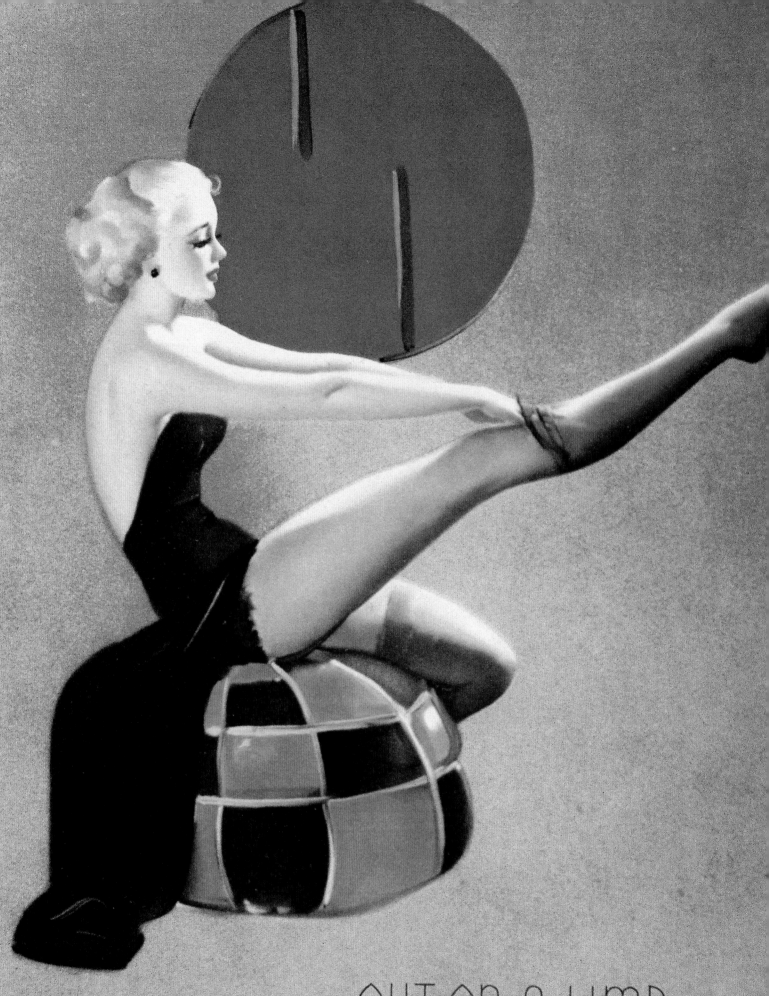

OUT ON A LIMB

ELVGREN
143

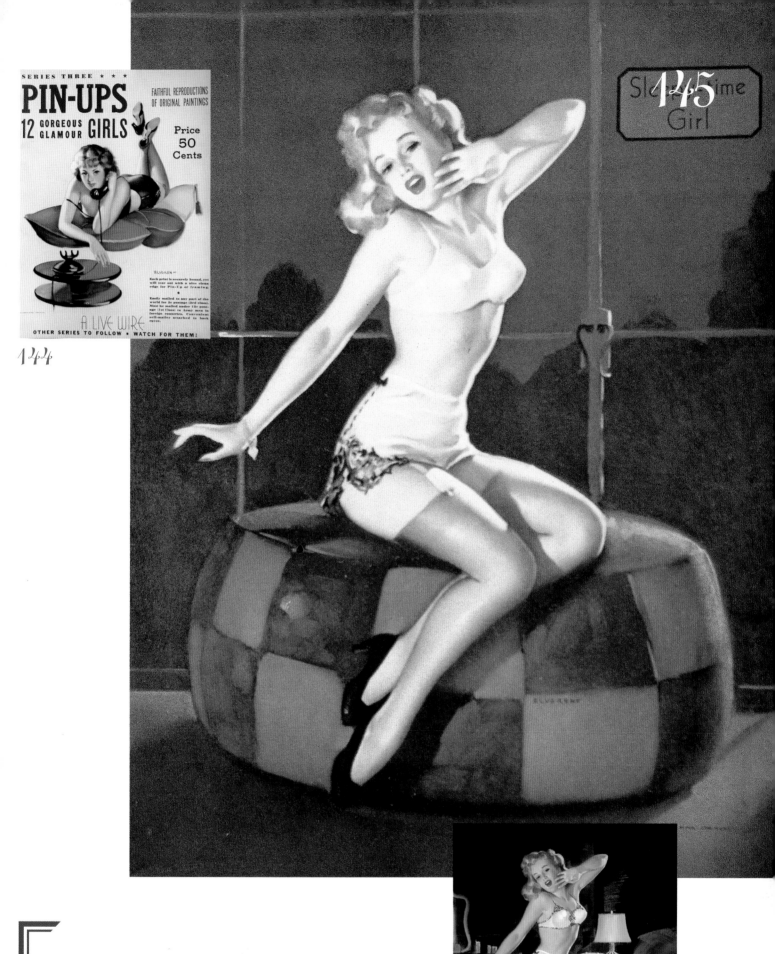

Sleepy Time Girl

144

143   *Out on a Limb*, 1937
144   *A Live Wire*, 1937
145   *Sleepy Time Girl*, undated
146   *Sleepy Time Gal*. Repaint of figure 145, c. 1944–1947

146

TRIM LIMBS

© LITHO U.S.A.

ELVGREN

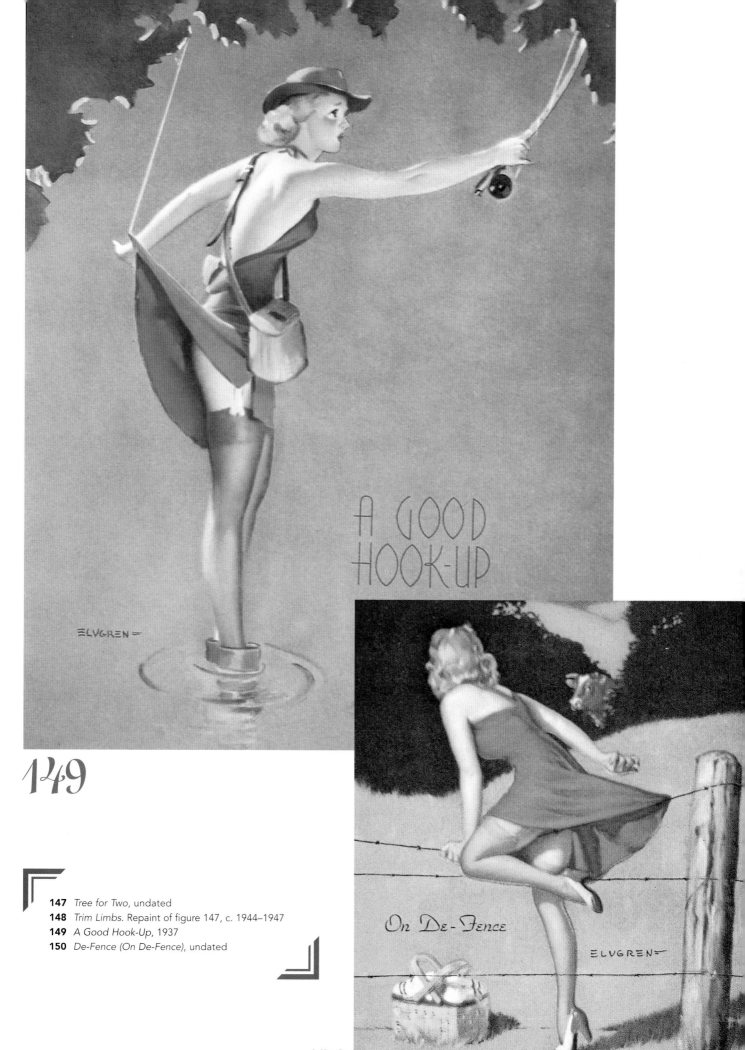

A GOOD
HOOK-UP

ELVGREN

149

On De-Fence

ELVGREN

150

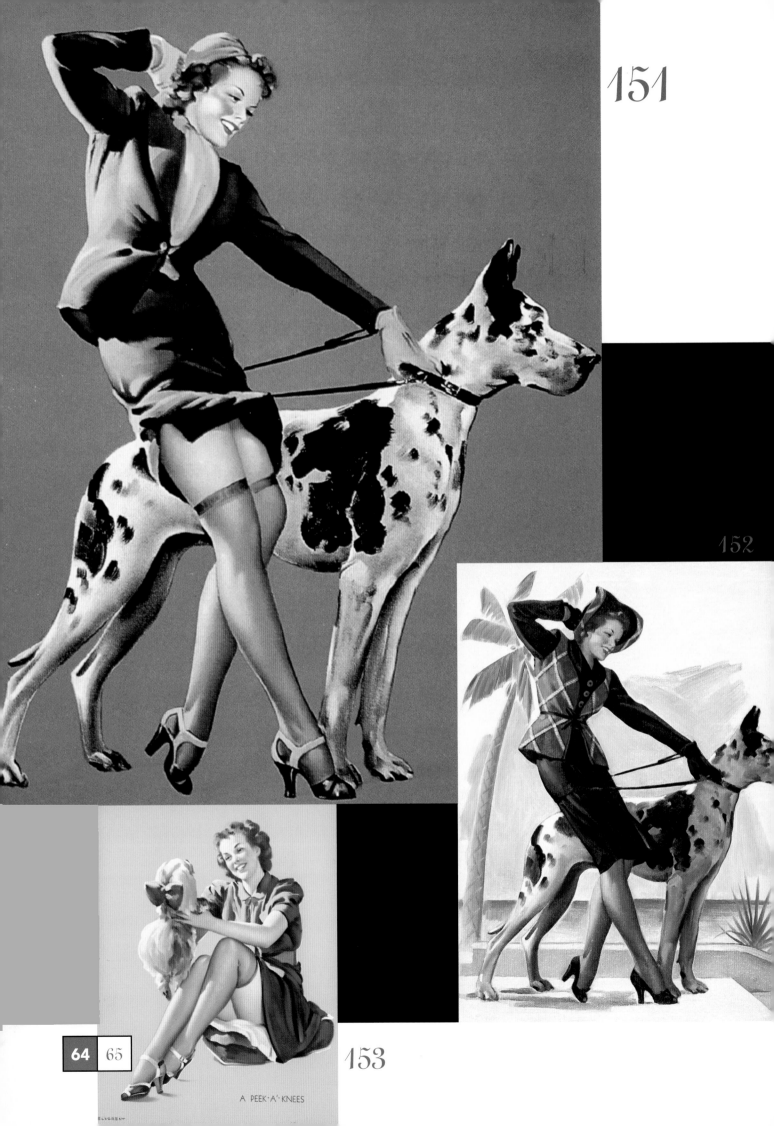

151

152

153

A PEEK·A·KNEES

64 65

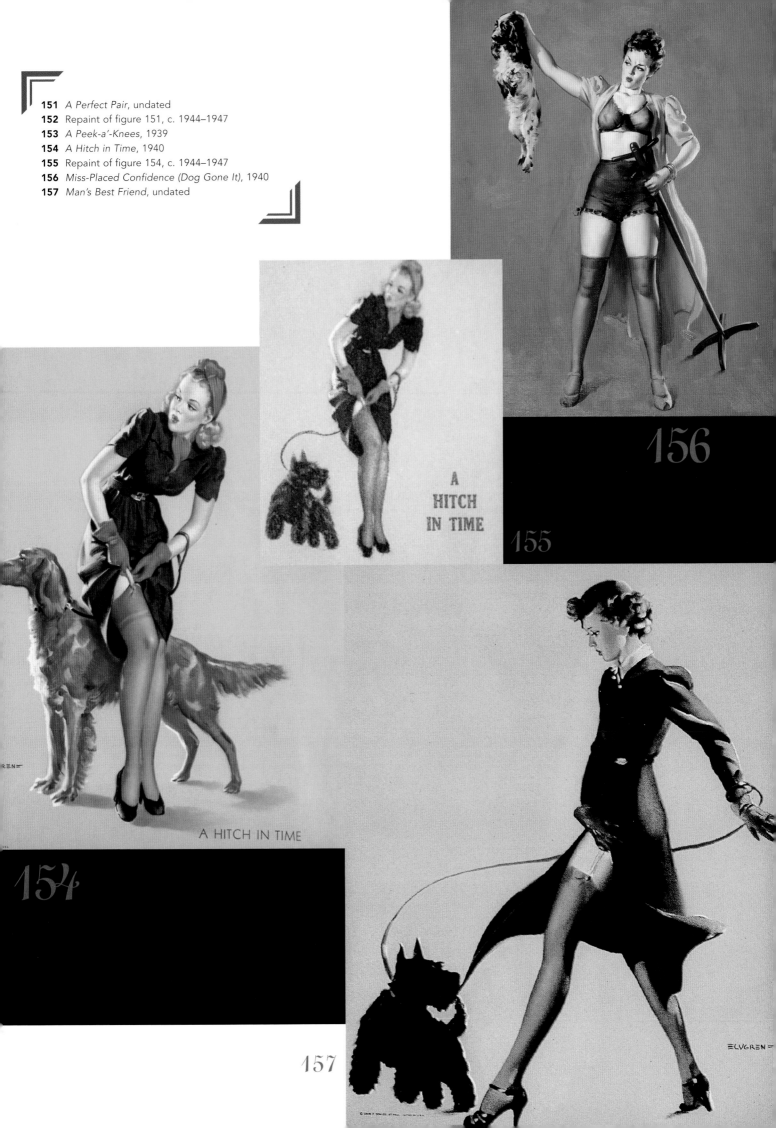

A
HITCH
IN TIME

156

155

A HITCH IN TIME

154

157

158

159

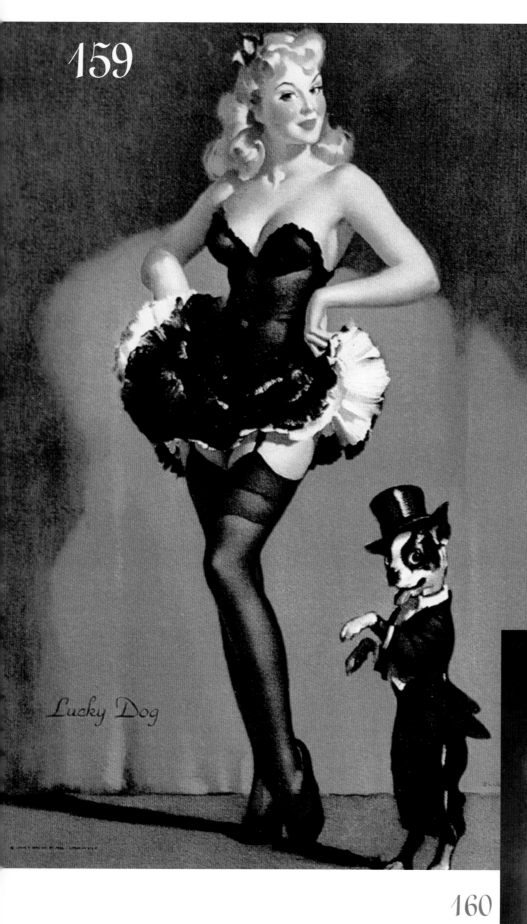

Lucky Dog

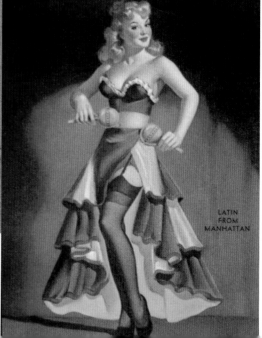

LATIN
FROM
MANHATTAN

160

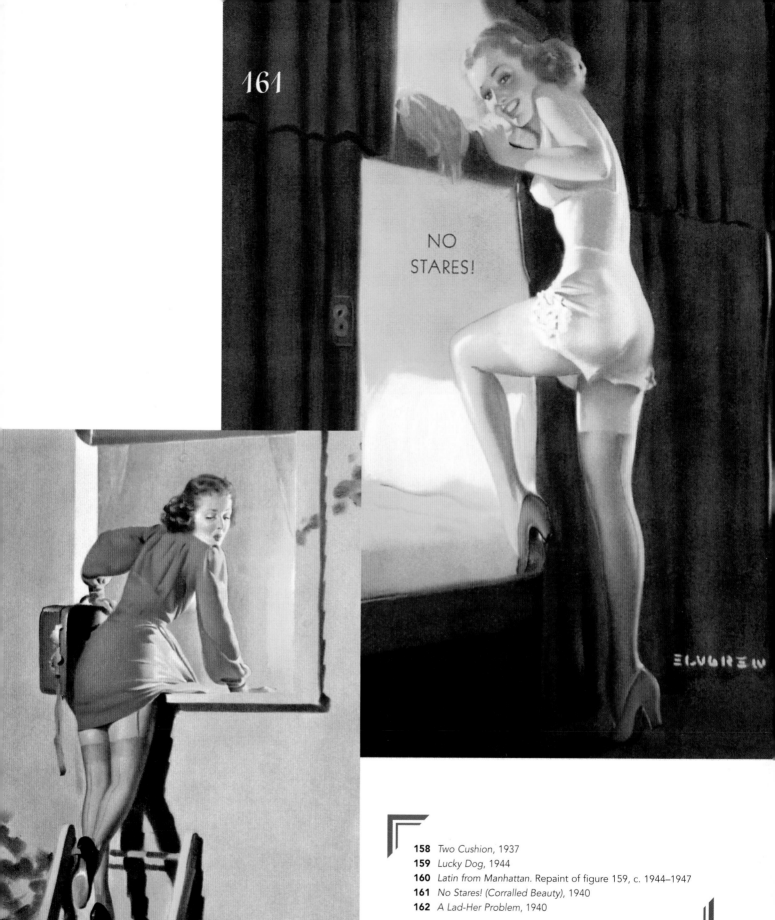

161

NO
STARES!

ELVGREN

A LAD HER PROBLEM

162

**158** *Two Cushion*, 1937
**159** *Lucky Dog*, 1944
**160** *Latin from Manhattan*. Repaint of figure 159, c. 1944–1947
**161** *No Stares! (Corralled Beauty)*, 1940
**162** *A Lad-Her Problem*, 1940

# THE 1940s

## The Early
## BROWN & BIGELOW
### Years

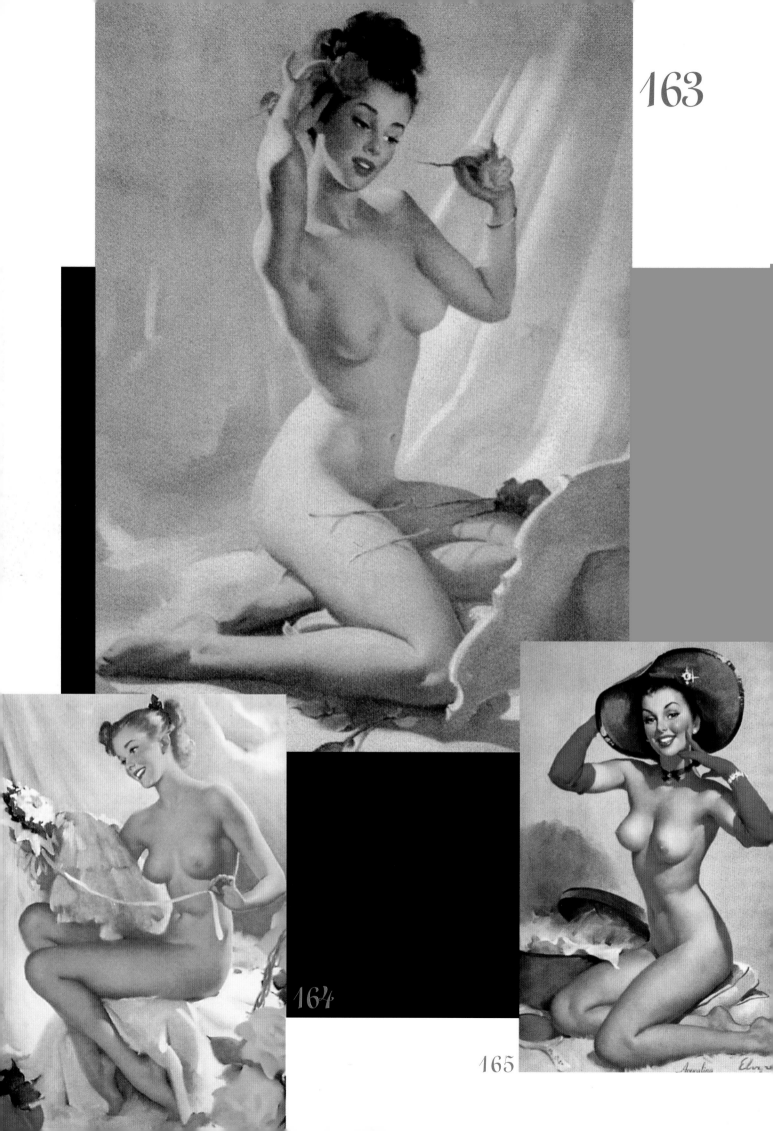

163

164

165

166

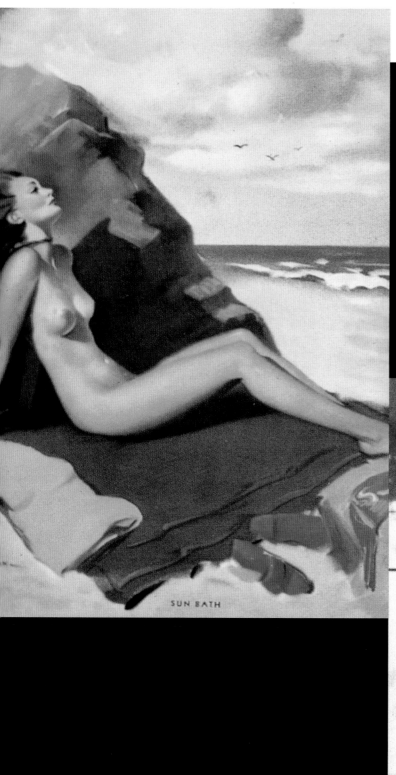

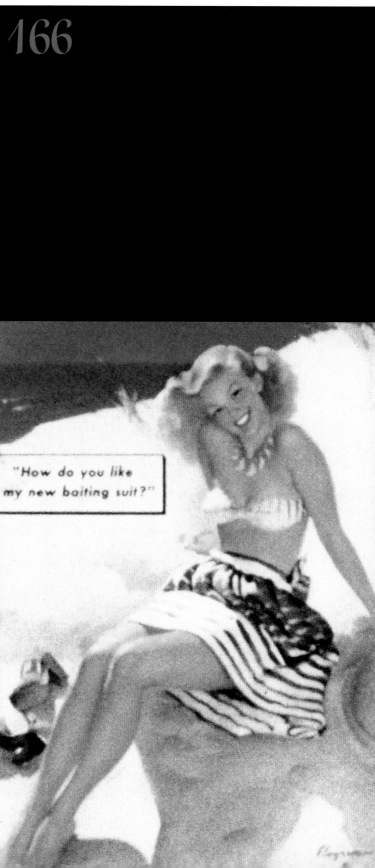

167

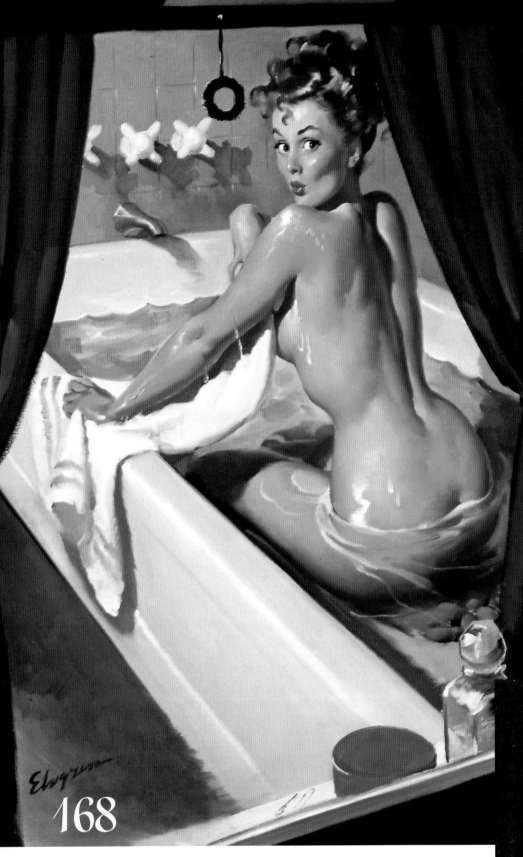

**168**

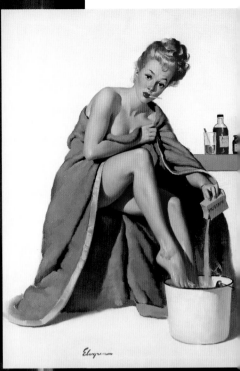

**169**

"I Guess I'm a Poor Loser"

**170**

171

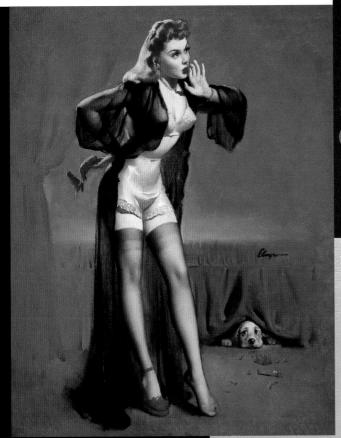

172

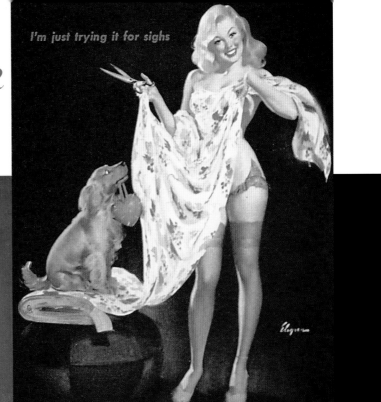

I'm just trying it for sighs

173

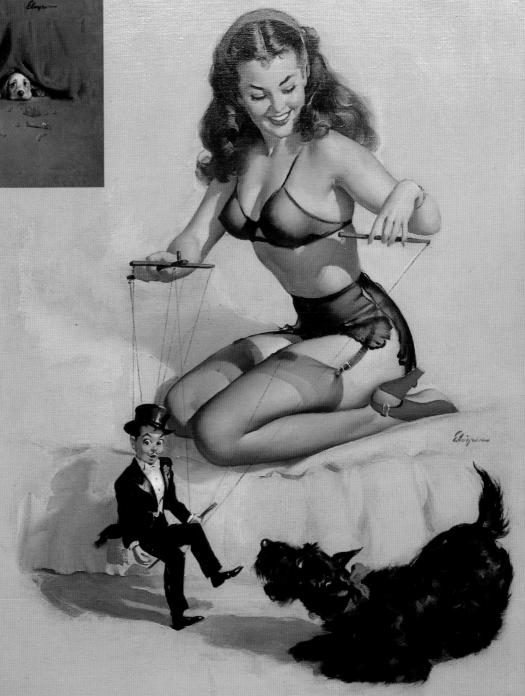

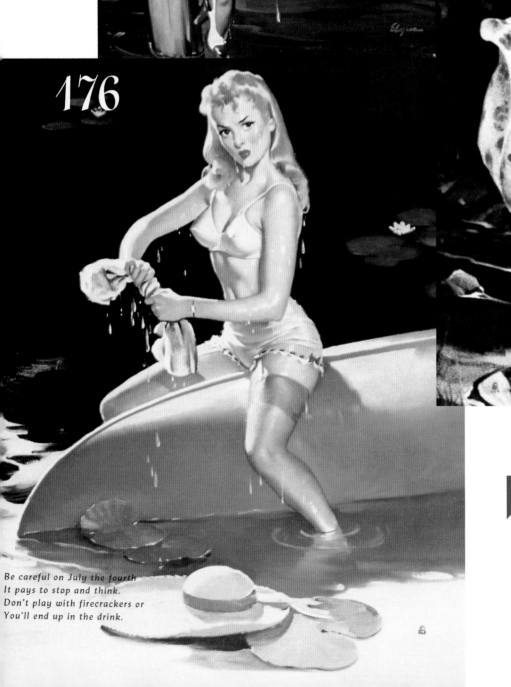

Be careful on July the fourth
It pays to stop and think.
Don't play with firecrackers or
You'll end up in the drink.

174

175

176

174 *He Was Neither a Gentleman Nor a Sculler*, 1948
175 *I Barely Made It*, 1948
176 *We Had a Little Falling Out (Be careful on July the fourth. It pays to stop and think. Don't play with firecrackers or you'll end up in the drink)*, 1946
177 *Finders Keepers*, 1945

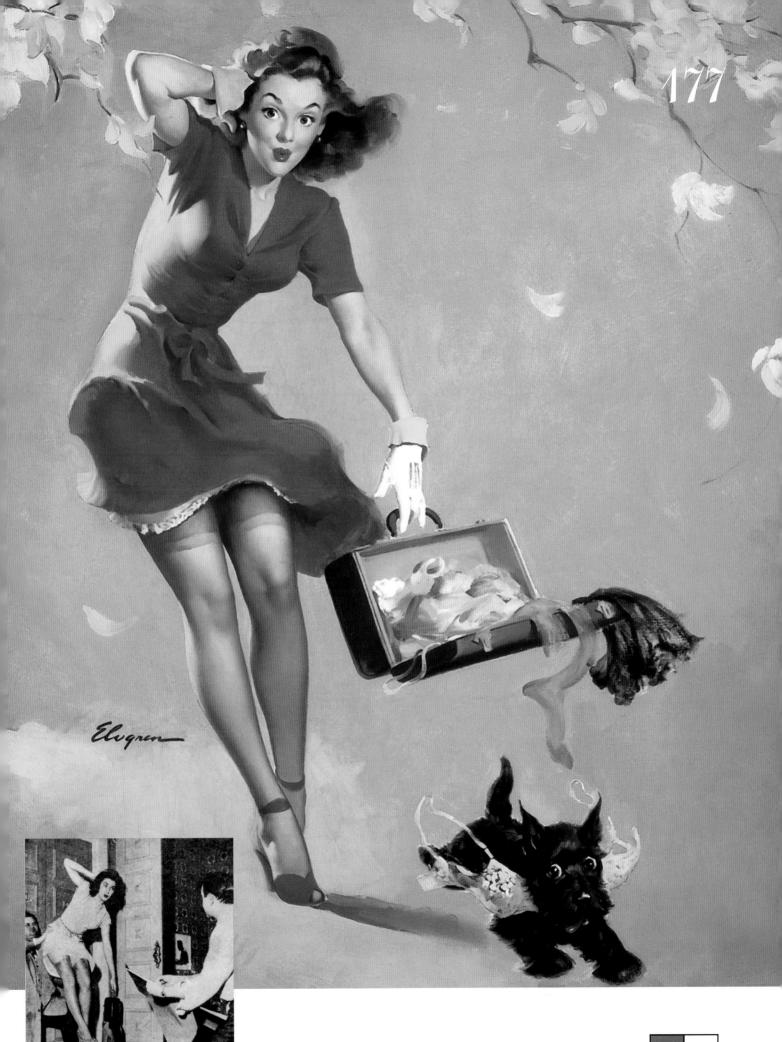

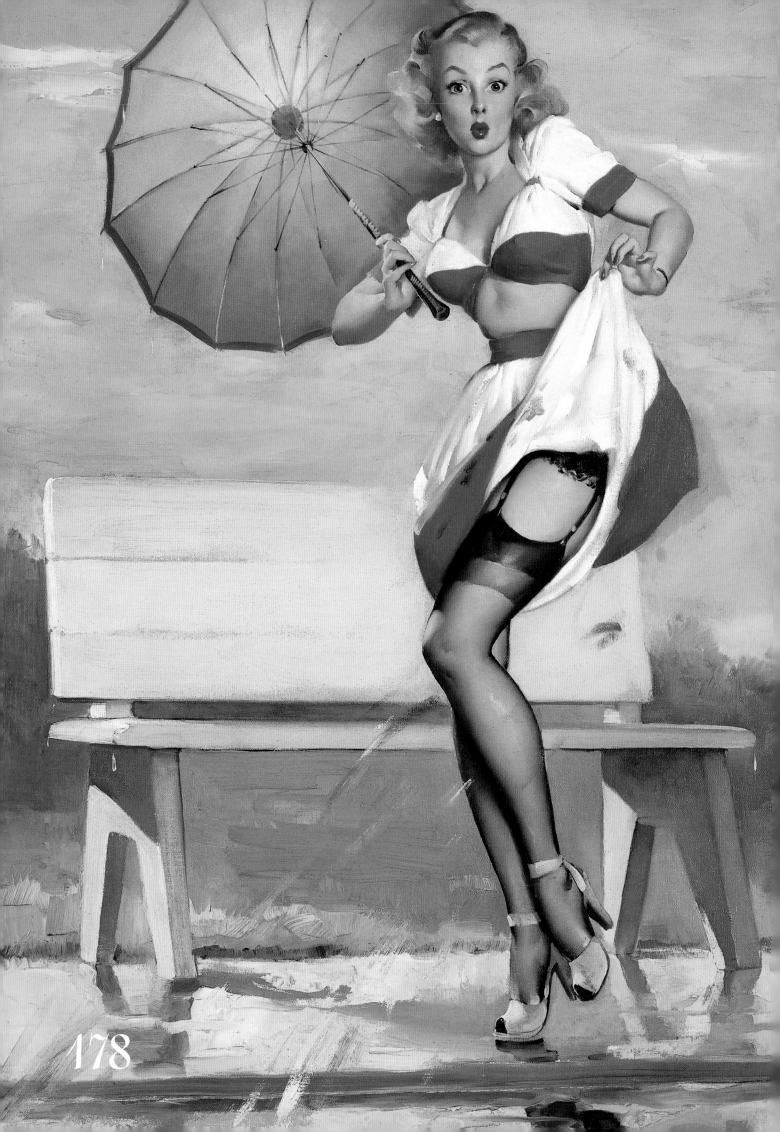

178

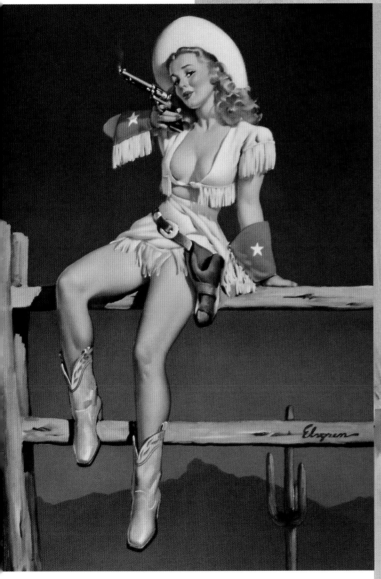

**179**

"Is this worth cultivating?"

**180**

"Isn't this the open season?"

**181**

**182**

*We're back in the saddle again!*

178  I've Been Spotted, 1949
179  Is This Worth Cultivating?, 1946
180  Isn't This the Open Season?, 1946
181  Aiming to Please (I Shot Him in the Excitement), 1946
182  Back in the Saddle (Close Pals) (We're Back in the Saddle Again!), 1946

BROWN & BIGELOW
*Remembrance Advertising*
SAINT PAUL 4, MINNESOTA

183

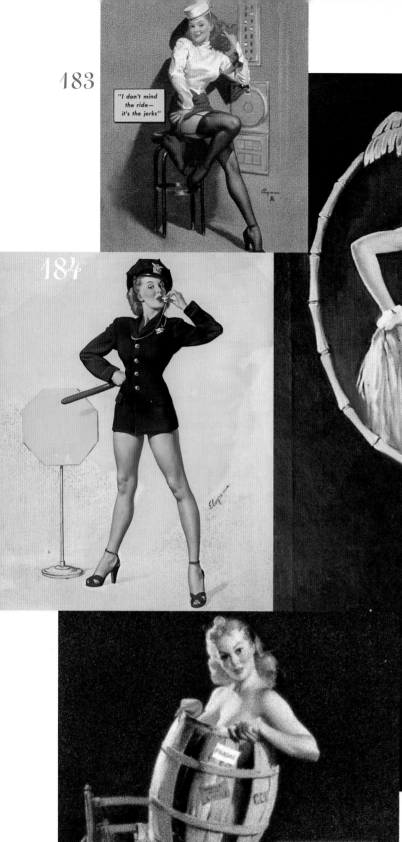

184

"I don't mind the ride— it's the jerks"

"The cads were stacked against me"

186

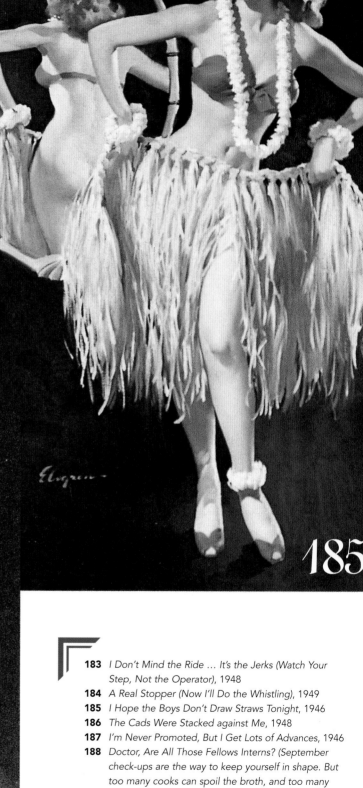

185

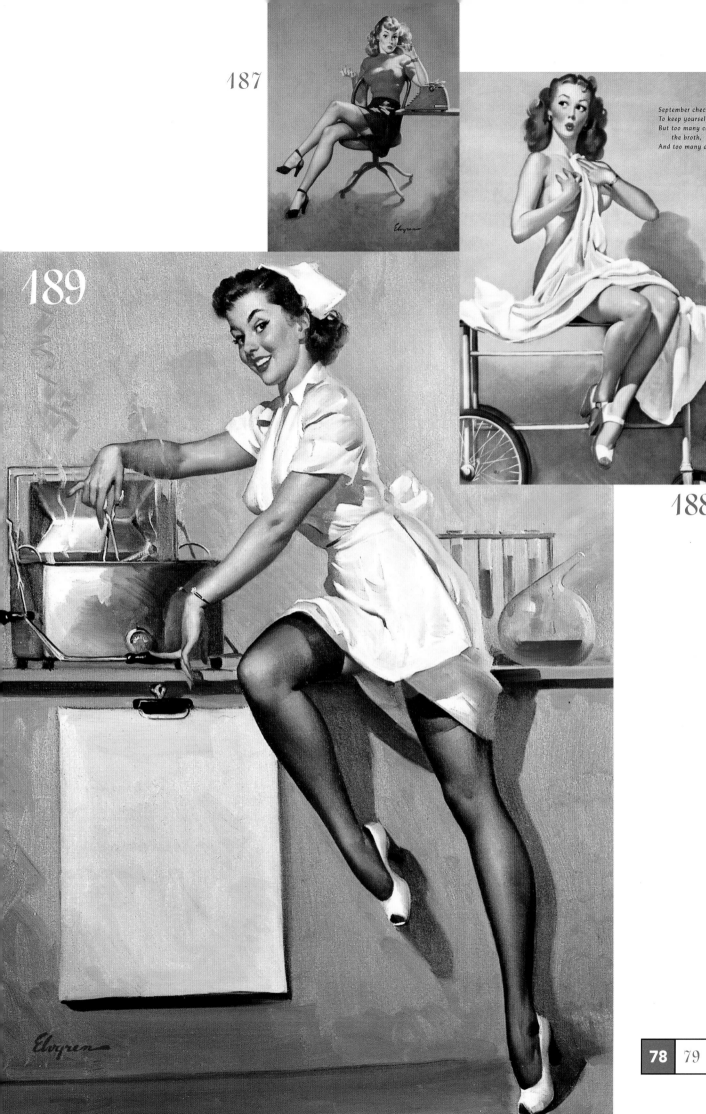

187

188

September check-ups are the way
To keep yourself in shape
But too many cooks can spoil
the broth,
And too many doctors—gape.

189

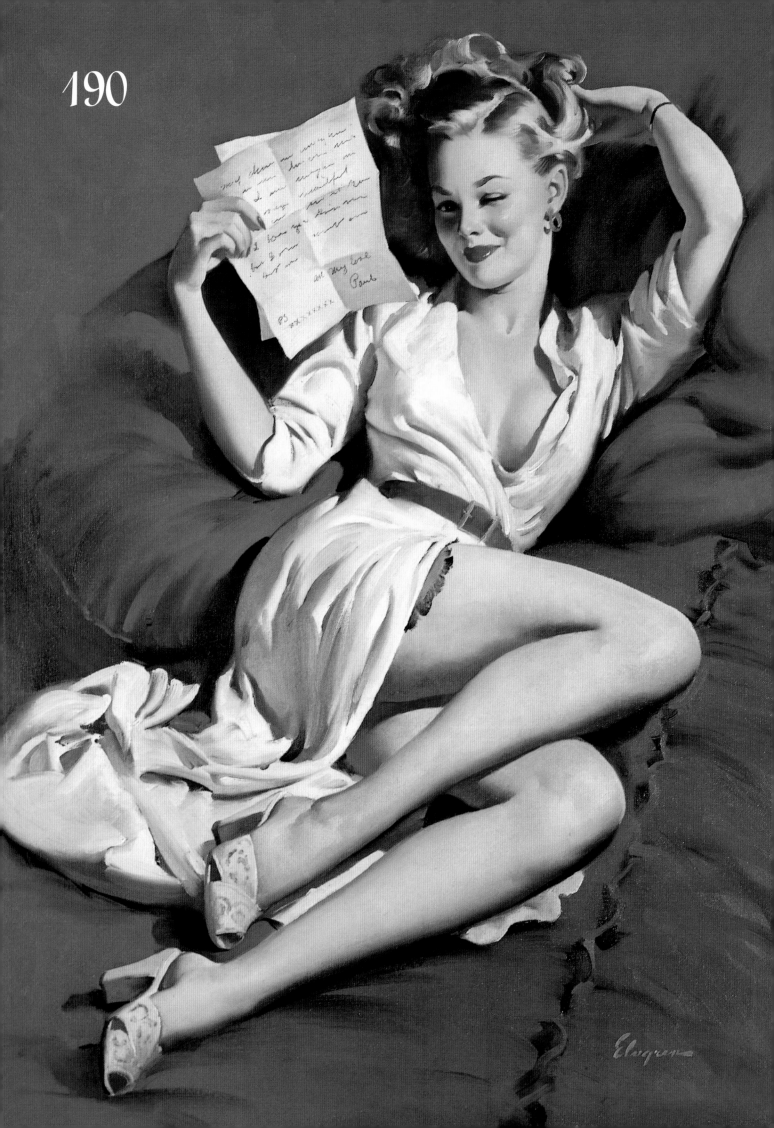

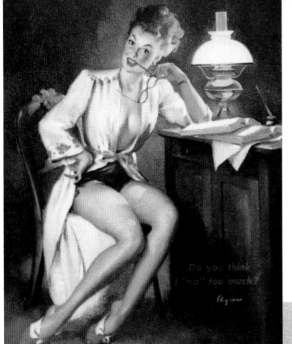

**191**

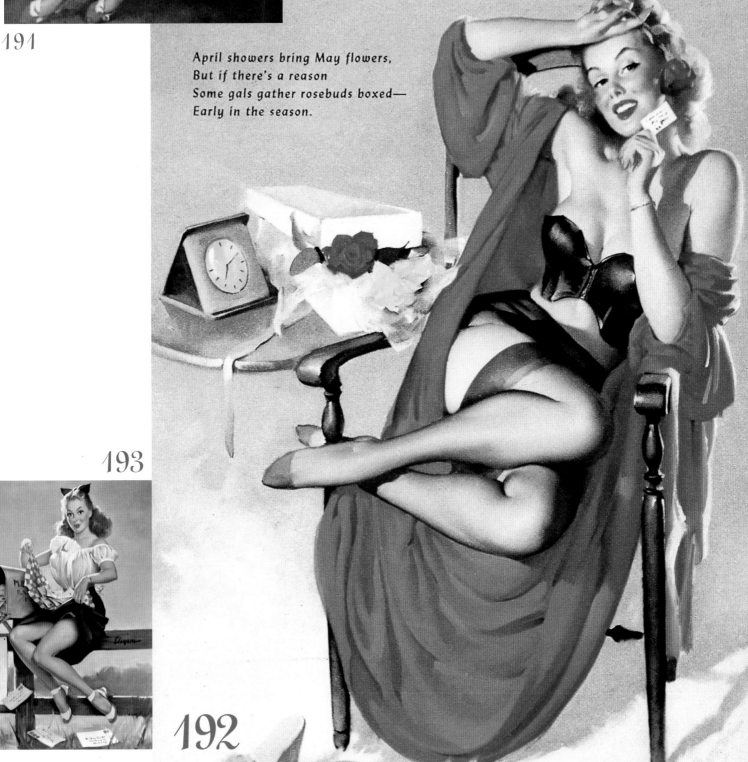

April showers bring May flowers,
But if there's a reason
Some gals gather rosebuds boxed—
Early in the season.

**193**

**192**

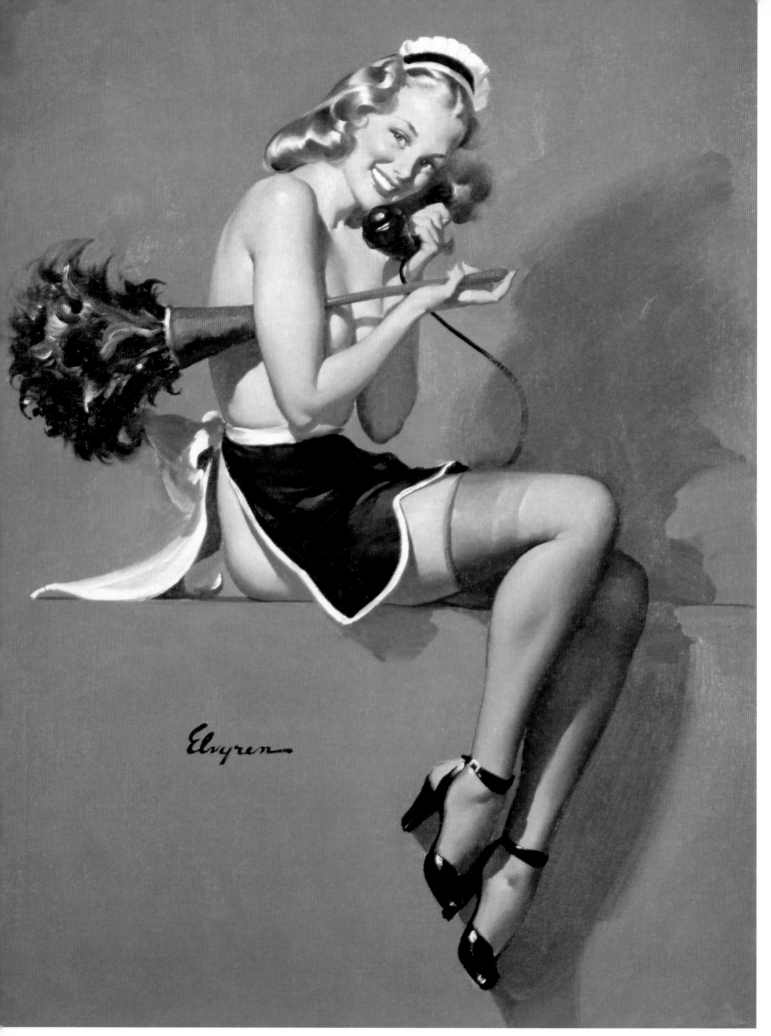

194

195

*"Everything seems awfully high around here."*

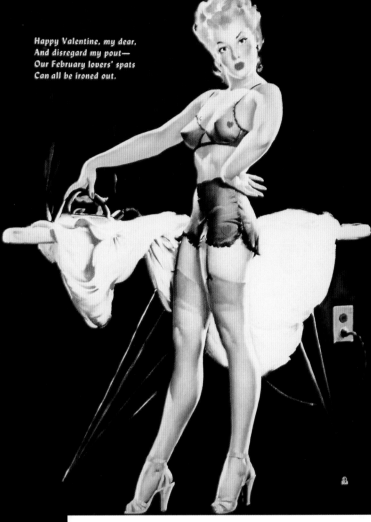

Happy Valentine, my dear,
And disregard my pout—
Our February lovers' spats
Can all be ironed out.

196

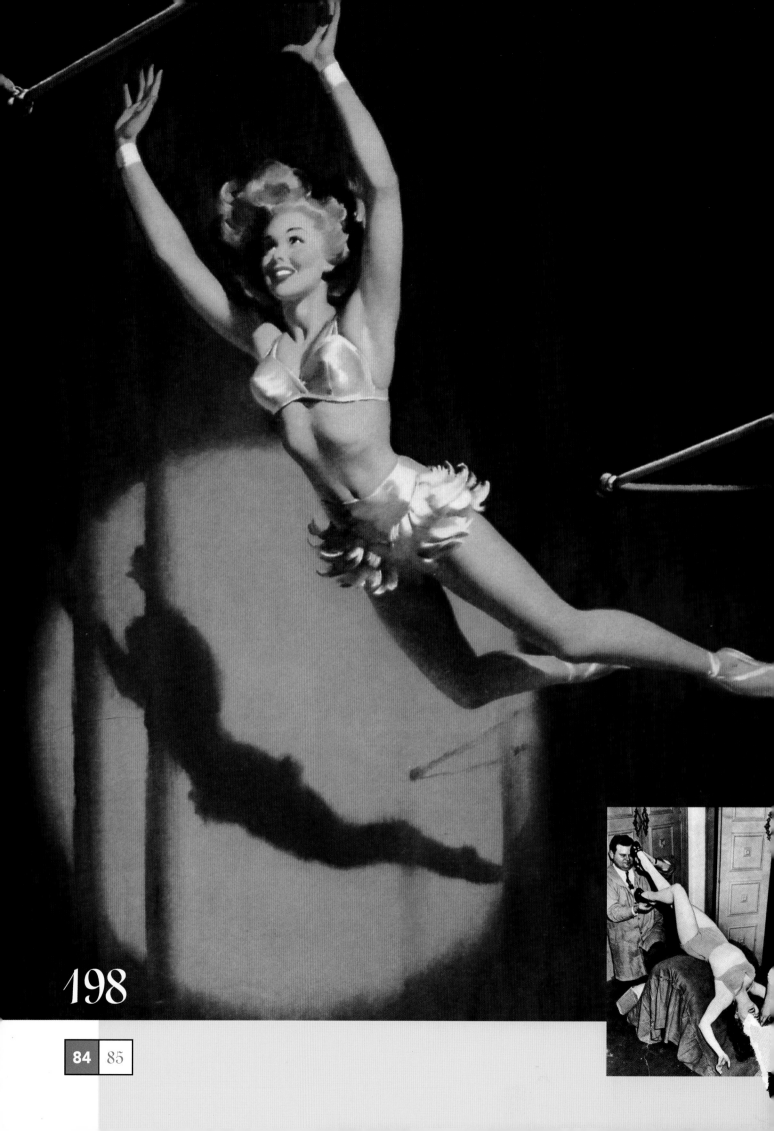

198

84 85

199

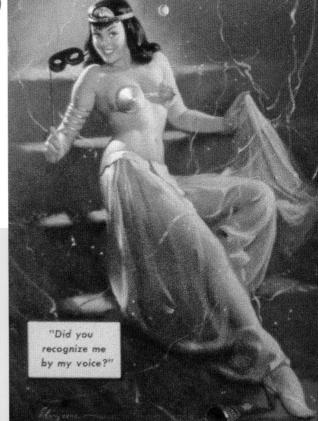

"Did you recognize me by my voice?"

200

"It's time to put the motion before the house"

201

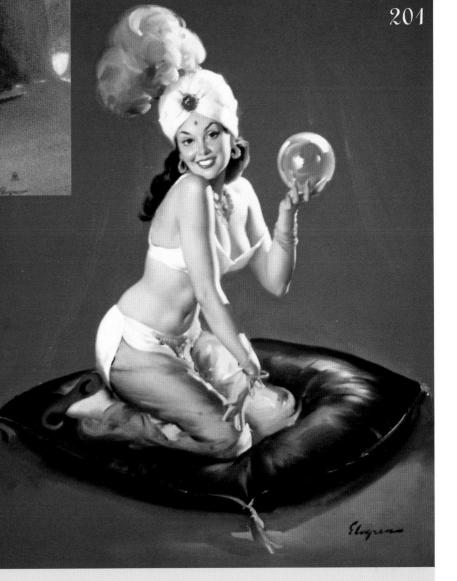

202

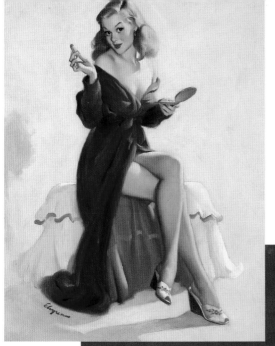

203

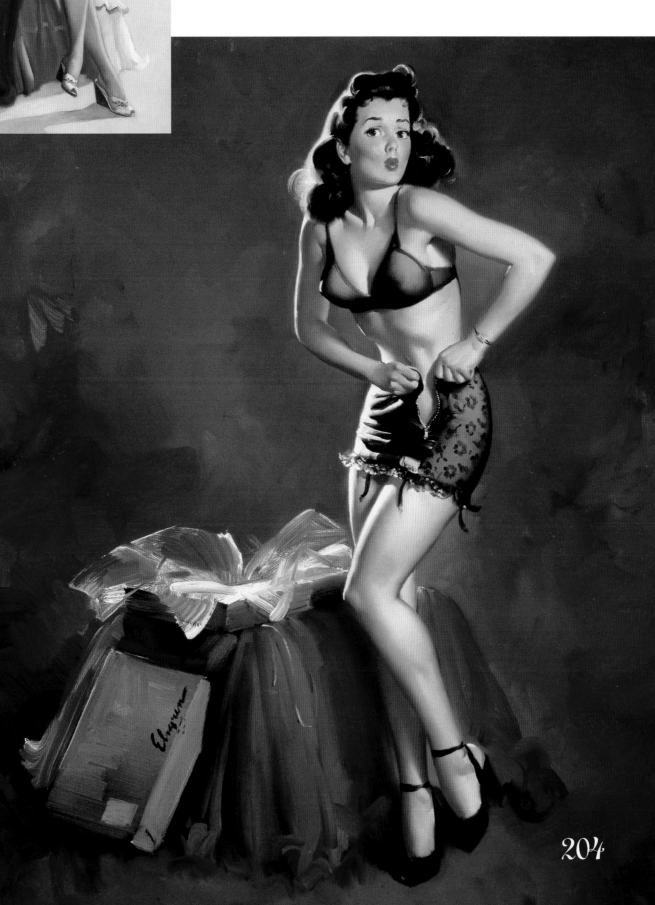

204

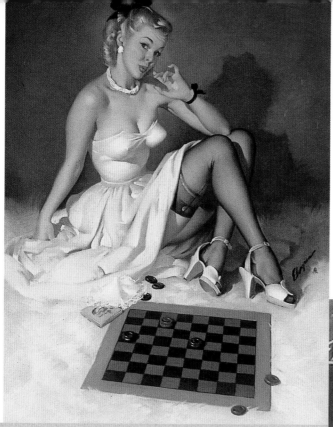

205

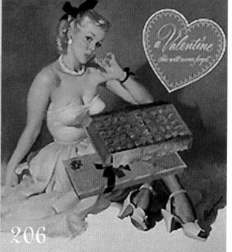

206

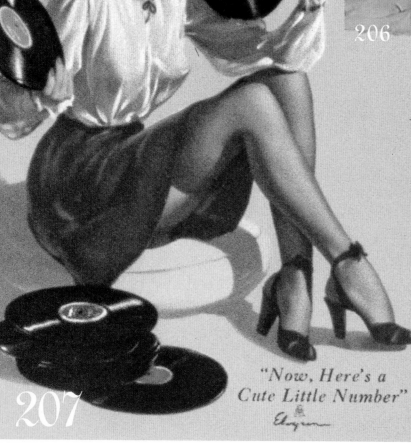

"*Now, Here's a
Cute Little Number*"

207

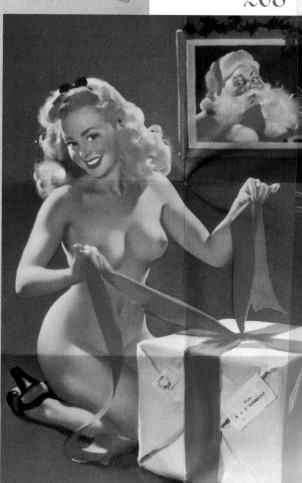

208

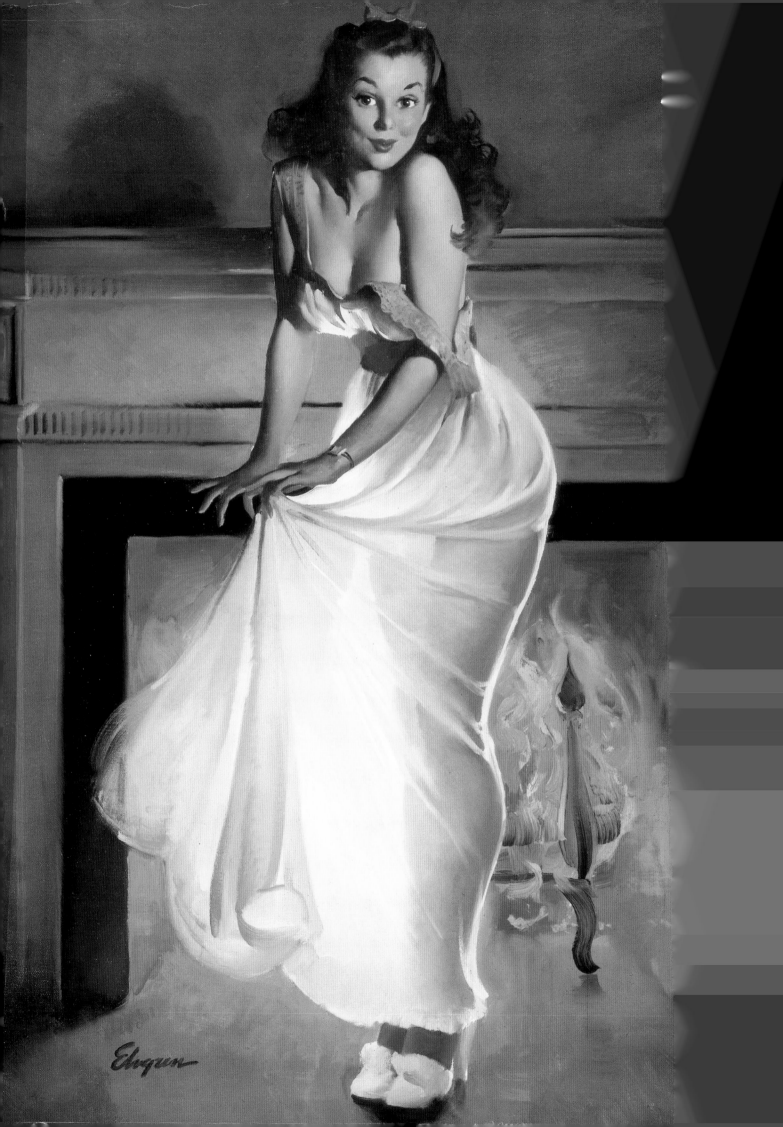

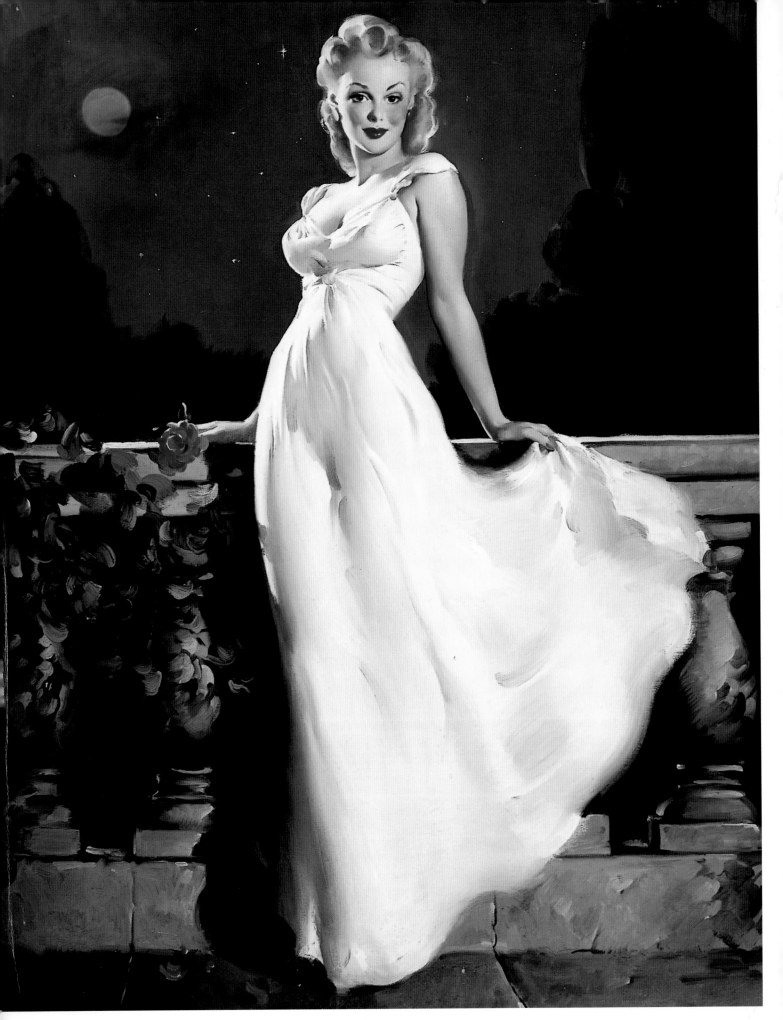

**212**

He almost scared
out of my skin

**213**

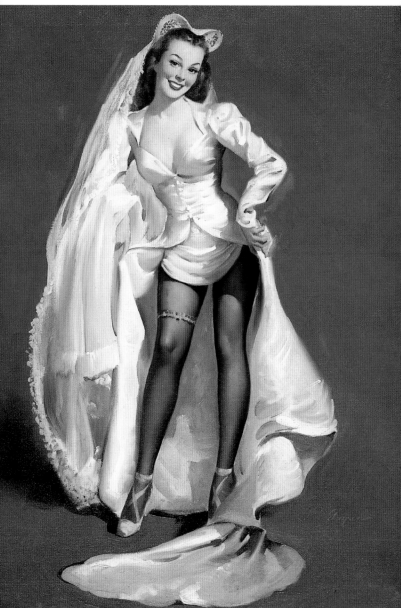

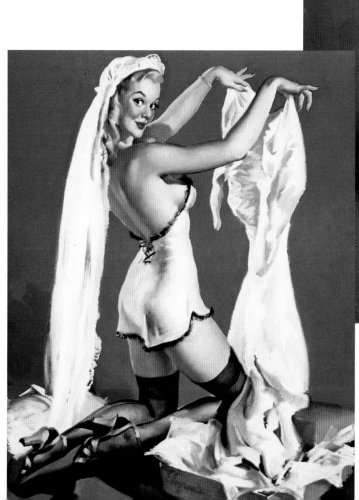

**211**

**214**

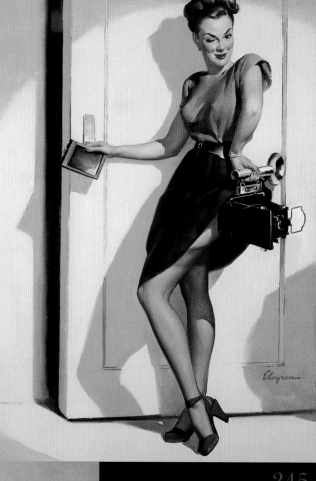

215

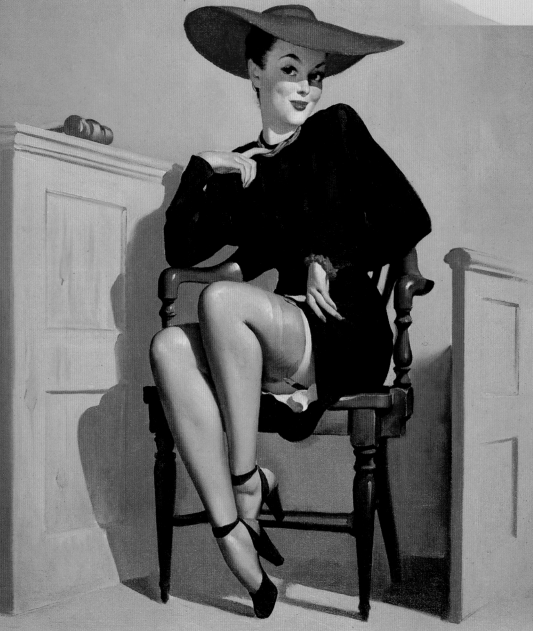

216

217

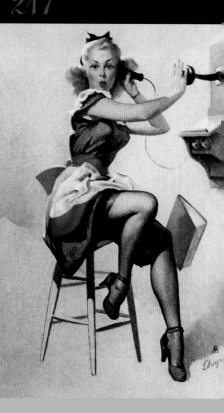

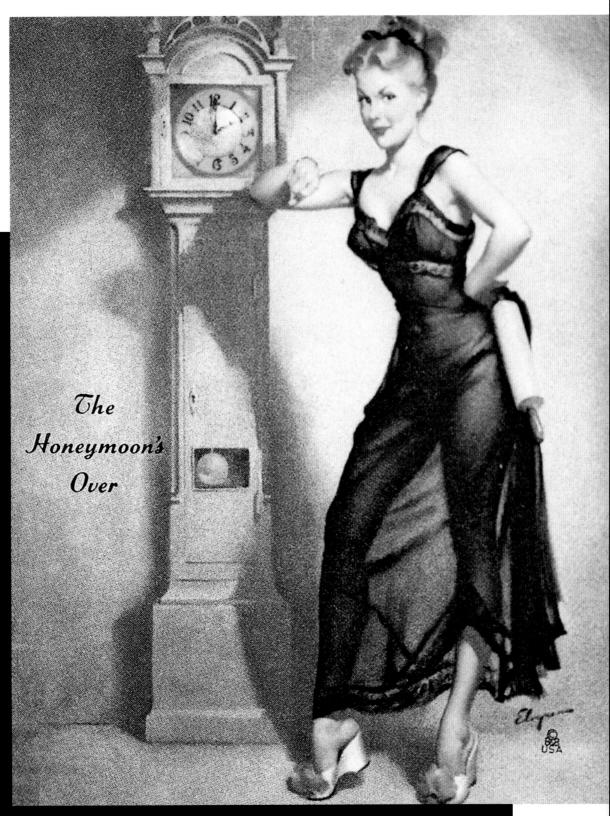

The
Honeymoon's
Over

218

219

220

Drawing Attention

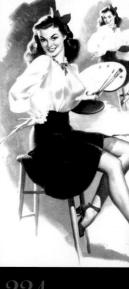

221

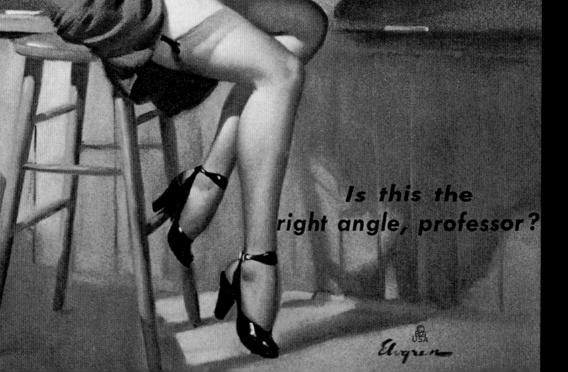

Is this the
right angle, professor?

Elvgren

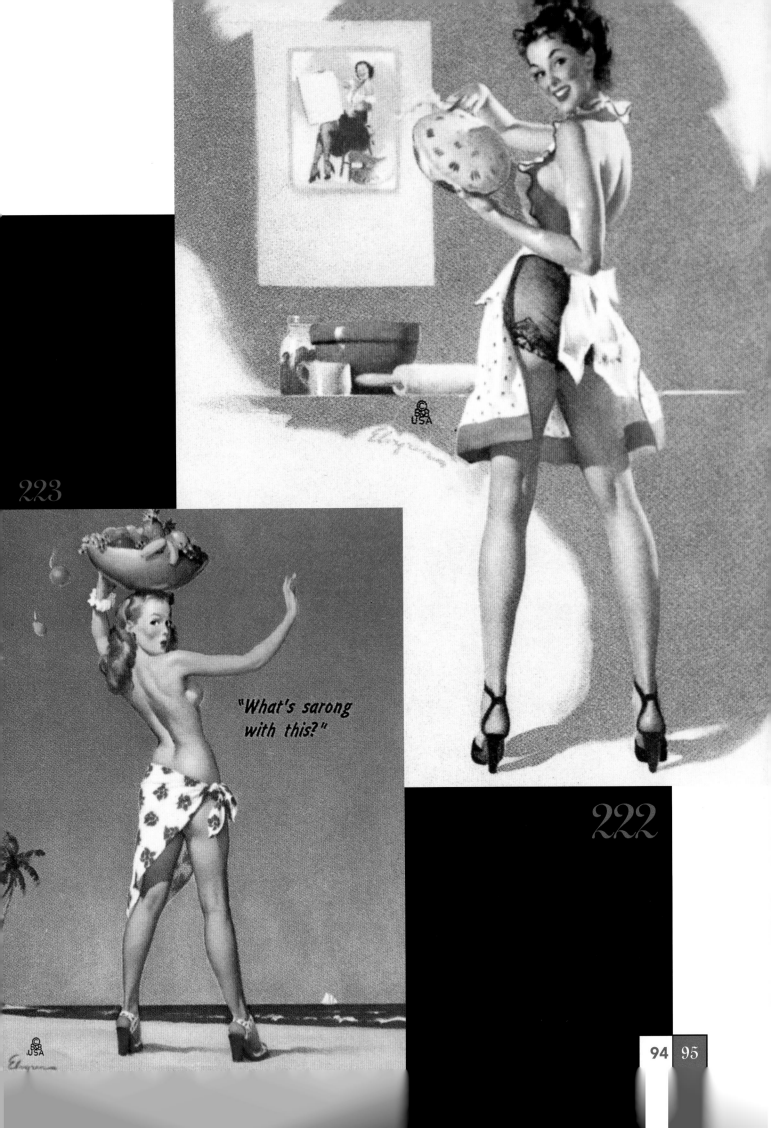

"What's sarong
with this?"

223

222

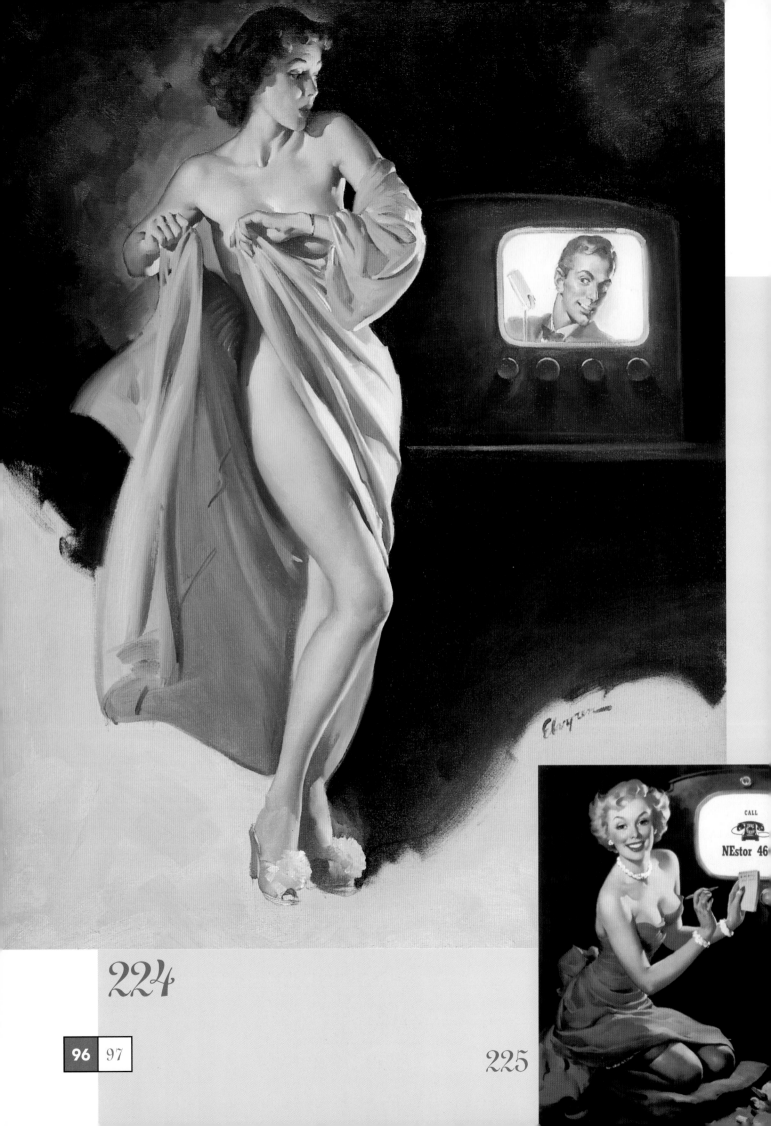

224

225

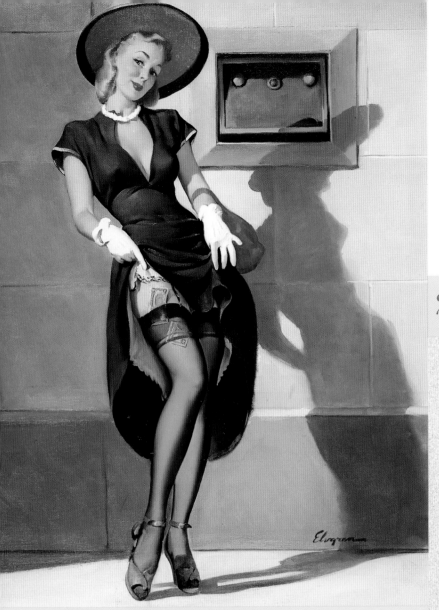

226

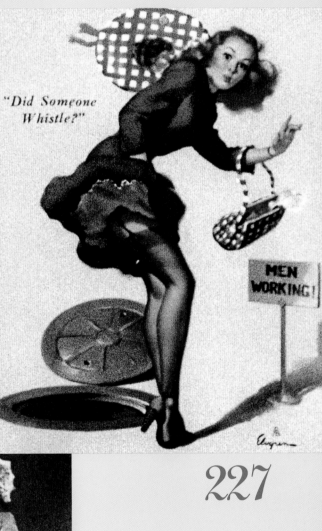

227

228

229

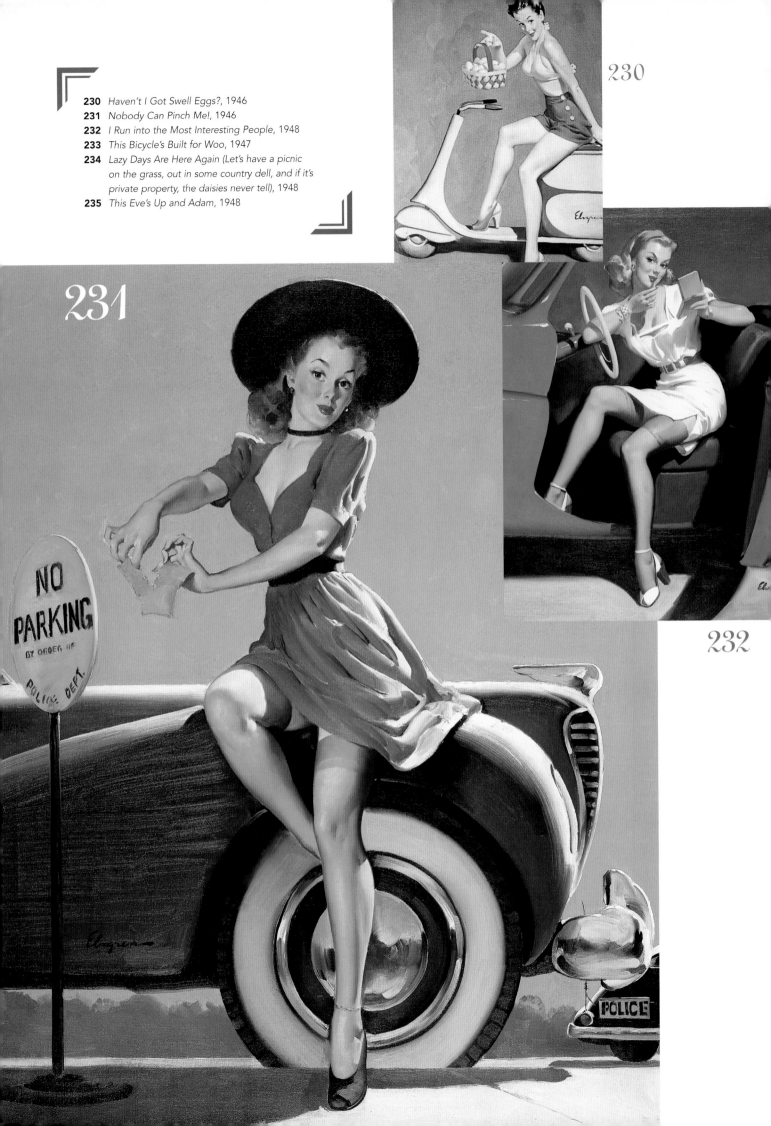

230

231

232

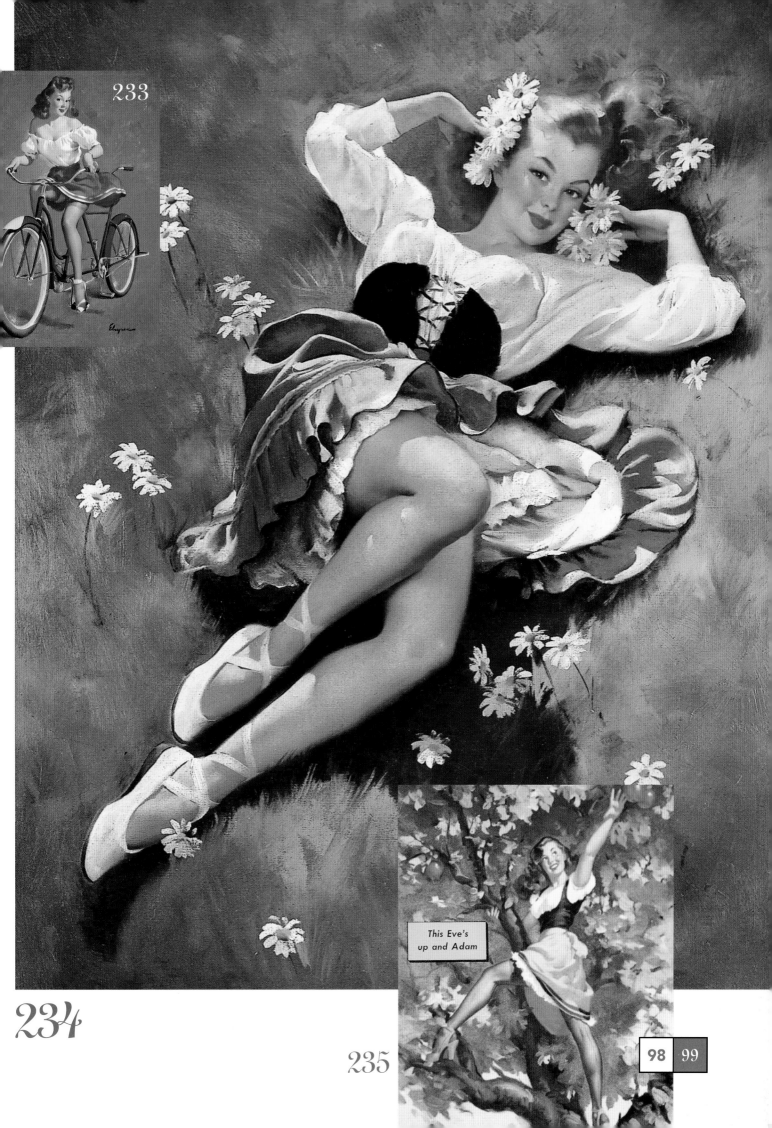

233

234

235

This Eve's
up and Adam

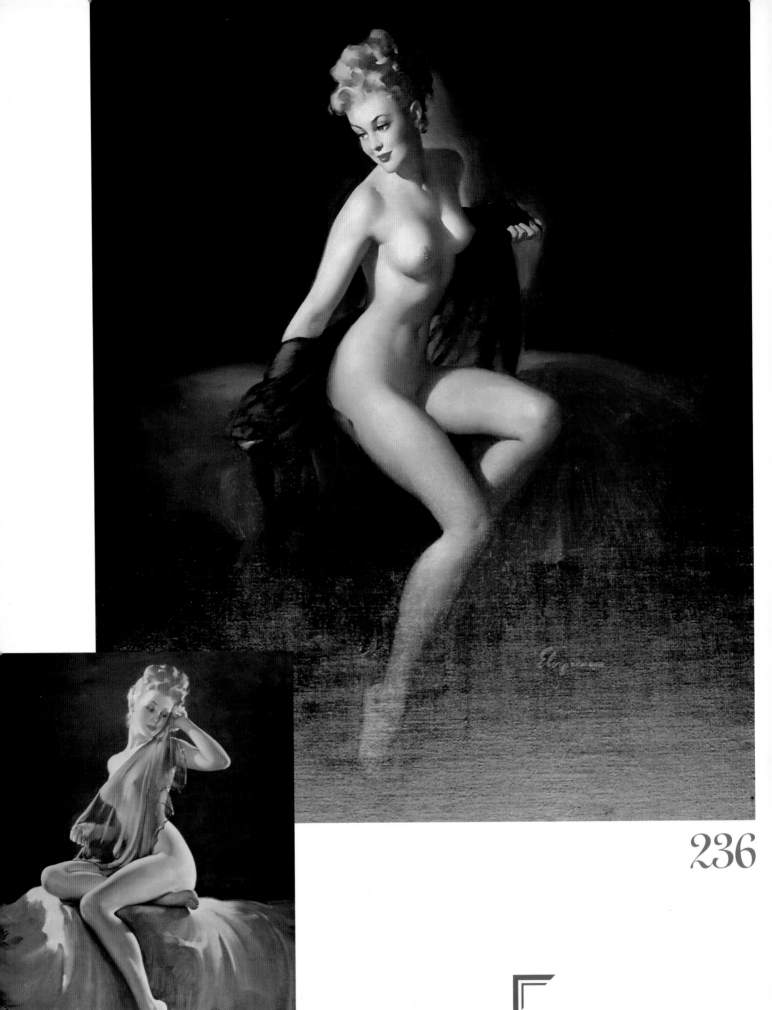

236

237

236 *Vision of Beauty (Unveiling), 1947*
237 *Adoration, 1945*
238 *Gay Nymph, 1947*

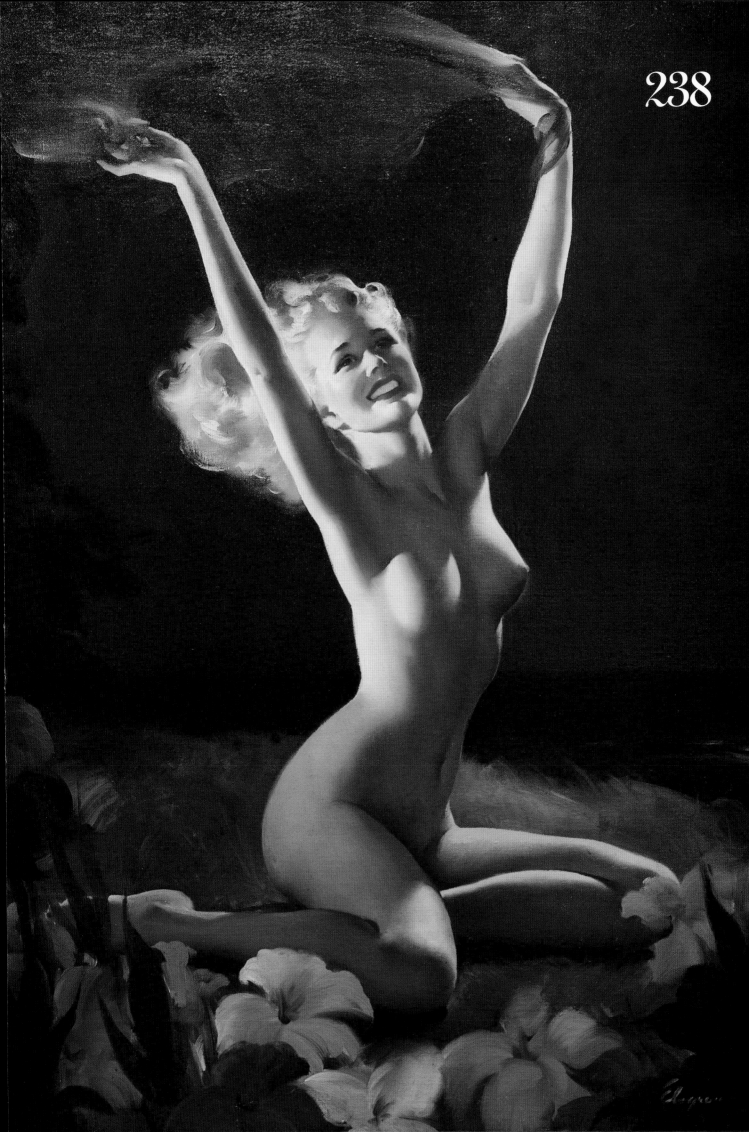

# THE 1950s

## The Middle
## BROWN & BIGELOW
### Years

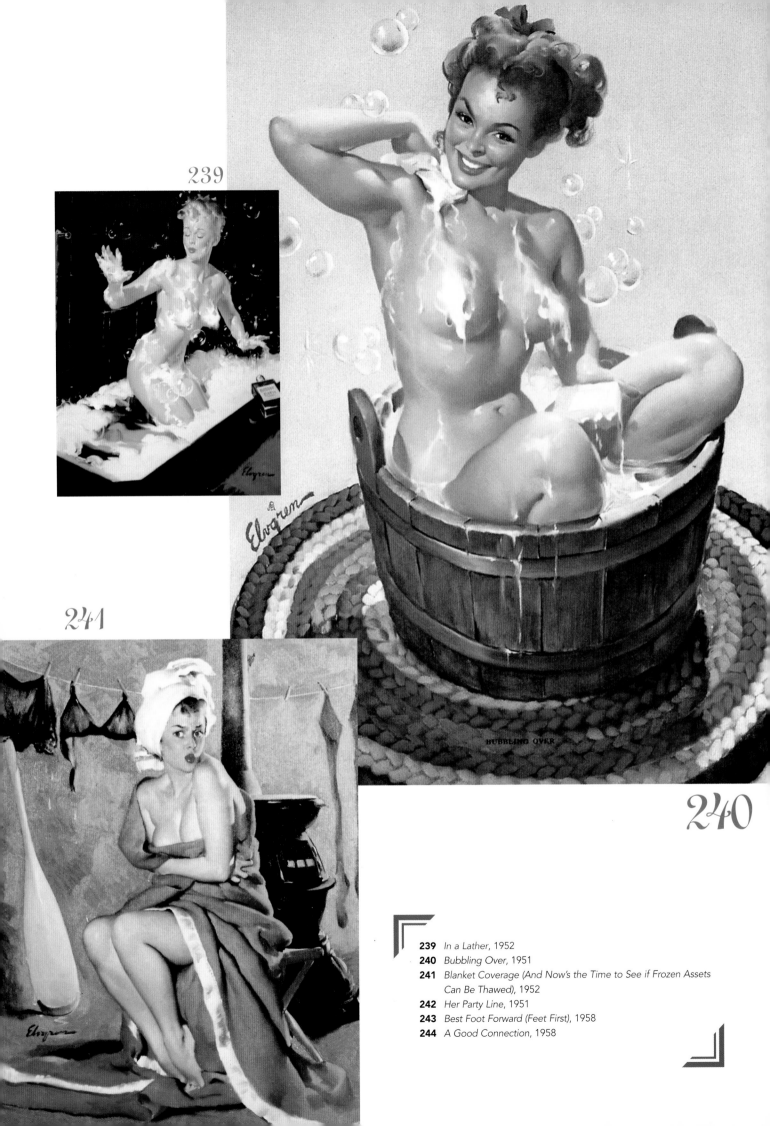

**239**

**244**

**240**

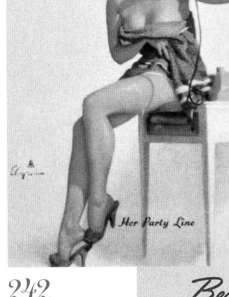

*Her Party Line*

242

*Best Foot Forward*

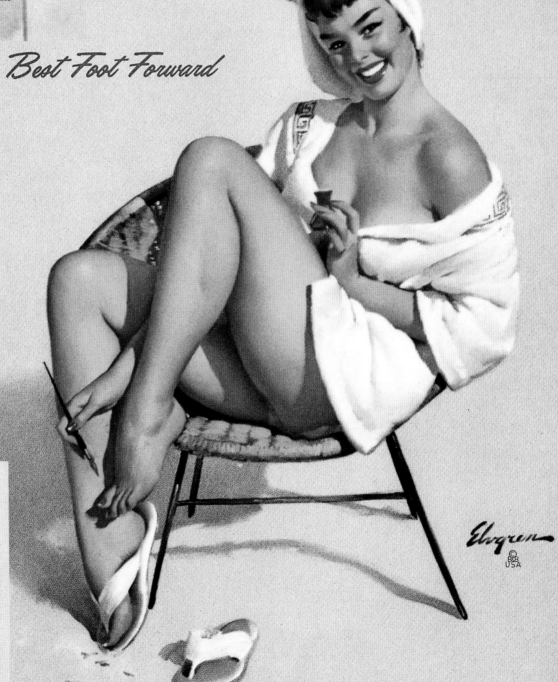

*Elvgren*

*A Good Connection*

244

245

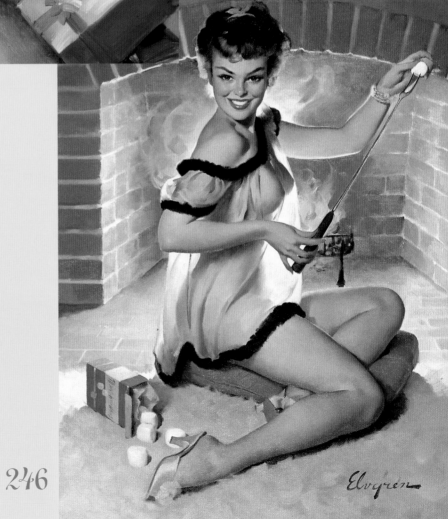

246

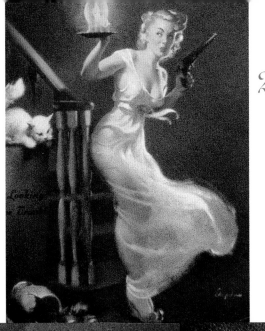

247

249

248

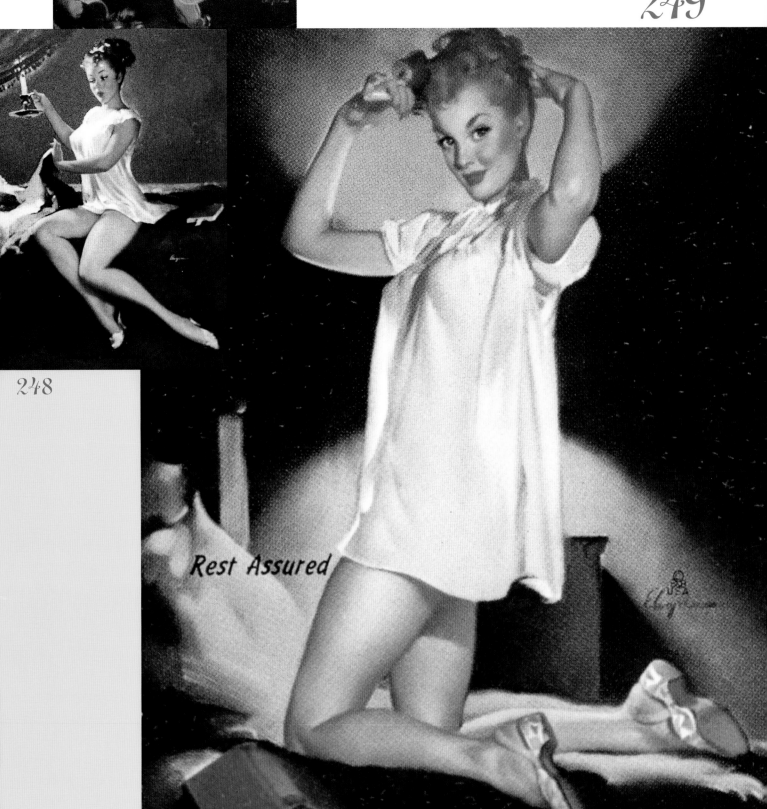

Rest Assured

250

251

To my good friend Harold
Gil

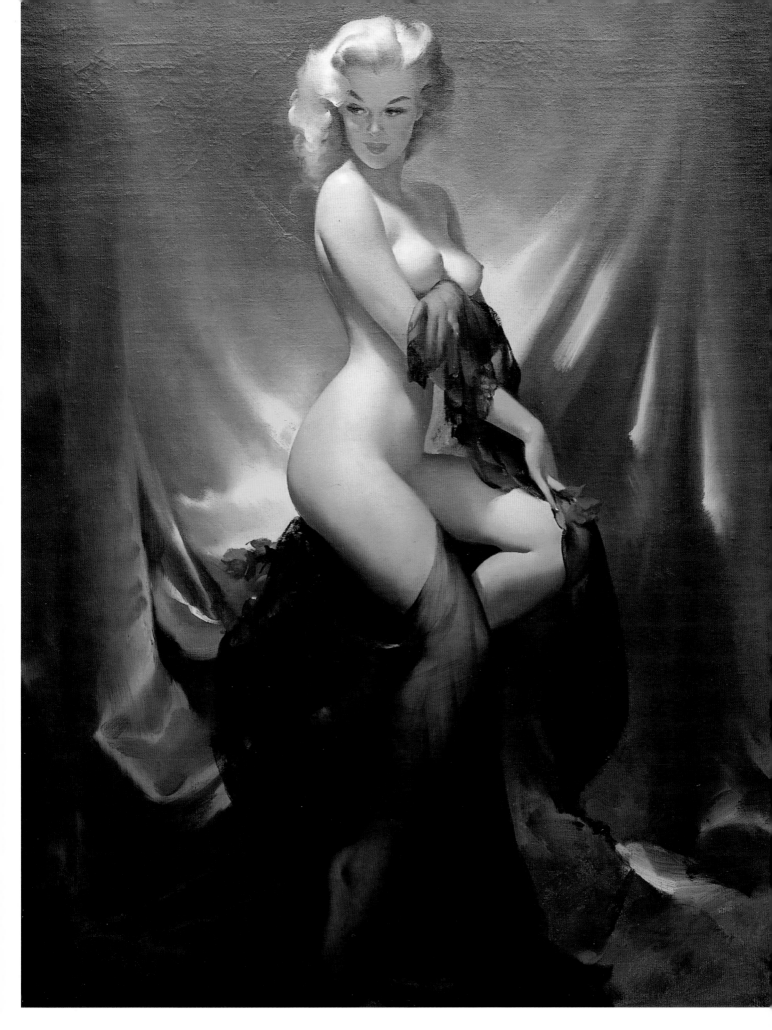

252

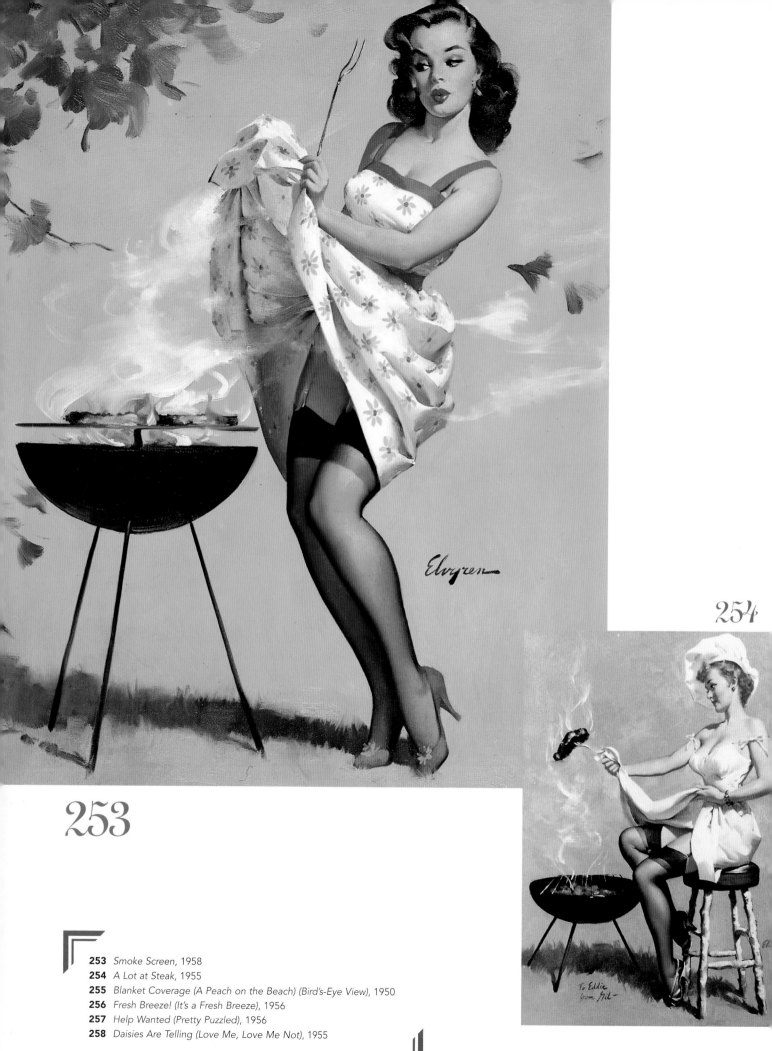

**253**

**254**

**255**

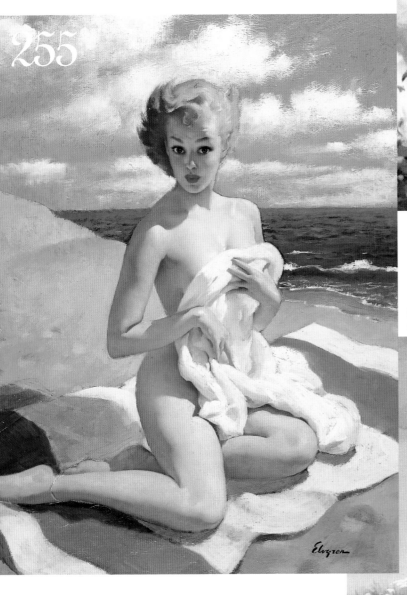

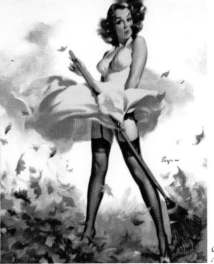

**256**

**258**

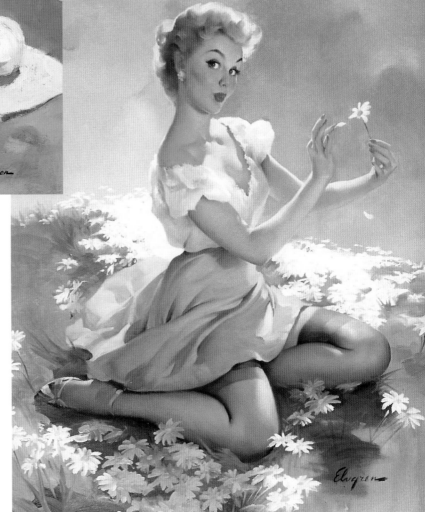

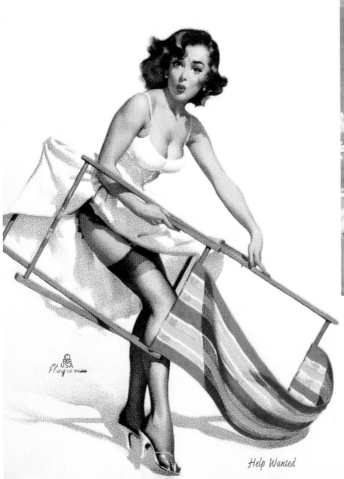

**257**

Help Wanted

259

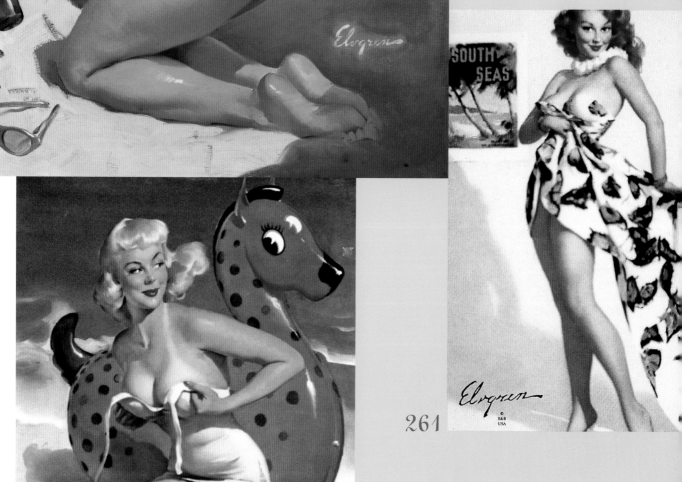

261

260

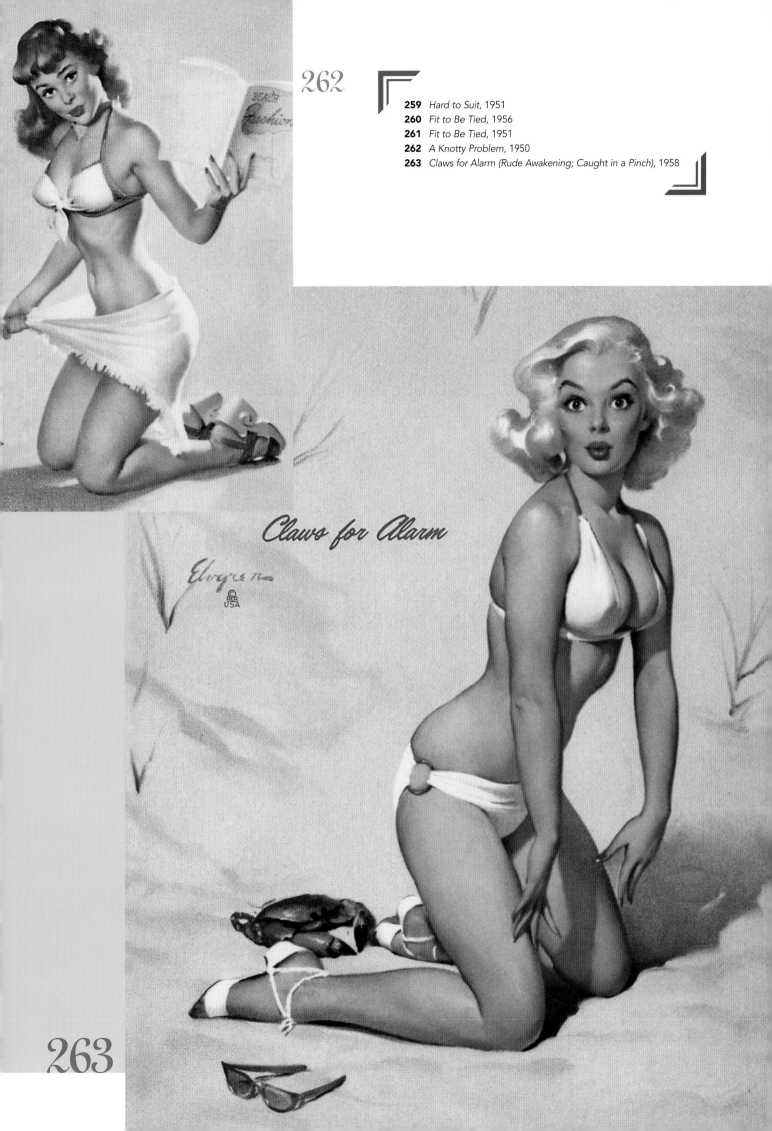

262

*Claws for Alarm*

263

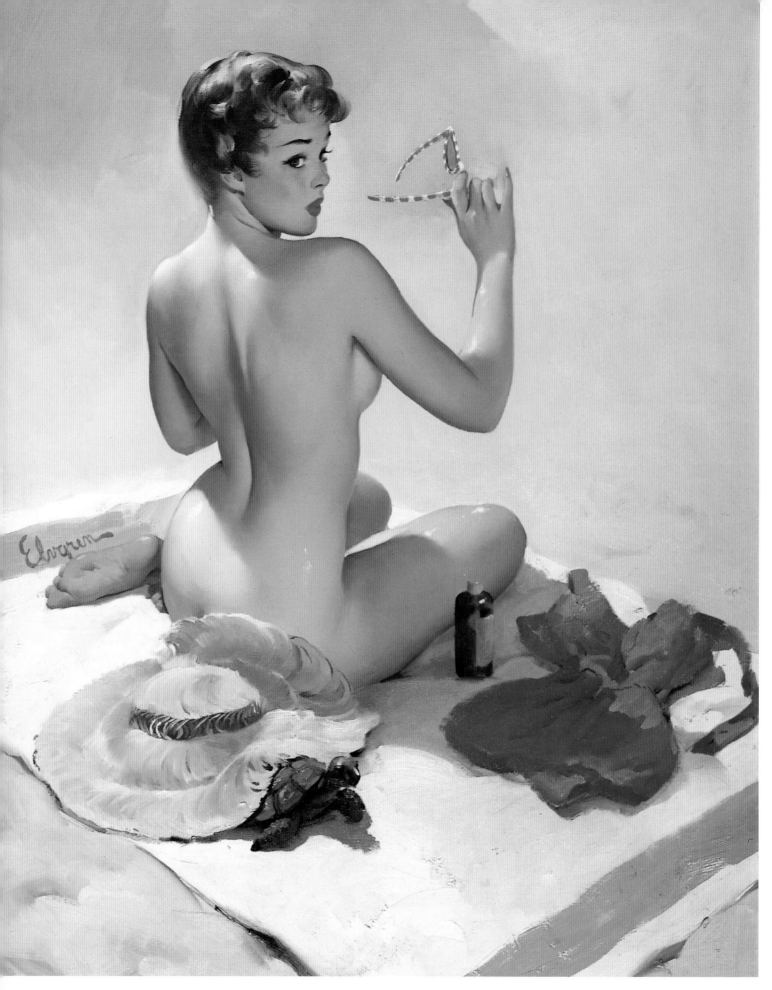

264

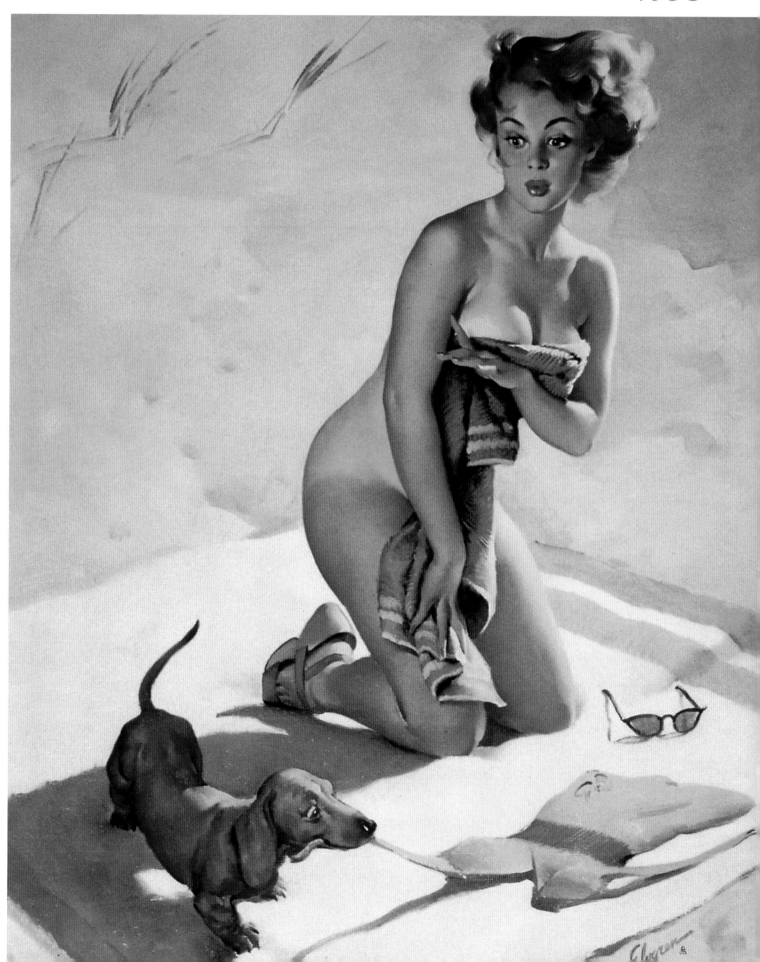

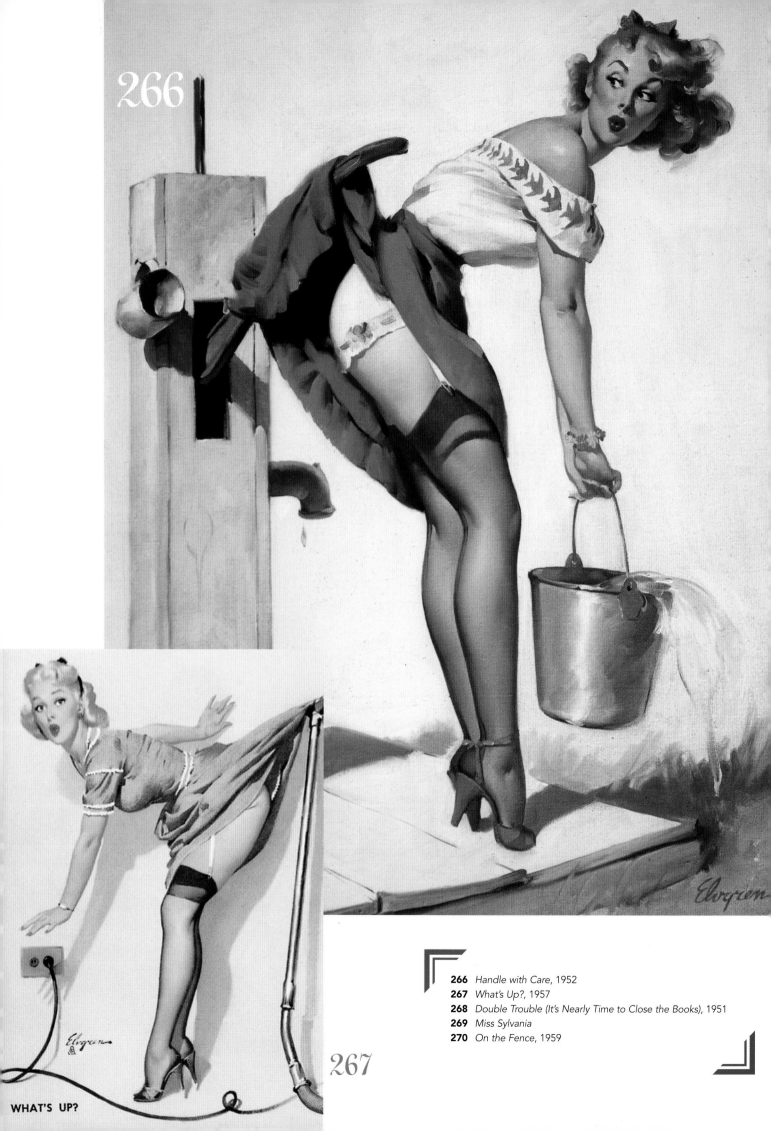

266

267

WHAT'S UP?

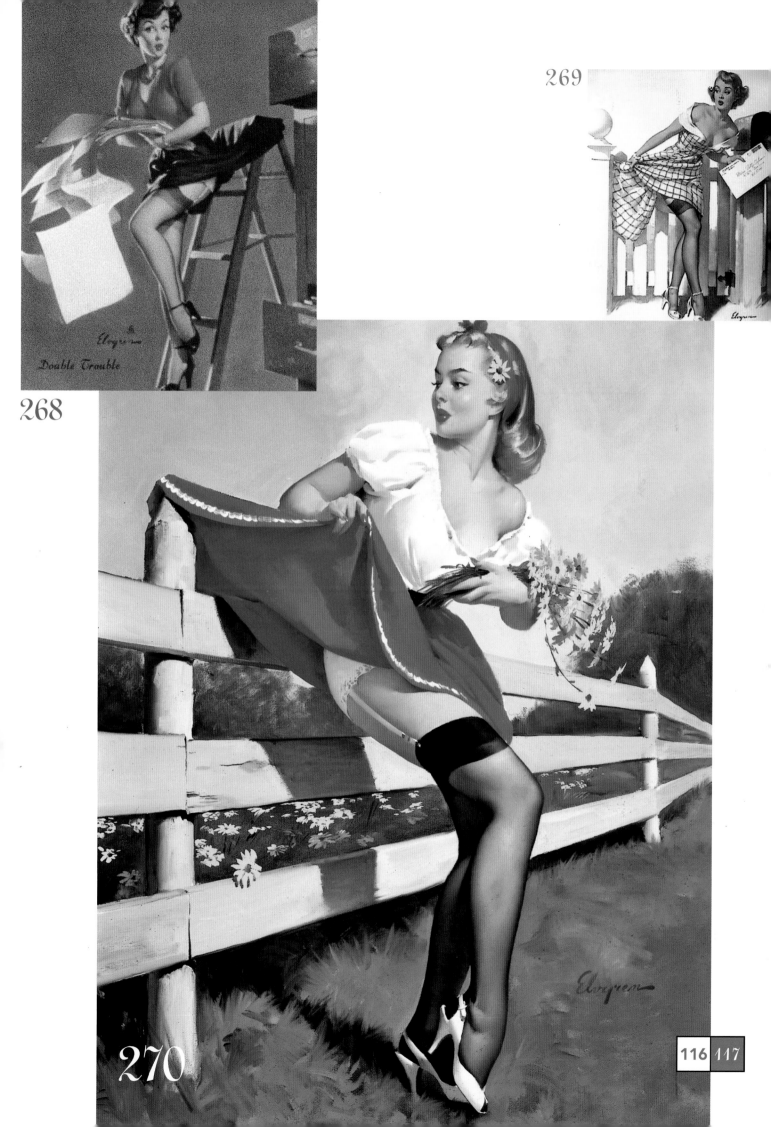

268

Double Trouble

269

270

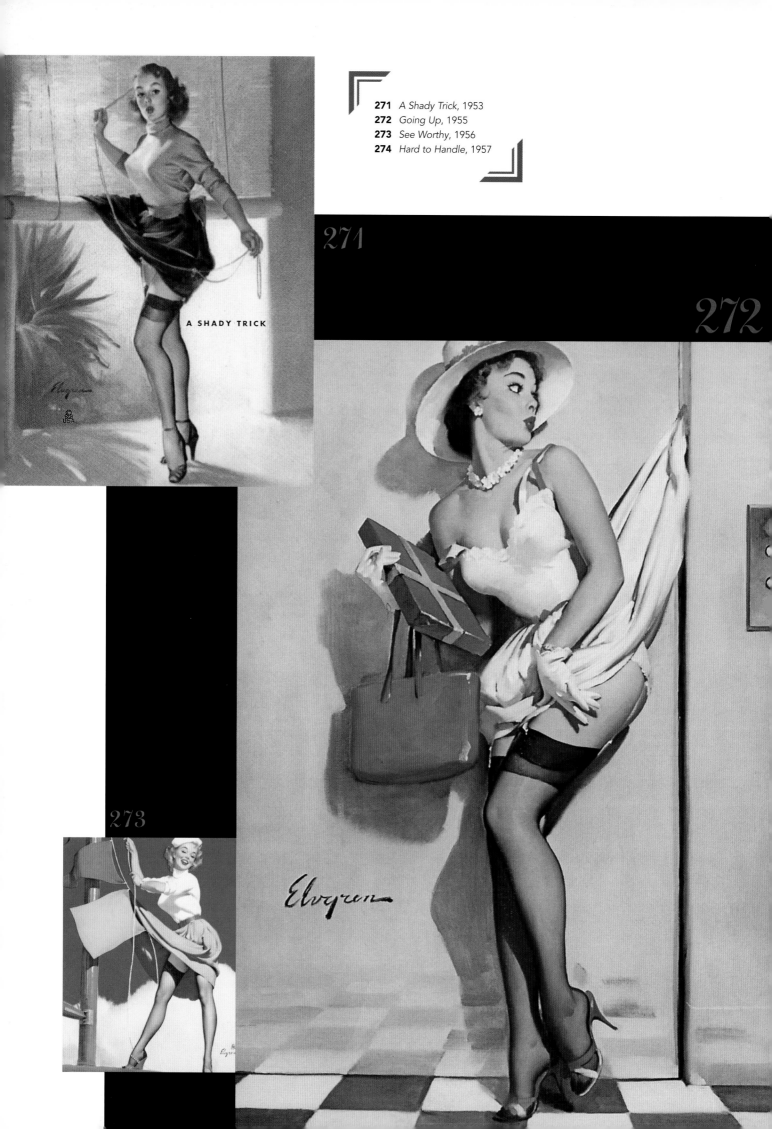

A SHADY TRICK

271

272

273

Elvgren

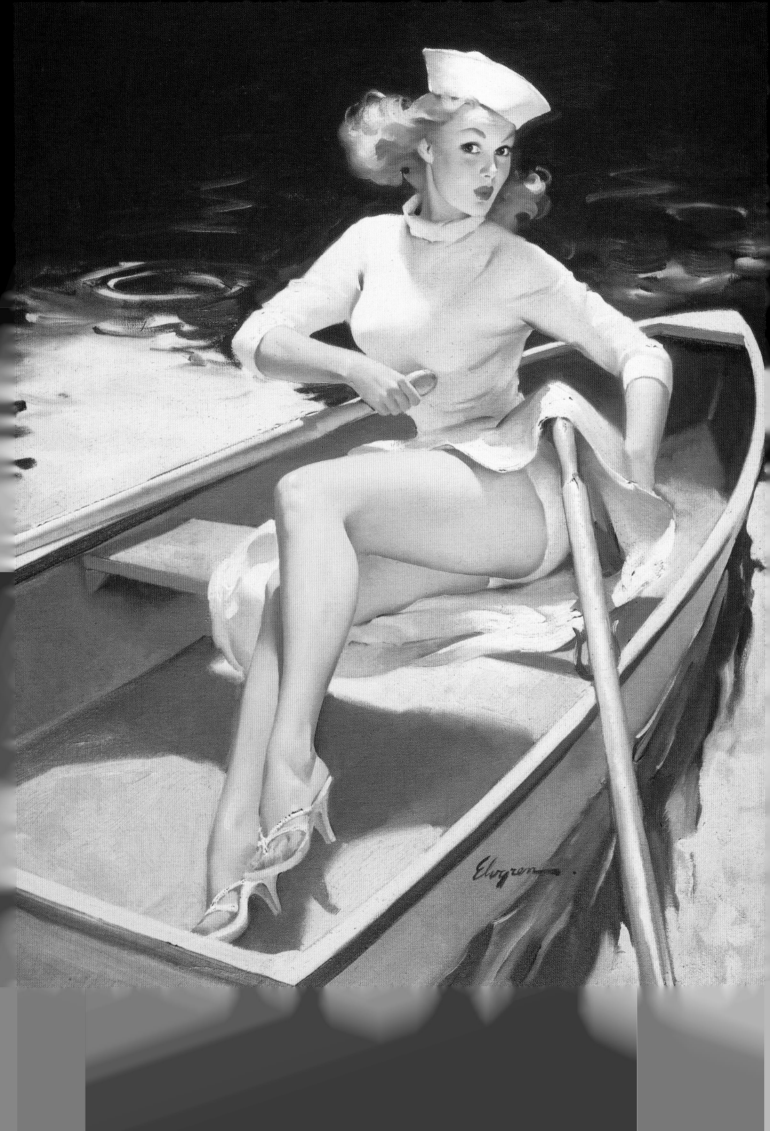

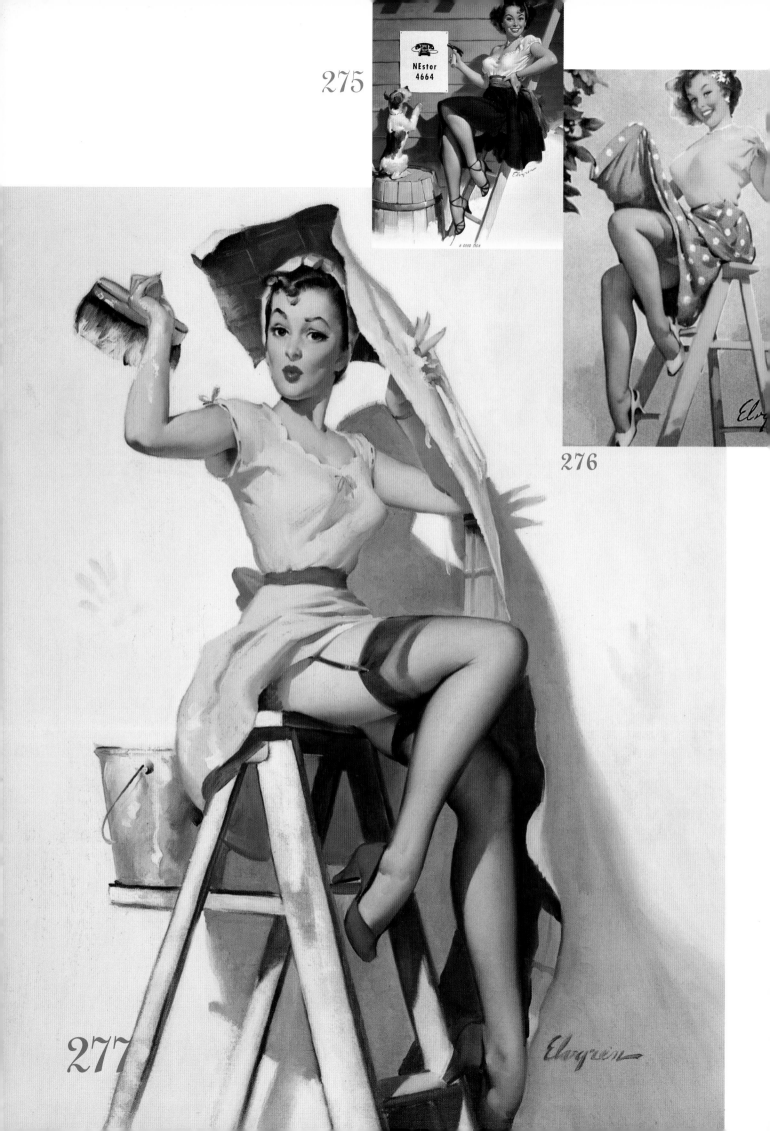

275

276

277

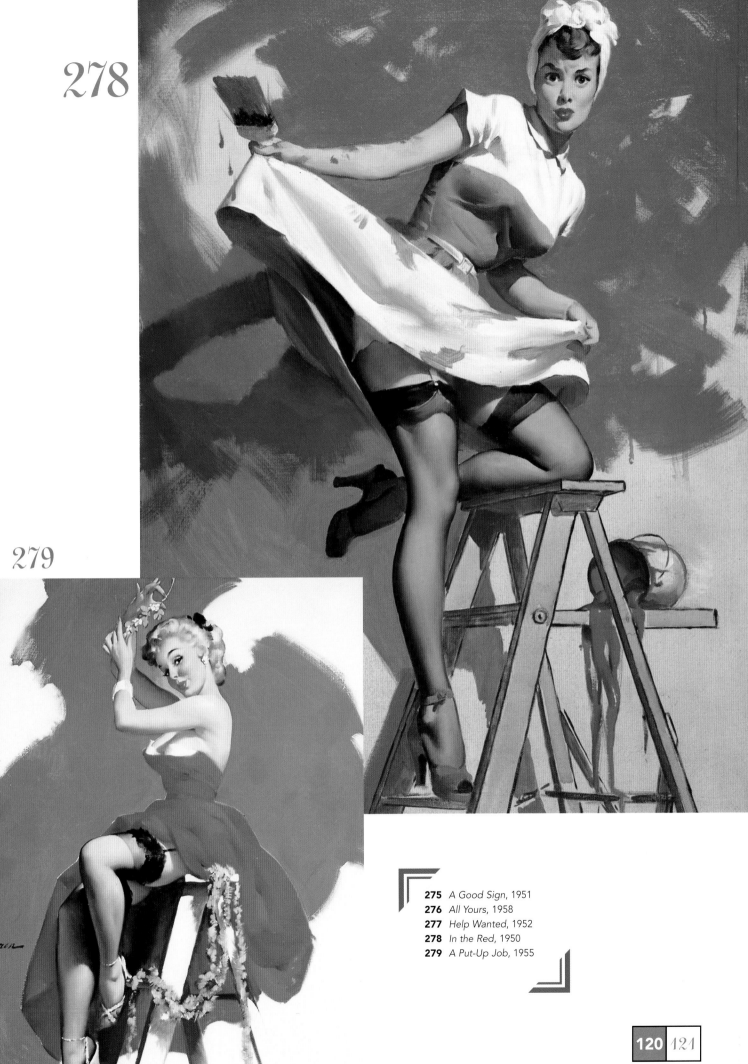

278

279

275 *A Good Sign*, 1951
276 *All Yours*, 1958
277 *Help Wanted*, 1952
278 *In the Red*, 1950
279 *A Put-Up Job*, 1955

**280**

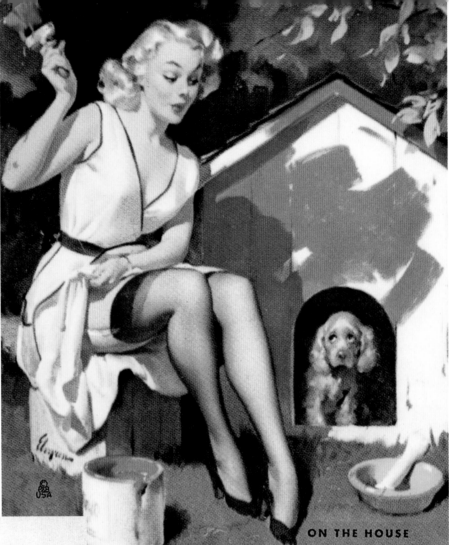

ON THE HOUSE

**281**

**282**

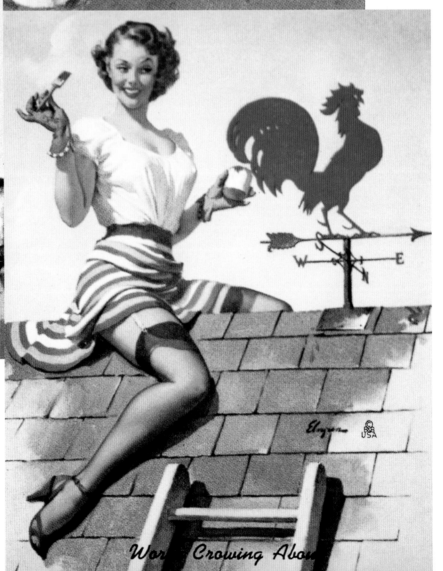

*Wor.. Crowing Abou.*

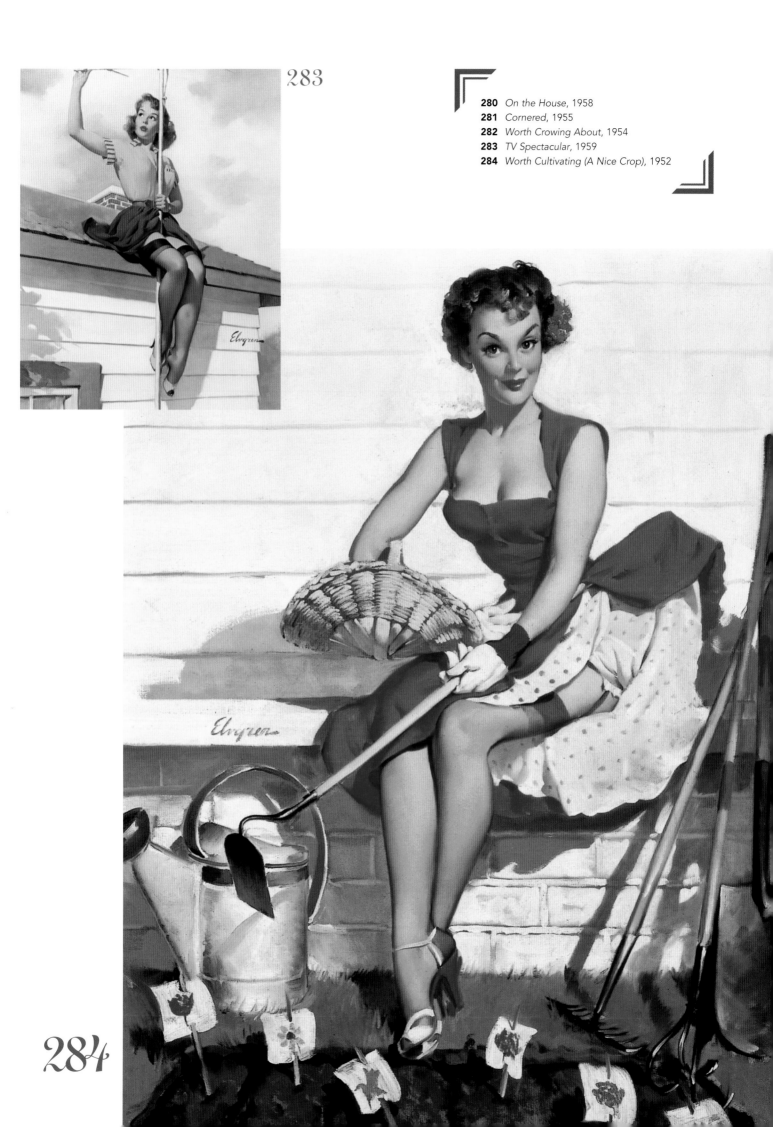

283

284

285

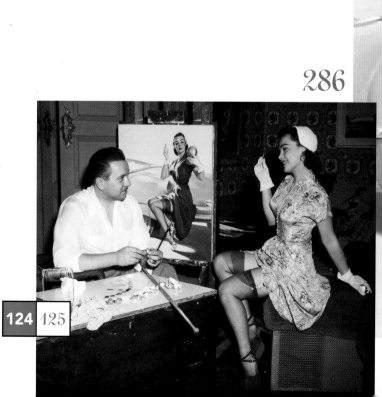

286

287

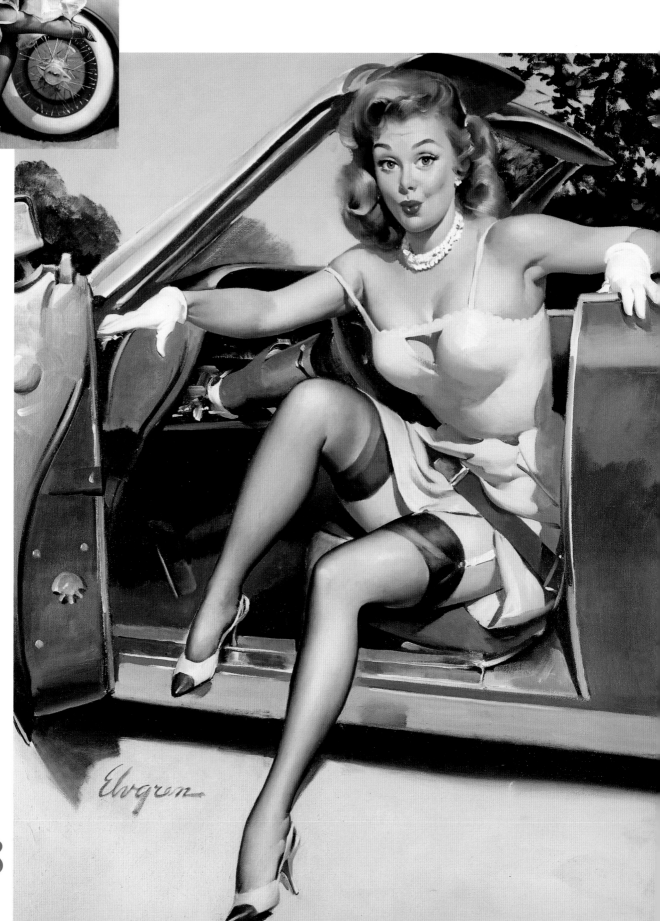

288

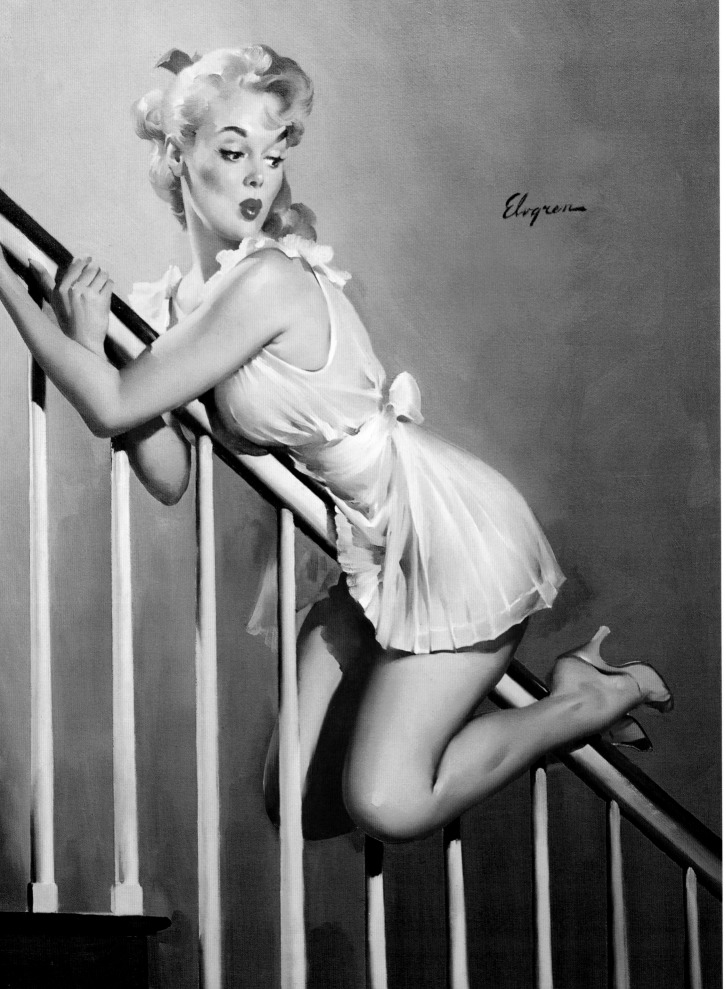

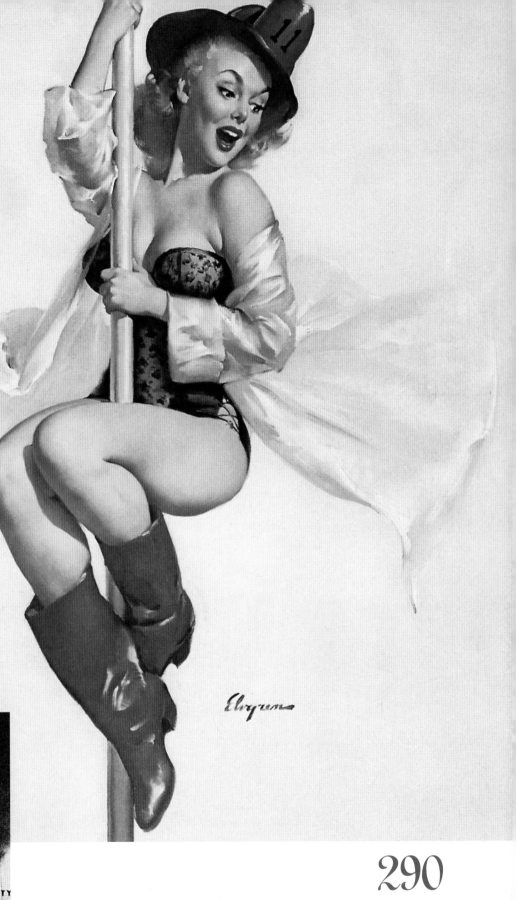

291

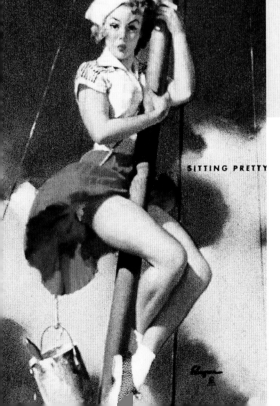

SITTING PRETTY

290

289  Look Out Below (Easy Does It), 1956
290  Fire Belle (Always Ready), 1956
291  Sitting Pretty, 1953

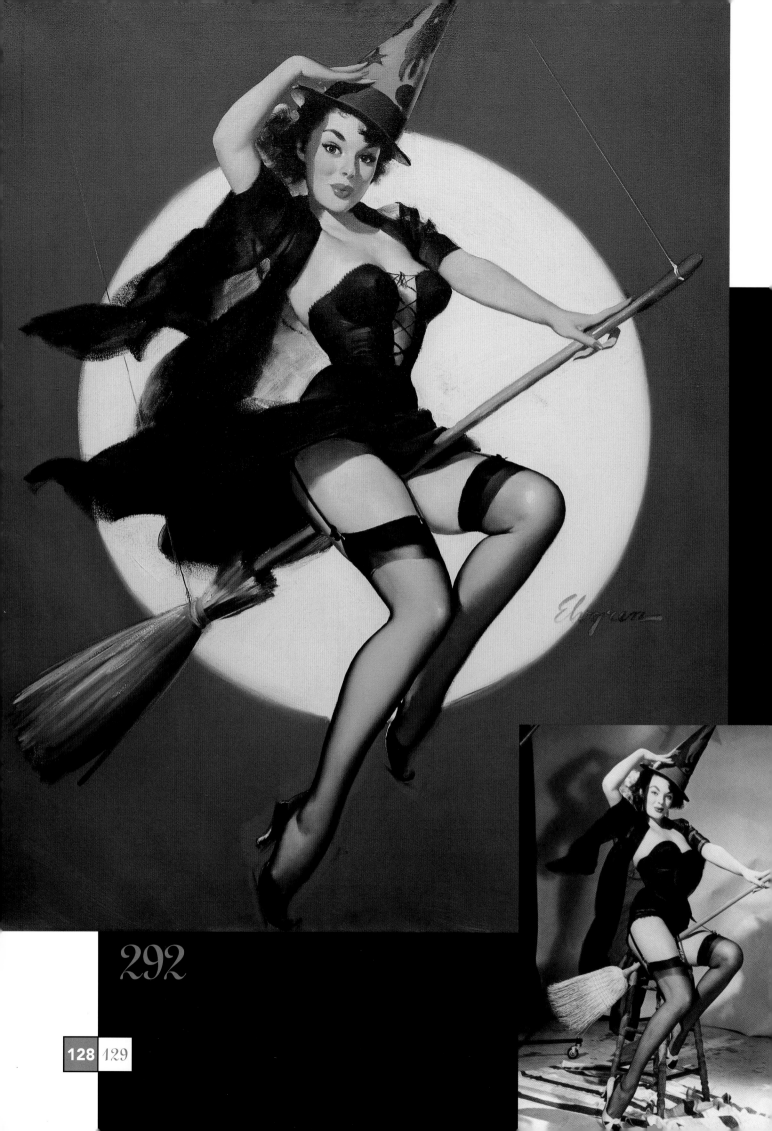

292

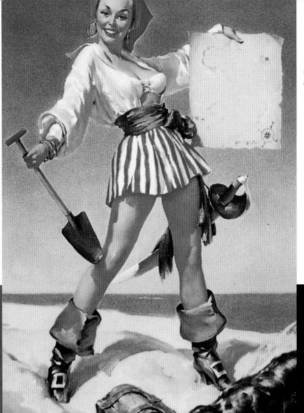

293

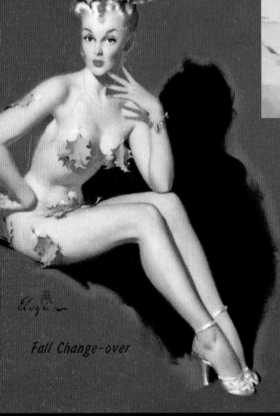

*Fall Change-over*

294

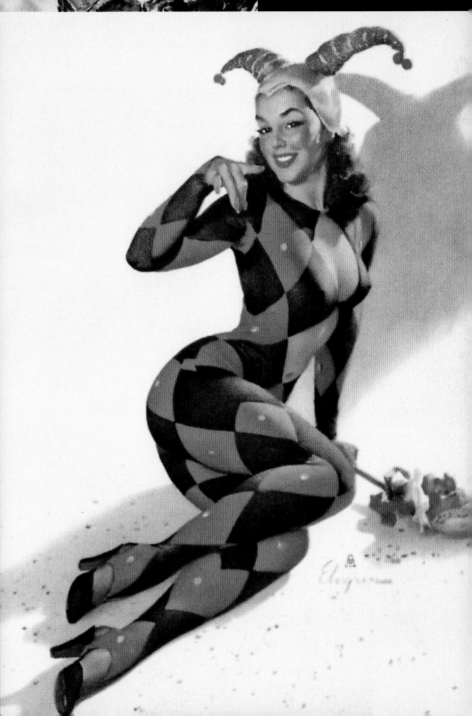

295

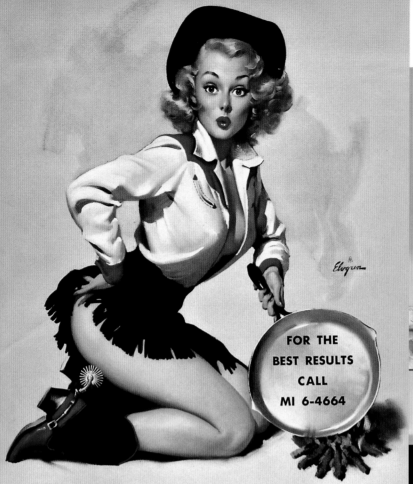

FOR THE
BEST RESULTS
CALL
MI 6-4664

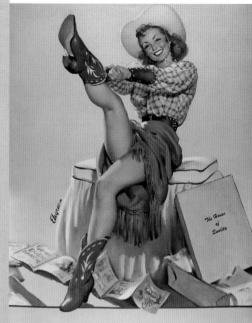

## BROWN & BIGELOW
*Remembrance Advertising*
SAINT PAUL 4, MINNESOTA

297

296

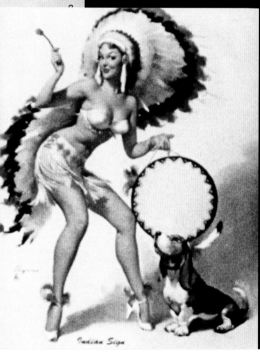

*Indian Sign*

298

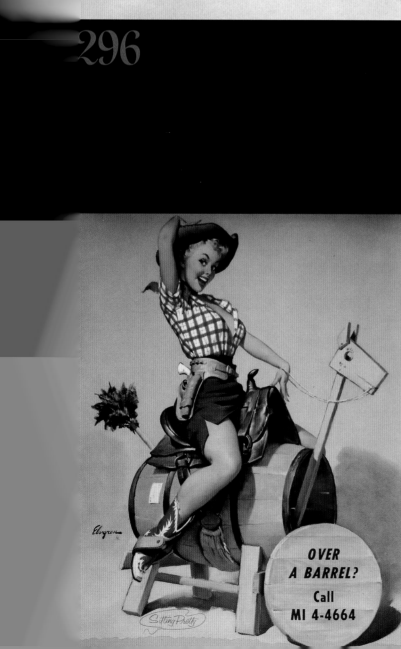

OVER
A BARREL?
Call
MI 4-4664

*Sitting Pretty*

299

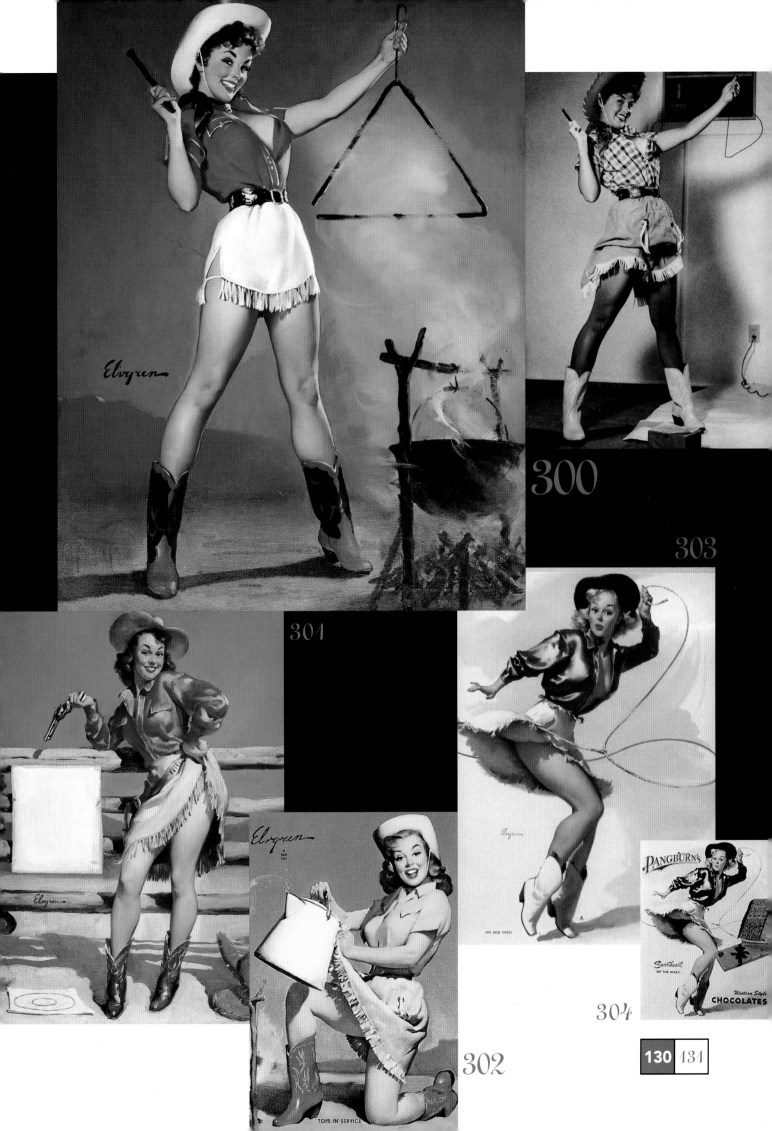

300

303

301

302

304

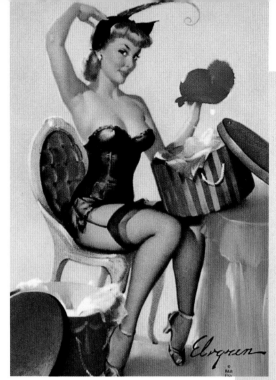

305

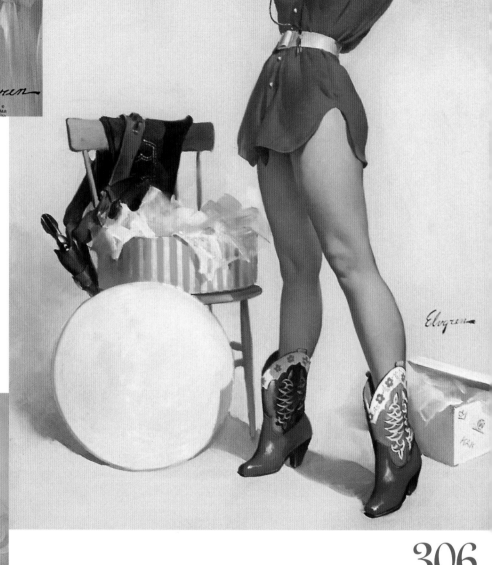

307

306

*Well Heeled*

308

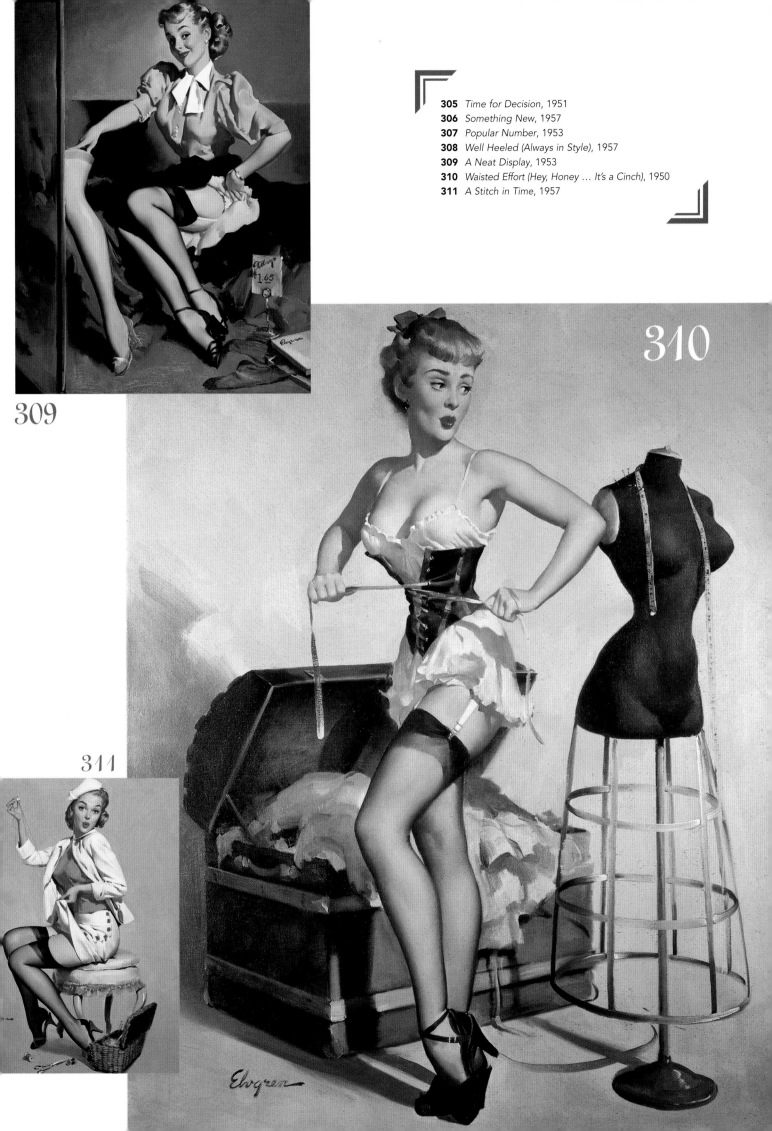

309

310

311

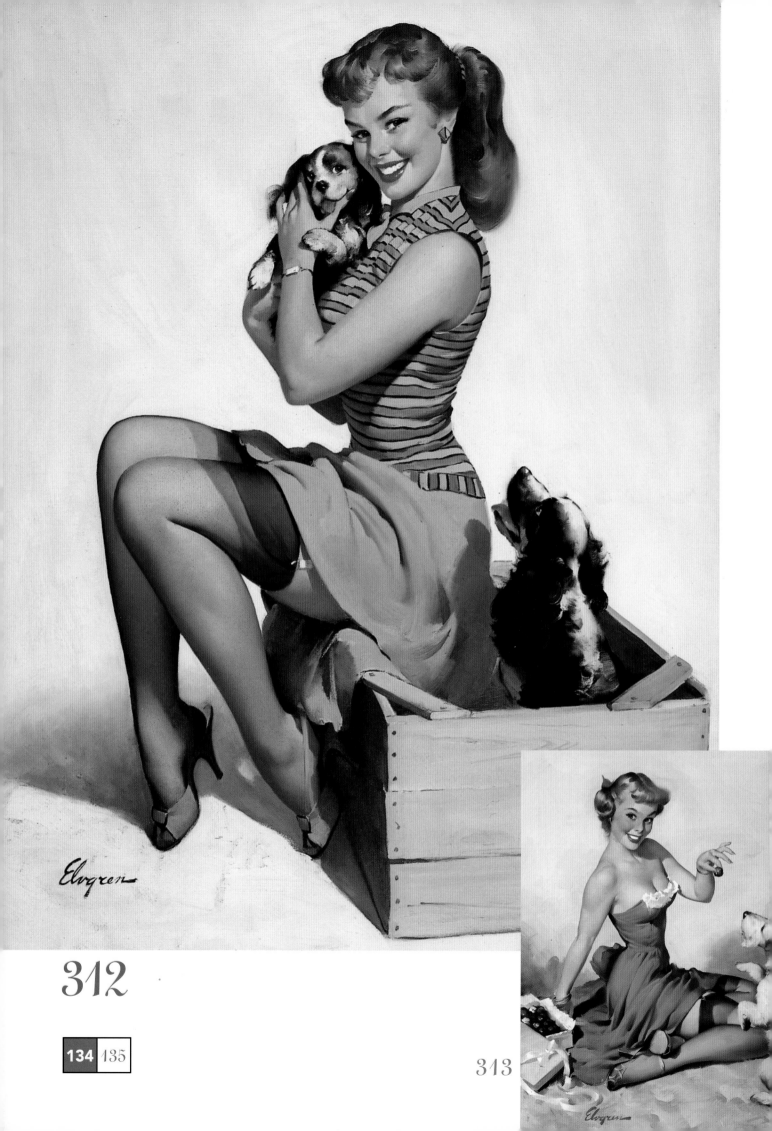

Elvgren

312

313

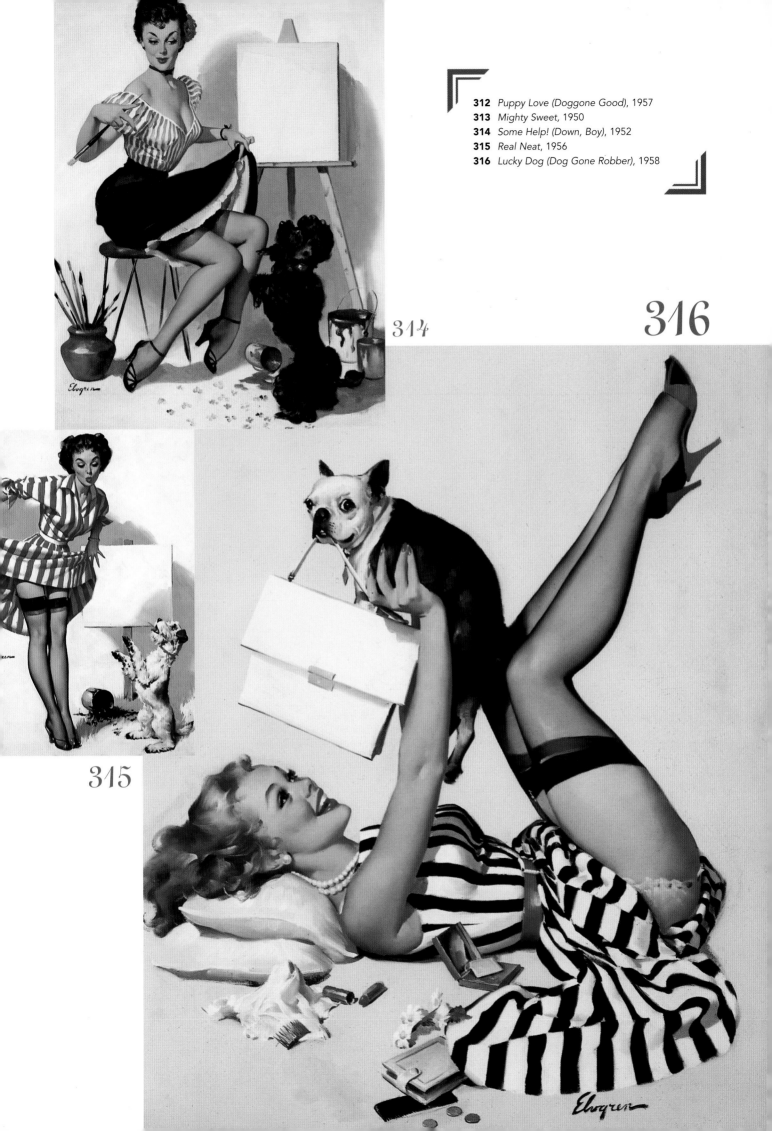

314

316

315

317

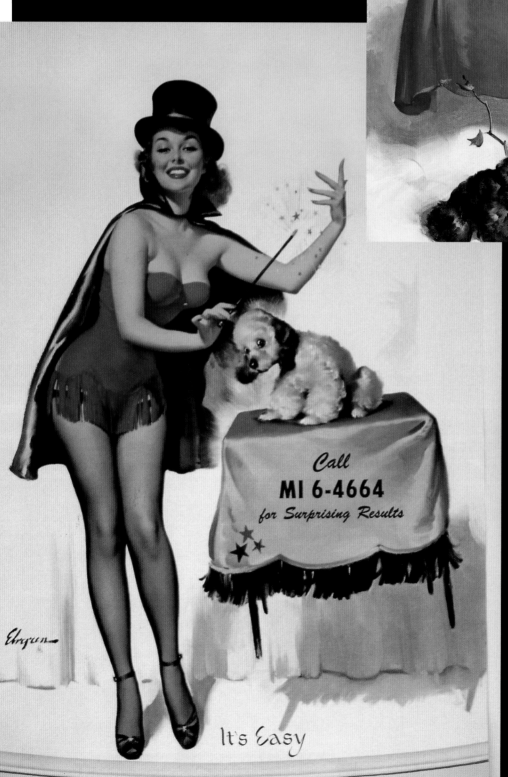

Call
MI 6-4664
for Surprising Results

It's Easy

318

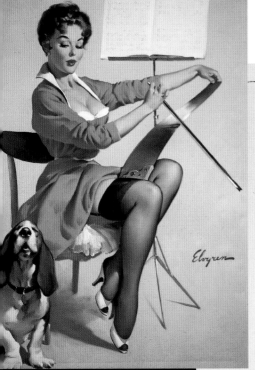

319

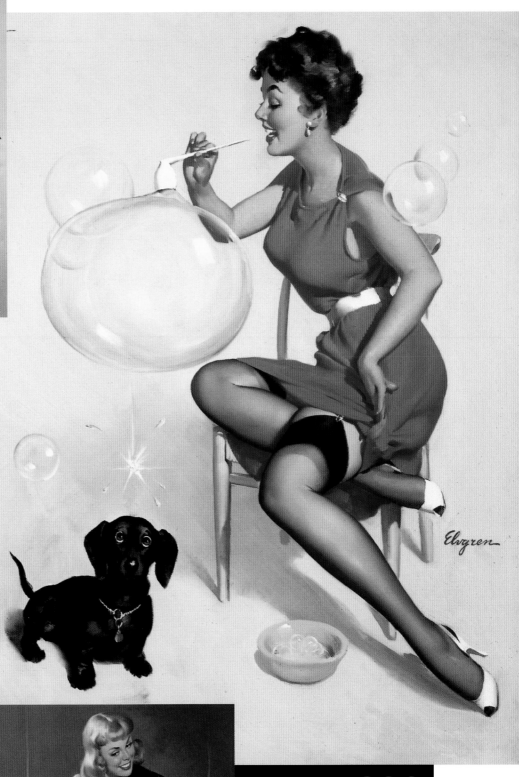

320

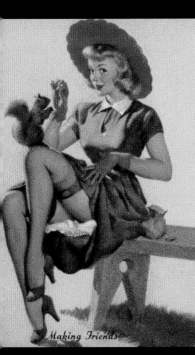

Making Friends

321

322

# 324

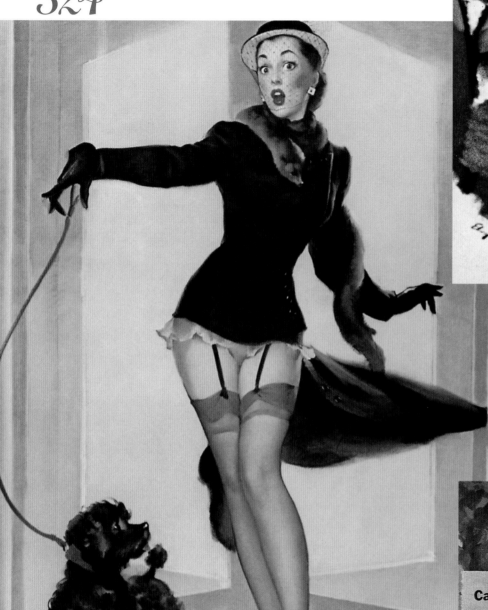

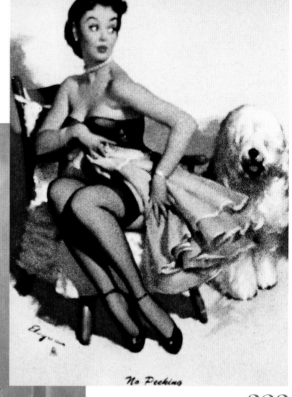

*No Peeking*

## 323

Call Me at 9129

## 325

NEstor 4664

### 326

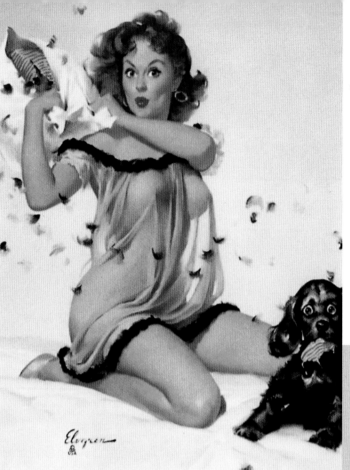

TICKLISH SITUATION

327

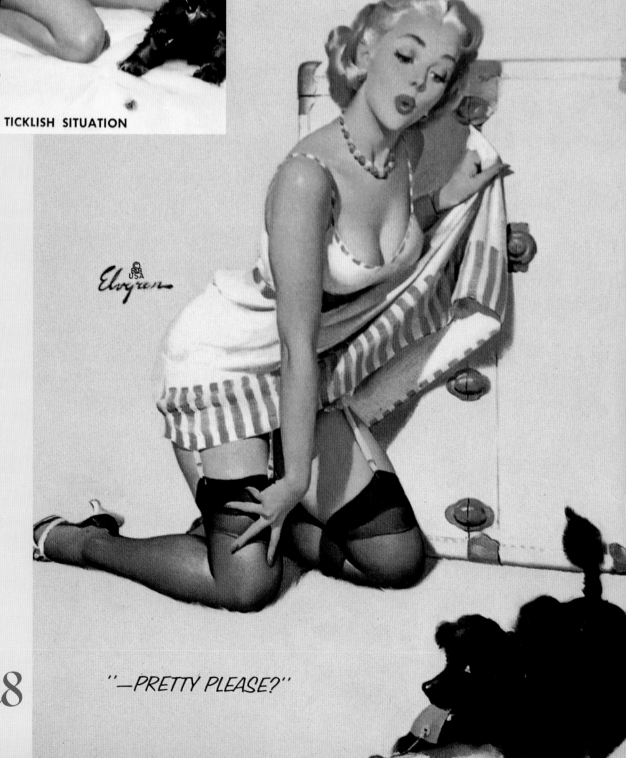

328

"—PRETTY PLEASE?"

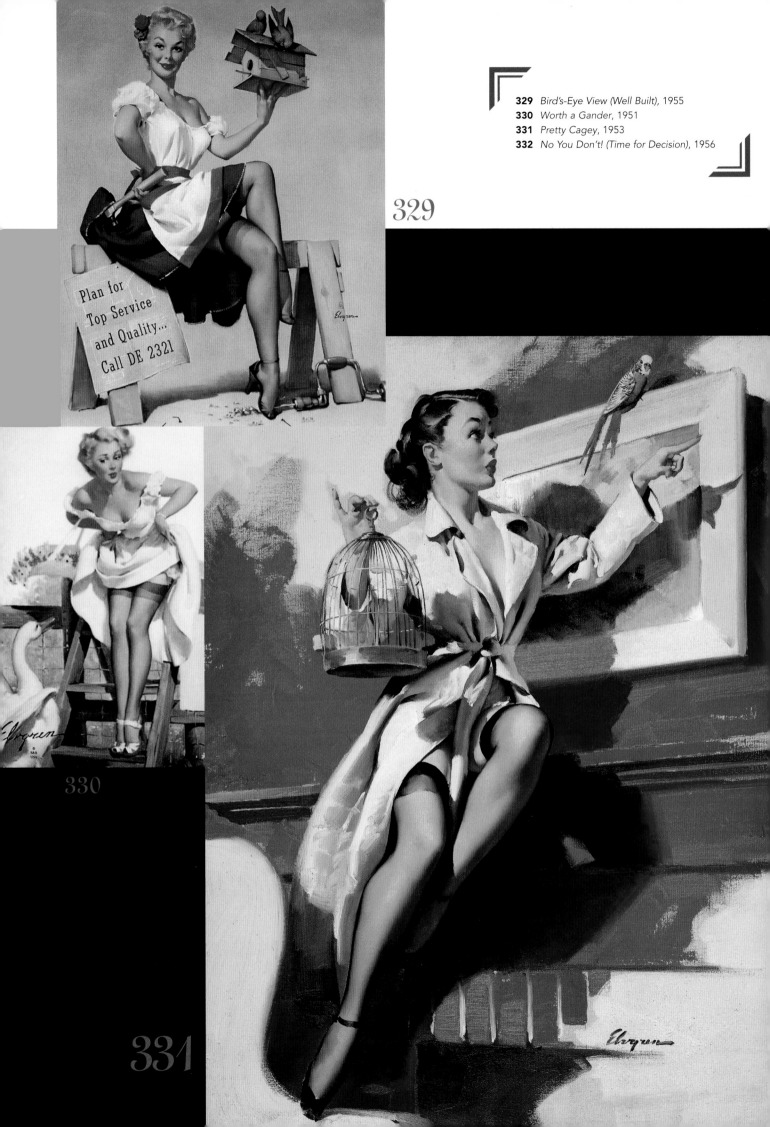

329

Plan for
Top Service
and Quality...
Call DE 2321

330

331

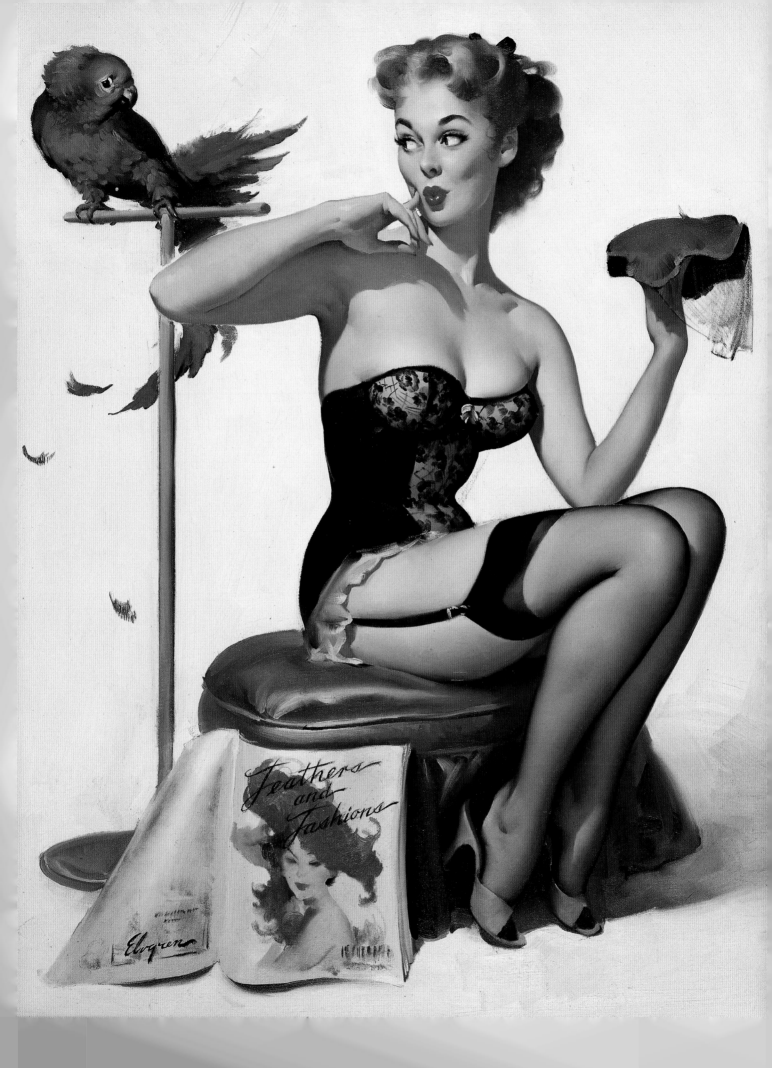

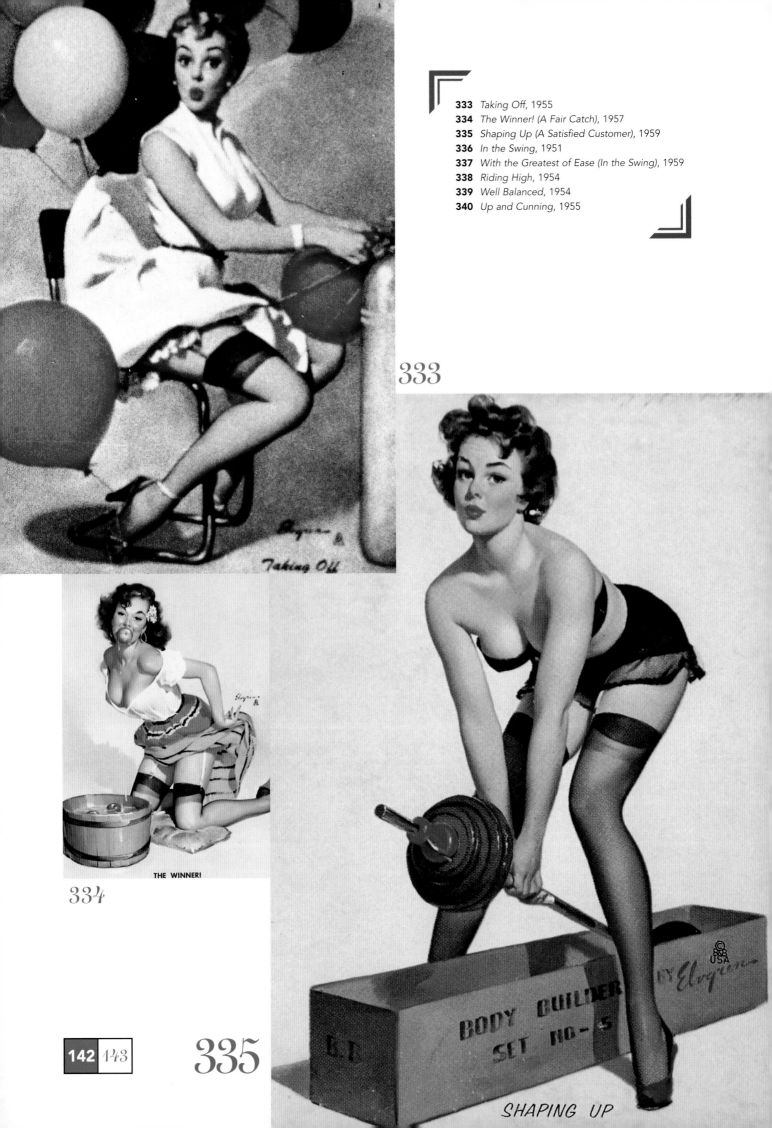

333

THE WINNER!

334

142 143

335

BODY BUILDER SET NO. 5

SHAPING UP

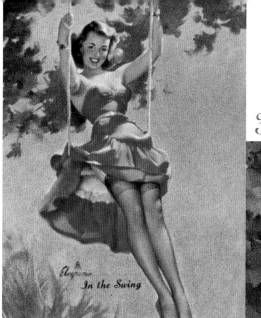

In the Swing

336

337

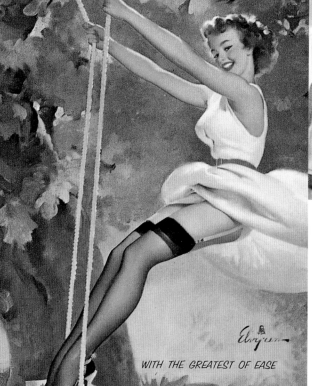

WITH THE GREATEST OF EASE

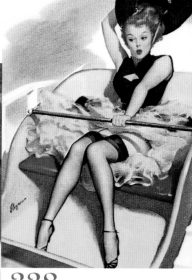
338

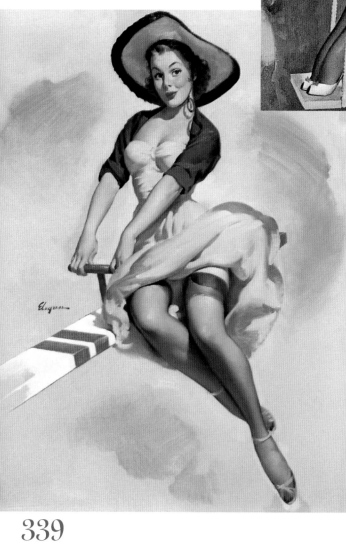
339

340

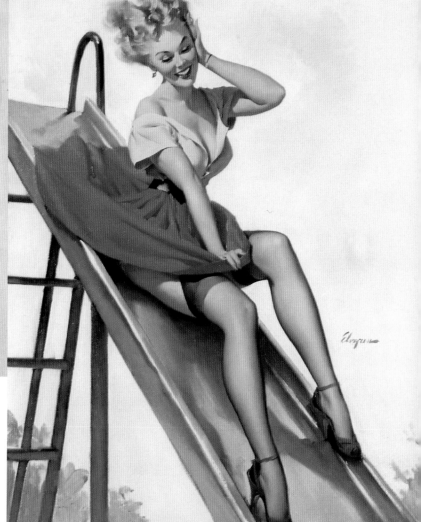

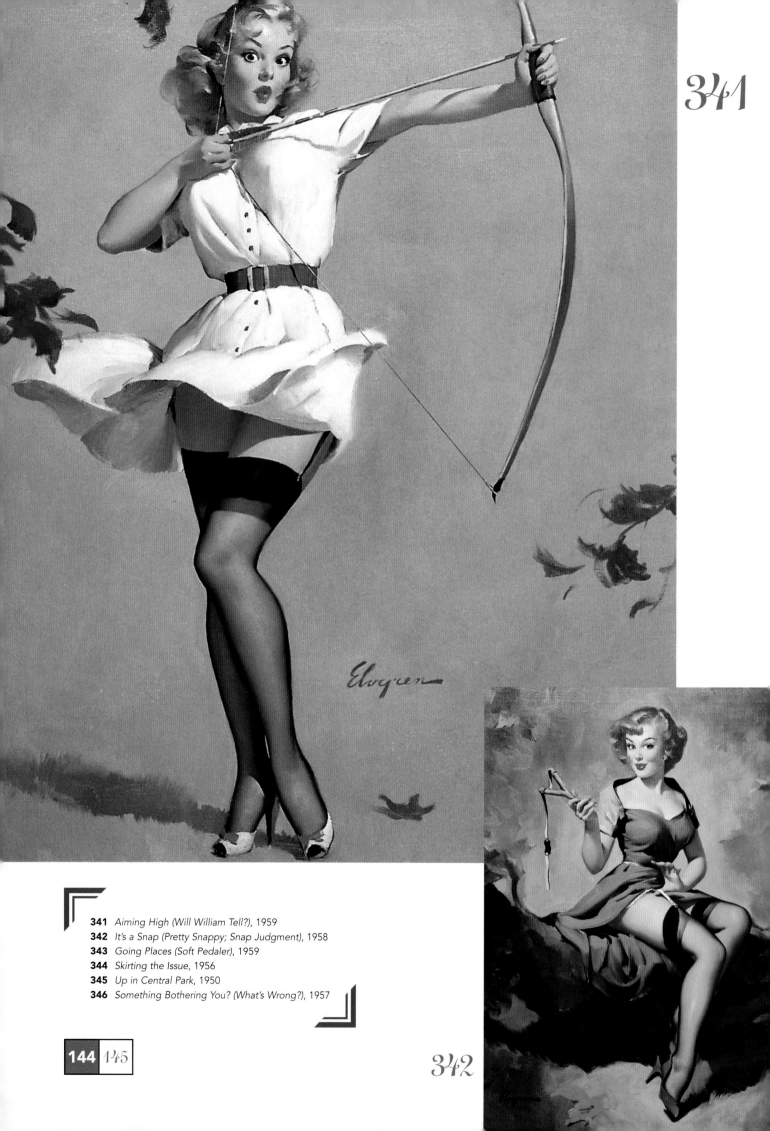

342

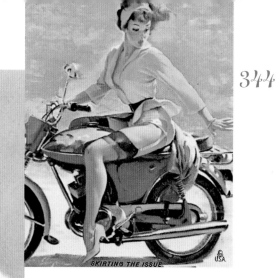

344

SKIRTING THE ISSUE

GOING PLACES

343

346

345

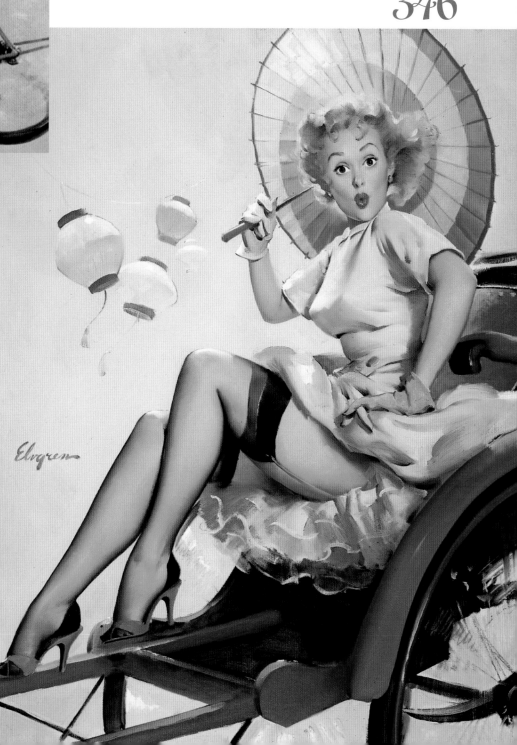

Elvgren

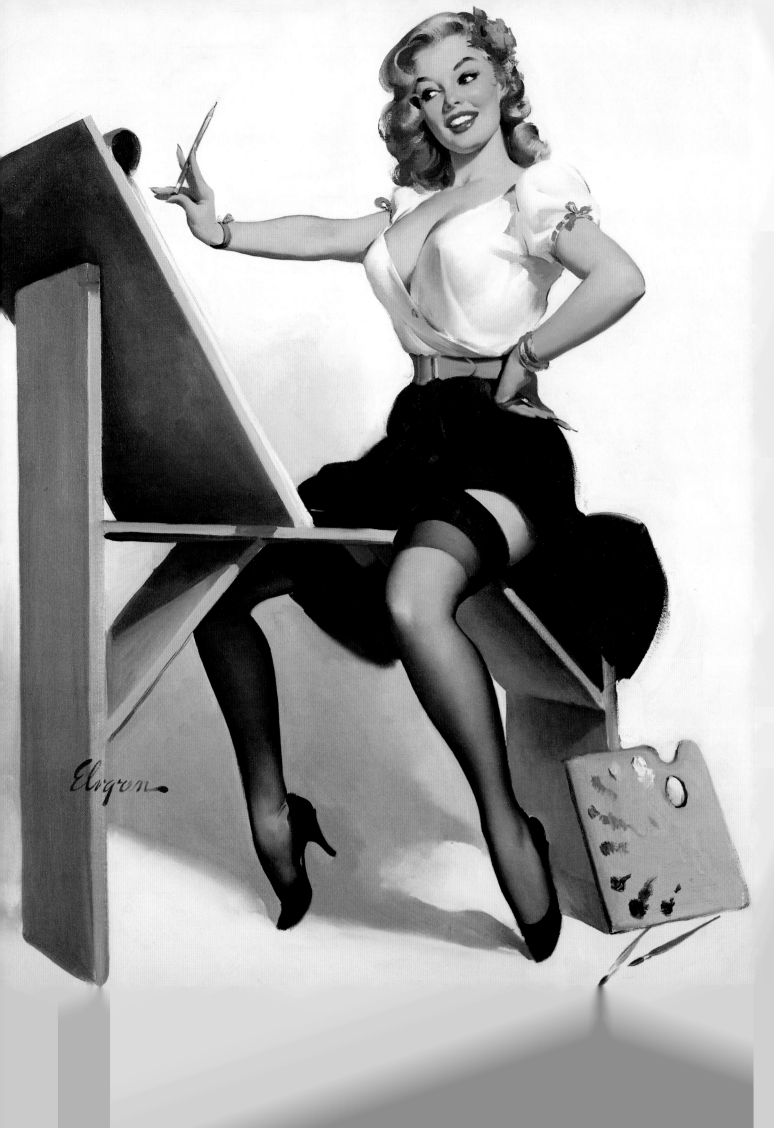

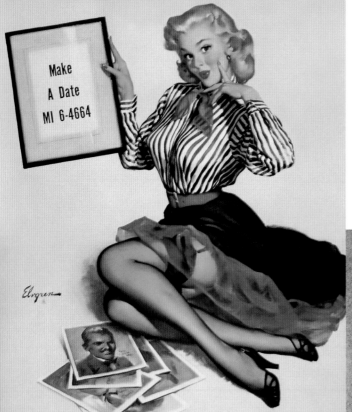

348

349

350

351

352

PARTIAL COVERAGE

353

354

355

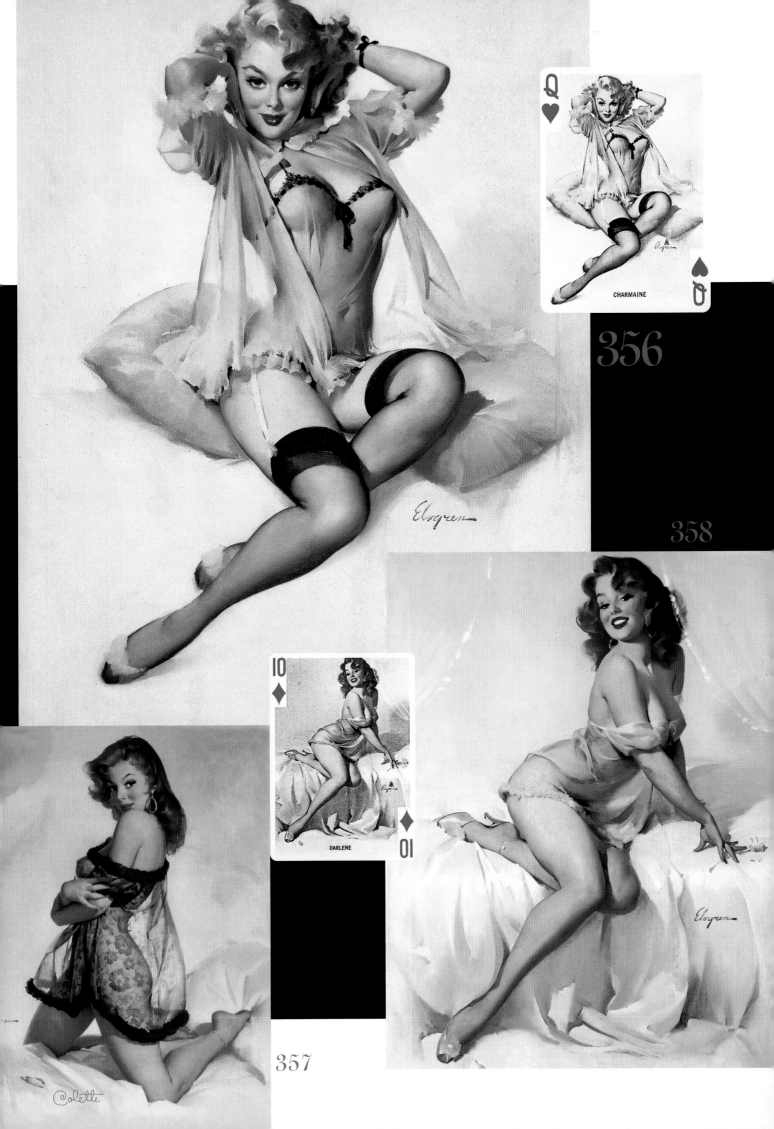

356

358

357

CHARMAINE

DARLENE

**359**

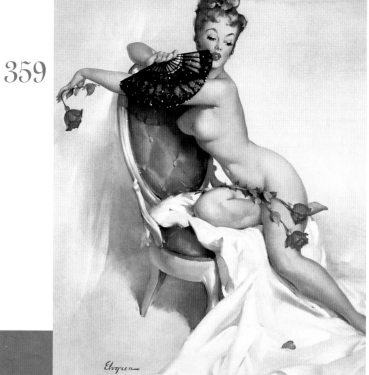

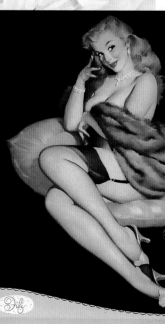

**364**

Brown & Bigelow

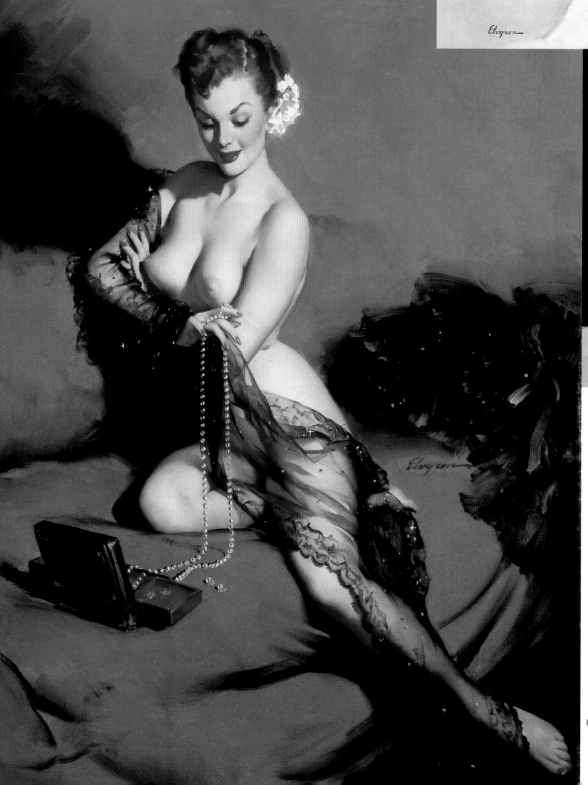

**360**

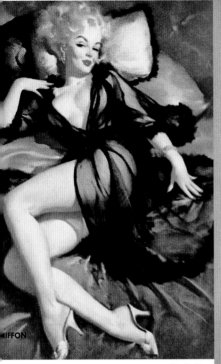

IFFON

362

363

364

TING PRETTY

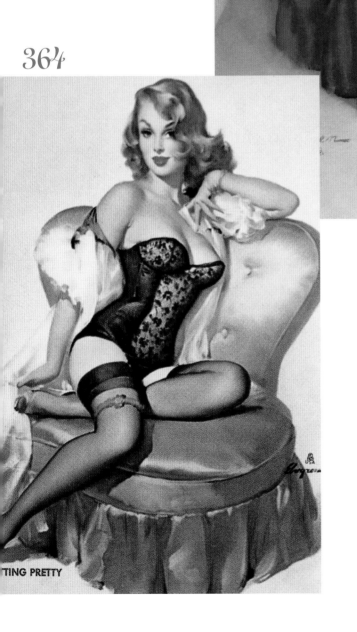

365

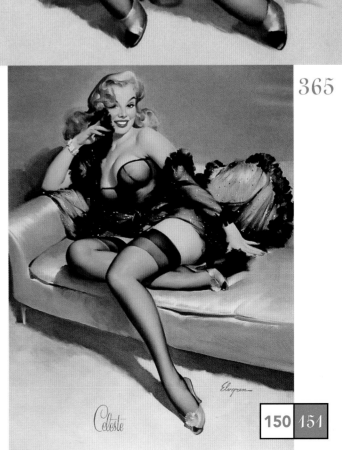

Celeste

Brown & Bigelow

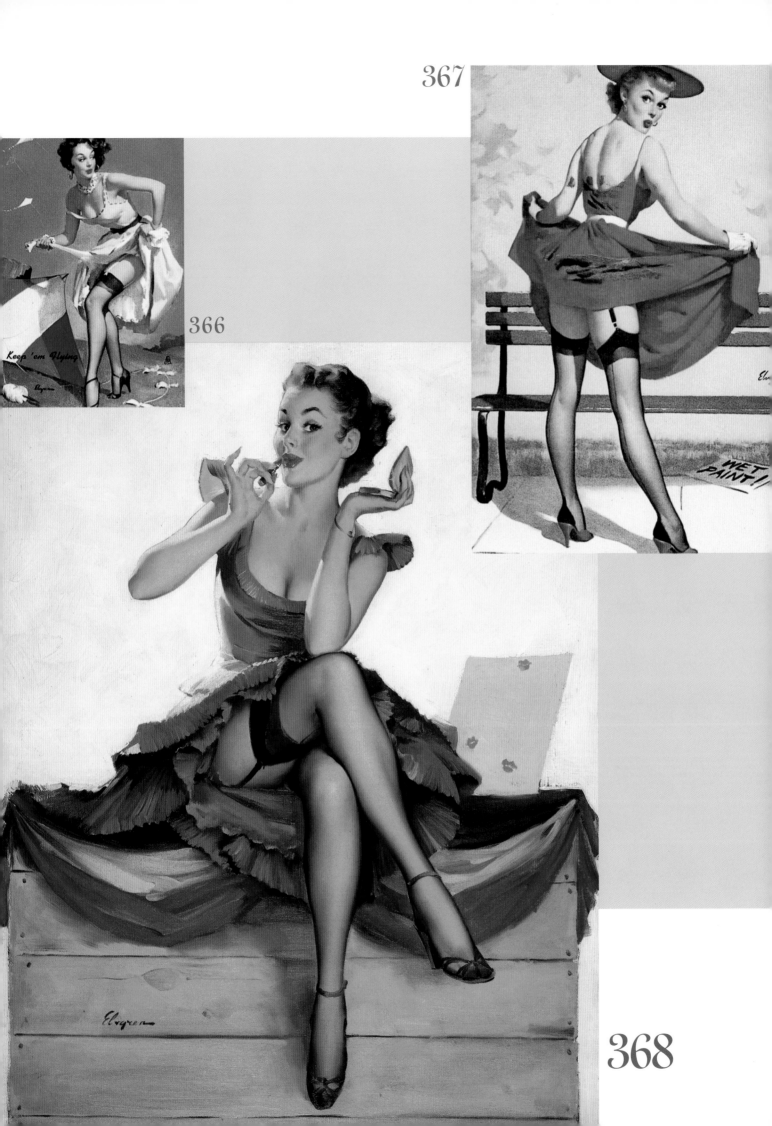

367

366

368

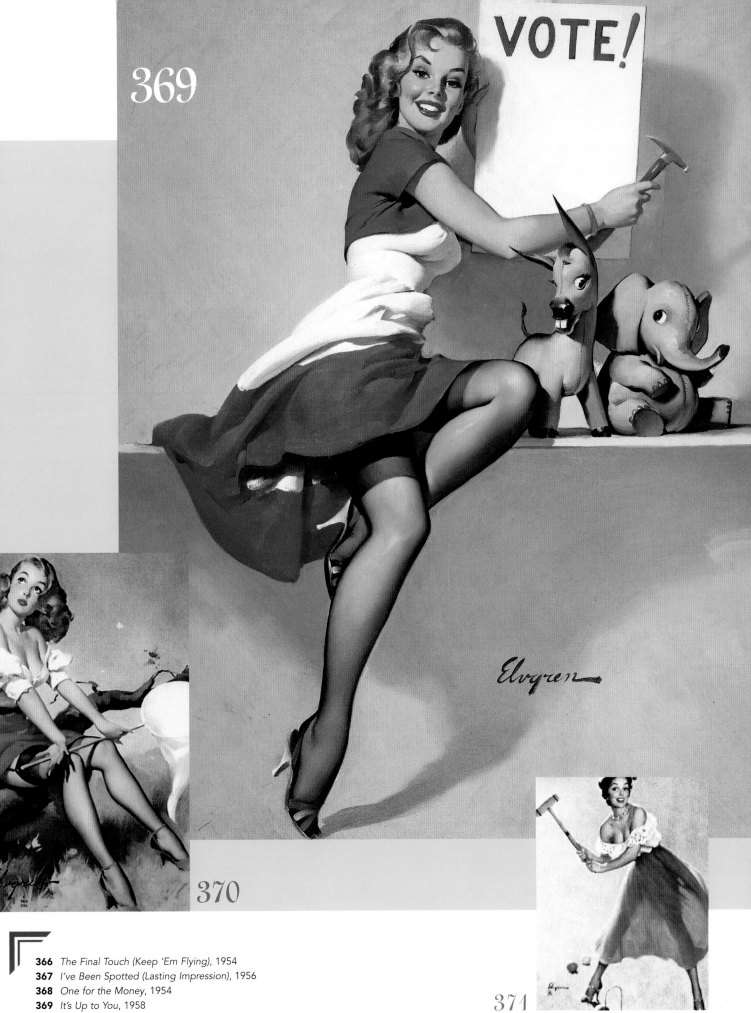

369

370

371

**372**

**373**

**374**

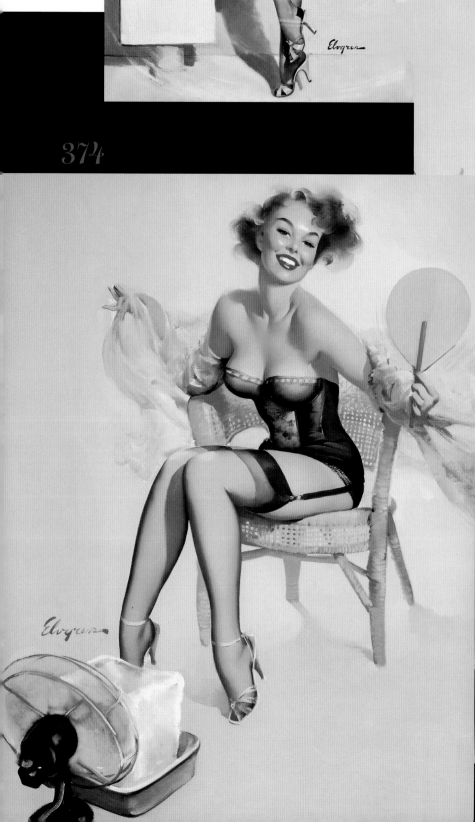

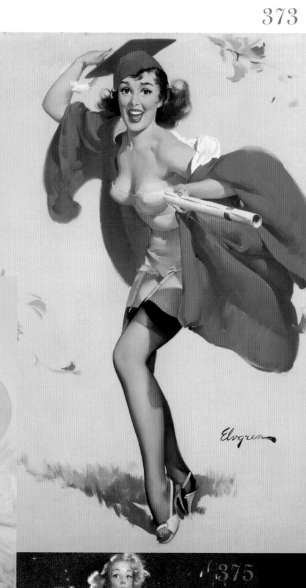

**375**

Air
Conditioned

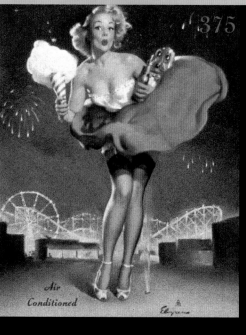

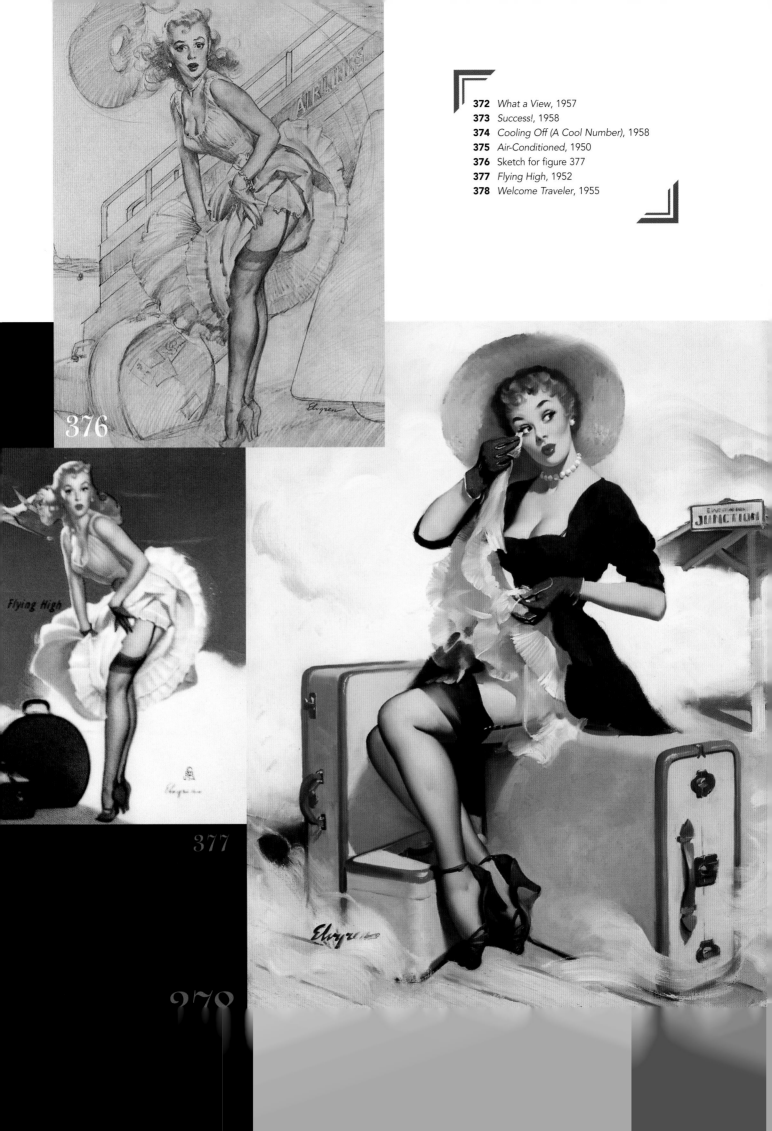

376

377

Flying High

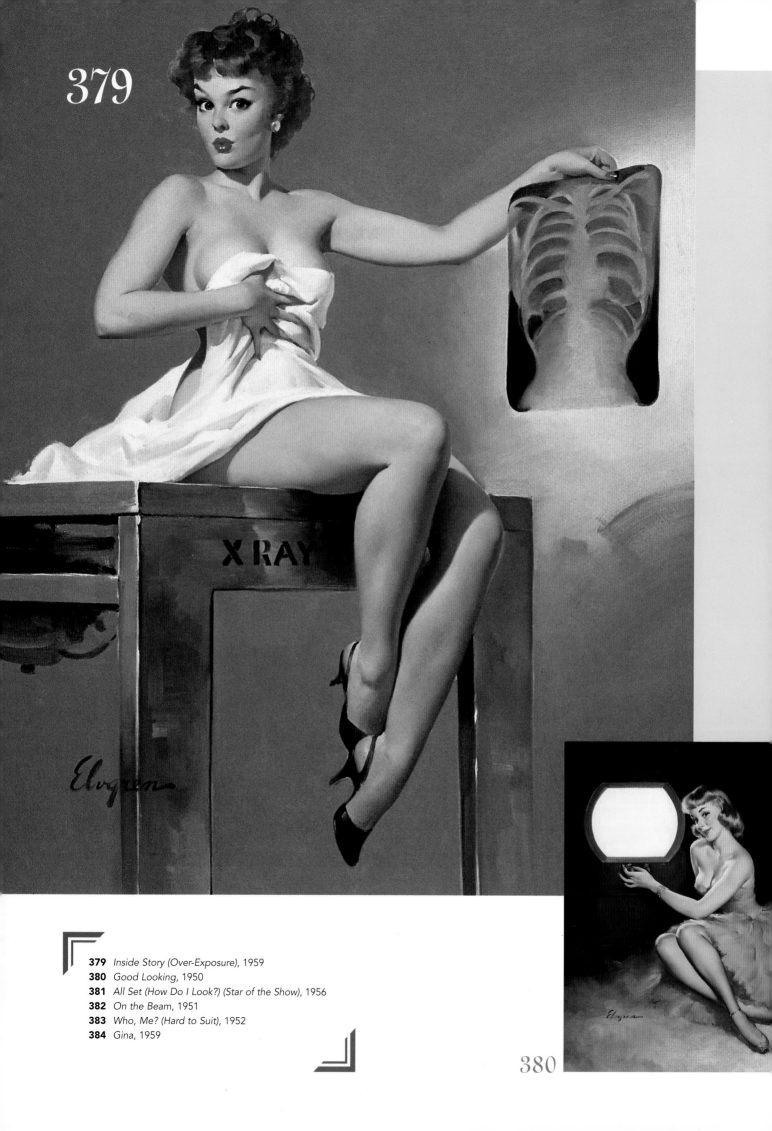

**379**

X RAY

Elvgren

**380**

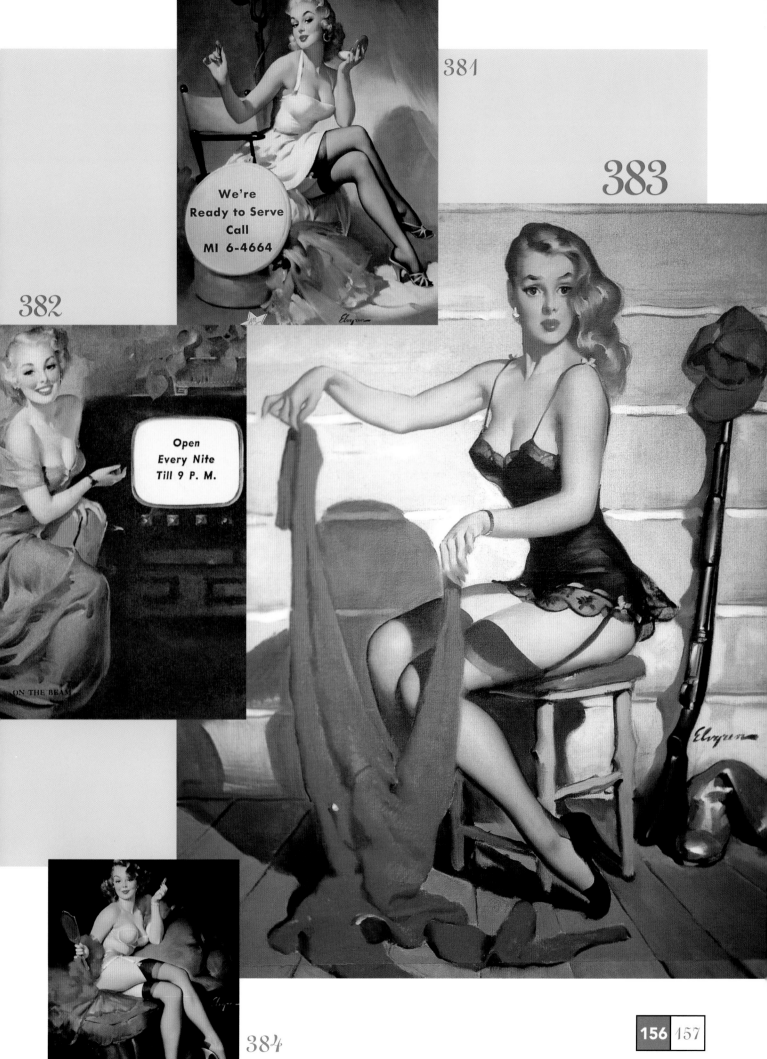

381

383

382

We're
Ready to Serve
Call
MI 6-4664

Open
Every Nite
Till 9 P. M.

ON THE BEAM

384

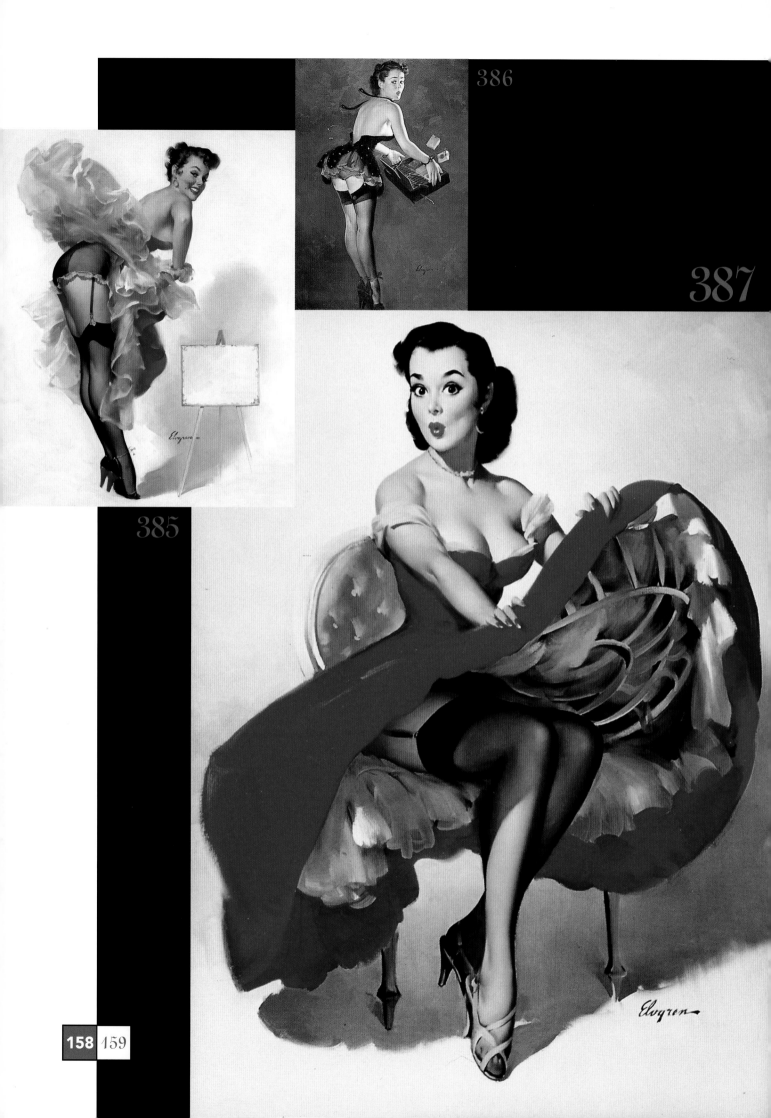

386

387

385

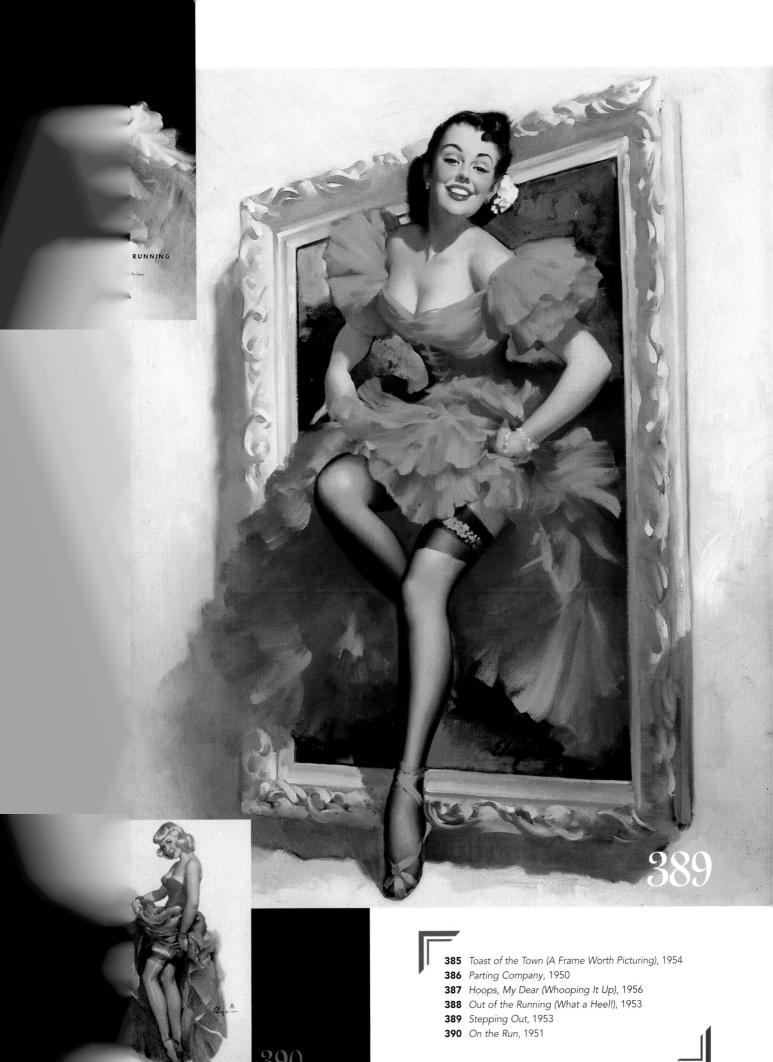

RUNNING

389

390

391

392

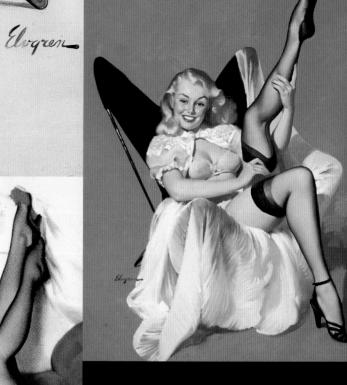

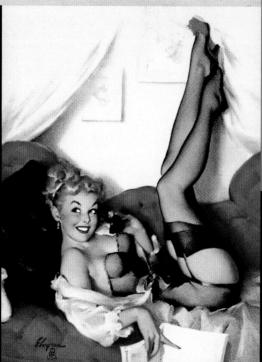

393

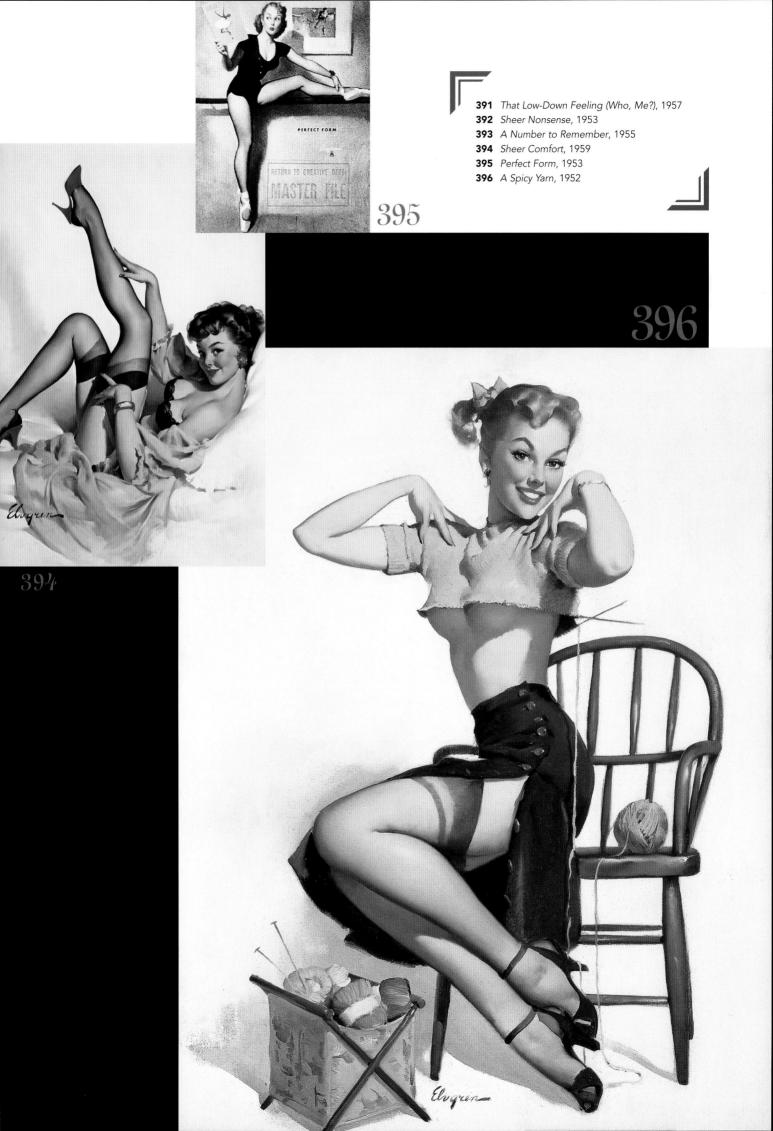

395

396

394

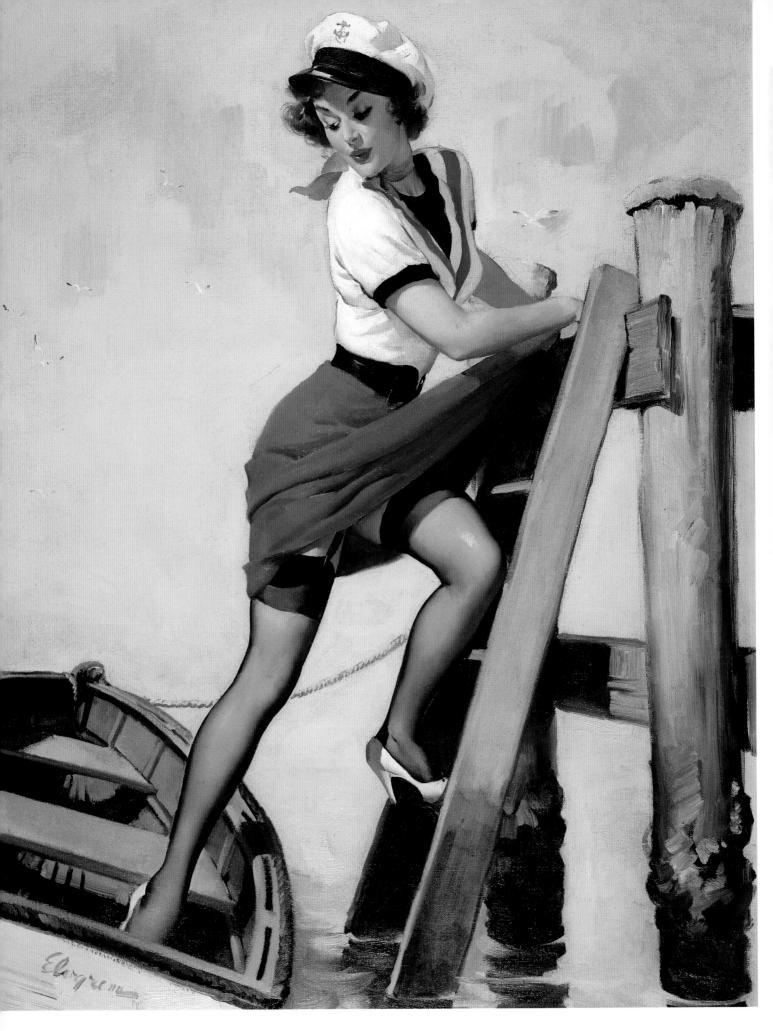

397

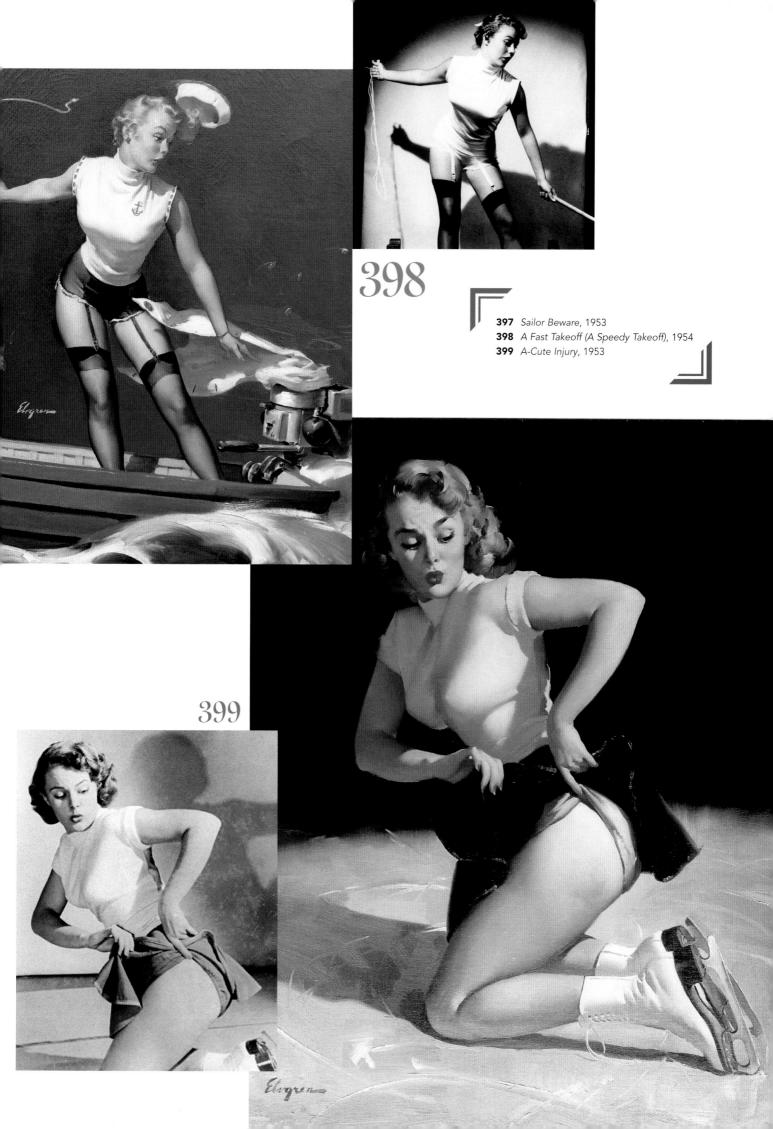

**398**

**399**

400

401

402

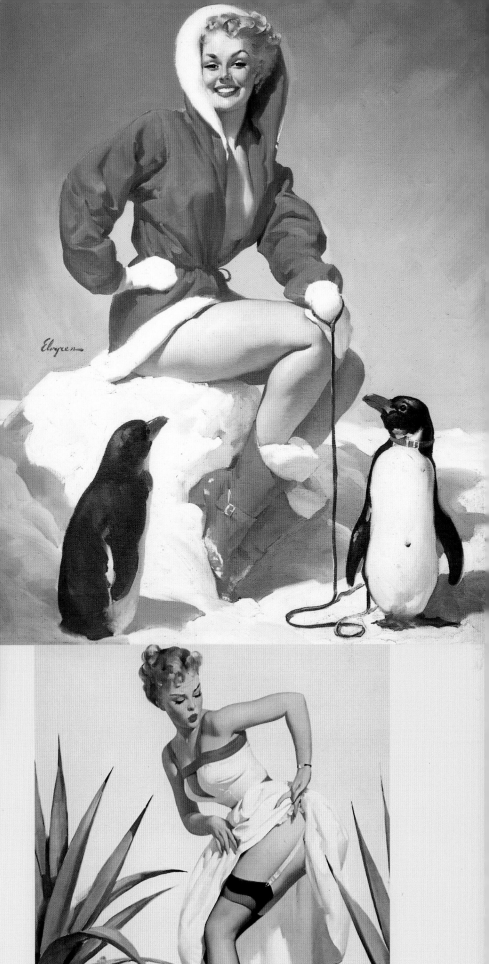

403

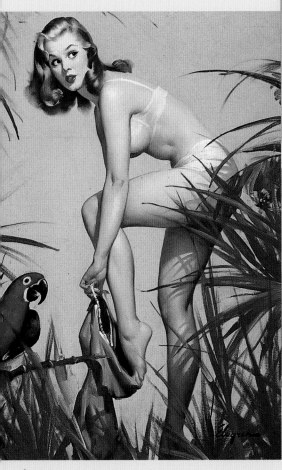

404

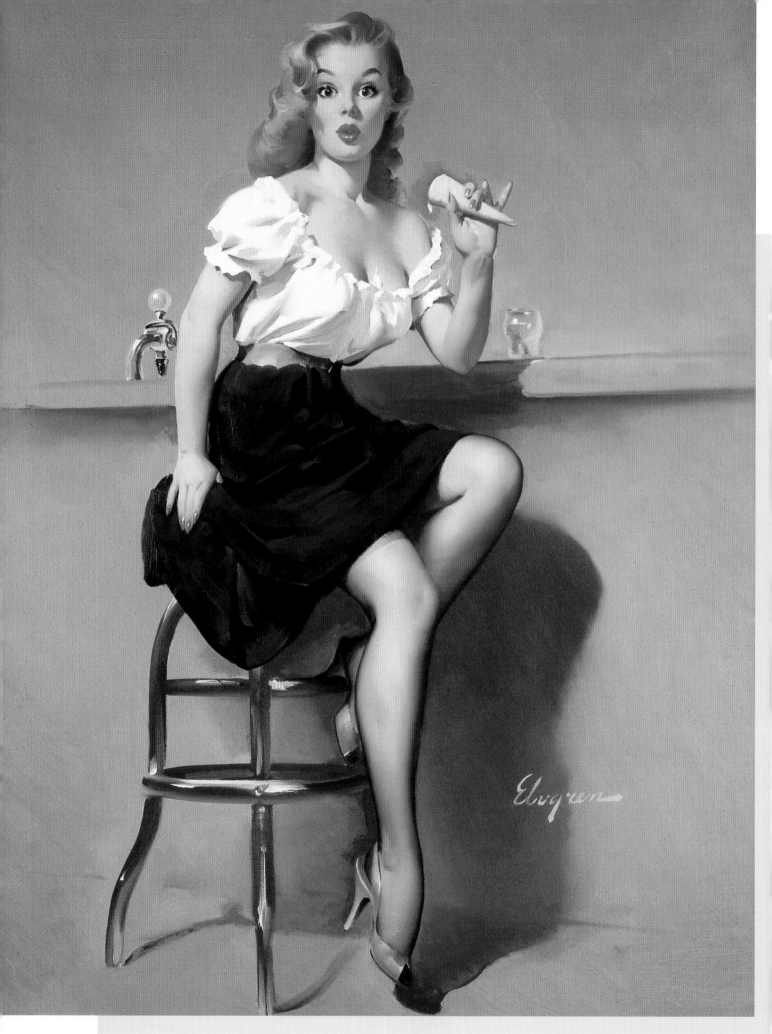

405

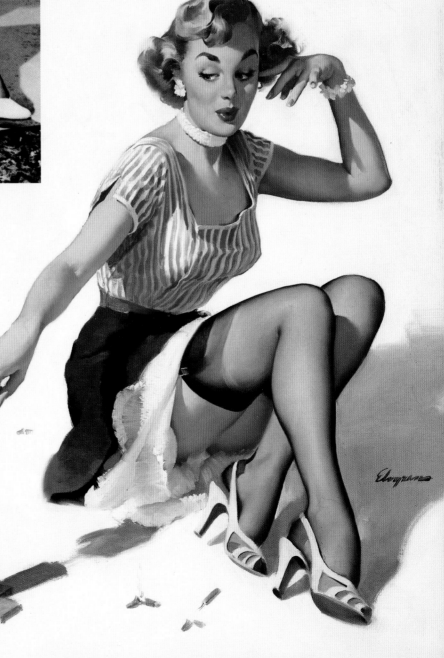

406

407

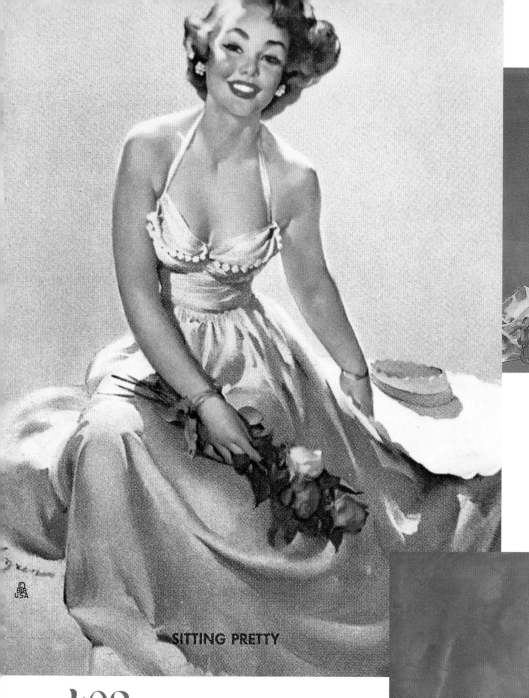

SITTING PRETTY

408

409

410

411

ght to Be Held

412

WAITING FOR YOU

413

# 1960
# 1972

*The Late*
# BROWN & BIGELOW
*Years*

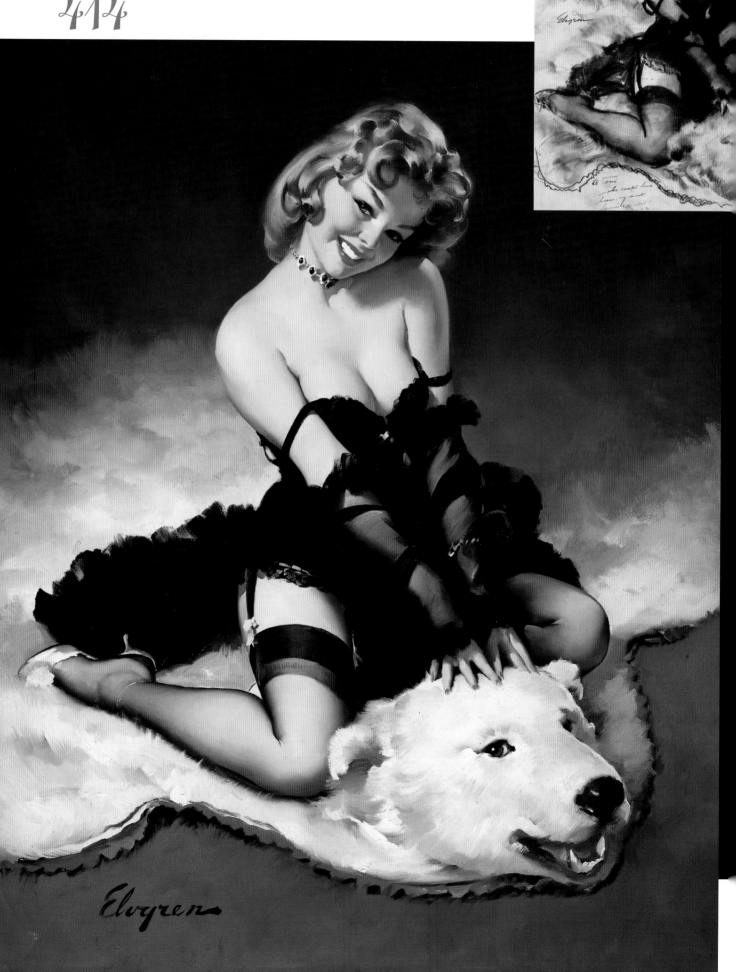

Elvgren

416

MEASURING UP

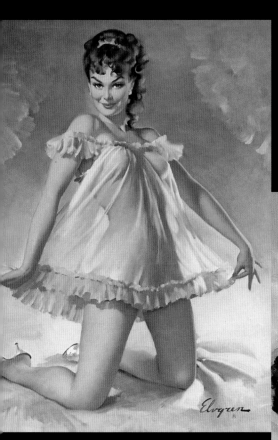

417

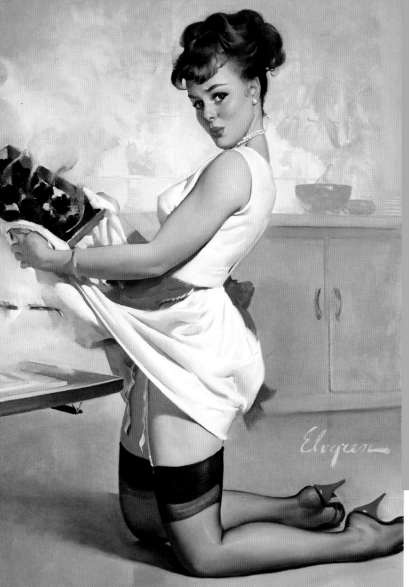

418

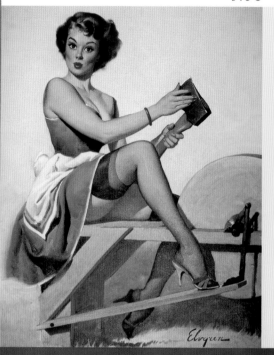

419

420

421

A Neat Package

422

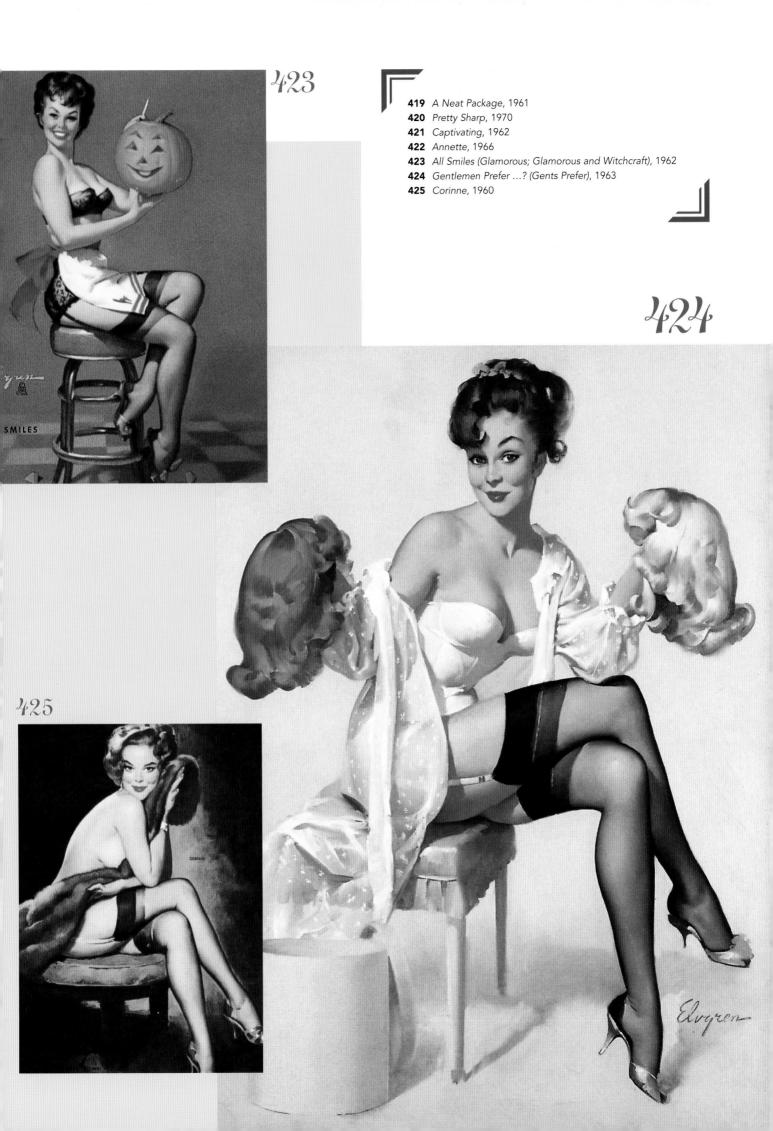

423

424

425

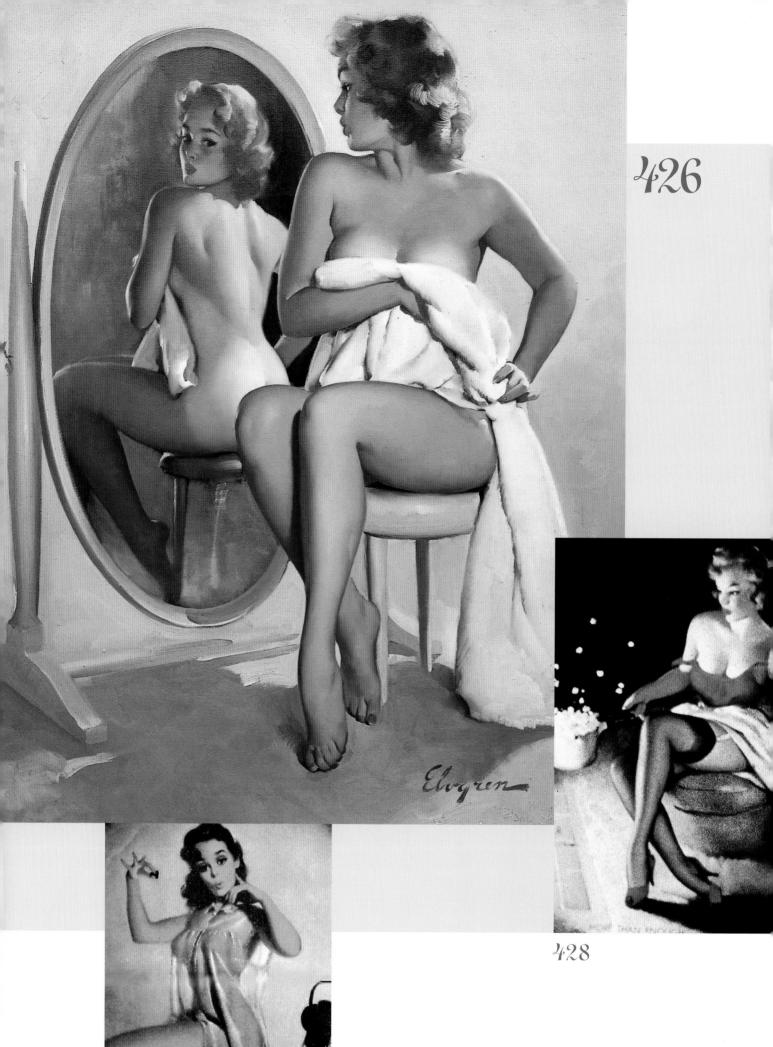

426

427

428

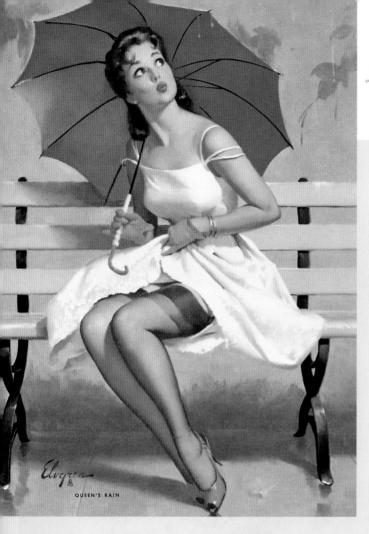

429

QUEEN'S RAIN

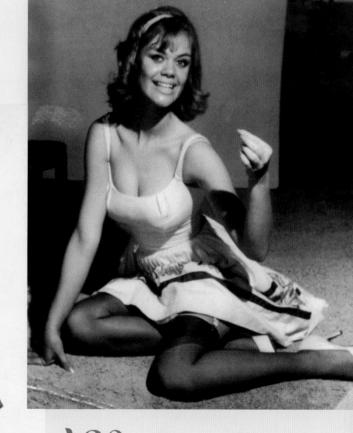

430

SWEET PRESENTATION

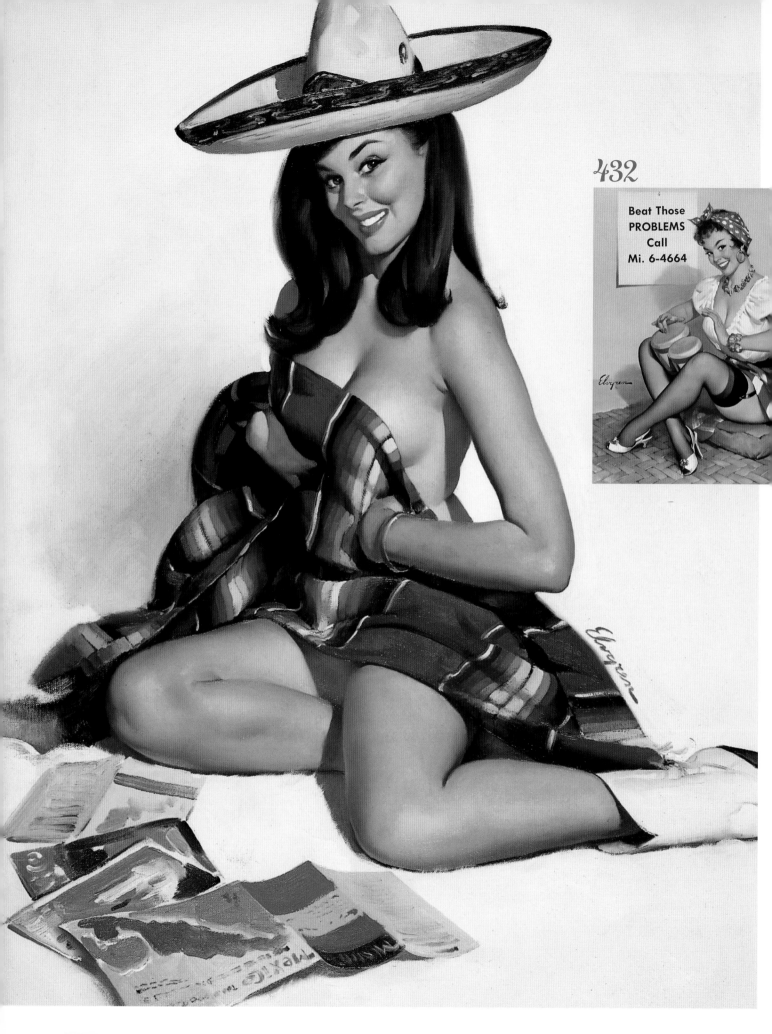

432

Beat Those
PROBLEMS
Call
Mi. 6-4664

431

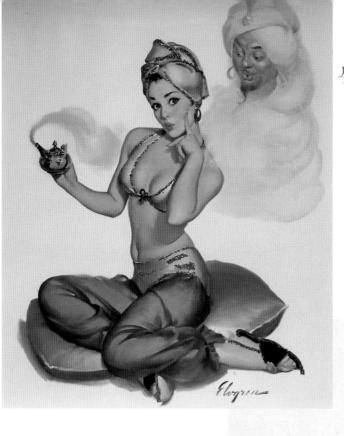

433

435

434

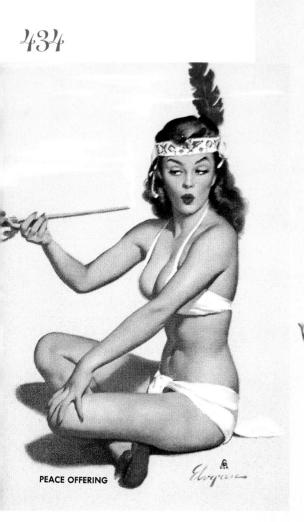

PEACE OFFERING

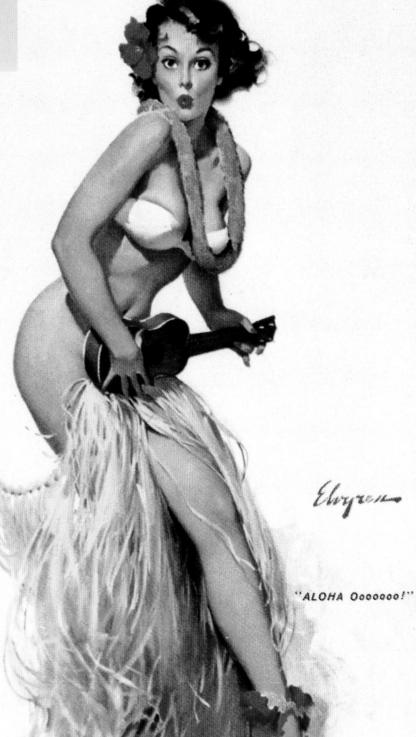

"ALOHA Ooooooo!"

436

Elvgren

438

437

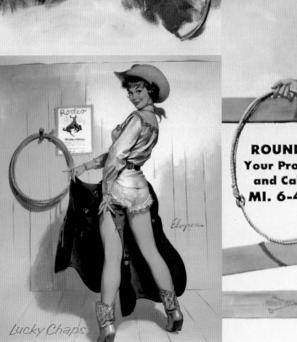

ROUND-UP
Your Problems
and Call . . .
MI. 6-4664

Elvgren

Lucky Chaps

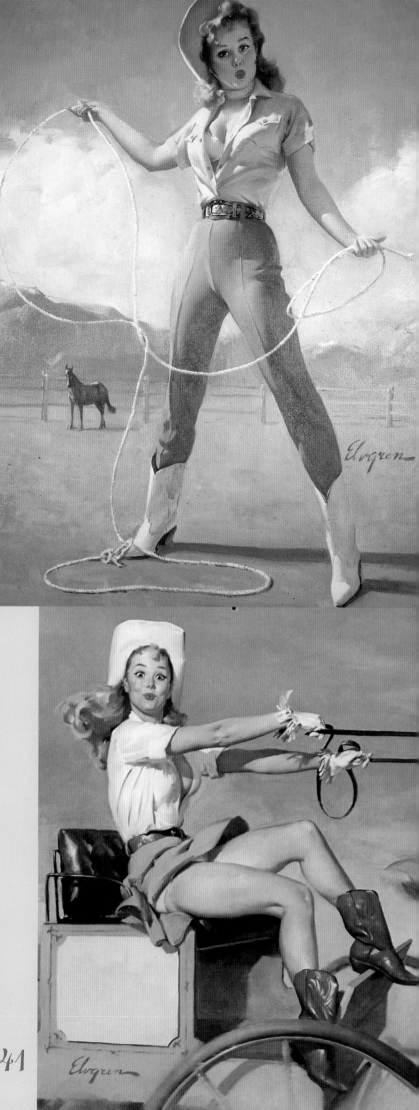

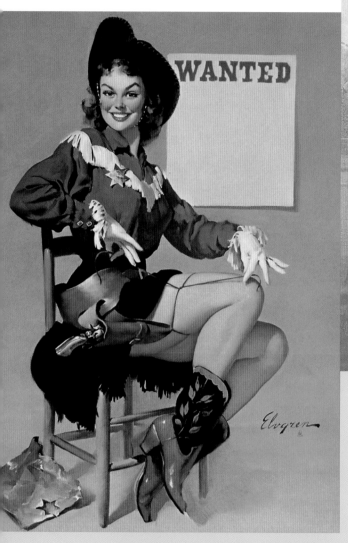

439

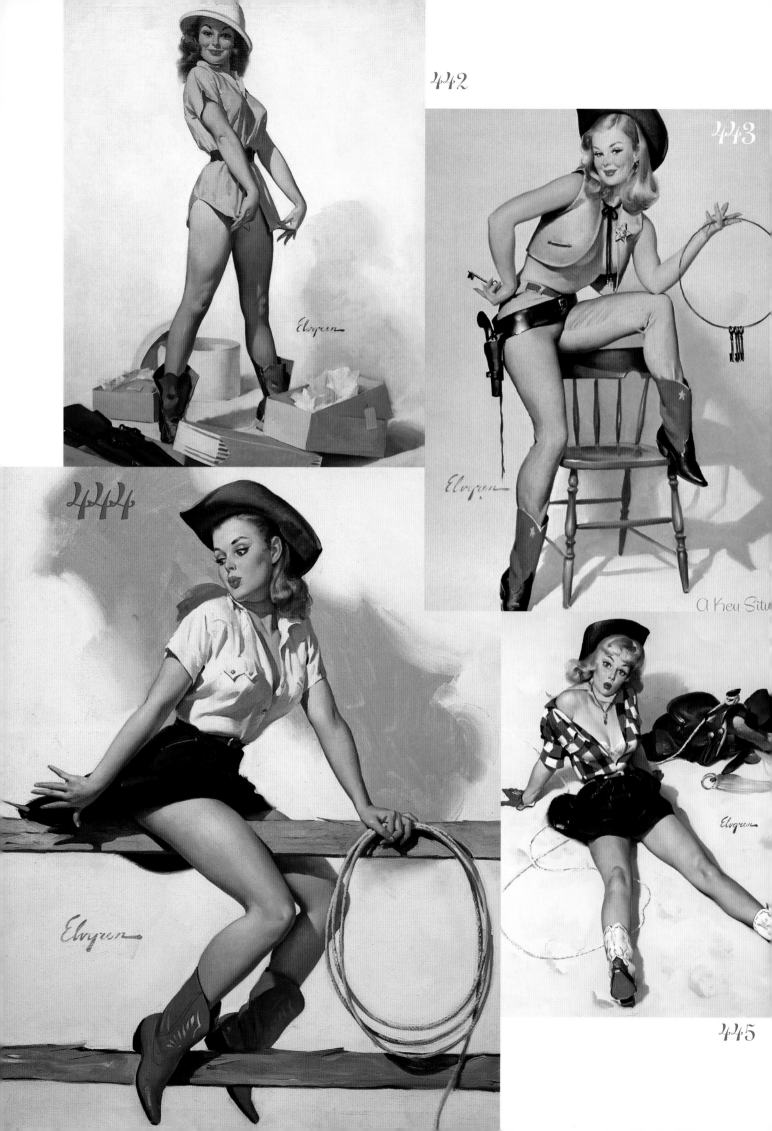

442

443

444

445

A Key Situ...

446

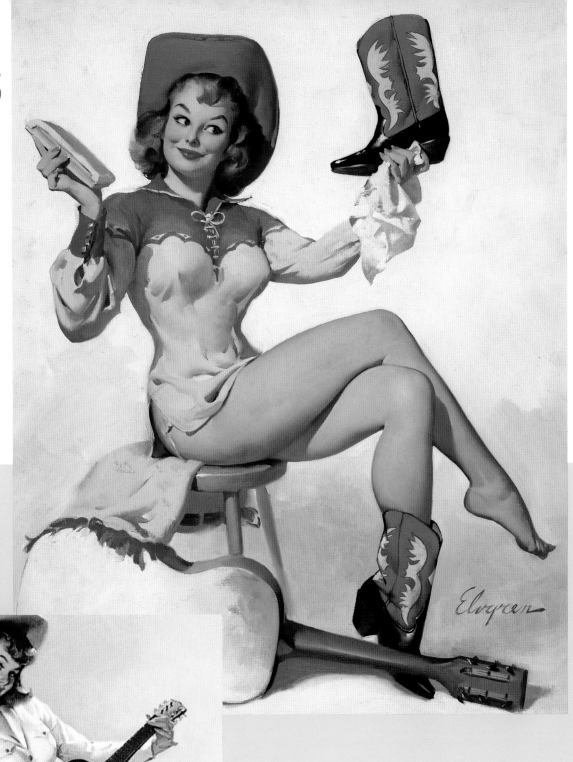

Elvgren

Elvgren  447

©
B&B
USA

Elvgren

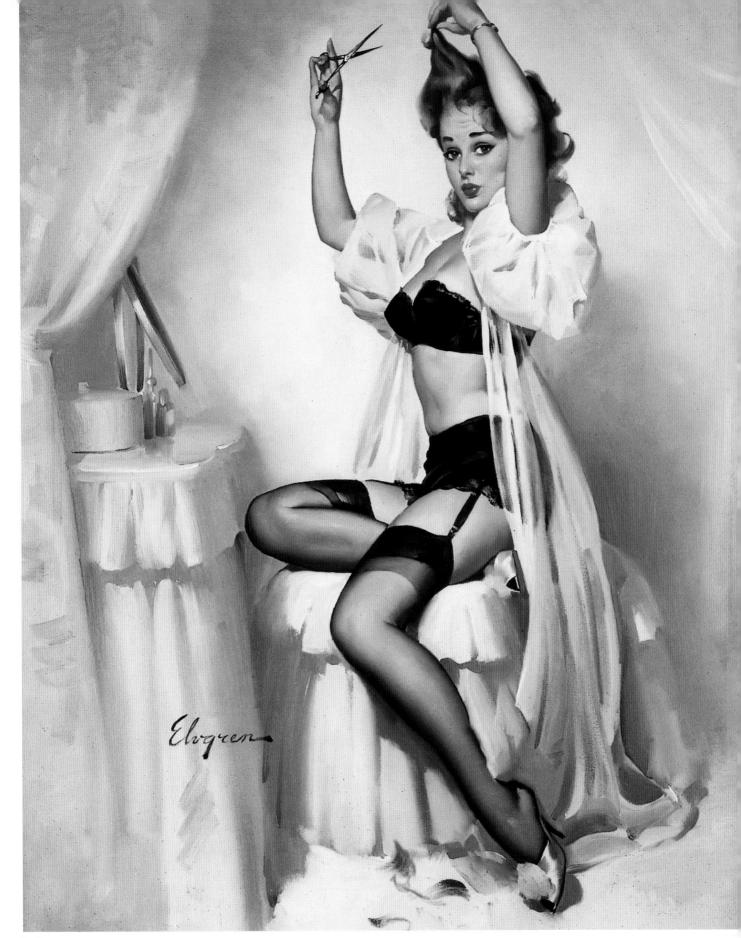

449

450

451

452

WELL SEATED

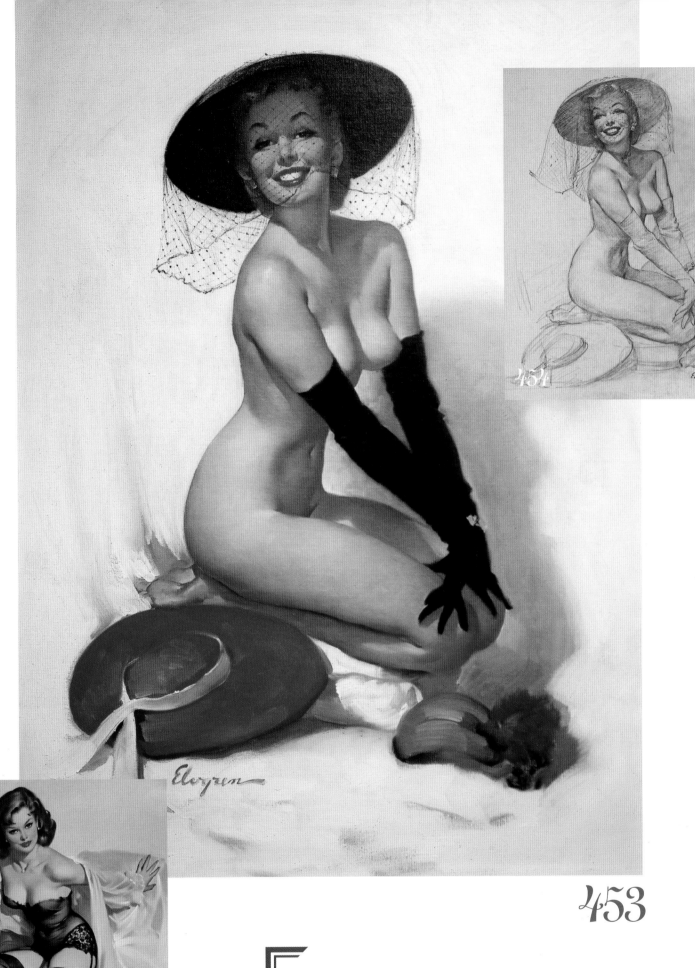

454

453

455

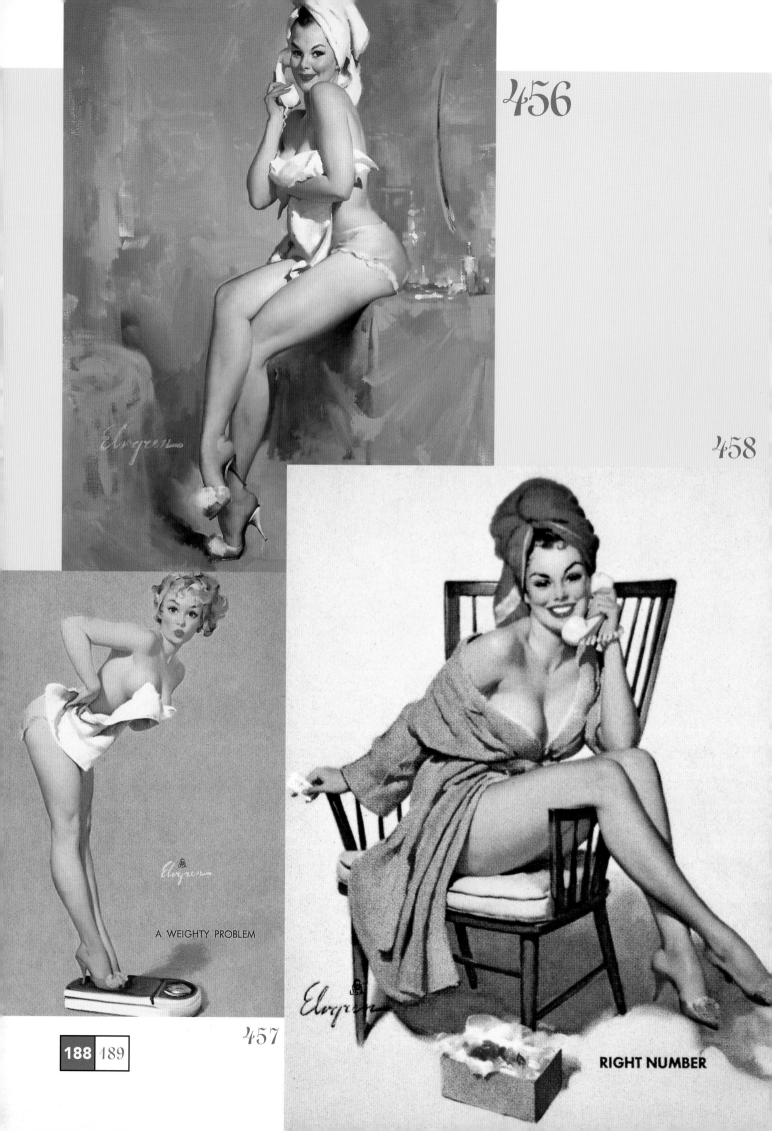

456

458

A WEIGHTY PROBLEM

457

RIGHT NUMBER

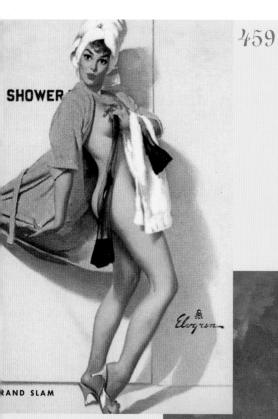

459

460

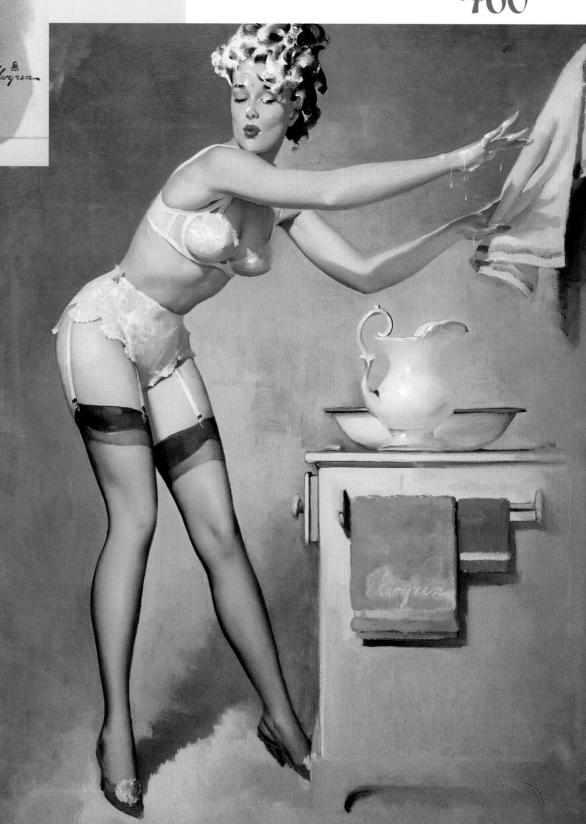

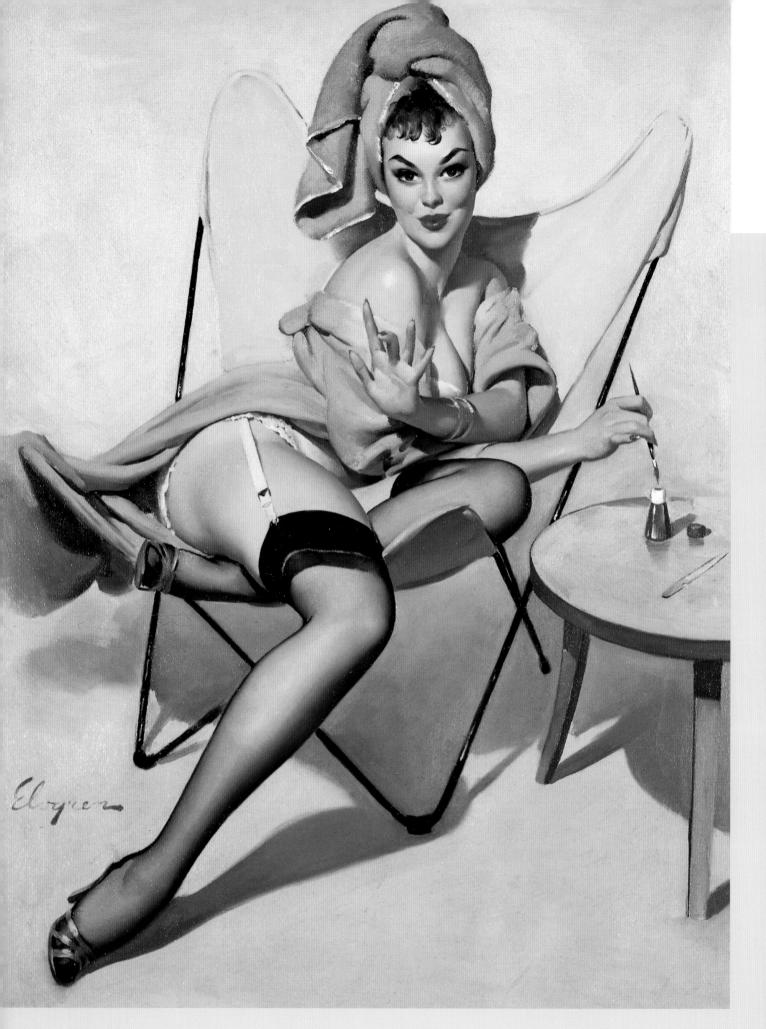

461

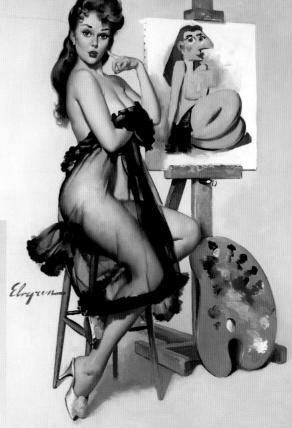

463

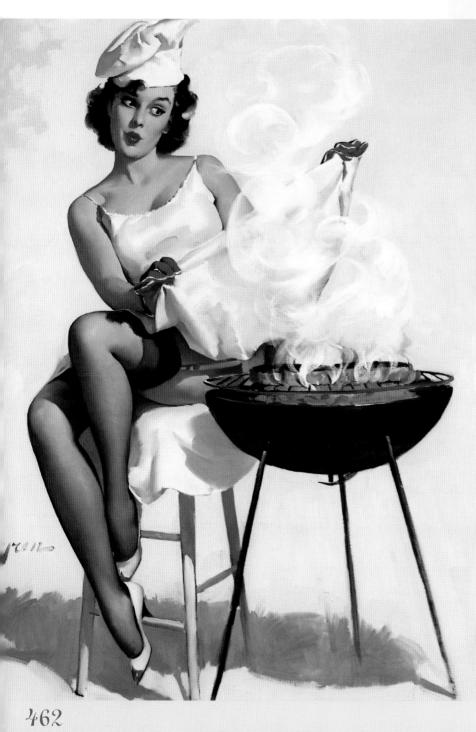

462

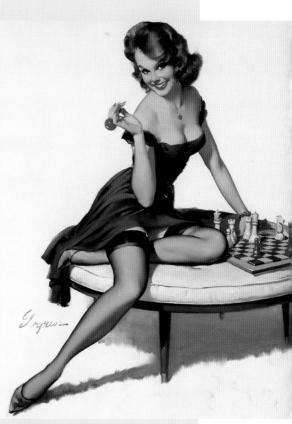

464

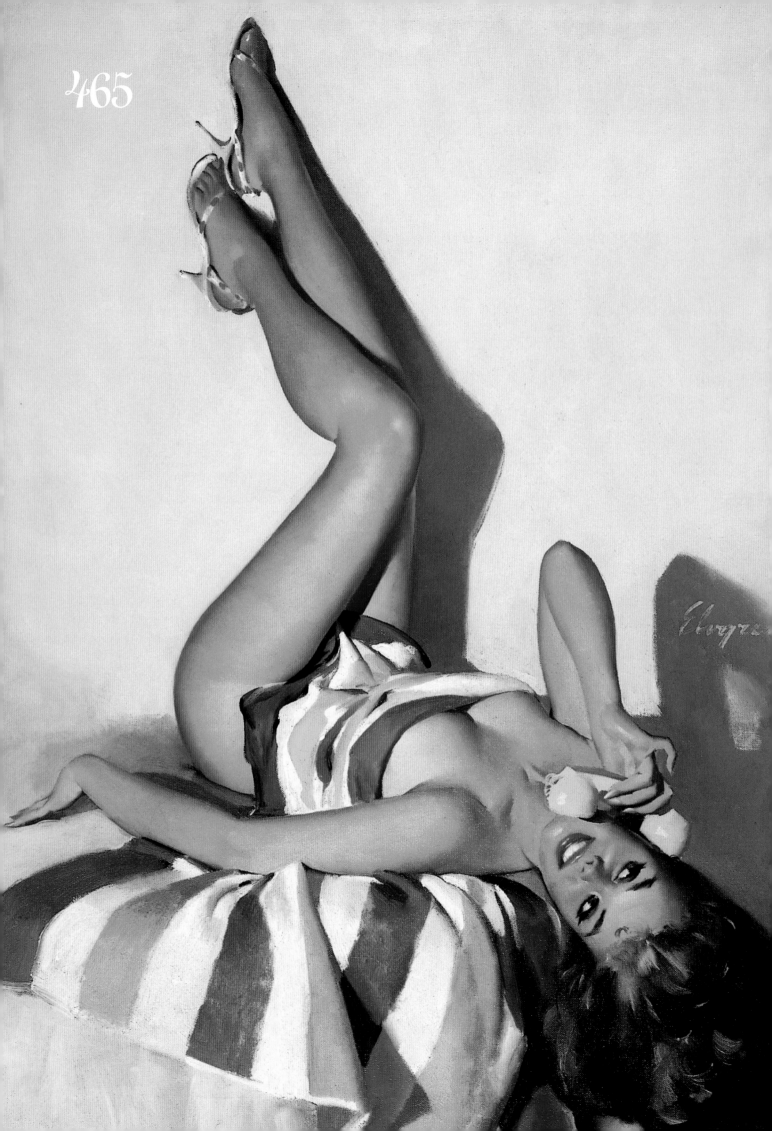

465

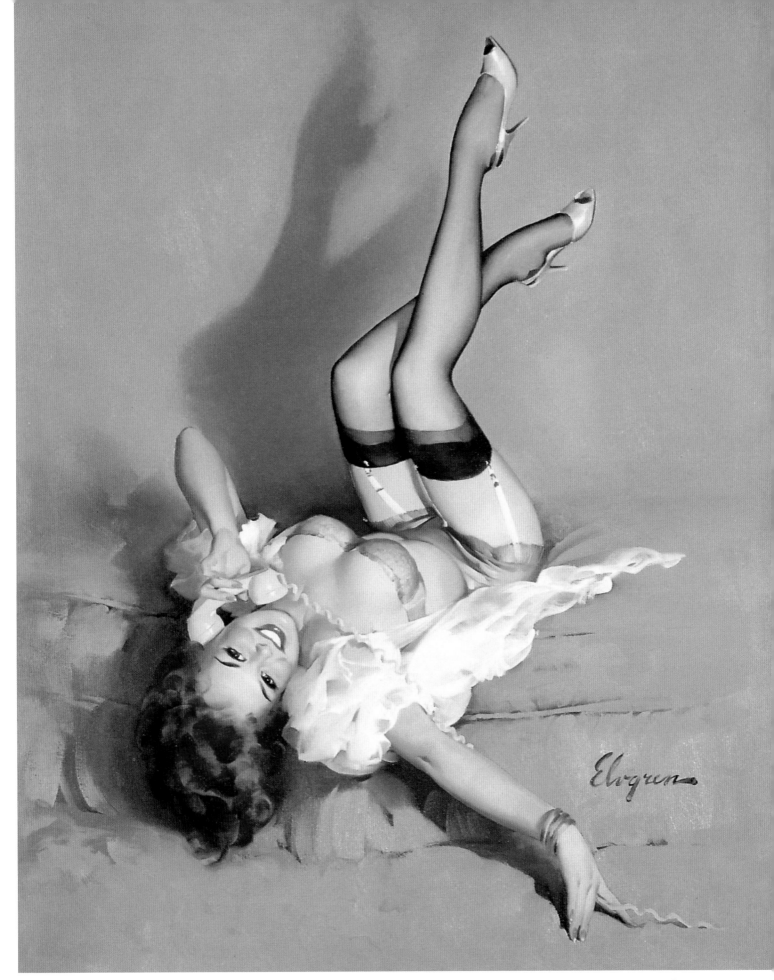

466

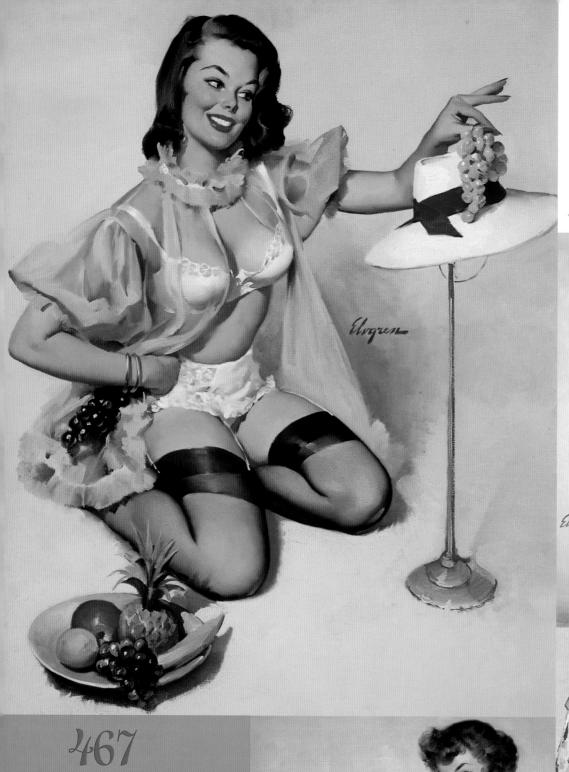

468

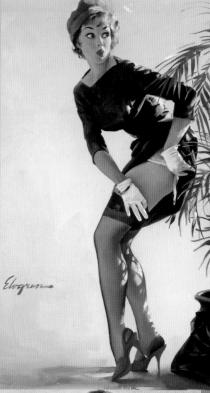

467

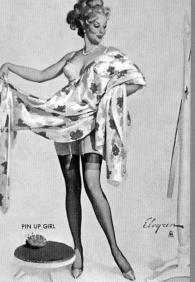

PIN UP GIRL

470

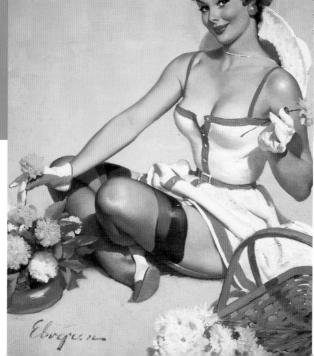

469

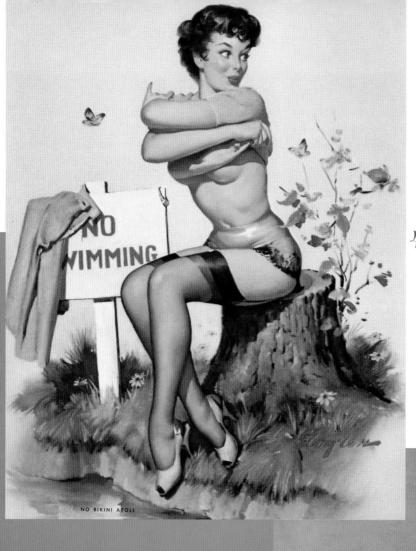

NO BIKINI ATOLL

471

473

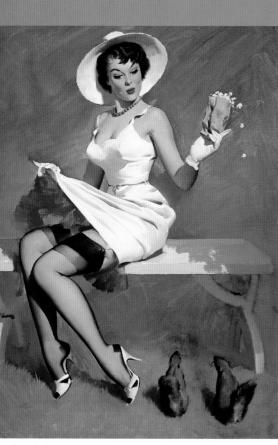

472

BU STOP

Elvgren

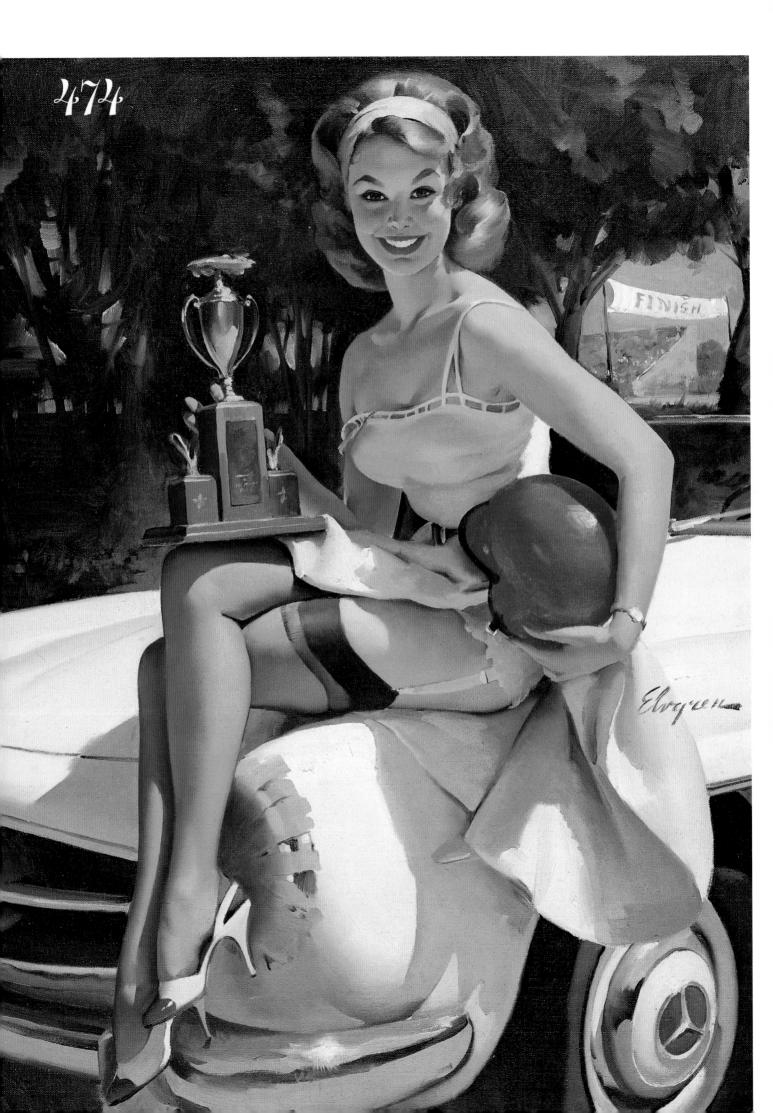

474

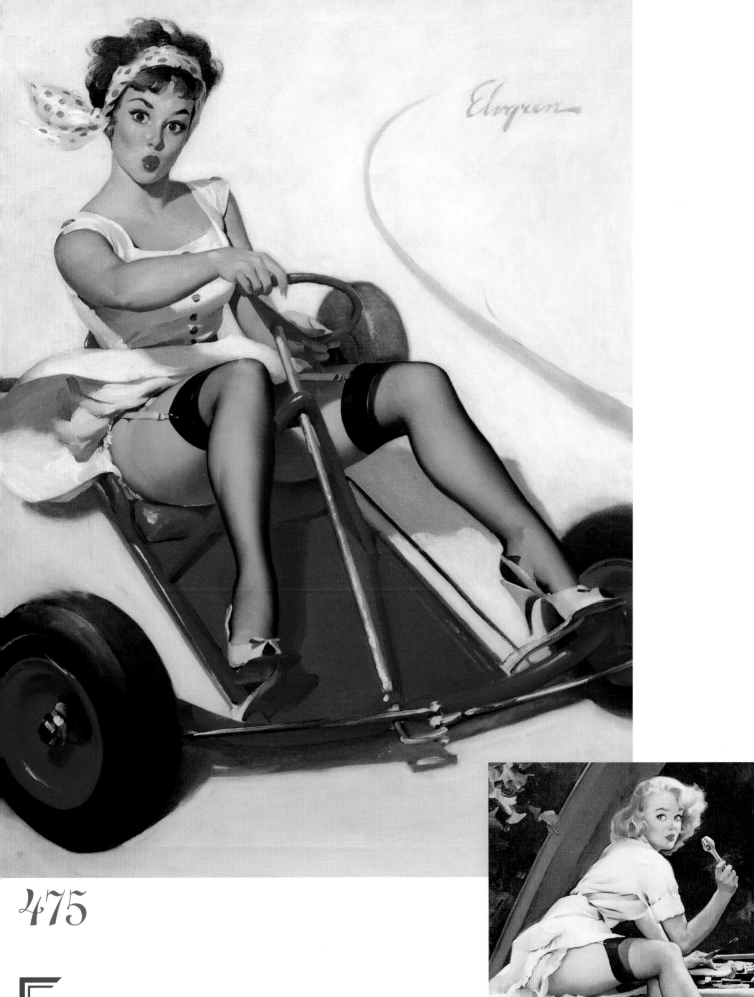

475

PRETTY PERPLEXED

476

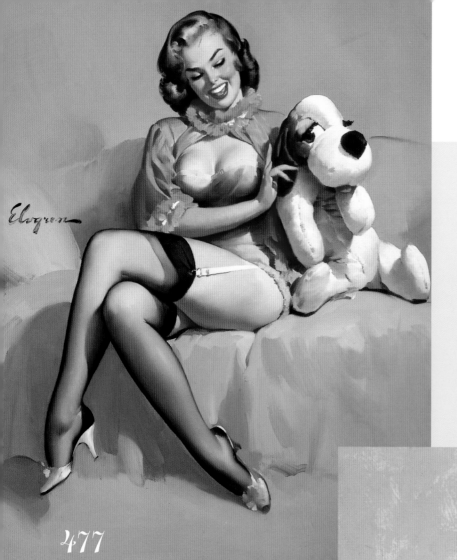

477

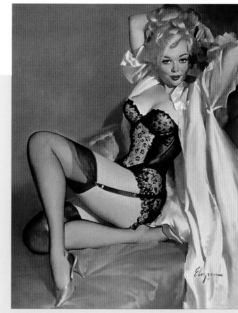

478

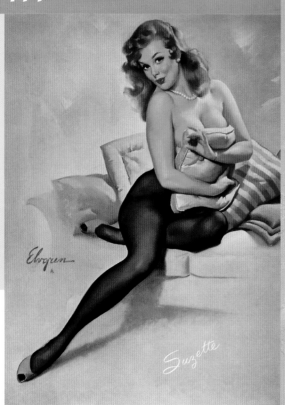

479

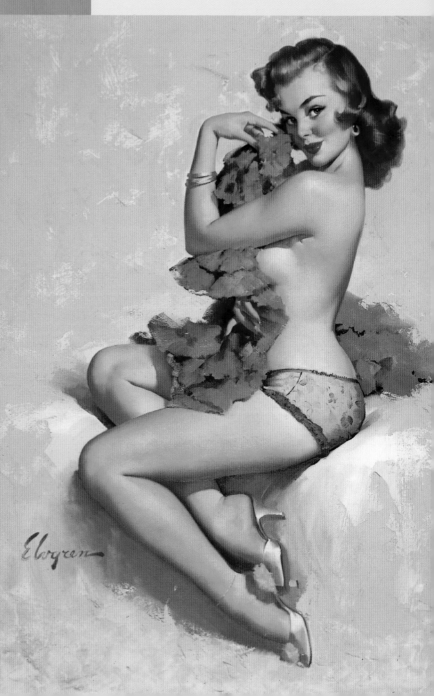

480

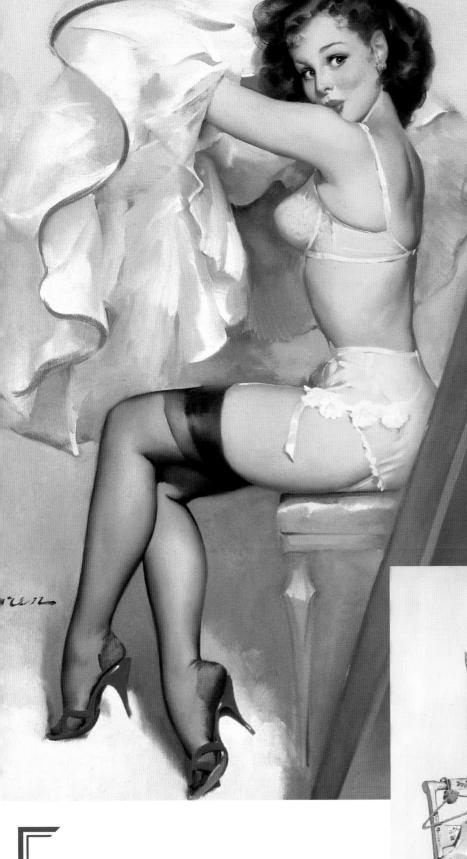

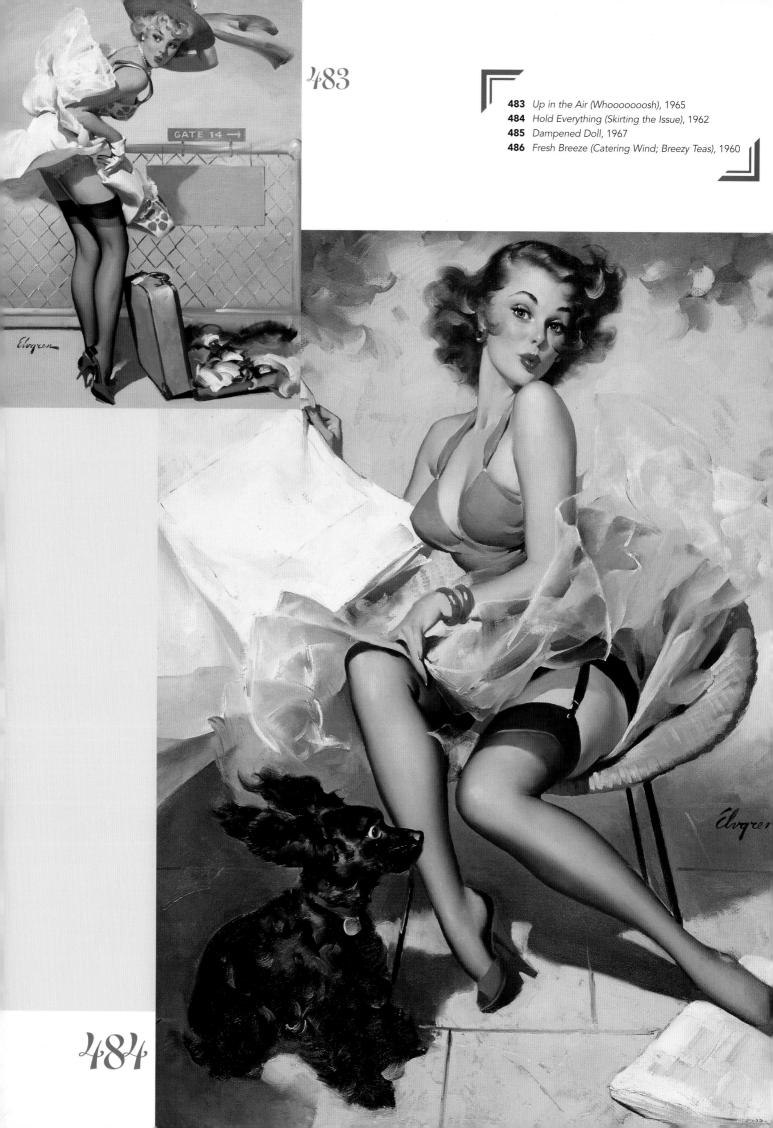

483

484

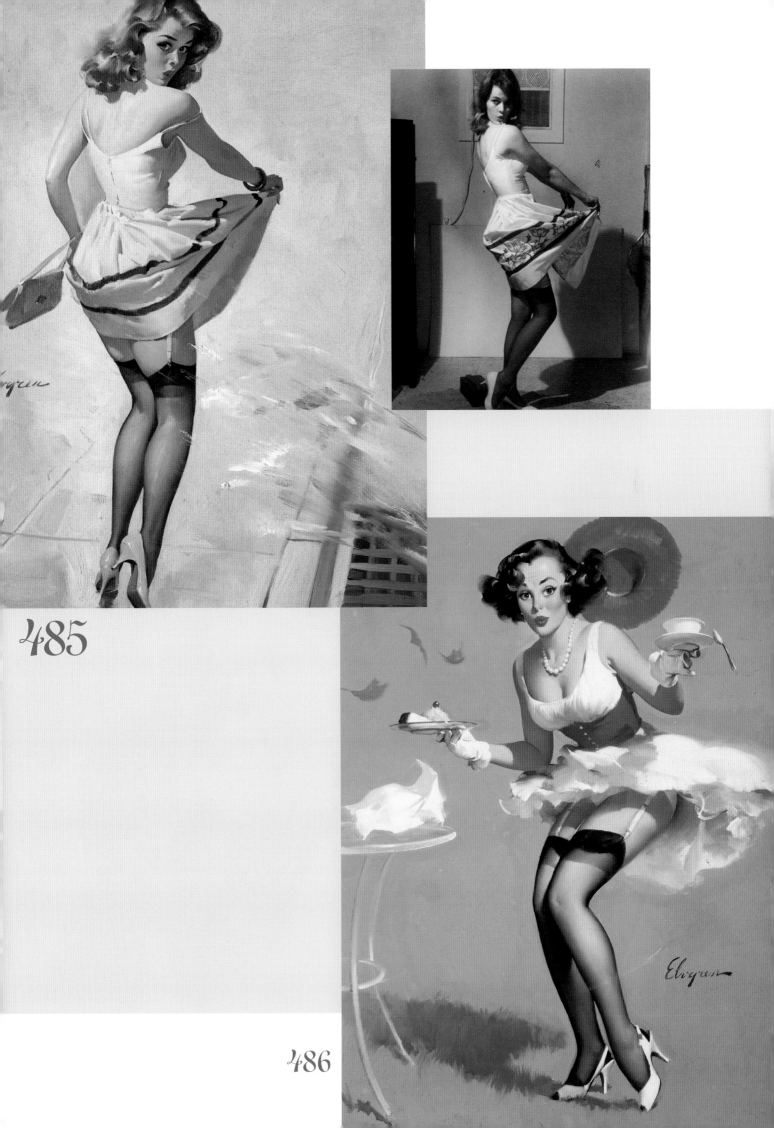

485

486

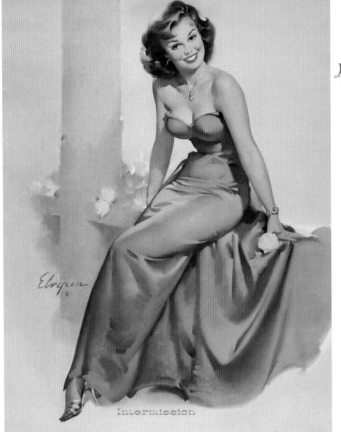

Intermission

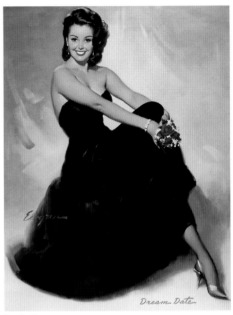

Dream Date

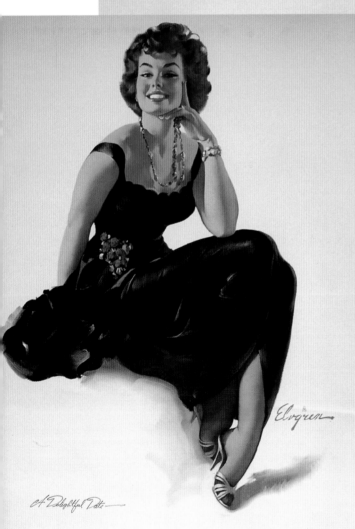

A Delightful Date

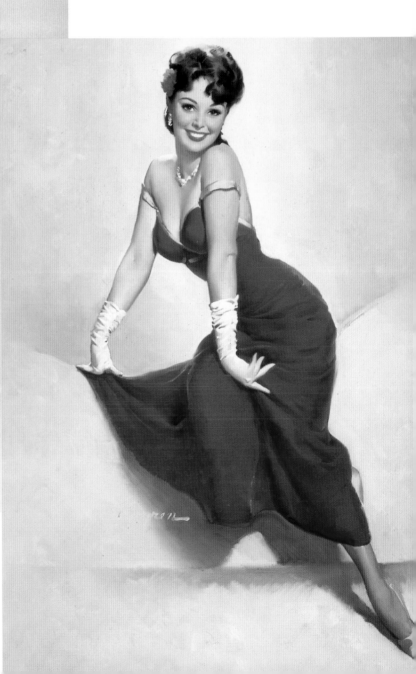

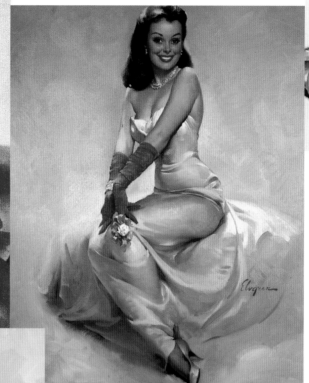

**491**

**493**

LAVENDER LOVELY

**492**

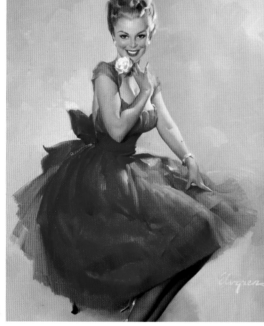

**494**

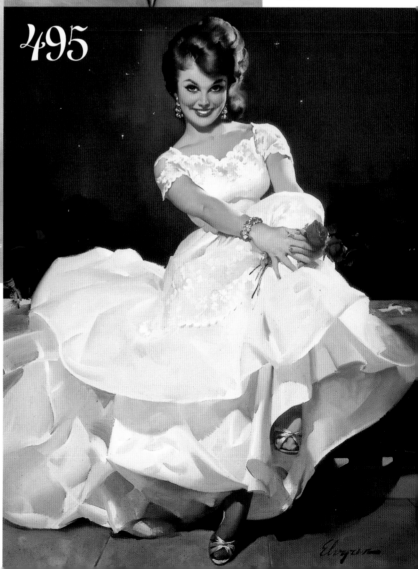

**495**

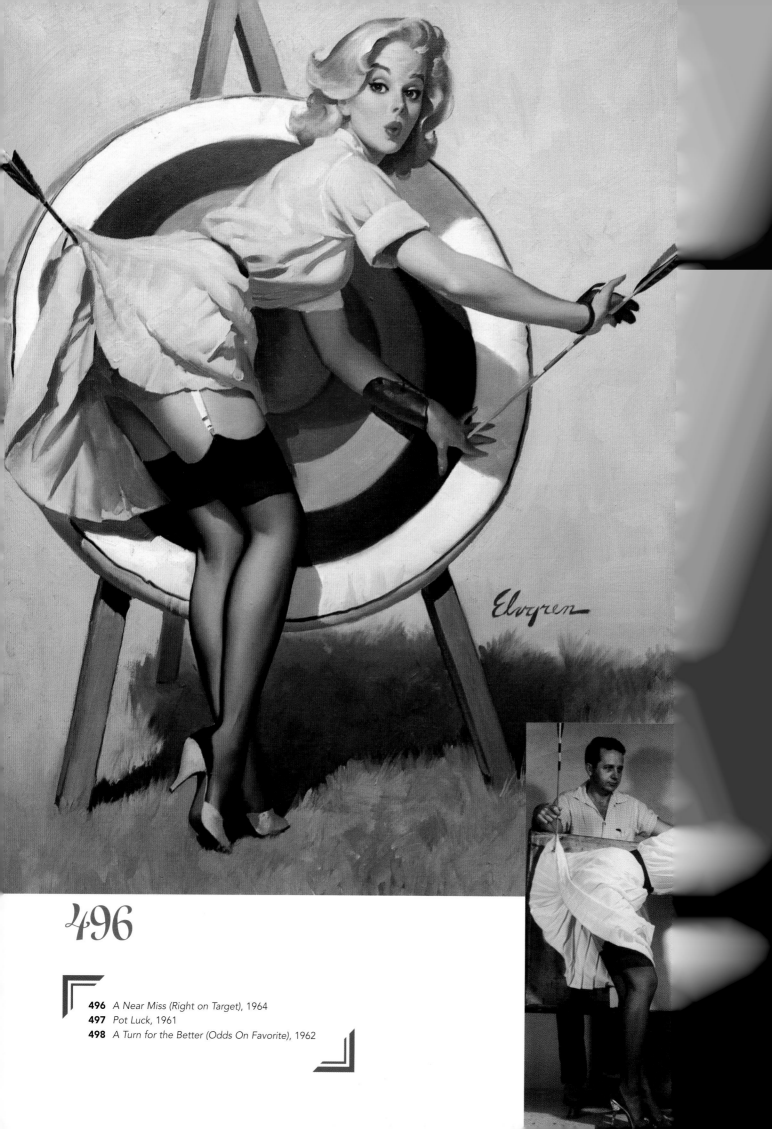

# 496

496 *A Near Miss (Right on Target)*, 1964
497 *Pot Luck*, 1961
498 *A Turn for the Better (Odds On Favorite)*, 1962

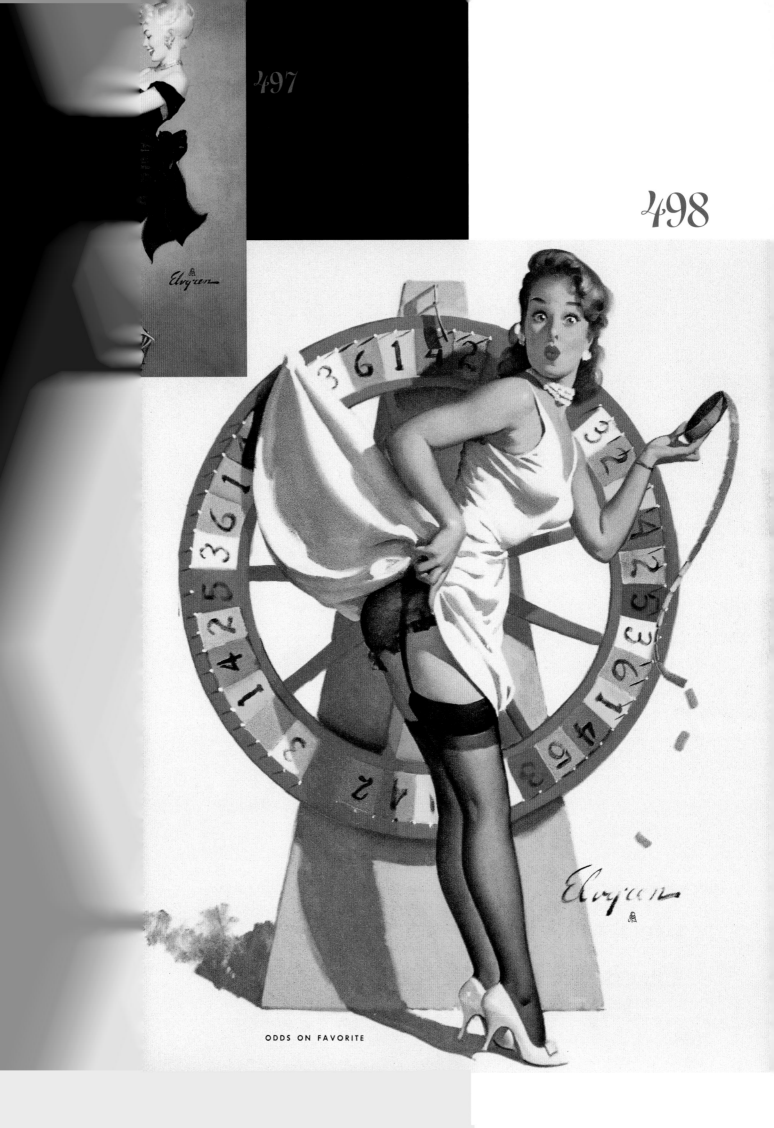

497

498

ODDS ON FAVORITE

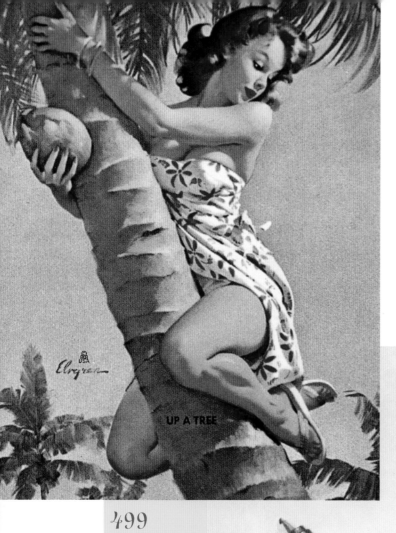

UP A TREE

499

500

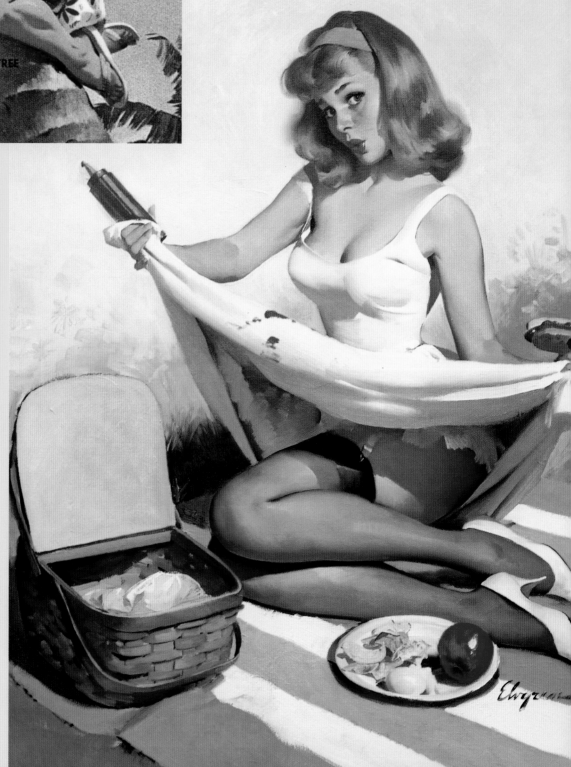

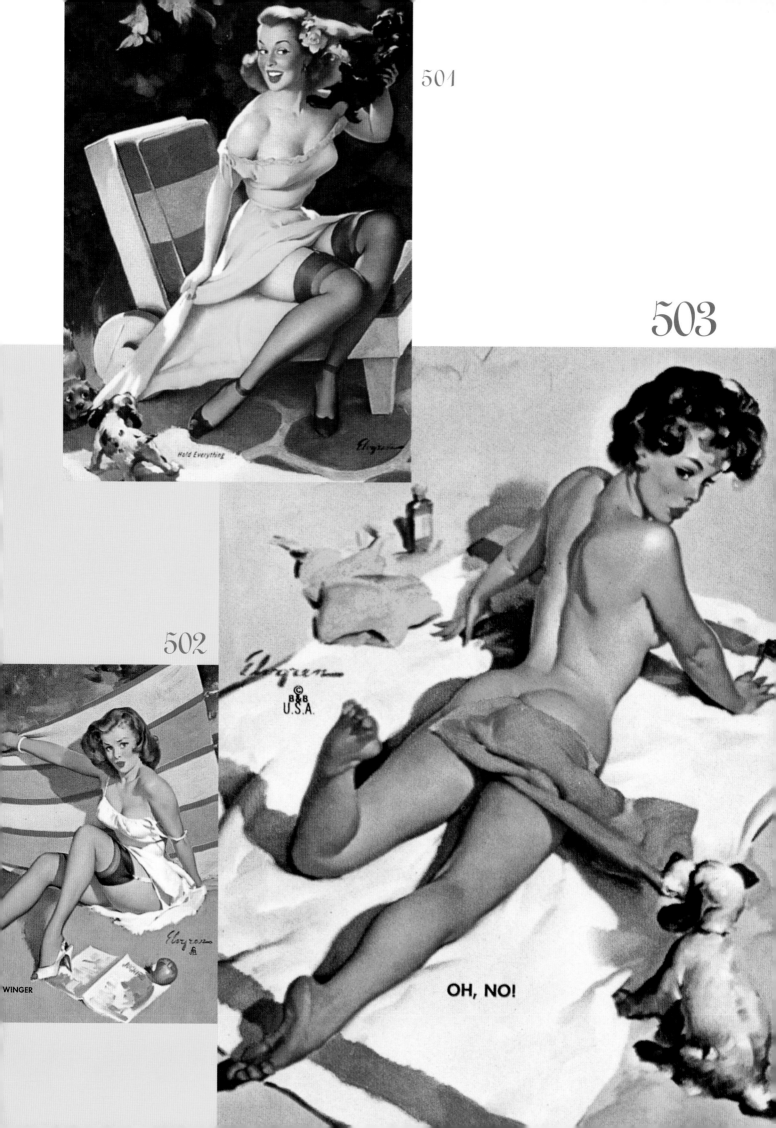

501

503

502

Hold Everything

WINGER

OH, NO!

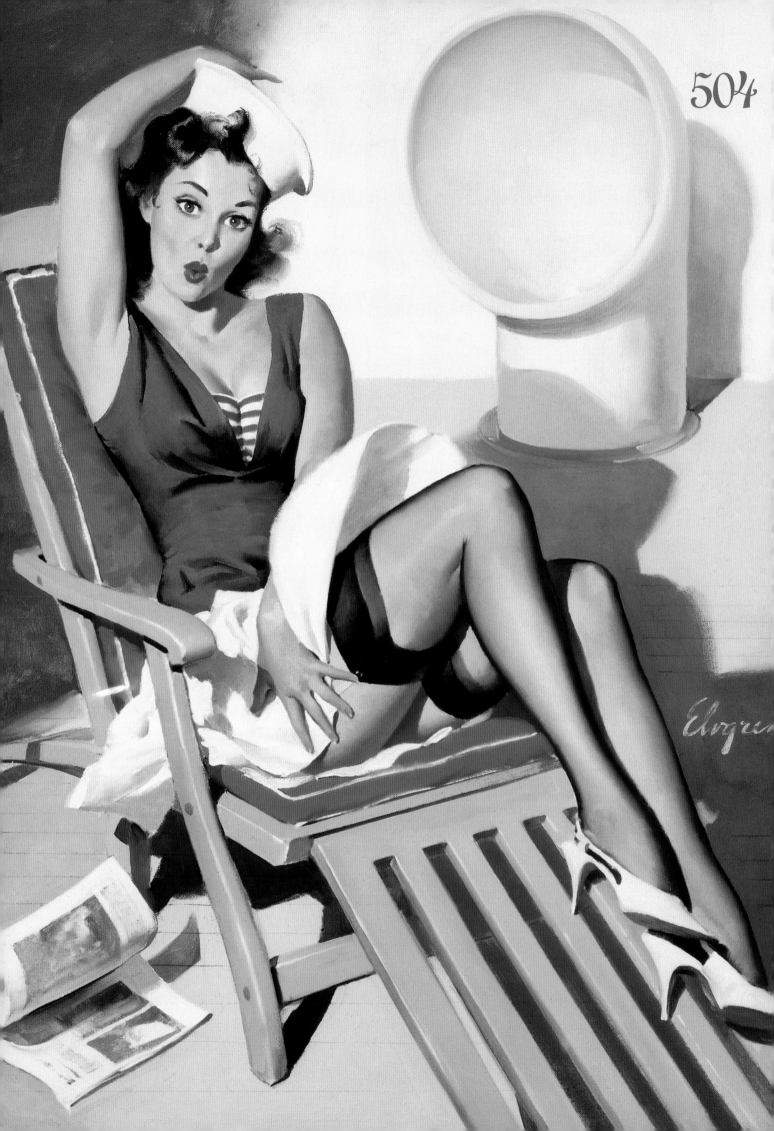

504

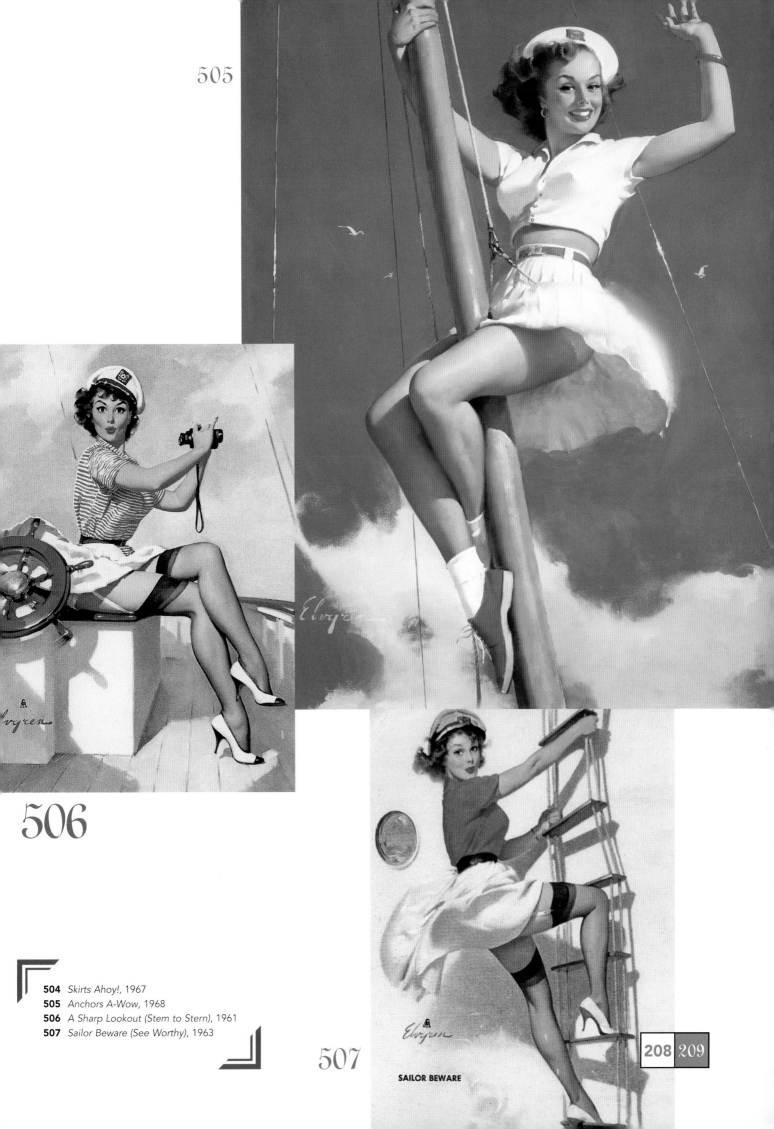

505

506

507

**SAILOR BEWARE**

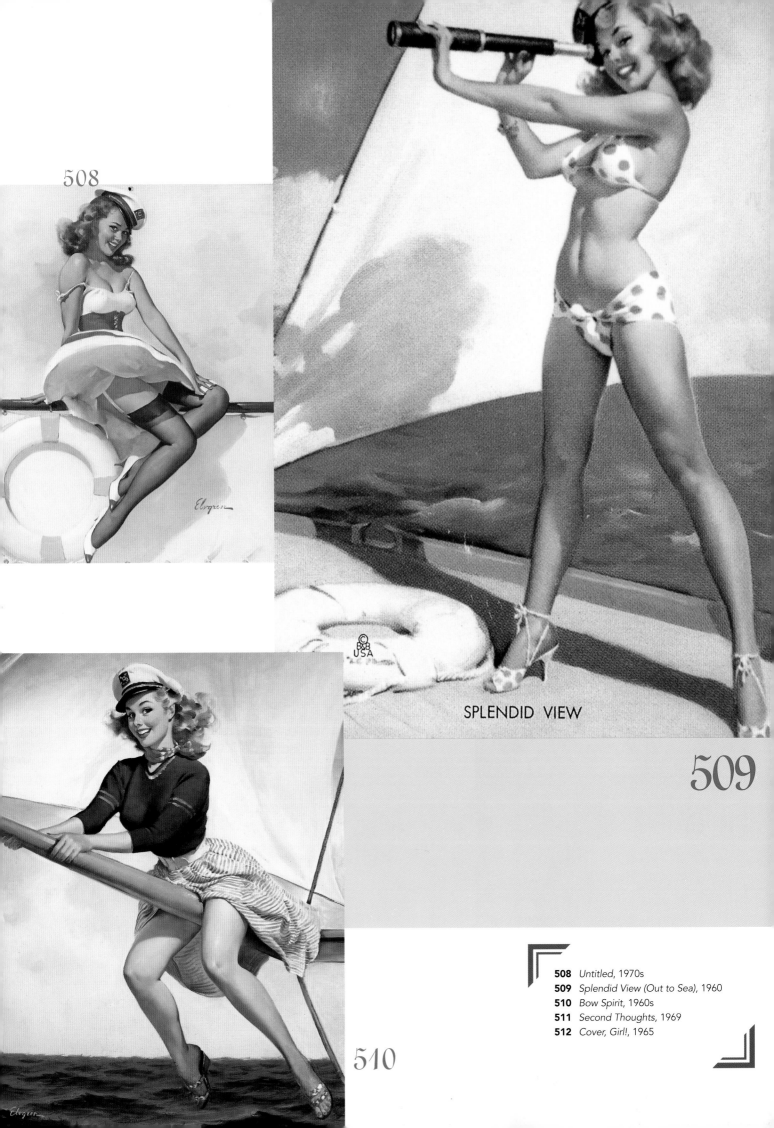

508

SPLENDID VIEW

509

510

511

512

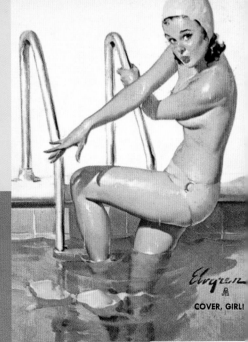

COVER, GIRL!

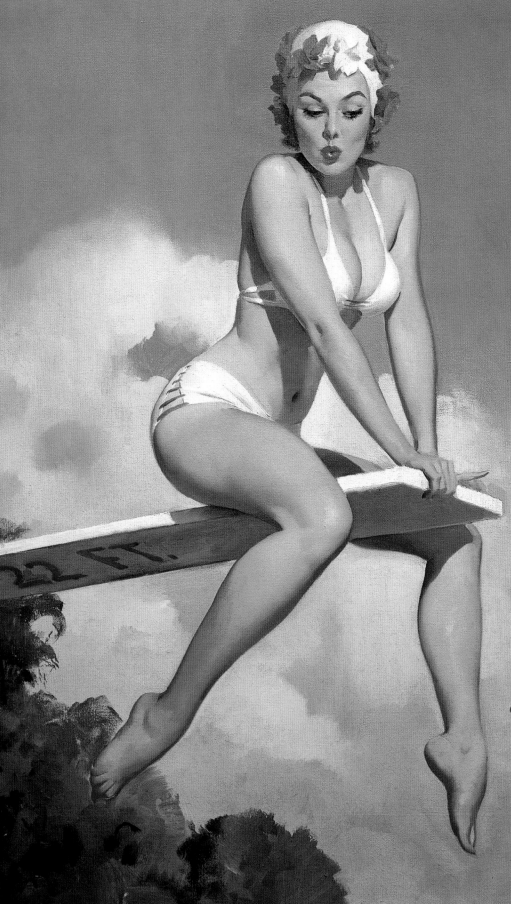

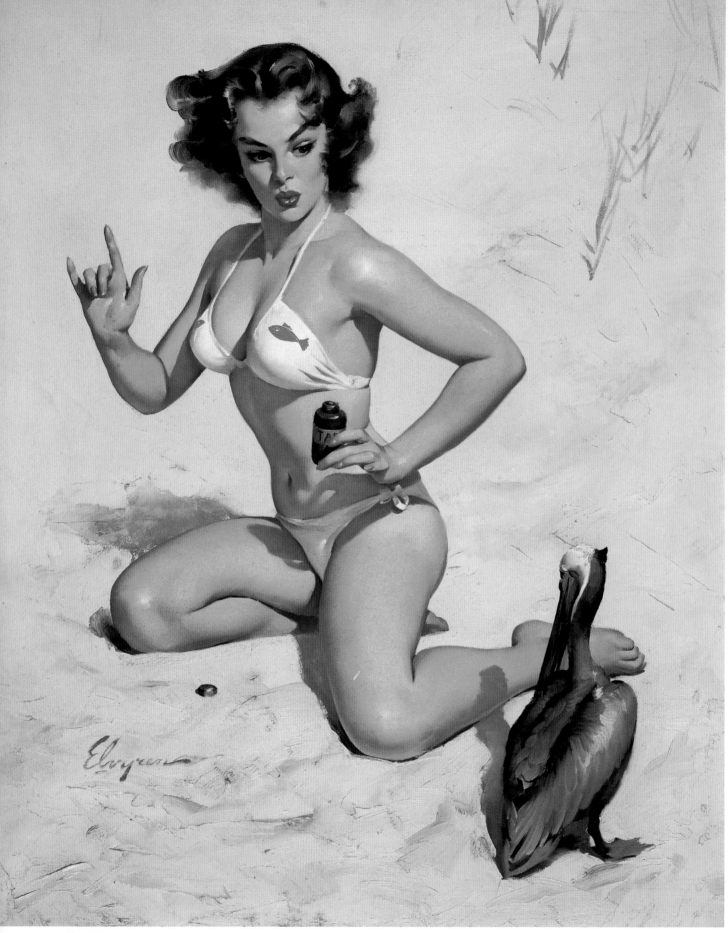

543

513 *Appreciative Audience (Bird's-Eye View)*, 1960
514 *Just for You (Sand Witch)*, 1961

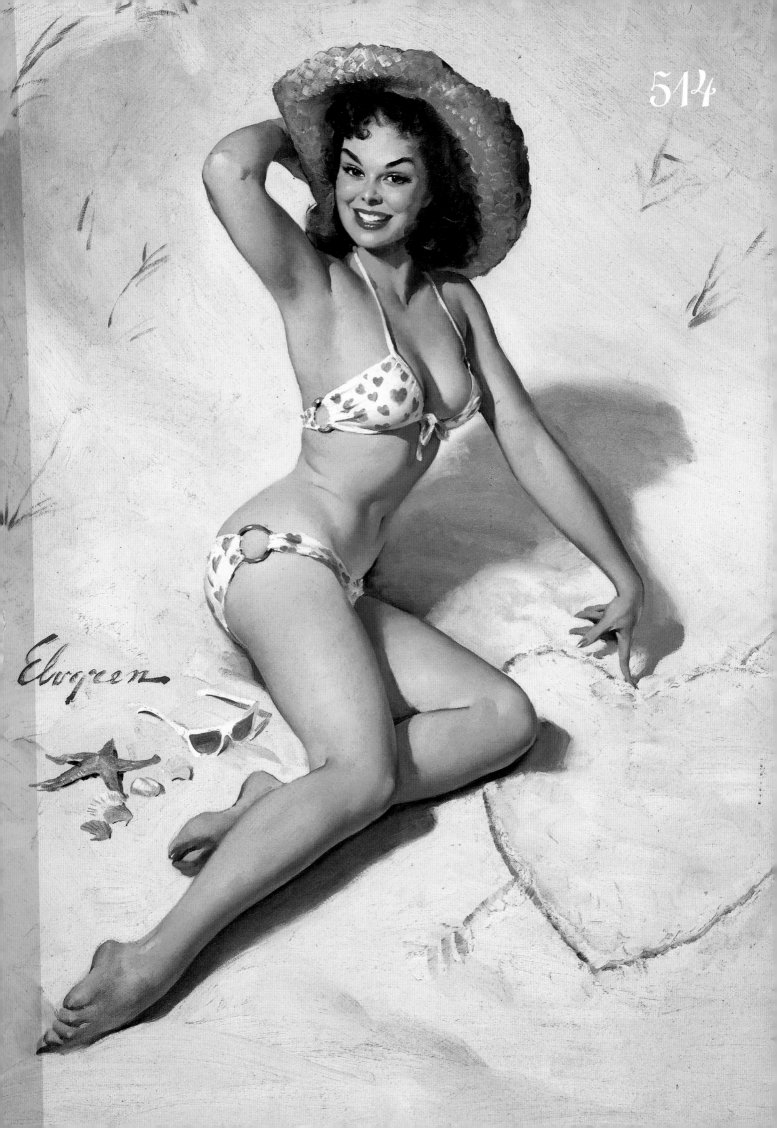

514

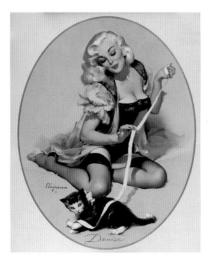

546

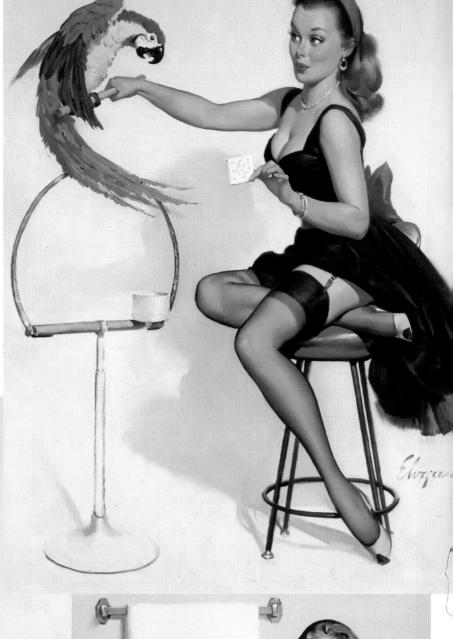

515

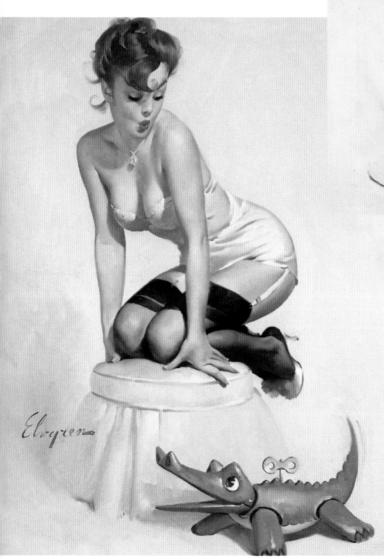

WE'LL HELP!
Call
MI. 6-4664

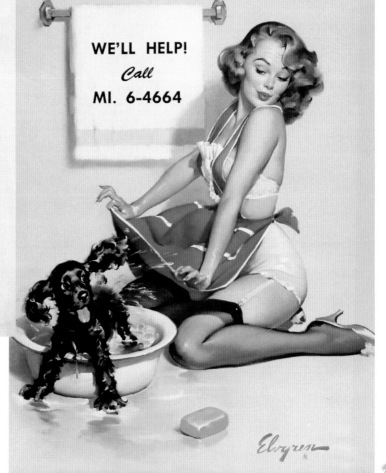

517

518

519

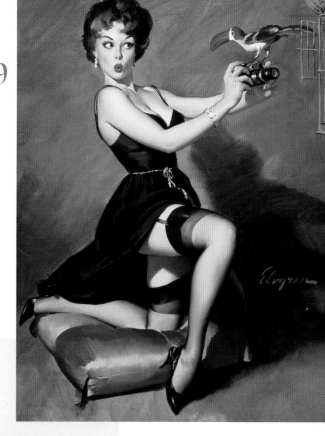

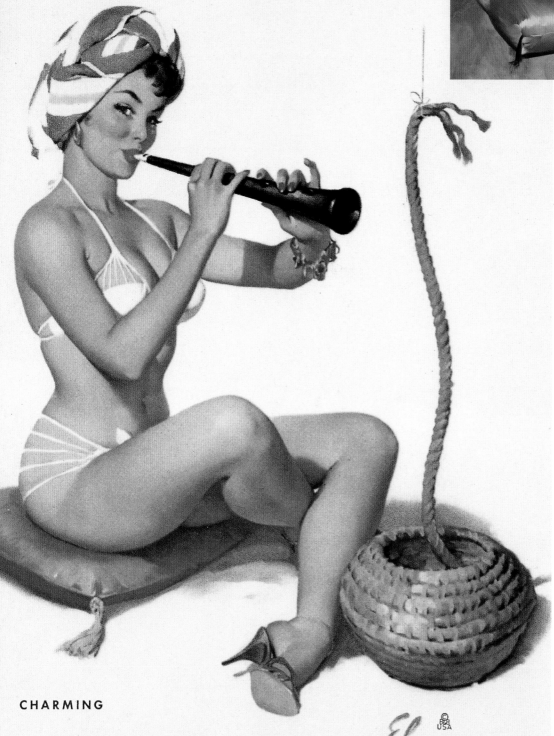

CHARMING

520

521

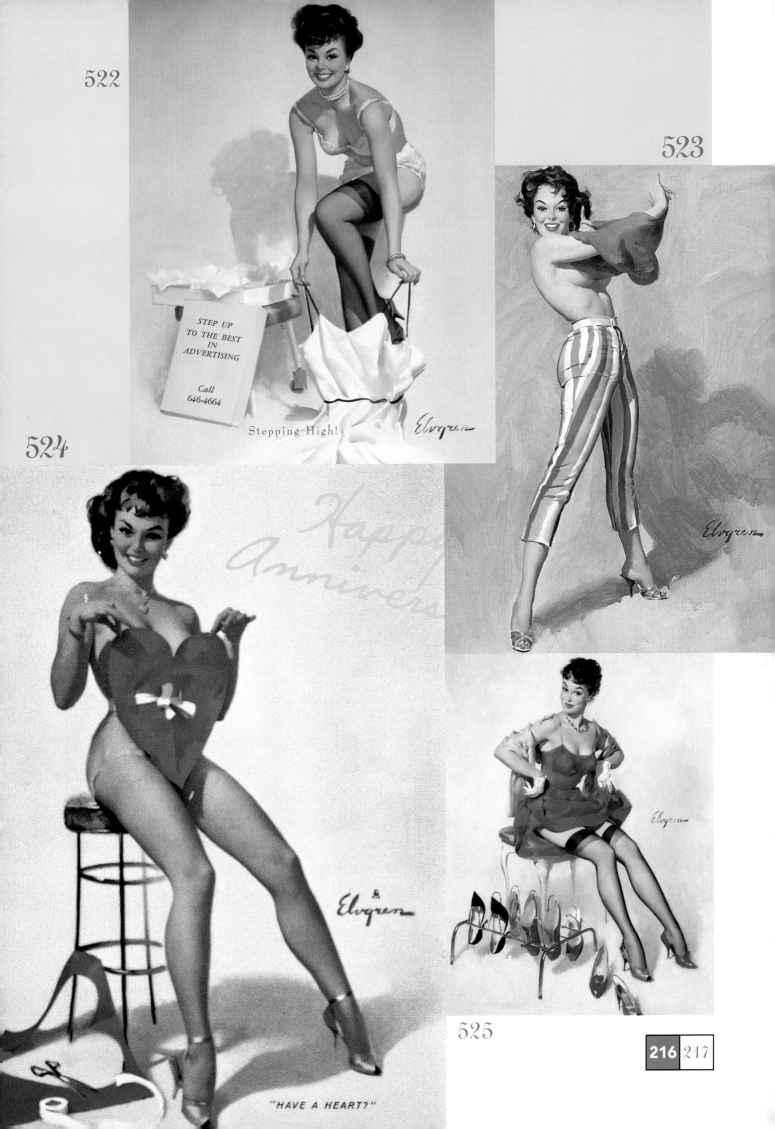

522

524

523

STEP UP
TO THE BEST
IN
ADVERTISING

Call
646-4664

Stepping High!

*Elvgren*

*Elvgren*

*Elvgren*

*Elvgren*

"HAVE A HEART?"

525

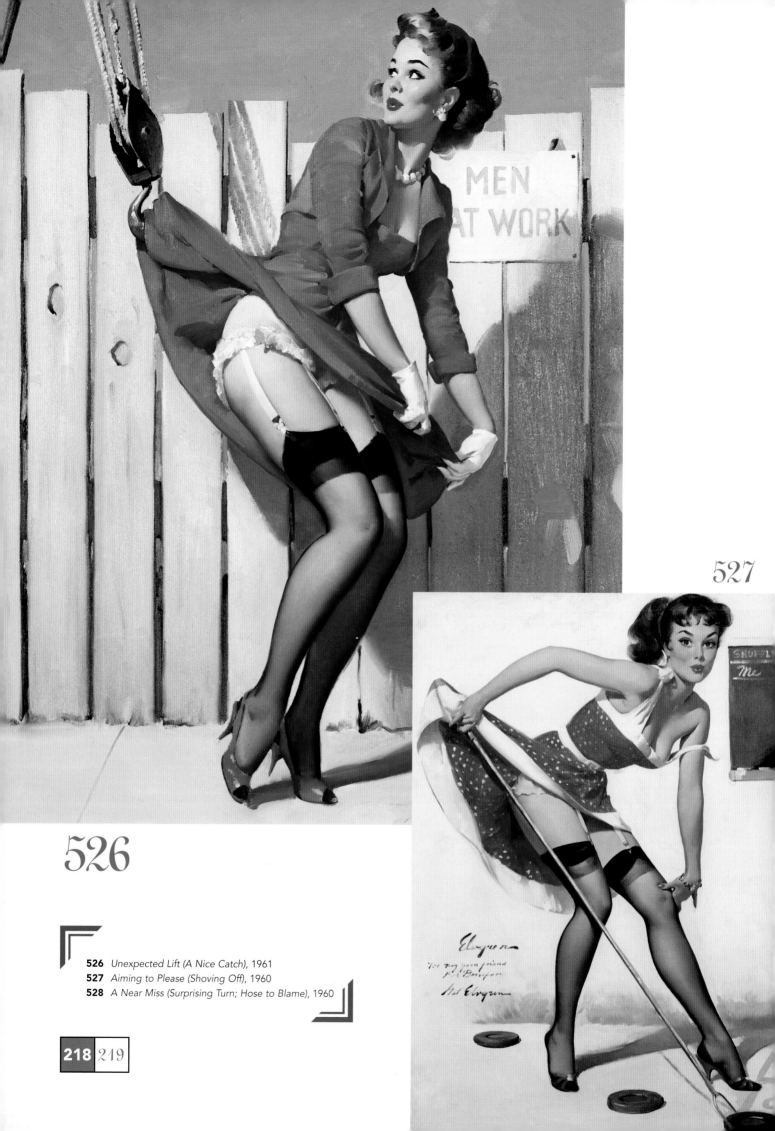

527

526

526   Unexpected Lift (A Nice Catch), 1961
527   Aiming to Please (Shoving Off), 1960
528   A Near Miss (Surprising Turn; Hose to Blame), 1960

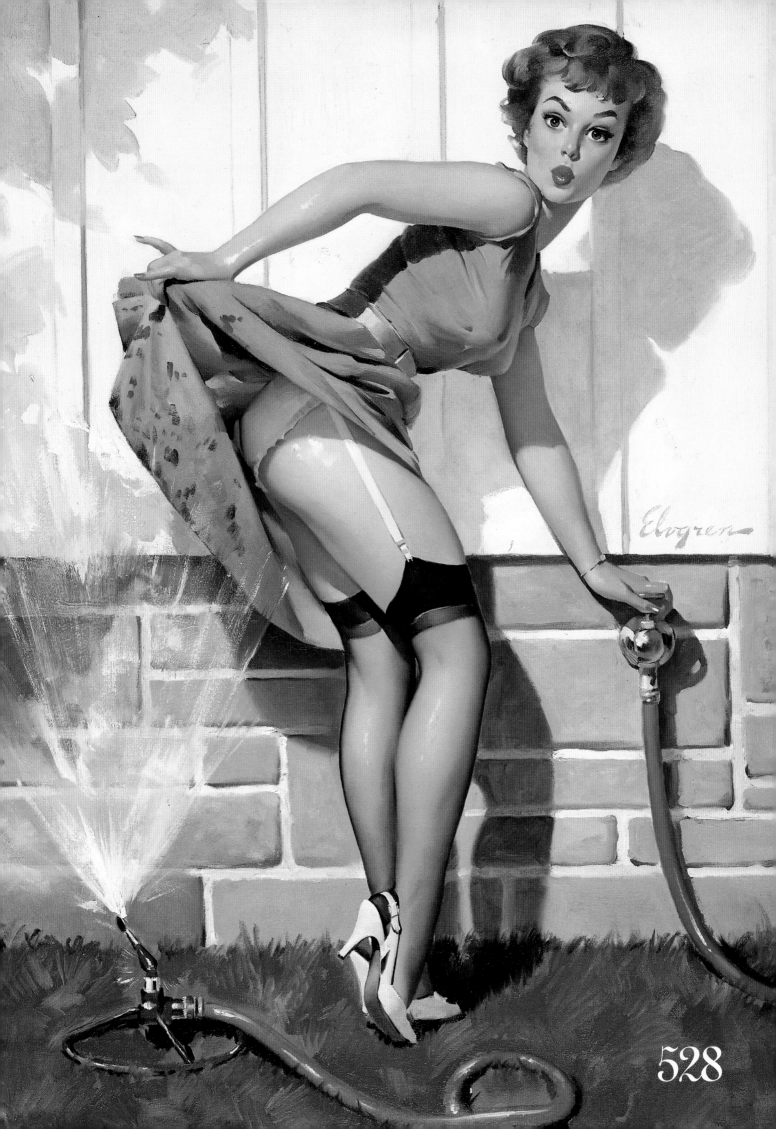

528

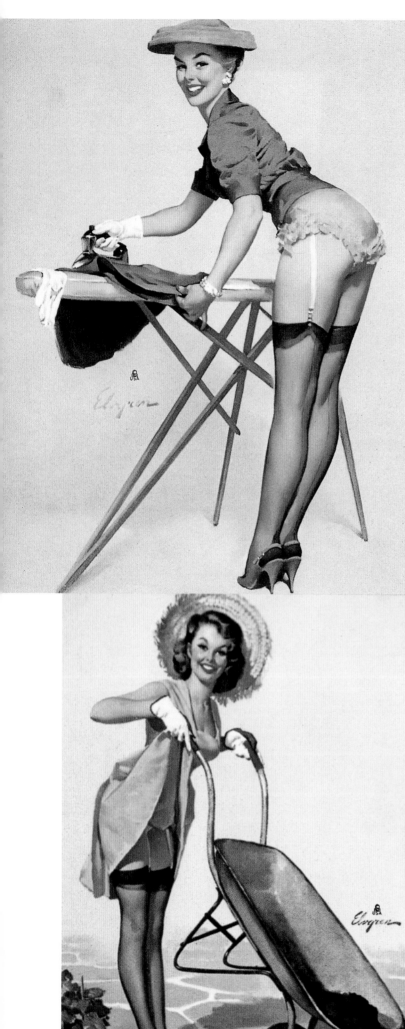

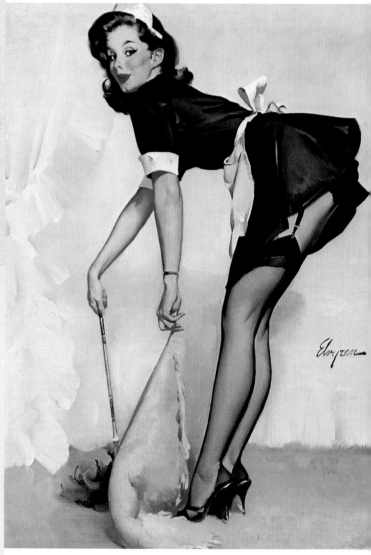

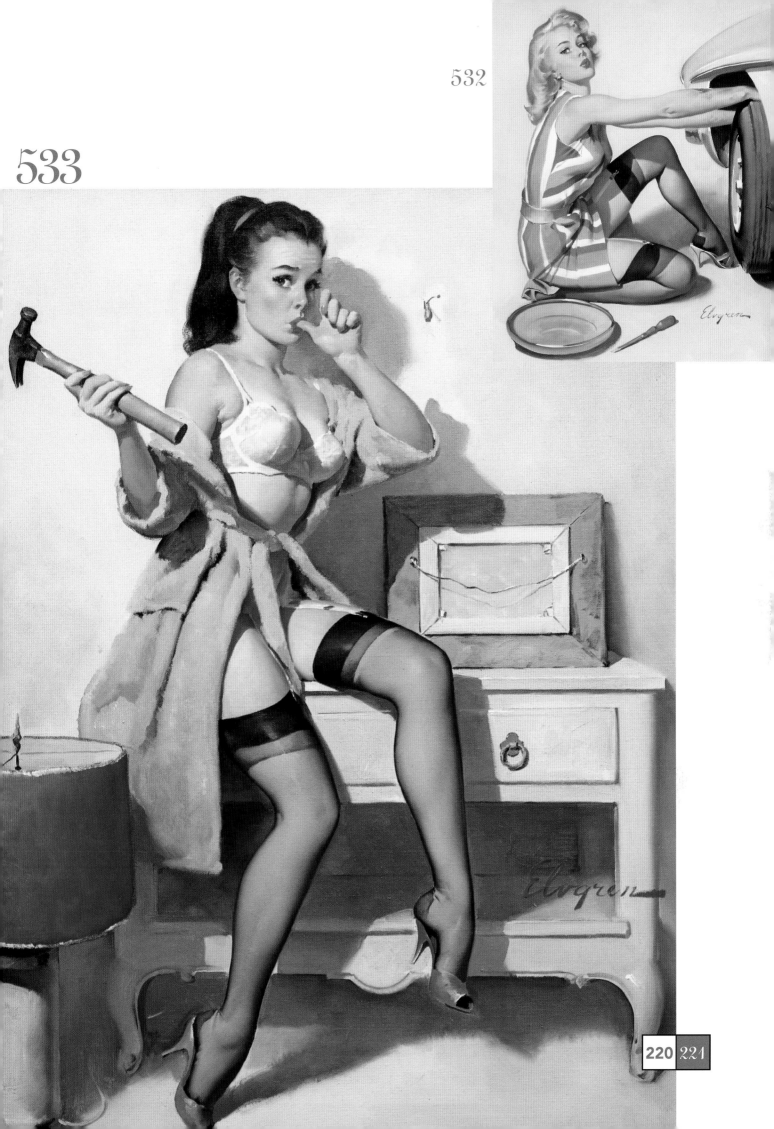

532

533

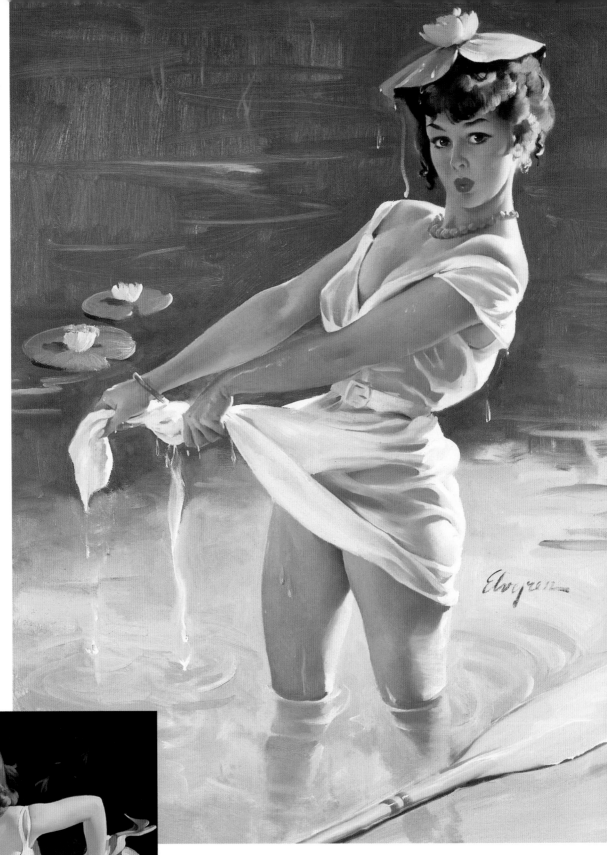

534

535

536

537

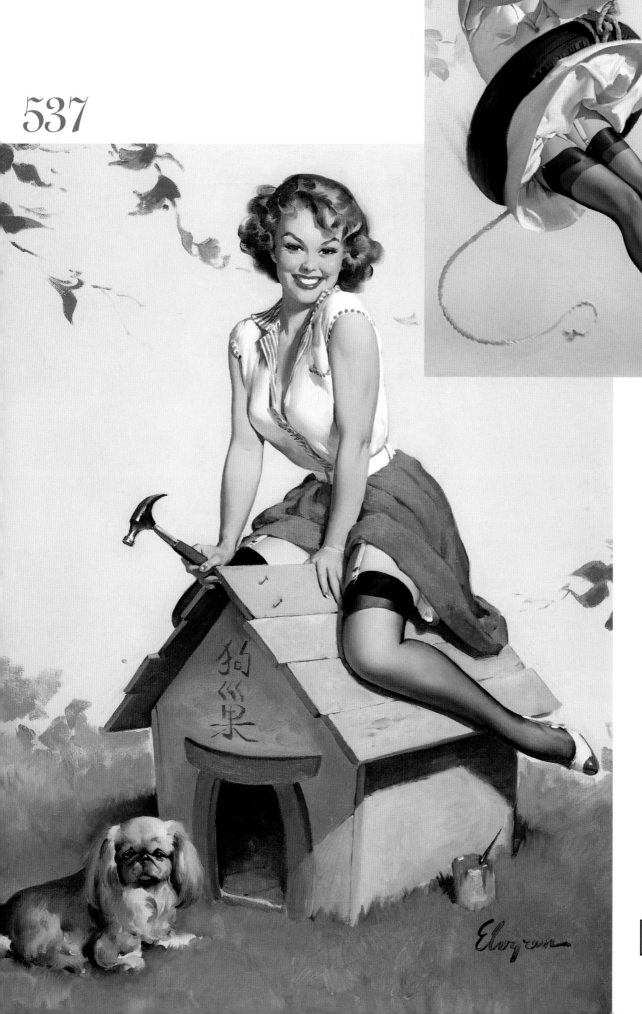

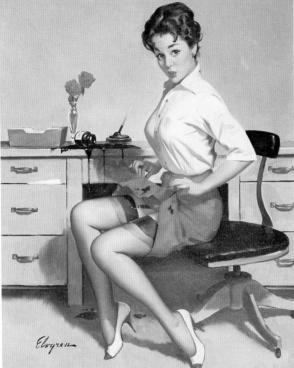

538

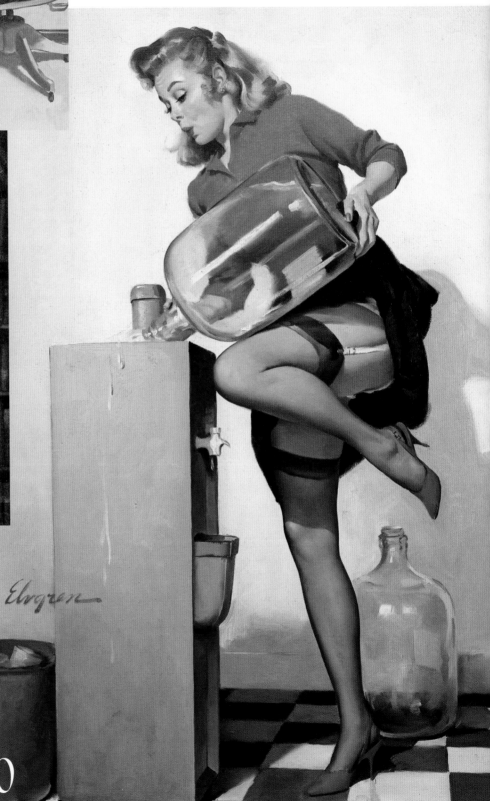

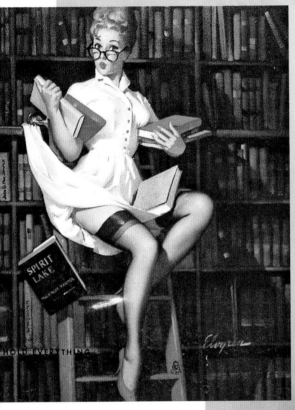

539

540

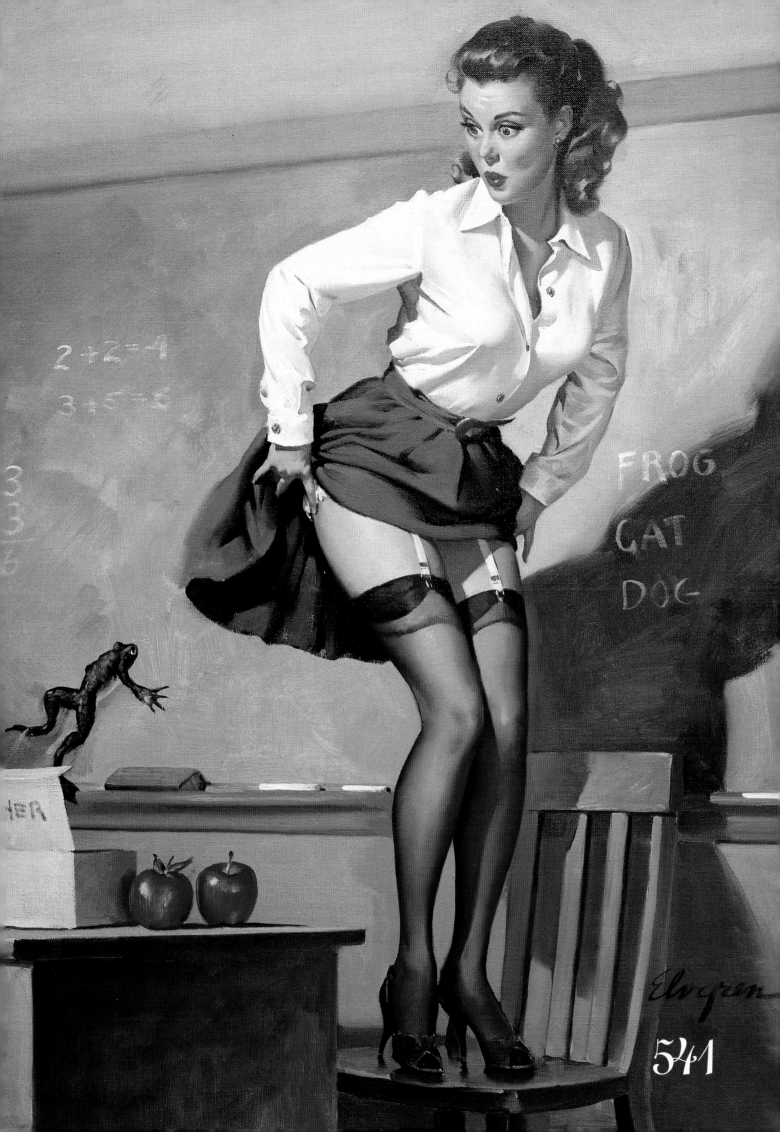

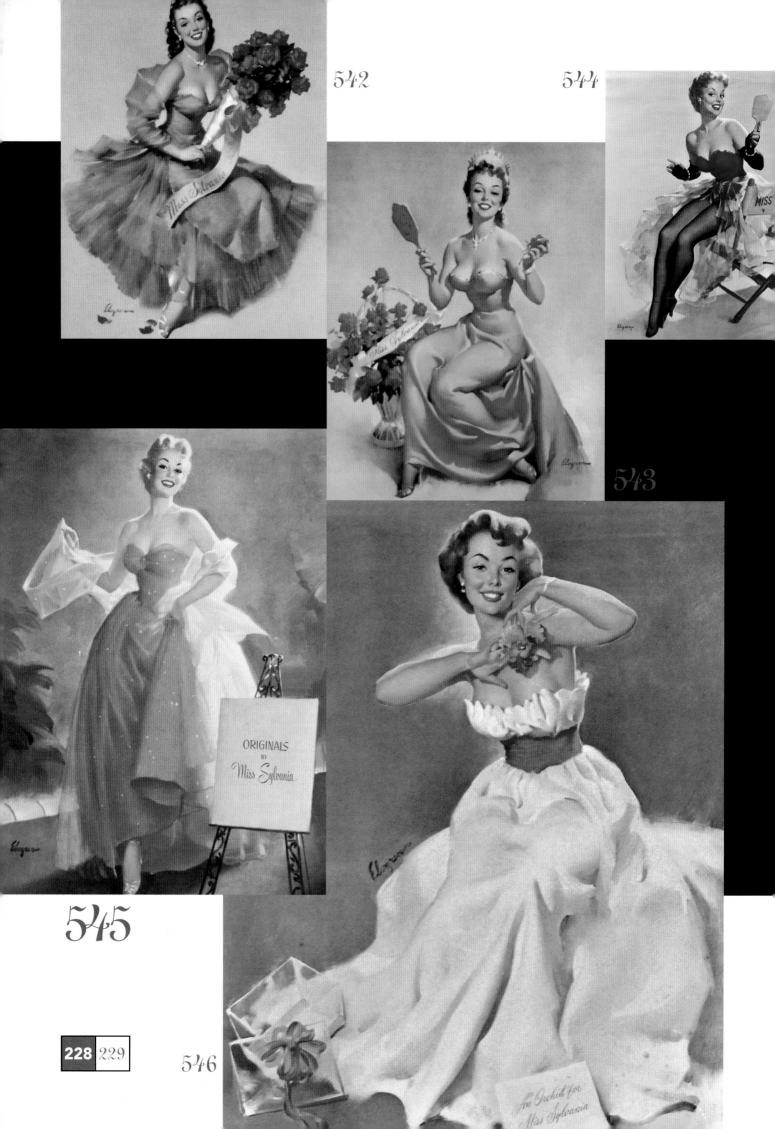

542

544

543

545

546

228 229

548

MISS SYLVANIA

547

WELCOME
Miss Sylvania

549

**542–549** Sylvania calendars,
1951–1960

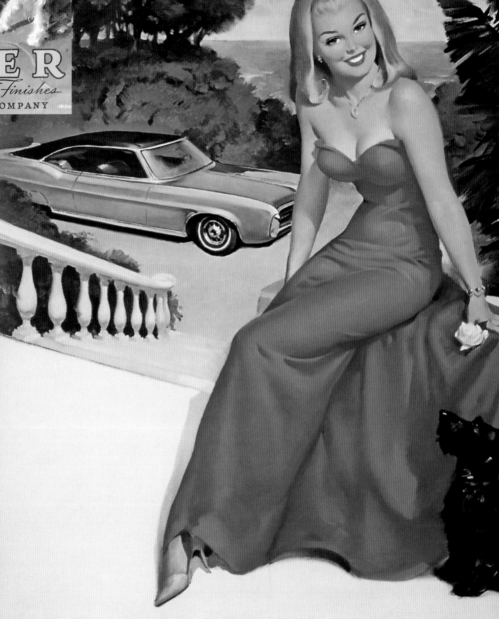

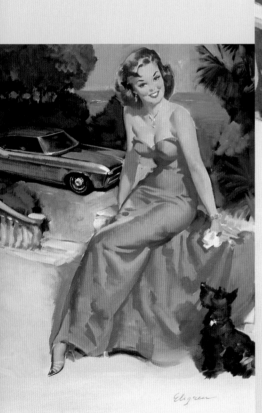

551

550

552

553

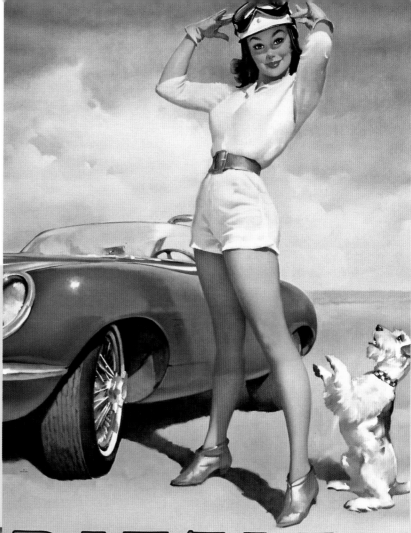

**DITZLER**

*Automotive Finishes*

PITTSBURGH PLATE GLASS COMPANY

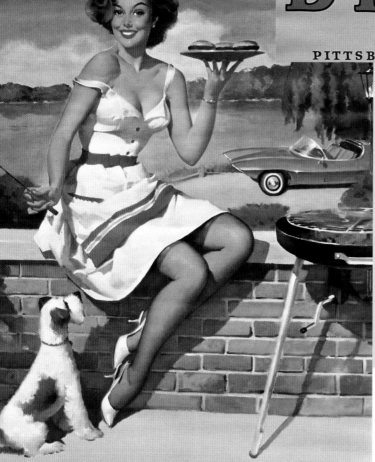

**DITZLER**

*Automotive Finishes*

PITTSBURGH PLATE GLASS COMPANY

554

555

**DITZLER**

*Automotive Finishes*

556

557

558

559

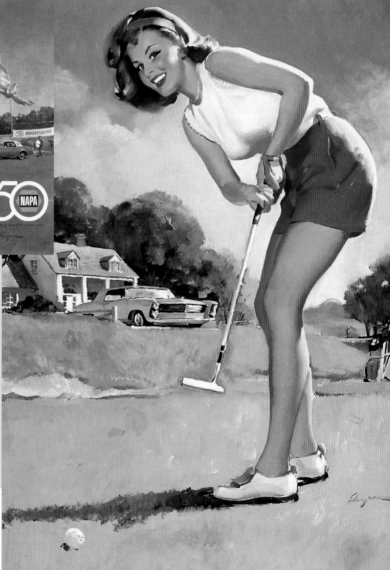

560

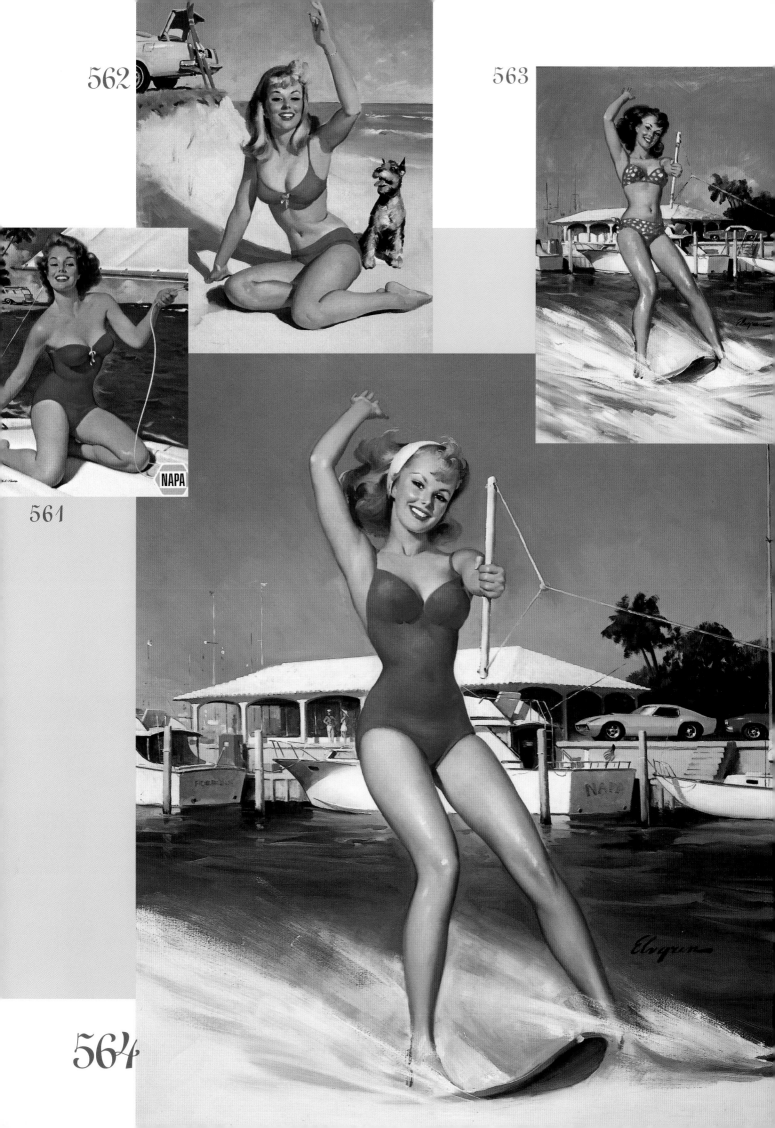

562

563

561

564

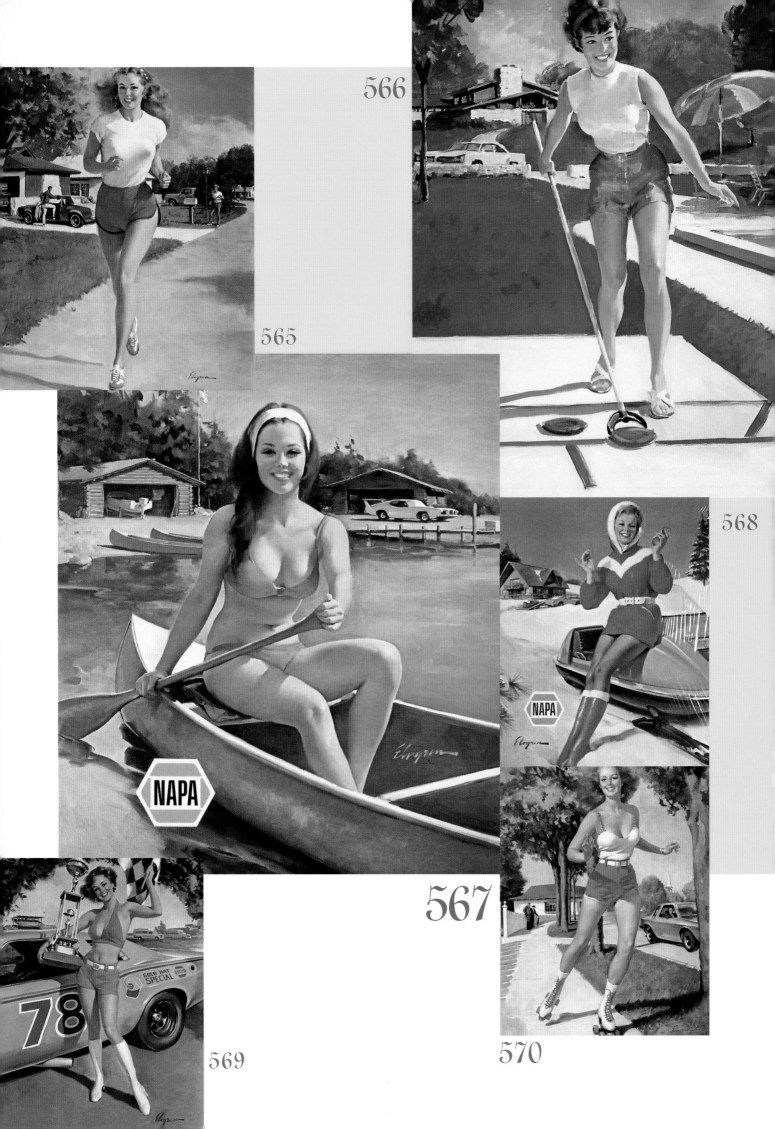

565

566

567

568

569

570

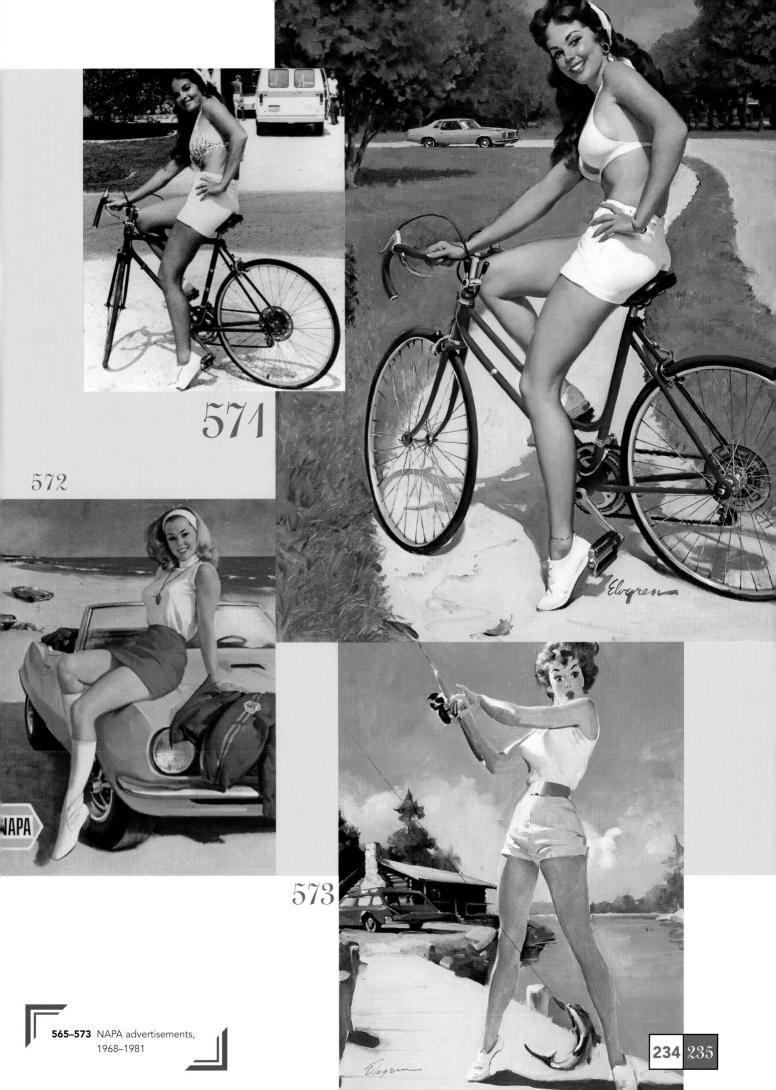

571

572

573

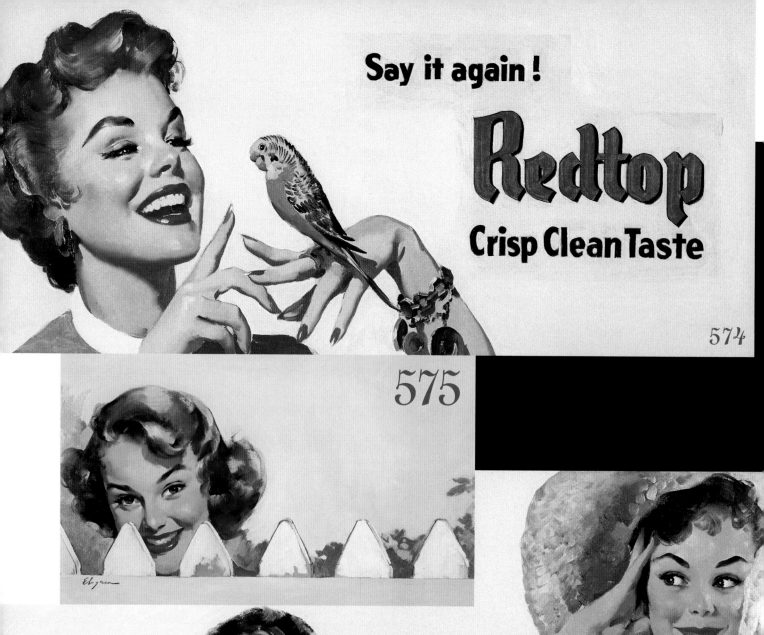

Say it again !

# Redtop

## Crisp Clean Taste

574

575

577

576

578

579

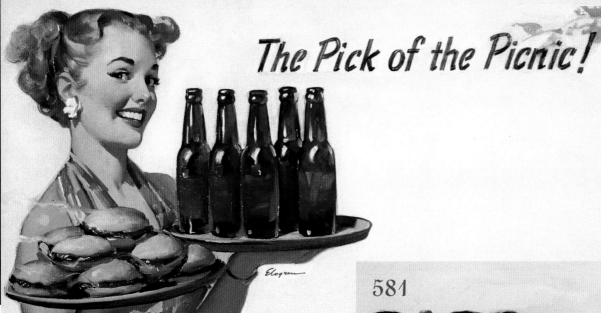

The Pick of the Picnic!

580

581

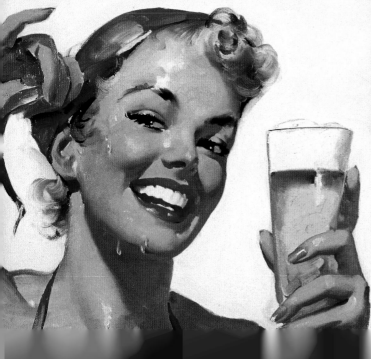

582

**For All Weath PROTECTIO**

583

584

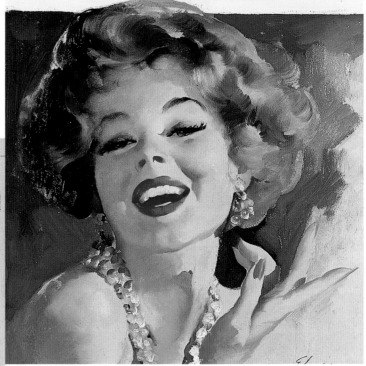

585

586

587

588

# GIL ELVGREN
## Alle Glamour-Pin-ups in einem Band

**FÜNF GUTE GRÜNDE FÜR EINE ELVGREN-MONOGRAPHIE**
*Louis K. Meisel*

1. In der Geschichte der amerikanischen Illustration ist Gil Elvgren der mit Abstand beste Pin-up-Künstler.
2. Sein Talent ist so bedeutend und fruchtbar gewesen, daß ein umfangreiches Buch durchaus angemessen ist.
3. Sowohl als Künstler wie auch als Lehrer hat er viele seiner Zeitgenossen stark beeinflußt.
4. Nachdem unser Buch *The Great American Pin-Up* erschienen war, erlebten wir eine überwältigende Nachfrage nach seinen Werken.
5. Unser Freund Art Amsie hatte Gil versprochen, ein Buch über ihn zu machen.

1. Ich glaube, man kann ohne jede Diskussion sagen, daß Gil Elvgren der beste Pin-up-Zeichner war, den die Welt je gesehen hat, und es bis heute noch ist. Weltweit kennen bereits ungefähr eine Viertelmillion Menschen die Arbeiten aller 77 Künstler dieses Genres durch das Buch *The Great American Pin-Up*, das Charles G. Martignette und ich im Benedikt Taschen Verlag herausgegeben haben. Darin ist auch Gil Elvgren an prominenter Stelle vertreten. Würde man zur Abstimmung über den besten Künstler aufrufen, ich bin mir sicher, Elvgren könnte die Mehrheit aller Stimmen auf sich vereinen.

2. Ab Mitte der 30er Jahre bis 1972 schuf Elvgren mehr als 500 Zeichnungen und Gemälde schöner Frauen und Mädchen. Die Mehrzahl dieser Arbeiten hat er in Öl auf Leinwand ausgeführt, und alle sind wahre Meisterwerke. Schon seine ersten Zeichnungen und Gemälde verdienen die Note „sehr gut". Und dennoch war Elvgren steigerungsfähig. Immer wieder übertraf er sich selbst, indem er neue Ideen, Kompositionen, Farbzusammenstellungen und Techniken entwickelte.

3. Während seiner künstlerischen Laufbahn hat er Dutzende junger Künstler beeinflußt, die entweder direkt bei ihm lernten oder seine Werke studierten – viele von ihnen haben versucht, in die Fußstapfen des „Meisters" zu treten. Elvgrens Einfluß beschränkte sich nicht auf Künstler, die explizit in der Tradition der Pin-up-Illustration standen, er wirkte sich auch auf die Karriere des Pop-art-Künstlers Mel Ramos aus (Abb. 1 und 2, S. 10). Der Maler John Kacere, ein Fotorealist, kannte Elvgren persönlich und verdankt ihm wesentliche Impulse (Abb. 6, S. 11). Kacere berichtet: „Als ich Gil fragte, ob ich in seinem Studio arbeiten könne, antwortete er, er glaube nicht, daß es das richtige für mich sei, Illustrator oder Pin-up-Zeichner zu werden. Ich solle mir meinen Weg vielmehr in der bildenden Kunst suchen."

4. Nach der Veröffentlichung des Buches *The Great American Pin-Up*, war die Resonanz auf Elvgrens Arbeiten überwältigend. Häufig wurde auch die Bitte an uns herangetragen, mehr aus seinem Werk zu publizieren. Es war immer schon unser Wunsch gewesen, diesem großen Künstler die verdiente Ehrung zuteil werden zu lassen, und die Neugier unserer Leser spornte uns nur noch mehr an.

5. Art Amsie, ein Freund von Charles G. Martignette und mir, war viele Jahre lang eng mit Elvgren befreundet. Art führte uns nicht nur in Elvgrens Werk ein, sondern stellte uns aus seinem Besitz auch viele von dessen Arbeiten zur Verfügung. Art war auch ein Freund des berühmten amerikanischen Pin-up-Models Betty Page, das er in den 50er Jahren fotografiert hatte (Abb. 3, S. 10). In den 60er und 70er Jahren betrieb Art eine Galerie namens „The Girl Whirl", die sich damals als einzige auf Pin-up-Kunst spezialisiert hatte. Als Elvgren an Krebs starb, versprach Art ihm, alles Menschenmögliche zu tun, damit Elvgrens Traum von einer Künstler-Monographie eines Tages in Erfüllung ginge. Als ich Art vor vielen Jahren traf, sagte ich ihm zu, daß es uns in Teamwork gelingen könnte, dieses Versprechen einzulösen: Nun, Gil, Art und ihr Elvgren-Liebhaber aus aller Welt, dies sei hiermit geschehen!

Es hat ungefähr zehn Jahre gedauert, das Bildmaterial für dieses Buch zusammenzutragen. Wir zeigen, so glaube ich, fast 98 Prozent aller Pin-up- und Glamourzeichnungen, die Elvgren in seiner ungemein produktiven Karriere geschaffen hat. Bei der Auswahl waren mir die Listen und Copyrightinformationen, die Art Amsie zusammengetragen hatte, eine große Hilfe, ebenso wie sein wertvolles persönliches Wissen. Zusätzlich erhielt ich sowohl von Earl Beecher als auch von Michael Stapleton Listen mit Titeln und Beschreibungen der einzelnen Werke. Direkte Informationen bekam ich in Interviews mit Joyce Ballantyne, einer Künstlerkollegin Elvgrens, und mit Myrna Hansen, die für Elvgren – und so auch für *Sitting Pretty* (Abb. 4 und 5, S. 11) in Glamourcon, Los Angeles – Modell saß. Janet Rae, die Tochter von Elvgrens Nachbarn, diente ihm als Modell für viele seiner besten Gemälde, einschließlich *Inside Story*, *Well Built*, *Puppy Love* und *Sheer Comfort*; unsere Freundin Marianne Phillips hat sie ausführlich interviewt. Marianne handelt mit Pin-up-Devotionalien, wichtiger noch, sie hat viele Jahre damit verbracht, die Karrieren und Werke der bedeutenden Pin-up-Künstler zu dokumentieren. Sie ist eine unerschöpfliche Informationsquelle zu Zoë Mozert, Joyce Ballantyne und natürlich Gil Elvgren. Wir waren sehr glücklich, daß sie ihr Wissen so bereitwillig mit uns geteilt hat.

Unsere wichtigste Quelle war natürlich Brown & Bigelow, der größte Kalenderverlag, den ich kenne. Die Firmeninhaber William Smith sen. und William Smith jun. sowie Teresa Roussin, die für Lizenzen und das Archiv zuständig ist, haben uns nicht nur ihre Unterlagen und viele Fotografien zur Verfügung gestellt, sondern bereitwillig ihre Erinnerungen mit uns geteilt und unsere endlosen Fragen beantwortet. Ihre nicht nachlassende Unterstützung und Ermutigung haben wesentlich zum Gelingen des Buches beigetragen. Angesichts der ständigen Nachfrage nach Elvgren-Bildern freuen wir uns mit dem Verlag auf viele weitere Nachdrucke und Lizenzen von Pinups aus den Archiven von Brown & Bigelow.

An den Anfang unseres Buches haben wir die Lebensgeschichte des Künstlers gestellt, gefolgt von einer Werkschau. Anders als im Fall von Künstlern, die ihre Arbeiten primär für die Ausstellung in Galerien und den Verkauf anfertigen – und sie aus diesem Grund akkurat datieren, betiteln und katalogisieren – waren Elvgrens Zeichnungen als Reproduktionsvorlagen gedacht. So ist es beispielsweise nicht ungewöhnlich, daß ein 1948

fertiggestelltes Gemälde den Copyrightvermerk 1949 trägt, aber nicht vor 1951 oder sogar noch später abgedruckt wurde. Da Elvgrens Arbeiten nur selten datiert sind, konnten wir nur eine ungefähre zeitliche Einordnung leisten, die auf dem Malstil, dem Modell, der dargestellten Szene, dem Copyright oder der Datierung der auf der Anzeige beworbenen Produkte basiert. Aufgrund dieser Hinweise konnten wir das Entstehungsjahr in vielen Fällen exakt angeben, und auch unsere Schätzungen haben nur eine Marge von einem oder zwei Jahren. In den einzelnen Kapiteln werden Elvgrens Illustrationen in chronologischer Folge vorgestellt: Auf seine ersten Jahre bei der Louis F. Dow Company (1937–1944) folgen drei Kapitel über seine Zeit bei Brown & Bigelow (die 40er und die 50er Jahre sowie die Jahre 1960 bis 1972) und seine Werbeaufträge einschließlich der Arbeiten für NAPA und Sylvania (ebenfalls für Brown & Bigelow), die im allgemeinen ein Jahr vor der Veröffentlichung des jeweiligen Kalenders entstanden sind, und schließlich diverse Arbeiten, die wir nach bestem Wissen und Gewissen datiert haben.

Ein weiteres Problem stellten die Titel dar. Auch wenn Elvgren selbst hin und wieder einen Titel vorgeschlagen hat, so entsprangen doch die meisten von ihnen der Feder der Redakteure und Werbetexter, die für die Kalenderverlage oder andere Verlagshäuser arbeiteten. Manchmal wurde ein Gemälde unter einem Titel urheberrechtlich geschützt und unter diesem Titel auch als Kalenderabbildung veröffentlicht. Später mag dieselbe Arbeit als Notizblock oder als Notizheft unter jeweils anderen Titeln reproduziert worden sein. Wenn im folgenden nur ein Titel in einer Legende steht, so ist es entweder der urheberrechtlich geschützte Titel oder der einzige Titel, der uns bekannt ist (manche Titel haben sich unter Sammlern eingebürgert). Varianten erscheinen in Klammern nach dem Haupttitel.

Fast alle Arbeiten für Brown & Bigelow hat Elvgren in Öl auf Leinwand im Format 76 x 61 cm ausgeführt. Die Zeichnungen für die Louis F. Dow Company maßen 71 x 56 cm.

Wir haben uns bemüht, für jede abgebildete Arbeit die beste Vorlage ausfindig zu machen. Unglücklicherweise existiert in manchen Fällen nur noch eine schlechte Kopie oder das vergilbte Foto eines alten Kalenders. Dennoch ist es uns in fast allen Fällen gelungen, gute Reproduktionsvorlagen ausfindig zu machen. In etwa 200 Fällen war es uns möglich, die Bilder neu zu fotografieren, da sie sich in unserem Besitz befanden oder noch befinden. Inzwischen tauchen immer mehr Originale auf. Um unser Archiv zu vervollständigen, hoffen wir auf Ihre Mithilfe, indem Sie uns Ihre Wiederentdeckungen mitteilen.

## GIL ELVGREN: LEBEN UND WERK
*Charles G. Martignette*

Gil Elvgren (1914–1980) war der bedeutendste Pin-up- und Glamour-Künstler des 20. Jahrhunderts. Im Lauf seiner beruflichen Karriere, die Mitte der 30er Jahre begann und mehr als 40 Jahre andauerte, wurde er unter Pin-up-Sammlern und -Fans auf der ganzen Welt zum eindeutigen Favoriten. Auch wenn es sich bei dem größten Teil seines Werkes um kommerzielle Auftragsarbeiten handelt, gilt es unter privaten Sammlern, Kunsthändlern, Galerien und Museen zunehmend als „wahre" Kunst. Und in der Tat muß man Elvgren, der ein dreiviertel Jahrhundert lang vor allem als Pin-up-Künstler bekannt war, als einen klassischen amerikanischen Illustrator würdigen, der in vielen verschiedenen Bereichen kommerzieller Kunst arbeitete. Er war immer schon ein Meister im Porträtieren der schönen Weiblichkeit, aber sein Engagement galt keinesfalls nur den Kalender-Pin-ups.

Elvgrens Ruhm resultiert zum einen zweifelsohne aus seinen mittlerweile legendären Pin-ups, die er in einem Zeitraum von 30 Jahren ausschließlich für den in St. Paul, Minnesota, ansässigen Kalenderverlag Brown & Bigelow gemalt hat. Aber auch die Tatsache, daß er mehr als 25 Jahre für Coca-Cola Reklamebilder malte, trug dazu bei, daß er sich als einer der großen Illustratoren auf diesem Gebiet etablieren konnte. Während sich unter seinen Arbeiten für Coca-Cola auch einige „Elvgren Girl"-Pin-ups finden, zeigen doch die meisten von ihnen typisch amerikanische Familien, Kinder und Teenager – gewöhnliche Menschen, die alltäglichen Beschäftigungen nachgehen. Während des Zweiten Weltkriegs und des Koreakriegs malte er

für Coca-Cola sogar Kriegsszenen. Wie seine berühmten Pin-ups für Brown & Bigelow, gelten auch seine Coca-Cola-Anzeigen mittlerweile als Ikonen des amerikanischen Lebensstils.

Elvgrens Coca-Cola-Sujets porträtieren den amerikanischen Traum eines gesicherten und bequemen Lebens, während er in seinen bekannten Illustrationen für Geschichten in Zeitschriften oft zeitlose Momente festhielt, die die Hoffnungen, Ängste und Freuden der Leser widerspiegelten. Solche redaktionellen Aufträge erhielt er in den 40er und 50er Jahren von etablierten amerikanischen Zeitschriften wie *McCall's, Cosmopolitan, Good Housekeeping* und *Woman's Home Companion*.

In der Werbebranche zählte er neben Coca-Cola so bekannte amerikanische Unternehmen wie Orange Crush, Schlitz Beer, Sealy Mattress, General Electric, Sylvania und Napa Auto Parts zu seinen Kunden. Seine Anzeigen für Brown & Bigelow und Coca-Cola sowie seine Arbeiten für andere landesweit agierende Werbekunden und die Illustrationen für Magazinbeiträge machten Elvgren zu einem überaus vielbeschäftigten Künstler, der zumeist ein Jahr im voraus ausgebucht war.

Elvgren war nicht nur ein talentierter Maler und Werbegrafiker, sondern auch ein professioneller Fotograf: Im Umgang mit der Kamera war er genauso geschickt wie mit dem Pinsel. Und schließlich – als weiterer Beweis seiner erstaunlichen Energie und seines ungewöhnlichen Talents – war er vielen Studenten ein respektierter, sogar verehrter Lehrer. Viele von ihnen wurden selbst berühmt, was sie nicht zuletzt Elvgrens persönlicher Unterweisung und Förderung verdankten.

Lange bevor er 1933 zum ersten Mal eine Kunstklasse besuchte, war Elvgren von den frühen Pretty-Girl-Illustratoren beeinflußt. „Pretty Girl" nannte man die im Glamour-Stil gehaltenen Frauendarstellungen in seriösen Zeitschriften. Zu den Hauptvertretern des Genres zählten Charles Dana Gibson, Howard Chandler Christy, Harrison Fisher und James Montgomery Flagg sowie deren Nachfolger, die romantischen Glamour-Künstler McClelland Barclay, Haddon H. Sundblom, Andrew Loomis, Charles E. Chambers und Pruett Carter. Elvgren hatte bereits früh damit begonnen, einzelne Seiten oder die Titelblätter unzähliger Zeitschriften mit Illustrationen von Künstlern, die ihn interessierten oder die er bewunderte, zu sammeln. So kam im Lauf der Zeit ein umfangreiches Archiv zustande. Woche um Woche, Monat um Monat wurde es für Elvgren zu einem Ritual, alle größeren Zeitschriften durchzublättern und Abbildungen von Werken der Künstler, die er bewunderte, auszuschneiden. Diese Ausschnitte sollten später nicht nur seinen Zeichenstil, sondern auch seinen Zugang zu speziellen Themen beeinflussen.

Um Gil Elvgrens Fertigkeiten richtig würdigen zu können, muß man einen kurzen Blick auf die beiden Künstlergruppen werfen, deren Einfluß vor allem zu Beginn seiner Karriere in seinem Werk spürbar ist. Wenn im folgenden sein Leben und Werk chronologisch vorgestellt wird, werden immer wieder die Werke der anderen Künstler, die ihn inspirierten, hinzugezogen. Zusätzlich werden auch die Künstler gezeigt, die versuchten, seinen Stil nachzuahmen. Einige unter ihnen waren ehemalige Studenten, andere Freunde, während wieder andere ihn nie kennengelernt hatten und seine Illustrationen – genau wie er – aus Magazinen ausschnitten und sammelten. Durch die Darstellung des Kontextes, der für das Verständnis von Elvgrens Œuvre von Bedeutung ist, entsteht ein informatives, abgerundetes und hoffentlich auch unterhaltsames Bild des Menschen und Künstlers Gil Elvgren.

Felix Octavius Carr Darley (1822–1888) gilt unter Kunsthistorikern als der erste bedeutende amerikanische Illustrator. Seine Karriere war überaus produktiv. Zum einen illustrierte er für verschiedene Verlage die Bücher der führenden Autoren seiner Zeit, unter ihnen beispielsweise Edgar Allen Poe, Nathaniel Hawthorne und Henry Wadsworth Longfellow, zum anderen war er fester Mitarbeiter bei *Harper's Weekly*. Wichtiger noch, Darley war der erste amerikanische Illustrator, der erfolgreich die Führungsrolle der englischen und europäischen Schulen für illustrative Kunst in Frage stellte, die diese bis dahin auf dem Gebiet der kommerziellen amerikanischen Kunst innegehabt hatten.

1853, in dem Jahr, in dem Darley Mitglied der National Academy wurde, kam in Wilmington, Delaware, Howard Pyle zur Welt, der 25 Jahre später als der wahre Vater der amerikanischen Illustration gelten sollte. Pyle war ebenfalls ein überaus produktiver Künstler, Autor vieler berühmter Bücher und Geschichten und schließlich Begründer der Brandywine School, die die nächsten 100 Jahre die amerikanische Illustrationskunst maßgeblich beeinflussen sollte.

Fast alle Illustratoren des 20. Jahrhunderts, deren Stil eher an Malerei denn an Werbegrafik erinnert, waren unmittelbar von den Lehren Howard Pyles (1853–1911) und seiner besten Studenten, Harvey T. Dunn (1884–1952) und Frank Schoonover (1877–1972) beeinflußt.

Elvgren teilte seine Bewunderung für das Grundverständnis von Malerei, wie es die Brandywine School lehrte, mit seinem Freund Norman Rockwell (1894–1978). Die beiden Männer lernten sich 1947 auf der Brown & Bigelow Managers' Convention in St. Paul (Abb. 7, S. 15) kennen und wurden Freunde. Elvgren und Rockwell hatten eines gemeinsam: Beiden gelang es, authentisch wirkende Menschen in absolut glaubwürdigen Kontexten abzubilden. Während Rockwell die Möglichkeit hatte, in seinen Gemälden eine fast unbegrenzte Anzahl von Sujets zu behandeln, genoß Elvgren bei seinen Pin-up-Aufträgen weniger Freiheit. Aber Rockwell nahm schnell die Gelegenheit wahr, Elvgren das zu sagen, was der junge Mann in der Vergangenheit schon oft von anderen Künstlern gehört hatte: daß er seine Arbeiten bewunderte und ihn um seinen Job, die schönsten Frauen der Welt zu zeichnen, beneidete. Ihre erste Begegnung war zugleich der Beginn einer langen Verbindung, die schließlich bei ihren jährlichen Treffen sogar das Teilhaben an den künstlerischen Geheimnissen des anderen einschloß.

Im Amerika des 20. Jahrhunderts ging die Entwicklung der Glamour-Illustration Hand in Hand mit der steigenden Nachfrage nach kommerzieller Kunst, die vor allem aus der Weiterentwicklung und Verbesserung der Drucktechnik resultierte. Die neuen wöchentlich und monatlich erscheinenden Periodika verlangten unablässig nach immer neuen Bildern. Die Zeitschriftenverleger hatten schnell gelernt, daß ihre Magazine sich wesentlich besser verkaufen ließen, wenn das Titelblatt und die einzelnen Beiträge illustriert waren. Zusätzlich erlebten die Vereinigten Staaten zur selben Zeit einen rapiden Bevölkerungszuwachs, der die Nachfrage nach Zeitungen und Zeitschriften ebenso wie den Wunsch nach qualitativ hochwertigen Arbeiten steigerte.

Zehn Jahre nach der ersten Veröffentlichung von Pyles Illustrationen erschien 1887 in den USA das erste echte Pin-up. Diese idealtypische Schöpfung, „Mädchen von nebenan" und Traumfrau zugleich, stammte aus der Feder des aus Boston, Massachusetts, stammenden Charles Dana Gibson (1867–1944). Schnell avancierte das „Gibson Girl", zumeist eine Tuschfederzeichnung, zum Liebling der ganzen Nation. Ihr Bild fand sich in allen Magazinen, einschließlich *Scribner's*, *Century* und *Harper's Weekly*. Der Erfolg war so überwältigend, daß man Zeichnungen des „Gibson Girl" bald sowohl auf den Titelblättern wie auch als doppelseitiges Centerfold im Innenteil von so populären Zeitschriften wie *Life* und *Collier* sah. Die einzelne Frau der frühen Zeichnungen wurde bald um eine Gruppe von Frauen, dann um einen Mann und eine Frau oder gemischte Gruppen erweitert. Die männliche Figur wurde als „Gibson Man" bekannt und von den Fans des „Gibson Girl" enthusiastisch begrüßt.

1900 hatte das „Gibson Girl" (zusammen mit dem „Gibson Man") internationale Berühmtheit erlangt, überall in den Vereinigten Staaten und in Europa stieß man auf ihr Ebenbild. Gibsons Zeichnungen wurden als Drucke, Lithographien, Kalenderblätter, Centerfolds und Zeitschriftencover reproduziert und fanden sich auf zahlreichen Alltagsgegenständen wie etwa Kartenspielen, Notizblöcken, Fächern und Taschentüchern. Sogar Porzellanteller, Schmuckkästchen, Schirme und Tapeten zierte ihr Konterfei. Zwischen 1898 und 1900 wurden bei *Harper's* und *Scribner's* fünf gebundene Kunstbücher mit Gibsons Zeichnungen verlegt. Das letzte von ihnen, betitelt *A Widow and Her Friends* (Eine Witwe und ihre Freunde), zeigte auf dem Umschlag eine Zeichnung, die der Künstler als Inbegriff des „Gibson Girl" (Abb. 9, S. 15) bezeichnet hatte.

Das „Gibson Girl" bezauberte mehr als eine Generation Amerikaner. Sein Erfolg begann im frühen Art déco und hielt bis in die Roaring Twenties an, wo es als „Flapper" („Flapper" war die amerikanische Bezeichnung für emanzipierte Frauen) Jitterbug und Charleston tanzte. Gibson paßte Stil und Manier seiner Zeichnungen ebenso wie die modischen Accessoires der Zeit an, um ein neues Publikum zu gewinnen (Abb. 12, S. 15).

Als nächstes betrat das gefeierte „Christy Girl" die Szene. Von Howard Chandler Christy (1873–1952) ins Leben gerufen, erfreute es sich bald großer Popularität, die der des „Gibson Girl" gleichkam. Der „Christy Man" folgte zwangsläufig, allein schon, weil der Künstler so viele romantische Liebesszenen ersann.

Christys Karriere als hauptberuflicher Illustrator begann mit Titelbildern für führende Zeitschriften (Abb. 8, S. 15), denen bald Buchillustrationen folgten (Abb. 10, S. 15). Sogar so berühmte Romane wie James Fenimore Coopers *Der letzte Mohikaner* waren mit Szenen, die das „Christy Girl" zeigten, illustriert. Christy lebte und arbeitete im New Yorker Hotel des Artistes, wo er auch ein Studio unterhielt. Auf die Wände des Hotelrestaurants malte er eine bahnbrechende Serie lebensgroßer, sinnlicher Akte, die auch heute noch Besucher aus aller Welt anziehen. 1921 zog er sich auf dem Gipfel seines Erfolgs aus dem Geschäftsleben zurück, um sich ganz dem Porträtzeichnen zu widmen. Seine berühmteste Auftragsarbeit, ein 1932 fertiggestelltes Porträt von Amelia Earhart in Öl auf Leinwand (Abb. 11, S. 15), war am 1. Februar 1933 Titelbild der Zeitschrift *Town & Country*. Dies war die einzige Ausnahme von Christys Entscheidung aus dem Jahr 1921, seine Werke nicht kommerziell zu verwerten. Im Januar 1936 wurde das Porträt in der Ausstellung „Portraits of Celebrities" im Baltimore Museum of Art gezeigt, wo Amelia Earharts Bild zwischen Porträts von Will Rogers und William Randolph Hearst hing. Kurz danach verschwand es und wurde erst vor kurzem wieder entdeckt; hier ist es zum ersten Mal seit mehr als 60 Jahren zu sehen.

Harrison Fisher (1875–1934) war ein weiterer Künstler, der wie Gibson und Christy so berühmt wurde, daß seine „Geschöpfe" seinen Namen trugen. Sein „Fisher Girl", das mit den Kreationen von Gibson und Christy rivalisierte, wurde um 1898 zum ersten Mal in der Zeitschrift *Puck* veröffentlicht. In den ersten beiden Jahrzehnten des 20. Jahrhunderts malte Fisher alle Titelseiten für *Cosmopolitan* (Abb. 13, S. 16) – eine prestigeträchtige Aufgabe. Schließlich beschloß er (genau wie Christy) sich ganz auf das Porträtzeichnen und andere Staffeleibilder zu beschränken. Tatsächlich war diese Haltung auch für zukünftige Generationen charakteristisch: Nachdem sie auf kommerzieller Ebene den größtmöglichen Erfolg erreicht hatten, sehnten sich die Werbezeichner nach Akzeptanz in der bildenden Kunst. Das Porträtzeichnen schien ihnen der beste Weg zu sein, um die ersehnte Anerkennung seitens der Museen, Kritiker und Kunstszene zu erlangen. (Unglücklicherweise waren viele der Künstler zu dem Zeitpunkt, als ihre kommerzielle Karriere endete, nicht mehr auf dem Höhepunkt ihrer künstlerischen oder körperlichen Fähigkeiten.)

Gil Elvgren hatte das Werk dieser frühen klassischen Glamour-Künstler genau studiert, denn der Gibson-Christy-Fisher-Clan hatte die Basis für alle späteren Glamour- (und Pin-up-) Bilder geschaffen. Ein anderer Künstler, dem Elvgren nacheiferte, war John Henry Hintermeister (1870–1945). Auch wenn in seinem Werk hauptsächlich amerikanische Themen dominierten, so schuf er jedoch auch eine Reihe sinnlicher Pin-up- und Glamour-Gemälde für Kalenderpublikationen (Abb. 14, S. 16).

Der letzte unter den großen frühen amerikanischen Illustratoren, der sowohl Gil Elvgren als auch Norman Rockwell beeinflußte, war J. C. (Joseph Christian) Leyendecker (1874–1951). Rockwell verehrte Leyendecker und bezeichnete ihn in seiner Autobiographie als sein Vorbild, seinen Mentor und seine Inspirationsquelle. Am frühen Abend ging Rockwell oft nach Downtown New Rochelle, nur um Leyendecker bei seiner Rückkehr aus seinem Studio in Manhattan dem Zug entsteigen zu sehen. Jahre später, als auch Rockwells Karriere zu genau so einer Leyendeckerschen Erfolgsgeschichte geworden war, wurden die beiden zu Freunden. Elvgrens Bewunderung für Leyendecker datierte aus der Zeit, als er Klassen an der Chicago Academy of Art belegt hatte. Gelegentlich stattete er dem Art Institute einen Besuch ab, um Leyendeckers frühe Zeichnungen zu sehen, die dort ausgestellt waren.

Leyendeckers Karriere begann um 1895, als er den Auftrag für die Titelseite eines Modekatalogs erhielt. Seine Zeichnung für diese Arbeit *Art in Dress – Fall and Winter* (Die Kunst, sich zu kleiden – Herbst und Winter; Abb. 15, S. 16) ist ein außergewöhnlich seltenes Beispiel für die Umsetzung des Art-déco-Stils in die Darstellung eines jungen, schönen und überaus modischen jungen Paares. 1899 erlebte Leyendecker die Veröffentlichung seines ersten Covers für *The Saturday Evening Post*, die gleichzeitig der Beginn einer nahezu lebenslangen Verbindung zwischen dem Künstler und der Curtis Publishing Company war. Die besten seiner mehr als 300 *Post*-Titelblätter, die verspielt und kapriziös sind, entstanden Mitte bis Ende der 30er Jahre (Abb. 16, S. 16).

Nach dem „Gibson Man" kreierte Leyendecker Amerikas zweiten berühmten Pin-up-Mann, den „Arrow Collar Man" (wörtl. Pfeilkragenmann), der in den 20er und 30er Jahren für die Hemden des Herrenausstatters Cluett

Peabody and Company warb. Leyendeckers modisch gekleideter und gutaussehender Held faszinierte die amerikanischen Frauen dermaßen, daß bei der Werbeagentur der Firma Woche für Woche Hunderte Heiratsanträge per Post eingingen. Obwohl Leyendeckers Bilder zumeist in Werbekampagnen für Herrenmode erschienen (Abb. 19, S. 17), „schmuggelte" er immer gerne ein hübsches Mädchen in seine Arbeiten. Seine legendäre Anzeigenkampagne für die Herrenbekleidungsfirma Hart, Schaffner and Marx (Abb. 17, S. 17) konnte es in bezug auf den Verkaufserfolg und die öffentliche Popularität mit dem „Arrow Collar Man" aufnehmen.

Elvgren und Rockwell bewunderten in Leyendeckers Werk zwei charakteristische Fertigkeiten, über die praktisch kein anderer Künstler oder Illustrator der Ära verfügte. Zum einen bedeckte Leyendecker beim Malen nicht die ganze Leinwand mit Farbe und bezog die freien weißen Flächen in die Komposition ein. Viele andere Künstler versuchten – allerdings vergeblich –, diesen speziellen Malstil zu kopieren. Zum anderen war Leyendecker ein ausgeprägt grafischer Designer, der seine Bilder fast auf dieselbe Art und Weise „entwarf" wie ein Architekt ein Haus. Auch in dieser Beziehung kam ihm kein anderer Künstler gleich. Elvgren und Rockwell durften sich zu den wenigen erfolgreichen Nacheiferern zählen, auch wenn fast jeder Illustrator des 20. Jahrhunderts sich darum bemühte.

Ein weiteres Mitglied im Klub der Glamour-Künstler um Gibson, Christy und Fisher war James Montgomery Flagg (1877–1960). Wie die anderen malte auch er viele Mainstream-Sujets, aber der Schwerpunkt seines Lebenswerkes war die Darstellung schöner amerikanischer Frauen. Flagg war ein Liebling der Medien wie Christy einer war; über beide wurde oft in Zeitungs- und Zeitschriftenartikeln sowie in den Nachrichtenüberblicken in den amerikanischen Kinos berichtet. Auch wenn er wegen seiner klassischen Plakate für die Rekrutierung von Soldaten während des Ersten Weltkriegs legendär wurde (*Uncle Sam – I Want You*), so hatte das „Flagg Girl" doch eine eigene Fangemeinde, zu der auch Elvgren zählte. (Die beiden Künstler sind einander Mitte der 50er Jahre kurz in New York begegnet.) Elvgren zeigte sich von Flaggs souveränem Umgang mit Feder und Tusche, wie es die Darstellung *Garbo and Friends* (Garbo und Freunde; Abb. 18, S. 17) belegt, überaus beeindruckt. Diese Illustration fand als Nachsatz von Susan Meyers *James Montgomery Flagg* (New York: Watson-Guptill, 1974) Verwendung. Obwohl Elvgren selbst nie in dieser Technik arbeitete, bewunderte er Flaggs (und Gibsons) Talent der brillanten Linienführung.

Viele der führenden Illustratoren, die Elvgren zu Beginn seiner Karriere in den späten 30er Jahren direkt beeinflußten, hatten an Howard Pyles Brandywine School studiert; der bedeutendste unter ihnen war Harvey T. Dunn, Pyles Protegé und begabtester Student. Dunn wurde ebenfalls zu einem einflußreichen Lehrer, der eine Mischung aus seiner eigenen und Pyles Philosophie an Hunderte von Künstlern weitergab. Dean Cornwell (1892–1960) war wahrscheinlich der berühmteste unter Dunns ehemaligen Studenten (Abb. 20, S. 18), und sein Einfluß auf die Künstler aus Elvgrens Generation war so groß, daß sie ihn als „Dean of Illustrators" bezeichneten, als Doyen ihres Faches.

Wie wichtig Dunn für Elvgrens künstlerische Entwicklung war, belegt die fast acht Zentimeter dicke Akte mit Ausschnitten von Dunns Zeitschriftenillustrationen und Anzeigenthemen, die Elvgren archiviert hatte. Unter den Unterlagen fand sich auch ein faszinierender *Time*-Artikel vom 9. Juni 1941 über Dunn und eines seiner berühmtesten Gemälde. Der Beitrag zeigt einen sinnlichen (und für die damalige Zeit höchst provokanten) Akt in Frontalansicht, den Dunn 1939 (Abb. 21, S. 18) gemalt hatte, sowie ein Foto des Künstlers, der stolz vor seinem Werk steht. Als Dunns Akt 1941 im Guild Artists Bureau in New York ausgestellt wurde (die Ausstellung trug den Titel „Sexhibition"), so berichtet der Artikel, forderte George Baker, der Direktor der Galerie, das Publikum auf, sein Votum abzugeben: für die beste Begleitung auf einer einsamen Insel sowie in der Wüste, die beste Begleitung überhaupt, das beste Werk und „Whew!". Die Bildlegende in dem *Times*-Beitrag weist die Resultate aus: *Four Bests and a Whew!* (Viermal die Bestnote und ein „Whew"!) – Dunns Gemälde hatte in allen fünf Kategorien gewonnen.

Auch McClelland Barclay (1891–1943) zählte in den 30er Jahren zu den Vorbildern für Elvgren und andere Künstler seiner Generation. In seinen überaus stilisierten Art-déco-Gemälden porträtierte er die „beautiful people" seiner Epoche – am liebsten den weiblichen Teil. Seine bekannte Anzeigenserie für den Zigarettenhersteller Lucky Strike zeigt u. a. Miss America 1932 beim Anzünden ihrer favorisierten Marke (Abb. 22, S. 18). Barclays kraftvolle Illustrationen für Beiträge in *Cosmopolitan* (Abb. 23, S. 18) faszinierten den jungen Elvgren; sie waren in einem fetten, starken Strich ausgeführt und zeigten ungewöhnliche Perspektiven. Seine Kampagne für Fisher Body (General Motors; Abb. 24, S. 18) half, seine Reputation zu festigen. Barclay starb im Zweiten Weltkrieg, als er an Bord eines Schiffes, das torpediert wurde, Kriegsszenen zeichnete.

Ausgehend von den hier dargelegten künstlerischen Einflüssen, die wesentlich für das Verständnis von Gil Elvgren und seines bemerkenswerten Werdegangs sind, werden wir uns in den folgenden Kapiteln Elvgrens Karriere zuwenden.

Im Jahr 1933 – die Weltwirtschaftskrise hatte die USA fest im Griff – brannte ein idealistischer 19jähriger mit seiner High-School-Liebe durch. Es war ein kalter Tag in St. Paul, Minnesota, aber für Gillette A. Elvgren und Janet Cummins schien die Sonne der Liebe. Vor dem jungen Paar lagen vielfältige Abenteuer und Herausforderungen. An kalte Tage war Elvgren gewöhnt, er war am 15. März 1914 an einem frostigen Wintertag geboren worden und hatte seitdem noch viele mehr erlebt, während er in der Umgebung von St. Paul aufwuchs. Seine Eltern, Alex und Goldie Elvgren, hatten in Downtown St. Paul ein Tapeten- und Farbengeschäft. Auf der Neonreklame war der Familienname in einem wie handgeschrieben aussehenden Schriftzug zu lesen, dem die frühe Künstlersignatur Gil Elvgrens sehr ähnlich sah.

Nach Abschluß der University High School wollte der junge Elvgren Architekt werden. Seine Eltern unterstützten ihn uneingeschränkt, weil sie bereits früh seine natürliche Begabung für das Zeichnen erkannt hatten. Als Achtjähriger war er aus der Schule nach Hause geschickt worden, weil er in seine Schulbücher gemalt hatte. Elvgren immatrikulierte sich schließlich an der University of Minnesota für Architektur und Design. Zusätzlich schrieb er sich am Minneapolis Art Institute für Kunstkurse ein. Während eines Sommerkurses im Jahr 1933 erkannte er, daß es seinem Naturell weit mehr entsprach, Kunst zu schaffen als Gebäude oder Reihenhäuser zu entwerfen.

Im Herbst desselben Jahres traf er eine zweite wichtige Entscheidung, eine, die sein Leben in den nächsten 33 Jahren bereichern sollte: Er heiratete Janet Cummins. Erst zwei Monate nach der Eheschließung erzählten die beiden es ihren Familien, die den jährlichen Thanksgiving- und Weihnachtskarten daraufhin eine besondere Anzeige beilegten. Neujahr 1934 beschlossen die Frischvermählten nach Chicago umzusiedeln, weil sich Elvgren dort bessere Möglichkeiten zur Entfaltung seines künstlerischen Talents boten. New York war sicherlich die erste Wahl gewesen, aber Chicago war nicht so weit von zu Hause weg und bot alles, was für Gils weitere künstlerische Ausbildung vonnöten war. Auch war Chicago kleiner und erschien den jungen Leuten deswegen vielleicht weniger bedrohlich als New York.

Unmittelbar nach ihrer Ankunft in Chicago hatte der junge Künstler das Gefühl, die Welt erobern zu können. Als ehrgeiziger und zugleich vorausschauender Mann schwor er sich, so schnell wie möglich so viel wie möglich zu lernen, um bald Geld verdienen zu können. Er schrieb sich an der renommierten American Academy of Art ein. Dort freundete er sich mit Bill Mosby an, einem befähigten Künstler und Lehrer, der zeit seines Lebens stolz darauf war, wie sich Gil unter seinen aufmerksamen Augen entwickelt hatte. In einem Interview, das sich mittlerweile in den Presseunterlagen des Brown & Bigelow Archivs befindet, erinnert sich Mosby an die Zeit im Institut:

Kunst zu unterrichten ist genau so wie Mathematik oder irgend etwas anderes zu lehren. Es gibt bestimmte grundlegende Prinzipien, die jeder lernen kann. Du kannst jedem beibringen, wie man malt und zeichnet, aber du kannst keinen zum Künstler machen.

Als Gil Elvgren an die American Academy kam, zeigte sich, daß er zwar talentiert war, aber auch nicht mehr als die meisten anderen Studenten. Was ihn vom Rest der Studenten unterschied, war seine feste Entschlossenheit, alles 100prozentig zu machen. Hierher kommen viele Studenten, die keine Vorstellung davon haben, was sie wirklich wollen. Gil wußte von Anfang an ganz genau, was er wollte. Mehr als alles andere wollte er ein guter Künstler werden. In zwei Jahren nahm er den Stoff von dreieinhalb Jahren auf. Tagsüber besuchte er seine Kurse, abends hatte er Zusatzklassen belegt und nahm dann noch an den Sommerkursen teil. In den Freistunden und am Wochenende malte er.

Er war ein guter Student und arbeitete härter als alle anderen, die ich je gekannt habe. Er belegte jeden Kurs, in dem er etwas über Malerei lernen konnte. Wir versuchten ihm zu sagen, daß es nicht gut ist, wenn man sich so ausschließlich auf eine Sache konzentriert, und daß er auch Kurse in Anzeigenlayout und Schriftsatz belegen sollte, um einen flexibleren Hintergrund für kommerzielle Arbeiten zu haben. Er gab zwar zu, daß dieser Gedanke etwas für sich hatte und freute sich über das Interesse an seinem Wohlergehen, lehnte aber hartnäckig jede Berührung mit anderen Feldern ab. In den zwei Jahren an der Academy machte er unglaubliche Fortschritte. Er ist zweifelsohne der Erfolgreichste unter unseren ehemaligen Schülern.

Er ist ein guter Zeichner – was das Handwerkliche angeht, können es nur wenige mit ihm aufnehmen. Seine Hände sind das Erstaunlichste, sie sehen überhaupt nicht aus wie die Hände eines Künstlers. Er ist wie ein Football-Spieler gebaut, und ein Bleistift verschwindet fast in seinen Pranken. Aber seine Linienführung und die subtilen Variationen, die er beherrscht, sind nur mit den sensiblen Fähigkeiten eines begabten Chirurgen zu vergleichen.

Von seiner Fähigkeit und seinem Talent abgesehen, ist er auch einer der Nettesten in der Branche. Er trägt immer noch denselben Hut wie damals, als noch niemand den Namen Gil Elvgren kannte.

Nachdem er sich an der American Academy of Art eingeschrieben hatte, gönnte sich Elvgren keine Pause und arbeitete unermüdlich – seinen Abschluß machte er in fast der Hälfte der normalerweise üblichen Zeit. Seine Studienarbeiten waren so gut, daß die Schule sie häufig zur Illustration ihrer Kataloge oder Broschüren verwendete. Während seiner Jahre an der Academy lernte Elvgren einige gleichgesinnte Künstler kennen, die Freunde fürs Leben wurden. Einige von ihnen bildeten ein informelles Netzwerk, dessen Mitglieder sich gegenseitig bei ihrem beruflichen Fortkommen unterstützten. Unter ihnen waren Harold Anderson, Joyce Ballantyne, Al Buell, Thornton Utz und Coby Whitmore, die alle entscheidend von Elvgren beeinflußt worden sind. Bereits in diesem frühen Stadium seiner Entwicklung staunten seine Künstlerkollegen angesichts seiner Kunstfertigkeit, der Art, wie seine Hände ein Bild auf die Leinwand zauberten.

An diesem Punkt seiner Karriere hatte Elvgren noch kein einziges Bild verkauft oder einen Auftrag erhalten, aber er fühlte, daß seine Zeit schon sehr bald kommen würde. Finanziell war die Chicagoer Zeit für die Elvgrens eine Durststrecke, doch die immensen Fortschritte, die Elvgren machte, entschädigten sie für den Geldmangel.

1936 entschlossen die Elvgrens sich, nach St. Paul zurückzukehren, wo Gil stolz ein eigenes Studio eröffnete. Glücklicherweise erhielt er bald seinen ersten Auftrag: die Gestaltung des Titelblatts für einen Modekatalog, das einen attraktiven jungen Mann zeigt, der sich mit einem flotten doppelreihigen Jackett und sommerlichen weißen Slippern herausgeputzt hat (Abb. 27, S. 20). Die ursprüngliche Arbeit war in Öl auf Zeichenkarton und auf ausdrücklichen Wunsch des Art Directors unsigniert. Elvgren hatte seine Arbeit gerade abgeliefert, als ihn schon der Präsident der Firma anrief, um ihm zu gratulieren und ihm den Auftrag für ein halbes Dutzend weiterer Katalogumschläge zu erteilen. Die ersten Schritte waren getan!

Innerhalb weniger Wochen kam der nächste interessante Anruf. Dieses Mal ging es um einen Werbeauftrag, für den sich Elvgren mit seiner Mappe vorstellen sollte. Es handelte sich, so erfuhr er, um ein Porträt der Dionne-Fünflinge, der franko-kanadischen Schwestern, die in den amerikanischen Medien für eine Sensation gesorgt hatten. Das war der Durchbruch, von dem Elvgren geträumt hatte, auf den er aber erst in einigen Jahren gehofft hatte. Von den schönen Mädchen abgesehen, hatte der Auftrag noch einen weiteren entscheidenden Vorteil: Bei seinem Auftraggeber handelte es sich um Brown & Bigelow, dem größten und bedeutendsten Kalenderverlag der Welt. Die beiden Elvgren-Bilder der Dionne-Fünflinge wurden in den Kalendern für die Jahre 1937 (Abb. 28, S. 20) und 1938 veröffentlicht und waren ein Riesenerfolg. Die Tatsache, daß Brown & Bigelow den Schwestern in einem Jahr Tantiemen in Höhe von 58 097,17 US $ zahlte, spricht für die Popularität der beiden ersten Kalenderbilder Elvgrens. Unnötig zu sagen, daß man bei Brown & Bigelow überaus zufrieden war. Indem er am Anfang seiner Karriere die berühmtesten und beliebtesten jungen Mädchen Amerikas malte, war er zu einem ganz besonderen Illustrator geworden und hatte quasi über Nacht kommerziellen Erfolg.

Anfang 1937 trat Brown & Bigelows größter Konkurrent, die Louis F. Dow Calendar Company, die ihren Sitz ebenfalls in St. Paul hatte, an Elvgren heran. Ihr Art Director bat Elvgren, eine Pin-up-Serie zu zeichnen – ein Auftrag, den Elvgren begierig annahm. Der junge Künstler konnte sein Glück kaum fassen: Er hatte nicht nur, kaum daß er sein Studio eröffnet hatte, schon bedeutende Aufträge erhalten, sondern auch noch das Privileg, schöne Frauen malen zu dürfen und sein Werk in großer Auflage in Kalendern zu veröffentlichen. Elvgren wußte nicht, daß die Dow Company seine Arbeiten auch in anderen Formaten vertrieb: auf Notizblöcken, Löschpapier, Guckkastenbildern, Streichholzschachteln und Spielkarten sowie als Broschüren mit einem Elvgren-Pin-up auf dem Umschlag und einem Dutzend Elvgren-Drucken im Format 20 x 25 cm im Innenteil.

Als Elvgren 1944 die Louis F. Dow Company verließ, um für Brown & Bigelow zu arbeiten, stellte die Firma einen Künstler ein, dessen Aufgabe darin bestand, Elvgrens Pin-ups teilweise zu übermalen; so konnte die Louis F. Dow Company die Bilder ein zweites Mal verwerten, ohne Elvgren dafür zu honorieren. Glücklicherweise wählte Dow für diese Aufgabe Vaughan Alden Bass aus, der seine Aufgabe kompetent meisterte und großen Respekt vor Elvgrens Talent hatte. So übermalte Bass im allgemeinen nur die Kleidung oder den Hintergrund und ließ die Figuren (Gesicht, Hände und Füße) unangetastet. Ein gutes Beispiel für die Arbeit von Bass ist die übermalte Version von Elvgrens *A Perfect Pair* (Ein perfektes Paar; Abb. 151, S. 64) im Vergleich mit dem Bild, das Dow in einer Serie von Porträts, einschließlich eines Kalenders, einer Broschüre mit zwölf Drucken, einem Guckkastenbild und einer Streichholzschachtel (Abb. 152, S. 64) veröffentlicht hatte.

1938 erhielt Elvgren seinen ersten Auftrag für einige große Displays, die in Läden aufgestellt wurden und Männer und Frauen zeigten: Mehr als 6500 seiner nahezu lebensgroßen Pin-ups für Royal Crown Soda (Abb. 25 und 26, S. 20) wurden an Lebensmittelgeschäfte in den ganzen USA verteilt. Seine Wand-Displays, die den großväterlichen Typ zeigten, der als „Toasting Scotsman" bekannt wurde, hatte er für die Frankfort Distilleries of Louisville, Kentucky, entworfen; die Herstellung übernahm die Mattingly and Moore Company. 1938 war noch in einer ganz anderen Hinsicht ein besonderes Jahr für Gil und Janet Elvgren: Die stolzen Eltern bekamen ihr erstes Kind, Tochter Karen.

In den nächsten beiden Jahren arbeitete Elvgren an verschiedenen Werbeaufträgen sowie Illustrationen für einige Zeitschriften und natürlich an seinen Pin-ups für die Louis F. Dow Company. Angesichts des phantastischen Erfolgs, den er in seinem Beruf hatte, und des privaten Glücks, als welches die Elvgrens ihr Kind empfanden, überlegten sie, wie sie ihre Zukunft am besten gestalten sollten. Die meisten Aufträge erhielt Elvgren aus Chicago und New York. Es bestand kein Zweifel mehr daran, daß es von Vorteil wäre, in eines der beiden großen Zentren der Kunst überzusiedeln. Wie schon zuvor fiel ihre Wahl auch diesmal auf Chicago, und die dreiköpfige Familie bereitete sich auf den Umzug vor.

Kurz nach seiner Ankunft in „Windy City" 1940 schloß Elvgren einen Vertrag mit dem berühmten Stevens/Gross Studio. Dort traf er den Mann, der sein wahrer Mentor werden sollte: Haddon H. Sundblom (1899–1976). Die beiden Männer wurden enge Freunde. Sundbloms Einfluß auf Elvgrens künstlerische Entwicklung war enorm. Der Ältere war immer schon Elvgrens Idol gewesen. Elvgren hatte, lange bevor sie sich persönlich begegneten, einen ganzen Aktenordner mit Zeitungsausschnitten von Sundbloms Arbeiten angelegt. Es handelte sich dabei zumeist um Illustrationen zu Zeitschriftenartikeln, aber auch die berühmten Coca-Cola-Anzeigen (Abb. 30, S. 21) waren vertreten. Sundblom führte seinen Freund Elvgren bei der Coca-Cola Company ein, und bald war Elvgrens Coca-Cola-Werbung neben der von Sundblom an Zeitungskiosken, auf Reklametafeln und Kalendern zu sehen.

Sundblom und Howard Stevens hatten ihr Studio, das später den Namen Stevens/Gross trug, bereits 1925 gemeinsam mit ihrem Freund Edwin Henry eröffnet. Elvgren bewunderte den Malstil aller drei Künstler, aber Sundblom beeindruckte ihn ohne Zweifel am meisten. Als die Familie Elvgren sich in Chicago niederließ, arbeitete Sundblom gerade an einer Anzeigenkampagne für die Cashmere Bouquet Soap Company (Abb. 31, S. 21), die in den gesamten Vereinigten Staaten erschien. Sundblom hatte für diesen Markt bis dahin nur wenige Pin-ups und Glamour-Bilder ausgeführt, aber deren Erfolg war durchschlagend gewesen. Meistens trugen seine Pin-ups seinen Namen und seine Signatur (Abb. 29 und 32, S. 21). Nur wenn das

Pin-up absichtlich provozierend sein sollte (das Model Dessous oder ein allzu durchscheinendes Material trug; Abb. 33, S. 22), signierte Sundblom seine Zeichnungen nicht. In solchen Fällen entschied sich der Verleger, zumeist war das Louis F. Dow, für Sundbloms Pseudonym Showalter.

Als sich ihre Freundschaft gefestigt hatte, machte Sundblom Elvgren mit Andrew Loomis (1892–1959) bekannt, der ebenfalls zu Elvgrens frühen Vorbildern zählte. Elvgren bewunderte Loomis' Glamour-Pin-ups (Abb. 34, S. 22) ebenso wie seine mehrfach preisgekrönten Illustrationen für Stories in Magazinen (Abb. 35, S. 22), die brillant konzipiert und ausgeführt waren. Loomis unterrichtete ebenfalls an der American Academy of Art, so daß sie einander ohnedies über kurz oder lang kennengelernt hätten. Nach der Begegnung mit Loomis erklärte Elvgren sich im Herbst 1940 bereit, Abendkurse an der Academy zu geben.

Earl Gross und Howard Stevens stimmten beide mit Sundblom darin überein, daß Elvgren der perfekte Kandidat sei, um einen großen Teil der Werbeaufträge für Coca-Cola zu übernehmen, die ihr Studio für die in Atlanta ansässige Firma produzierte. Die erste seiner Werbeanzeigen für Coca-Cola war wohl einer der Meilensteine in Elvgrens Karriere und der Beginn einer 25 Jahre währenden Zusammenarbeit. Heute gelten diese Werbeplakate Elvgrens als wegweisend in der Geschichte der amerikanischen Illustration. Als erstes zeichnete Elvgren die Vorlage für ein ausgestanztes, aufrecht stehendes Display für eine amerikaweite Werbekampagne (Abb. 36, S. 23). Der Art Director und die Verantwortlichen bei Coca-Cola reagierten auf diesen wie auch auf die folgenden Entwürfe Elvgrens ausgesprochen enthusiastisch.

Seine erste Reklametafel für Coca-Cola (Abb. 37, S. 23) nutzte er in seiner Klasse an der Academy of Art, um die wesentlichen Merkmale des Anzeigendesigns zu beleuchten. Er hoffte, seine Studenten damit beeindrucken zu können, daß sie dieses Bild bald als gigantische Reklametafel an den Highways würden sehen können. Für die Reproduktion wurde das Bild zunächst in 24 Felder geteilt, die dann später wieder zu einer riesigen Reklametafel zusammengesetzt wurden. Besonders stolz war Elvgren auf ein Coca-Cola-Girl, das er für eine ganzseitige Zeitschriftenwerbung gemalt hatte – er bat sogar um die Rücksendung des Originals (Abb. 38, S. 23); später schenkte er es seinem Freund Al Buell.

Unmittelbar nach der Bombardierung von Pearl Harbor gab General Electric Elvgren einige Anzeigen für ihre Kampagne zur Unterstützung des Krieges in Auftrag. Die erste Anzeige (Abb. 44, S. 24), die im Juni 1942 ganzseitig in Good Housekeeping (Abb. 45, S. 24) veröffentlicht wurde, trug die Bildunterschrift „She Knows What Freedom Really Means" (Sie weiß, was Freiheit wirklich heißt) und zeigte ein stolzes „Elvgren Girl" in der Uniform des motorisierten Rot-Kreuz-Korps. Bei Eintritt der USA in den Zweiten Weltkrieg hatte Elvgren bereits unzählige seiner Pin-ups veröffentlicht. Sie waren auf Millionen von Anzeigen für Spezialitätenprodukte zu sehen, ebenso auf Kalendern in allen Formaten und Größen. Die Louis F. Dow Company entwickelte ein raffiniertes Verfahren zur Unterstützung der Truppen: Sie verpackte Elvgrens kleine Pin-up-Broschüren (Abb. 40, S. 24) so, daß sie ohne Umschlag an die in Übersee kämpfenden Truppen verschickt werden konnten. Die Versandaktion erwies sich als unglaublicher Erfolg.

Auch an der Heimatfront war die Popularität von Elvgrens Pin-ups für die Louis F. Dow Company ungebrochen. Bei Großveranstaltungen wurden seine Kalenderdrucke gegen Kriegsspenden verkauft oder versteigert. Männer und Frauen entspannten sich bei einem Laubsägepuzzle, das ein Elvgren Pin-up (Abb. 41, S. 24) zeigte. Elvgrens erfolgreichstes und von der Louis F. Dow Company am häufigsten verkauftes Bild hieß A Perfect Pair, gefolgt von The High Sign (Ein unübersehbares Zeichen; Abb. 42, S. 24). Das letztgenannte war so erfolgreich, daß der Illustrator Vaughan Alden Bass, der in den Kriegsjahren zur Louis F. Dow Company gestoßen war, darum gebeten wurde, dieses Bild für eine Zweitverwertung zu retuschieren (Abb. 43, S. 24).

Für die Daheimgebliebenen, deren Nachbarn, Freunde, Männer oder Geliebte in der Armee waren, brachten die Zeitungen und Zeitschriften unaufhörlich Geschichten über die Soldaten in Übersee und die Moral in der Truppe. Diese Beiträge waren illustriert mit Schnappschüssen von Soldaten in ihren Unterkünften oder Zelten, und gelegentlich zeigte man die Soldaten auch im Schützengraben während einer Gefechtspause. Ziemlich oft konnte man auf den Fotos Elvgrens Pin-up-Broschüren oder -Drucke erkennen, die an der Wand hingen, auf einen Rucksack geklebt waren oder die ein junger, offensichtlich einsamer Soldat in der Hand hielt. Neben Elvgren besaß nur der Pin-up-Künstler Alberto Vargas, der für die Zeitschrift Esquire arbeitete, eine solche Popularität bei den Soldaten. Elvgrens Leistung ist auch deshalb so erstaunlich, weil seit der Eröffnung seines eigenen Studios erst fünf Jahre vergangen waren. Sicherlich war seine Kunst von der amerikanischen Öffentlichkeit so begeistert aufgenommen worden, weil sie eine Flucht vor der Realität ermöglichte und in diesen dunklen Zeiten des Krieges sogar Trost spendete.

Mit der Geburt von Gil jun. erhielt die Familie 1942 weiteren Zuwachs. Gegen Ende des Jahres begann Elvgren eine Serie von Illustrationen für eine US-weite Anzeigenkampagne von Four Roses, einem Whiskey-Produzenten, der sein Produkt als Bestandteil der Freizeitgestaltung vermarkten wollte. Das erste veröffentlichte Bild (Abb. 46, S. 25) zeigt eine Gruppe junger Männer beim Hochseefischen, wie sie ihre bevorzugte Whiskeymarke genießen. Es folgte eine Szene mit einem Paar, das sich vor einer Skihütte einen Drink genehmigt. Die Originalentwürfe der Four-Roses-Serie hatte Elvgren erstmals seit 1936 nicht in Öl auf Leinwand, sondern in Öl auf Zeichenkarton ausgeführt.

Al Buell, ebenfalls Illustrator und einer von Elvgrens Chicagoer Freunden, arbeitete zu der Zeit, als auch Elvgren dazustieß, ebenfalls für das Stevens/Gross Studio. 1980 habe ich Buell für einen Leitartikel über die amerikanische Pin-up- und Glamour-Kunst im Antique Trader mehrfach interviewt. Er erzählte mir, daß Elvgren immer wieder von drei Künstlern gesprochen hatte, deren Zeitschriftenillustrationen ihn besonders interessierten: Charles E. Chambers, Pruett Carter und John LaGatta. Elvgren hielt Chambers (1883–1941; Abb. 48, S. 25), der gemeinsam mit George Bridgman, dem Vater der modernen anatomischen Zeichnung, studiert hatte, für einen der besten Künstler der 30er Jahre.

Carter (1891–1955) war einer jener Künstler, deren Malstil Elvgren nachzuahmen suchte. Buell sagte, daß Elvgren immer gehofft hatte, einmal bei Carter an der Grand Central School of Art (wo auch Harvey Dunn lehrte) Unterricht nehmen zu können. Aber diese Gelegenheit bot sich ihm nie, da Elvgrens lebhafte Karriere ihm keine Zeit ließ. Carters romantische Illustrationen für Zeitschriften (Abb. 47, S. 25) hatten ihn berühmt gemacht. Buell schickte mir auch ein Blatt, das er sich einst aus Elvgrens Sammlung über LaGatta (1894–1977) entliehen hatte, ein weiterer bedeutender Künstler, der sich auf romantische Szenen zwischen Jungen und Mädchen (Abb. 49, S. 25) spezialisiert hatte. Buell zufolge erachtete Elvgren LaGatta als einen der besten von jenen Illustratoren, die ihre Wurzeln in der bildenden Kunst hatten und die im kommerziellen Bereich arbeiteten. Besonders seine Darstellung weiblicher Schönheit hatte es ihm angetan. LaGattas Illustrationen für Zeitschriftenstories und seine Werbeaufträge betonten oft die sinnlichen Aspekte der Schönheit.

1943 war Gil Elvgrens Terminkalender mit reizvollen Aufträgen prall gefüllt, seine Kinder wuchsen heran, und Janet war zum dritten Mal schwanger. Die Louis F. Dow Company vermarktete und promotete Elvgrens Pin-ups aggressiv. Das Leben ließ sich für den talentierten und gefragten Künstler und glücklichen Familienvater gut an. Aber in den nächsten Jahren sollte sein Erfolg bis dahin ungeahnte Ausmaße annehmen.

1944 bot Brown & Bigelow ihm eine Festanstellung an. Dies bedeutete, daß seine Arbeiten in mehr oder minder direkte Konkurrenz zu denen der anderen Pin-up- und Glamour-Künstler der Firma, der Crème de la Crème, treten würden. Rolf Armstrong, Earl Moran und Zoë Mozert hatten sich bereits als solide Einnahmequellen für das Verlagshaus etabliert, Elvgren hingegen hatte lediglich einige Jahre zuvor die Dionne-Fünflinge für zwei Kalenderproduktionen gemalt.

Während Elvgren noch darüber nachdachte, ob er das Angebot von Brown & Bigelow annehmen sollte, brachte Janet ihr drittes Kind zur Welt – wieder einen Jungen, Drake. Der neuerliche Familienzuwachs hat Elvgren sicherlich bei seiner Entscheidung beeinflußt, denn Brown & Bigelow boten ihm 1 000 US $ pro Bild und ein geschätztes Jahreseinkommen von 24 000 US $. 1944 war das eine Menge Geld. Elvgren zählte damit zu den bestbezahlten Illustratoren Amerikas und stand auch bei Brown & Bigelow unangefochten an der Spitze.

Bevor er sich entschloß, ausschließlich für Brown & Bigelow zu arbeiten, nahm Elvgren von der Joseph C. Hoover and Sons Company of Philadelphia seinen ersten und einzigen Auftrag für ein „Glamour Girl" an. Um keine Probleme mit Brown & Bigelow zu bekommen, stellte er die Bedingung, daß die Hoover Company das Bild unsigniert und nicht unter seinem Namen veröffentlichte. Für dieses mit einem Format von 102 x 76 cm größte Pin-up, das er je gemalt hatte, erhielt Elvgren 2 500 US $. Seine Pin-ups für die Louis F. Dow Company maßen 71 x 56 cm, mit Ausnahme von *Help Wanted!* (Ich brauche Hilfe!; Abb. 116, S. 52), das in dem ungewöhnlichen Format von 84 x 69 cm ausgeführt ist.

Elvgrens Pin-up aus dem Jahr 1945 für die Hoover Company war tatsächlich eher ein Glamour-Girl-Sujet. Unter dem Titel *Dream Girl* (Das Mädchen meiner Träume; Abb. 210, S. 90) wurde es zum meistverkauften Pin-up in Abendrobe, das Hoover jemals produzierte. Es blieb für mehr als zehn Jahre ein fester Bestandteil ihrer gehobenen Linie und fand 1945 auch als Ladendisplay für die Campana Balm Home Dispenser Gift Package Verwendung. Nach diesem schnellen Erfolg des *Dream Girl* bat Hoovers Präsident Elvgren noch um eine Serie von Kalenderzeichnungen, aber zu diesem Zeitpunkt hatte sich Elvgren bereits entschieden, das Angebot von Brown & Bigelow anzunehmen.

Elvgrens Vertrag mit Brown & Bigelow erlaubte es ihm, weiterhin Beiträge in Zeitschriften zu illustrieren sowie seine Anzeigenkampagne für Coca-Cola fortzuführen. Solange sie nicht mit den Interessen seines Hauptauftraggebers Brown & Bigelow kollidierten, durfte er sogar weitere Werbeaufträge annehmen. Und so wurde das Jahr 1945 zu einem wichtigen Wendepunkt in Elvgrens Karriere: Der Vertrag mit Brown & Bigelow leitete das bedeutendste Kapitel seiner langen Erfolgsstory ein, einer, die mehr als 30 Jahre andauern sollte.

Charlie Ward, der Präsident von Brown & Bigelow, der sich um Elvgrens Eintritt in die Firma bemüht hatte, war ein Spaßvogel, dessen Devise „Live hard, play hard, enjoy life" lautete. Elvgren und er gaben ein gutes Gespann ab, und Ward erzählte Elvgren, daß er seinen Namen und sein Werk vermarkten wolle wie niemals zuvor. Ward hielt sein Versprechen und machte Elvgren mit den Vertriebsmitarbeitern der Firma und ihren wichtigsten Kunden bekannt, selbstverständlich mit all den Fanfarenstößen, die einem solchen Star angemessen waren. Elvgrens Name und sein markanter Malstil waren sofort ein Begriff, als Ward erzählte, daß Elvgren der Verantwortliche für die allseits bekannten Coca-Cola-Anzeigen und -Reklametafeln längs der Highways war.

Als Elvgren seine Pin-up-Serien für Brown & Bigelow konzipierte, entschied er sich für Leinwände in der Größe 76 x 61 cm. Dieses Format war um einiges größer als das seiner Pin-ups für die Louis F. Dow Company (71 x 53 cm). Mit Ausnahme einiger Sonderaufträge, die diese Maße überschritten, blieb er in den nächsten Jahren bei all seinen Zeichnungen für Brown & Bigelow jenem Format treu, das er für seinen ersten Auftrag der Firma gewählt hatte.

Während seiner ersten Monate bei Brown & Bigelow im Jahr 1945 (seine ersten Pin-ups wurden allerdings erst 1946 veröffentlicht) war aus der Geschäftsleitung zu hören, daß Ward seinen neuen Künstler explizit um ein nacktes Pin-up gebeten hatte. Elvgren ging enthusiastisch auf das Angebot ein. Er hatte den Ehrgeiz, für Ward das bestverkäufliche Kalender-Pin-up zu malen. Im Format 91 x 76 cm sollte es das größte nackte Pin-up seiner Laufbahn werden. *Gay Nymph* (Die fröhliche Nymphe; Abb. 238, S. 101) zeigt eine wunderschöne nackte Blondine am Strand, die in purpurrotes Mondlicht getaucht und von blühendem Flieder umgeben ist. Die Schöne wurde so bekannt, daß Brown & Bigelow sich beeilte, ein Spielkartenset mit dem Motiv herauszubringen. Es erschien zusammen mit einem zweiten Kartenspiel, dessen nackte Pin-ups von der begabten Zoë Mozert gemalt worden waren. Der Doppelpack hieß *Yeux Doux* (Süße Spiele) und trug den Untertitel „In moderner Übertragung durch Gil Elvgren und Zoë Mozert". Die Kunden konnten ihren Firmennamen auf die Packung drucken lassen. Nicht wenige ließen sich von der Qualität des Sets überzeugen und überreichten es ihren Kunden nur zu gerne als bezauberndes Weihnachtsgeschenk.

Im folgenden Jahr forderte Ward Elvgren erneut auf, einen Akt zu zeichnen. *Vision of Beauty* (Visionen der Schönheit; Abb. 236, S. 100) war von Anfang an ein voller Erfolg. Die Verkaufszahlen reichten an die von *Gay Nymph*

heran, die für Brown & Bigelow einen neuen Standard gesetzt hatten. *Vision of Beauty* präsentierte sich wesentlich konservativer, fast schon wie eine Akt-Serie in der bildenden Kunst. Das entsprechende Doppelkartenspiel trug den Titel „*Mais Oui* [Aber ja] von Gil Elvgren". Zoë Mozert war 1947 nicht mit von der Partie.

Während seiner Laufbahn bei Brown & Bigelow konnte Elvgren nur ein einziges Aktsujet im Jahr malen. In manchen Jahren wollte die Firma sogar keinen einzigen Akt in ihrem Sortiment. Und so malte Elvgren gelegentlich künstlerische Akte nur zu seinem eigenen Vergnügen. Von diesen Ölgemälden existieren heute nur noch wenige, darunter die Darstellung eines wunderschönen asiatischen Models, das sich auf einer Couch in Elvgrens Studio erholt (Abb. 52, S. 27). Das Gemälde aus dem Jahr 1947 malte Elvgren auf Leinwand, die auf Karton aufgezogen ist, im Format 41 x 69 cm.

Einen anderen Akt, der gemeinsam mit dem gerade beschriebenen in Elvgrens Studio hing, hatte er in nur zwei Stunden gemalt (Abb. 54, S. 27). Das Bild zeigt eines von Elvgrens ständigen Models aus den 40er Jahren, das in einem großen und bequemen Sessel in seinem Studio sitzt. Elvgren signierte die 74 x 58 cm große Leinwand mit seinem Namen und fügte den Zusatz „in zwei Stunden gemalt" an. Diese Arbeit, die zwischen 1940 und 1945 entstand, demonstriert die außerordentliche handwerkliche Geschicklichkeit Elvgrens. Nur wenige Künstler vermögen ein Gemälde von solch impressionistischer Brillanz in so kurzer Zeit zu malen.

Im März 1946 wurde in *McCall's* Elvgrens erste doppelseitige Illustration für eine Zeitschriftenstory veröffentlicht. Das Gemälde (Abb. 50, S. 26) ist einer Erwähnung wert, weil hier zum ersten Mal der echte „Elvgren Man" zu sehen war – in romantischer Positur mit einem der schönsten „Elvgren Girls" (Abb. 51, S. 26). Obwohl die Resonanz auf diese für Elvgren neue Form der Darstellung spektakulär war, mußte Elvgren alle großen Zeitschriften enttäuschen. Der Tag hatte nicht genug Stunden, um auch nur einen kleinen Teil der Aufträge, die ihn erreichten, anzunehmen.

Die ersten drei Pin-ups, die Elvgren 1948 bei Brown & Bigelow ablieferte, wurden binnen weniger Wochen nach ihrer Veröffentlichung zu Bestsellern. Eines von ihnen war *He Thinks I'm Too Good to Be True* (Er denkt, ich bin zu gut, um wahr zu sein; Abb. 190, S. 80). Von den Akten einmal abgesehen, war es das erste Bild, das Brown & Bigelow in einem Überformat (76 x 51 cm) als „hanger" (ein großformatiger Kalender, der aus nur einem Blatt besteht) veröffentlichte. Es wurde so populär, daß das Bild bald auch auf einem Kartenspiel reproduziert wurde. 1952 kam es noch einmal als eines von zwölf Kalendermotiven für den „Ballyhoo-Kalender", eine Sonderpublikation, auf den Markt. Der Art Director von Brown & Bigelow, Clair Fry, wählte es auch als Covermotiv (Abb. 53, S. 27). Auf dem Kalenderdeckblatt war die Unterzeile „Limited Edition – 12 Enticing Eyefuls In Full Color!" (Limitierte Auflage – 12 vierfarbige verführerische Augenweiden) zu lesen. Und wieder war es ein Elvgren-Produkt, das erste seiner Art für Brown & Bigelow, das dem Verlagshaus einen unerwartet guten Umsatz bescherte.

Während Elvgrens Aktbilder und Pin-ups sich einer solchen Berühmtheit und hoher Auflagen erfreuten, stand auch Albert Dorne (1904–1965) im Rampenlicht, dessen Laufbahn Elvgren aufmerksam verfolgte. Dorne war der Schöpfer einer Anzeigenserie für die populäre 1015 Wurlitzer Juke Box (Abb. 55, S. 27). Seit 1946 wurden seine Anzeigen jeden Monat ganzseitig in allen führenden amerikanischen Zeitschriften veröffentlicht. In Elvgrens Sammelmappe nahmen sie einen bedeutenden Platz ein, denn er hatte erkannt, daß Dornes Kompositionen und seine Farbwahl für ihre Zeit überaus progressiv waren. Dorne wurde zum Präsidenten der Society of Illustrators gewählt und war Gründer und erster Direktor der berühmten Famous Artists Schools in Westport, Connecticut.

Zwischen 1948 und 1949 stellte Elvgren sein innovatives Talent unter Beweis und entwarf ein „Elvgren Girl" in Form eines Brieföffners, der seriell hergestellt werden konnte. Brown & Bigelow produzierte das Objekt in cremefarbigem Plastik und versandte den Brieföffner in einer Faltschachtel. Die Kunden, die dieses einzigartige Produkt kauften, konnten ihren Firmennamen auf die Schachtel drucken lassen. Elvgren hatte hierfür extra einen Wasserball vorgesehen, den das Mädchen über seinem Kopf hält (Abb. 59, S. 29). Außerdem hatten Brown & Bigelow folgenden Vermerk auf die Packung von Elvgrens „Eye Opener" drucken lassen: „Yes, Sir! Wenn es darum geht anzupacken, wenn ein Auftrag ausgeführt oder etwas erledigt

werden muß, sind wir für Sie da. Und wenn es Zeit ist für ein Lächeln, möchten wir dem sorgenvollen Stirnrunzeln mit etwas Schönem begegnen, denn die Arbeit ohne das Vergnügen macht aus jedem von uns einen Langweiler. Also ... lernen sie Ellen kennen, sie wird Ihnen die Augen öffnen und Ihre Instinkte ansprechen, wenn Sie Ihre Post öffnen. Vergessen Sie nicht, sich an uns zu erinnern, wenn Sie Ellens Dienste in Anspruch nehmen. Behandeln Sie sie gut, sie ist ein klasse Mädchen. Design: Elvgren."

Am Ende des Jahrzehnts war Elvgren der bedeutendste Künstler, der bei Brown & Bigelow unter Vertrag war. Seit seinem Eintritt in die Firma hatte er nicht nur mehr als ein Dutzend überaus erfolgreicher Bilder abgeliefert, sondern auch ein Produkt entworfen, das es noch nie zuvor in ihrem Sortiment gegeben hatte. Er hatte mit seiner Kunst in den Vereinigten Staaten ein großes Publikum erreicht, wobei ihn die Medien tatkräftig unterstützten. Im März 1948 veröffentlichte die Zeitschrift See einen fünfseitigen Artikel mit dem Titel „Eye-Catching Calendars" (Kalender als Blickfang) und legte das Schwergewicht auf Elvgrens Œuvre. Man sah ihn und seinen Studio-Assistenten Ewen Lotten, wie sie eines ihrer Pin-up-Modelle, die 18jährige Pat Varnum, vor einem speziellen Set in Szene setzten. Elvgren hatte es nur für dieses Model für einen einzigen Kalenderauftrag in seinem Studio aufgebaut.

Als nächstes veröffentliche die Zeitschrift U.S. Camera im März 1949 einen weiteren Artikel, in dessen Mittelpunkt wiederum Elvgrens Kalenderarbeiten sowie der künstlerische Prozeß beim Schaffen eines Pin-up-Gemäldes standen. Der Artikel mit dem Titel „An Artist Lights a Model" (Der Künstler leuchtet das Model aus) stellte ausführlich Elvgrens persönliche Vorlieben in bezug auf die Beleuchtung beim Fotografieren eines Models vor. Nur fünf Monate später, im August 1949, widmete ihm eine dritte Zeitschrift, die in den ganzen USA erscheinende Pix, eine Coverstory. Der Beitrag war betitelt „Legs Are Big Business" (Beine sind ein einträgliches Geschäft) und trug den Untertitel „Calendar Artist Elvgren's Sexy Masterpieces Are Big Sellers" (Die sexy Meisterwerke des Kalenderkünstlers Elvgren verkaufen sich gut). Er drehte sich um das Model Candy Montgomery, das für Elvgrens Keeping Posted (Warten auf den Postboten; Abb. 193, S. 81) posierte.

Wegen des phänomenalen Erfolgs, den Elvgrens Pin-ups Brown & Bigelow bescherten, gewann das Unternehmen kontinuierlich Kunden hinzu. 1950 hatte die Firma Hunderte neuer Klienten für ihre Werbegeschenke, auf deren Verpackungen Elvgrens Abbildungen prangten. Wie schon zuvor traten weitere Unternehmen und große Werbeagenturen an Elvgren heran, die ihn für verschiedene kommerzielle Aufträge gewinnen wollten. Und wieder hatte Elvgren einfach nicht genug Zeit, um auch nur einen Bruchteil dieser Aufträge anzunehmen. Unter den Firmen, die sich glücklich schätzen konnten, Elvgren für Werbegrafiken zu gewinnen, waren Coca-Cola, Orange Crush, Schlitz, Red Top Beer, Ovaltine, Royal Crown Soda, Campana Balm, General Tire, Sealy Mattress, Serta Perfect Sleep, Napa Auto Parts, Ditzler Automotive Finishes, Frankfort Distilleries, Four Roses Blended Whisky, General Electric Appliance und Pangburn's Chocolates.

Angesichts dieser Nachfrage überlegte Elvgren erneut, ein eigenes Studio zu eröffnen – und selbst Künstler einzustellen. Er dachte dabei an ehemalige Studenten seiner Schule, die als Sundbloms Chicago School of „mayonnaise painting" bekannt geworden war. Die Bezeichnung „mayonnaise painting" diente der Beschreibung der cremig seidenglatten Oberflächen in Sundbloms und Elvgrens Bildern. Nachdem er Pro und Kontra sorgfältig abgewogen hatte, nahm Elvgren von dieser Idee Abstand.

Mittlerweile schrieb man das Jahr 1950, und die amerikanische Nation hatte in den Nachkriegsjahren nicht nur ihre außenpolitische Stellung in der Welt neu definiert, sondern sich auch innenpolitisch neu formiert. Es war die Epoche des „Baby Booms", die Statistik verzeichnete mehr Haushaltsgründungen als je zuvor. Kein Wunder, daß auch auf dem Illustrationsmarkt Hochkonjunktur herrschte. Die Dekade von 1950 bis 1960 sollte als das Goldene Zeitalter der amerikanischen Illustration in die Geschichte eingehen, denn die Nachfrage nach Anzeigen, Buch- und Kalenderillustrationen erreichte Rekordhöhen. Elvgren beobachtete weiterhin aufmerksam den Markt. Seine Aktenordner mit Ausschnitten der Arbeiten von Künstlern, deren Karriere er besonders verfolgte und die ihm gelegentlich zu Referenzzwecken dienten, wurden immer voller.

Einer dieser Künstler war Tom Lovell (1909–1997), der in Elvgrens Sammlung den meisten Platz einnahm (seine Akte war fast acht Zentimeter dick und

enthielt nahezu jede Illustration, die Lovell jemals veröffentlicht hatte). Zu einer von Lovells Illustrationen, die ein dem Pin-up verwandtes Sujet zeigt (Abb. 57, S. 28), hatte Elvgren an den Rand einen Kommentar geschrieben und die Notiz, Al Buell auf diese Zeichnung anzusprechen. Elvgren und Lovell schätzten einander sehr und telefonierten ab und an, um Komplimente auszutauschen.

Ebenso von gegenseitigem Respekt gekennzeichnet war Elvgrens Beziehung zu dem amerikanischen Illustrator Walter Baumhofer (1904–1985). Von 1946 bis in die Mitte der 50er Jahre arbeiteten beide für den Art Director bei McCall's. Elvgren schätzte Baumhofers brillanten Einsatz des Lichts, mit dem er die ideale Stimmung für eine bestimmte Szene schuf (Abb. 56, S. 28). Wie Sundblom, der die Dramatik einer Geschichte durch Lichteffekte zu steigern wußte, war auch Baumhofer überaus geschickt darin, die spezifische Qualität einer geschriebenen Geschichte bildlich umzusetzen. Seit den 30er Jahren, als Baumhofer gemeinsam mit Robert G. Harris (geb. 1911) für die bei Street and Smith verlegten Pulp-Magazine Umschlagentwürfe geliefert hatte, verfolgte Elvgren seine Karriere. Harris malte in einem glatten, fast fotorealistischen Stil, den viele seiner Zeitgenossen bewunderten. Elvgren machte Brown & Bigelow auf ihn aufmerksam, und Harris erhielt seinen einzigen Auftrag für ein Kalender-Pin-up. Obwohl das Pin-up im Abendkleid (Abb. 58, S. 29) in Glamour-Manier ausgeführt worden war, begeisterte Harris' Kalenderzeichnung die Künstler und die Geschäftsleitung von Brown & Bigelow gleichermaßen.

Vor einigen Jahren erzählte mir Harris in einem Telefoninterview, wie sehr die meisten seiner Kollegen, insbesondere die der New Yorker Society of Illustrators, Elvgren beneideten. Er hatte eine Traumkarriere; er konnte tagein, tagaus schöne Frauen malen, während andere Illustratoren für gewöhnlich den oft weniger interessanten Anforderungen ihres Berufs nachkommen mußten.

Von Mitte der 40er bis Mitte der 50er Jahre ließ Elvgren sich von Walt Ottos Werk inspirieren. Wie Elvgren war auch Otto ein kommerzieller Illustrator, Pin-up- und Glamour-Künstler. Beide Männer hatten ihre Ausbildung in Chicago absolviert und dort auch ihre Karrieren begonnen. Sie kannten und schätzten sich gegenseitig. In Ottos Saturday Evening Post-Cover eines skifahrenden Mädchens (Abb. 60, S. 30) und in seinen Werbezeichnungen für Alka-Seltzer (Abb. 63, S. 30) kann man durchaus Ähnlichkeiten mit Elvgrens Malweise entdecken.

Weil Elvgren so populär war, repräsentierte er Brown & Bigelow oft auf großen Werbeveranstaltungen. Er traf mit Vertretern der Presse und anderer Medien zusammen und bei verschiedenen Terminen auch mit einer breiteren Öffentlichkeit. Diese öffentlichen Auftritte und die damit verbundenen Reisen boten Elvgren Gelegenheit, einige Berühmtheiten kennenzulernen, die oft enge Freunde von ihm wurden. So auch Harold Lloyd, der Star des Kinos, der Elvgren um 1950 mit der 35-mm-Stereo-Farbfotografie bekannt machte. Elvgren war immer schon ein leidenschaftlicher Fotograf gewesen, und so oft er die Zeit fand, widmete er sich diesem neuen Gebiet.

Lloyd schätzte Elvgren als persönlichen Freund. Aber natürlich war er auch ein ergebener Fan, und Elvgren schenkte ihm um 1951 einen seiner besten Brown-&-Bigelow-Akte (Abb. 251, S. 108). Es war das erste Pin-up (und zugleich der erste Akt), den er für Clair Fry gemalt hatte – ausschließlich zur Veröffentlichung als Deckblatt eines Kartenspiels. Das Ergebnis hieß To Have (Haben), war in Öl auf Karton ausgeführt und maß 69 x 48 cm. Ein zweites, ähnliches Bild trug den Titel To Hold (Festhalten). Der Doppelpack Karten wurde mit einer speziellen ausgestanzten „Fensterklappe" produziert, die nur das Gesicht des Models zeigte. Auf der inneren Klappe stand zu lesen: „Ob blond, ob braun oder rothaarig, ein Gentleman mag fesche Mädchen, vor allem jedoch die charmanten Mädchen, die Gil Elvgren malt. Welche Vorlieben auch immer Sie beim Kartenspiel haben, wir hoffen, daß die beiden Schönheiten Ihr Vergnügen noch erhöhen werden." Beim Aufblättern der inneren Klappe enthüllte sich das nackte Pin-up-Girl.

Elvgren konnte es sich mittlerweile leisten, seine Gemälde zu verschenken, denn 1951 hatte sich sein Vertrag geändert. Statt der ursprünglichen 1 000 US $ pro Bild erhielt er jetzt 2 500 US $, bei einer avisierten Abnahme von 24 Bildern im Jahr. Hinzu kamen noch die Honorare aus seinen Illustrationen für Zeitschriftenartikel und seinen zahlreichen Werbeaufträgen. So konnte die Familie Elvgren sich einen Umzug in den Chicagoer Vorort Winnetka leisten. Direkt nach ihrem Einzug in das neue Domizil begann Elvgren, das Dachgeschoß zum Studio auszubauen. Einschließlich der verglasten Giebel, durch die das Nordlicht von oben

ins Studio drang, wurde das Studio binnen weniger Monate fertiggestellt. Elvgrens Sohn Drake erzählte mir, daß sein Vater zunächst allein in dem Studio arbeitete, aber bereits nach kurzer Zeit einen Vollzeitassistenten einstellte, der ihm beim Ausleuchten des Sets und bei den Fotos half, die Kulissen für die verschiedenen Einstellungen aufbaute und sich um Elvgrens Malutensilien kümmerte. Mit einem Studio im eigenen Haus konnte Elvgren wesentlich effektiver arbeiten, weil ihm das tägliche Pendeln und zeitintensive Störungen erspart blieben.

Für Elvgren stellte es eine ständige Herausforderung dar, neue Ideen zu entwickeln. Wie viele andere Künstler der Pin-up- und Glamour-Branche hatte er oft das Gefühl, jedes nur erdenkliche Thema sei bereits erschöpfend behandelt worden. Als er mit einem Dutzend anderer Künstler im Stevens/Gross Studio arbeitete, suchte Elvgren regelmäßig bei ihnen Rat in bezug auf neue Themen, und umgekehrt wurde auch er immer wieder um Vorschläge gebeten. 1982 gewährte mir Joyce Ballantyne in einem Telefoninterview Einblick in den Arbeitsalltag. Im Stevens/Gross Studio war es üblich, daß man sich gegenseitig unterstützte. Wenn jemand sich nicht gut fühlte oder unter besonderem Terminduck stand, nahm einfach einer der anderen Illustratoren seinen Pinsel und beendete das Bild für den gestressten Kollegen. Bei sich zu Hause hatte Elvgren diesen Luxus nicht. Nur manchmal, wenn ihm partout keine zündende Idee kommen wollte, griff er zum Telefon, um sich von seinen Künstlerfreunden inspirieren zu lassen.

Umgekehrt konnten Freunde natürlich auch auf ihn zählen – so beispielsweise George Hughes, der mehr als 125 Titelbilder für *The Saturday Evening Post* entwarf. Elvgren erzählte ihm einmal von einer Szene, die er am Strand beobachtet hatte, und Hughes entwickelte die Idee weiter zu einem Pin-up (Abb. 61, S. 30), das am 28. August 1954 auf dem Titel der *Saturday Evening Post* veröffentlicht wurde. Und Elvgrens Freund Thornton Utz (geb. 1914) erzählte mir vor vielen Jahren in einem Interview: „Gil war wirklich gut, wenn es um Ideen ging. Einmal suchte ich verzweifelt nach einer neuen Idee für ein Cover der S*aturday Evening Post*, als Gil mir erzählte, daß er am Tag zuvor in einem Plattengeschäft gewesen war. Er beschrieb all die Leute in den beiden Boxen, wie sie sich Platten anhörten und überlegten, welche sie kaufen sollten. Ich griff diese Idee auf und machte einige Vorab-Skizzen. Schließlich wurde aus der Idee am 19. April 1952 ein Cover der *Saturday Evening Post*." (Abb. 62, S. 30).

1951 erschien in der Zeitschrift *Modern Man* ein Leitartikel über Elvgren. Auf dem Umschlag sah man Elvgren, wie er sein Modell Candy Montgomery für einen Auftrag, der den Titel *Keeping Posted* tragen sollte, fotografierte. In der Story wird Elvgren als „Amerikas größter Maler kommerzieller Kunst" bezeichnet. Als er gefragt wurde, wie er über amerikanische Frauen denke, sagte er, daß sie „heute unendlich viel schicker sind. Und schöner als jemals zuvor. Sie sind natürlicher und passen sich nicht an, wie es früher der Fall war. Und Gott sei Dank, sehen sie nicht länger wie Jungen aus." Weiter erzählte er in der Zeitschrift, daß „das Kino, das Fernsehen und die Zeitschriften einen enormen Einfluß auf den Wandel althergebrachter Werte haben. Und die Kalenderkunst hat möglicherweise einen größeren Anteil an diesem Wandel als irgendein anderes Medium."

Die Zeitschrift *Figure Quarterly* interviewte Clair Fry in den 50er Jahren mehrfach und befragte ihn unter anderem auch zu Gil Elvgren (Abb. 64, S. 30). Seine Einschätzung, wer Elvgren war und wie er sich in diesen Jahren gab, ist recht informativ:

Zuallererst ist Gil Elvgren einer der handwerklich begabtesten Zeichner und Maler auf kommerziellem Gebiet. Das ist aber nur ein kleiner Teil der Geschichte. Es gibt viele fähige Künstler, die niemals Elvgrens Niveau erreicht haben. Wenn ich über den Unterschied nachdenke, glaube ich, daß es wie bei zwei Männern ist, die beide ein gleich gutes Zimmermannswerkzeug haben. Aber nur einer der beiden Männer hat einen genauen Plan von dem Haus, das er bauen will, während der andere mit dem gleichen guten Rüstzeug ohne diese klar definierte Zielvorstellung arbeitet.

Gil Elvgren hatte einen ausgezeichneten Geschmack. Das ist eine Voraussetzung, die man sich nur schwer erarbeiten kann. Viele Künstler mit großem Talent werden nie akzeptiert, weil ihre Linien und Muster – auch wenn sie für sich betrachtet exzellent sind – in der Wirkung unbeholfen und langweilig sind, weil ihnen dieses besondere Etwas fehlt, durch welches im wirklichen Leben ein ganz besonderes Mädchen aus dem Durchschnitt herausragt.

Darüber hinaus hatte Gil Elvgren Humor. Nicht nur haben seine Bilder einen humoristischen Unterton, ihr eigentlicher Witz gründet in Elvgrens innovativem Potential und seiner Raffinesse, die sich in den Farbschemata, Posen und Gesten offenbaren und in lebendige und aufregende Sujets einfließen, die einfach Aufmerksamkeit erregen müssen. Seine Arbeiten sind ernsthaft und sehr ehrlich. Die Reaktion auf Gils Bilder ist immer die, daß da ein Mädchen von nebenan zu sehen sei. Die sorgfältig komponierten Gesten und Ausdrücke sind mit einer solchen Meisterschaft ausgeführt, daß sie genau die Bedeutung vermitteln, die Gil im Sinn hatte. Er mußte sich dazu nicht jener Kunstgriffe bedienen, die bei einem großen Prozentsatz kommerzieller Arbeiten zu finden sind. Gil war immer am Puls des jeweiligen weiblichen Schönheitsideals. Das war das Wichtigste. Wenn Sie sich im Vergleich eine Frauendarstellung von Rubens ansehen, dann erkennen Sie den eklatanten Wandel, dem das weibliche Schönheitsideal unterworfen ist. Elvgren wußte genau, mit welchen Zutaten er seinen Bildern jenen Touch von Phantasie verleihen konnte, der dem Geist seiner Zeit entsprach. Dieses Wissen und die Fähigkeit, es in seine Arbeiten einfließen zu lassen, sind womöglich der Schlüssel zu Gils herausragendem Erfolg.

Sein großes Talent, von dem Fry in dem Interview sprach, führte dazu, daß Elvgren sich vor Angeboten kaum retten konnte. Die Bandbreite seiner Kunden reichte von denen, die ihn förmlich anflehten, „nur diesen einen Job" zu übernehmen, bis zu jenen, die ihn für das gesamte Werbekonzept ihrer Firma oder ihres Produktes gewinnen wollten. In den frühen 50er Jahren gelang es der Schmidt Lithograph Company of Chicago and San Francisco, Elvgren für einige Reklametafeln diverser Klienten zu verpflichten. Die Reklametafeln trugen die Bezeichnung „universal", weil ihr Format und ihre Abbildungen für den Verkauf von fast jedem beliebigen Produkt einsetzbar waren. Sie zeigten nur den Kopf eines Glamour Girls, keine Requisiten, keinen Hintergrund – auch wenn die ersten beiden Aufträge Elvgrens eine Ausnahme waren. Das erste Gemälde für die Schmidt Lithograph Company hieß *Poolside Fun* (Spaß am Schwimmbecken; Abb. 65, S. 32) und zeigte ein hübsches „Elvgren Girl", das sich nach einem kurzen Bad ihr Haar trocknet, während im Hintergrund ein Butler einem Paar, das an einem Tisch sitzt, ein Bier serviert. In der oberen linken Ecke des Bildes steht ein anderes „Elvgren Girl" auf einem Sprungbrett, bereit, sich ins Wasser zu stürzen. Elvgrens brillant gewählte Perspektive und seine Komposition halten die ganze Szene zusammen.

Elvgrens zweiter Auftrag für die Schmidt Lithograhy Company war das Porträt einer lächelnden Schönheit, die ein Tablett mit Bierflaschen trägt (Abb. 66, S. 32). Den Titel *The Pick of the Picnic!* (Räum das Picknick weg!) hat Elvgren direkt auf die Zeichnung geschrieben. Die meisten seiner Arbeiten für Schmidt führte er auf Zeichenkarton im Format 38 x 76 cm aus. Meistens nutzte er nur ein Drittel der Fläche auf der linken Seite für sein Bild und ließ den Rest frei, so daß Platz für den Firmen- oder Produktnamen blieb. Wenn ein Sammler das Werk ohne störendes Beiwerk rahmen lassen wollte, schnitt er das Originalbild aus. Es gibt allerdings auch hartgesottene Sammler, die die Reklametafeln in ihrem ursprünglichen Zustand belassen.

In einer anderen Version von *The Pick of the Picnic!* (Abb. 67, S. 32) waren die Flaschen gegen eine einzige Viertelliterflasche A-1 Pilsner Beer „ausgetauscht" worden. Für das „Elvgren Girl", das mit dem Finger zeigt und lächelt (Abb. 70, S. 33), stand Myrna Hansen Modell, die ab 1951 – damals war sie 15 Jahre alt – für Elvgren arbeitete. Im Lauf der Jahre wurde sie zu einer seiner Favoritinnen. Ein anderes Bild von einem Mädchen, das eine Perlenkette trägt (Abb. 585, S. 238), wurde von der Schmidt Lithography Company in zwei verschiedenen Versionen vermarktet, um unterschiedliche Produkte zu bewerben. Auch für die Pangburn's Chocolates-Werbung (Abb. 68 und 69, S. 33) wurde Elvgrens Original in Abwandlung reproduziert.

In den 50er und 60er Jahren verfolgte Elvgren die Karrieren bestimmter Künstler, die – genau wie er – redaktionelle Beiträge für Zeitschriften illustrierten. Seine umfangreiche Akte über Jon Whitcomb (geb. 1906; Abb. 71, S. 34) scheint fast jede Illustration zu enthalten, die im Lauf von Whitcombs fruchtbarer Karriere jemals erschienen ist. Anders als Elvgren arbeitete Whitcomb hauptsächlich auf Zeichenkarton, bei der Illustration von Zeitschriftengeschichten entschied er sich gelegentlich auch für Öl auf Leinwand.

Auch Edwin Georgi (1896–1964) war – vor allem ab Mitte der 30er bis in die 50er Jahre – ein wichtiger Illustrator. Georgi verwandte – lange bevor es in Mode kam – irisierende Pastellfarben. Der geradezu dramatisch anmutende Einsatz von Farben war sein Markenzeichen. Seine Themen waren vorzugsweise schöne Frauen (und gutaussehende Männer), und seine Arbeiten erschienen in allen führenden amerikanischen Zeitschriften (Abb. 72, S. 34). Elvgrens Bewunderung für das Talent seiner Zeitgenossen unterstreicht, was für ein souveräner und unprätentiöser Mensch er war.

Nachdem sie sich in ihrem neuen Haus in Winnetka eingerichtet hatten, machten Elvgren und seine Familie um 1953 Urlaub in Florida. Schon bei der Ankunft verliebte sich der Künstler in dieses beliebte Urlaubsziel. Für jemanden, der so lange mit Schnee und Eis gelebt hatte, waren der klare blaue Himmel, die tropischen Winde und die sich sanft im Wind wiegenden Palmen zu schön, um wahr zu sein. Obwohl er sich gerade erst eine neue Existenz in Winnetka aufgebaut hatte, trug er sich mit dem Gedanken, in den Golden State zu ziehen.

Im Januar 1955 wandte sich Charlie Ward an Elvgren und bat ihn um eine Aktdarstellung, die Brown & Bigelow in ihrer Kalenderserie für das Jahr 1957 als sogenannten „hanger" herausbringen wollte. Ein solcher Kalender besaß für gewöhnlich ein Überformat, das die Maße 51 x 76 oder 56 x 71 cm haben konnte. Ein „hanger" besteht aus einem kartonierten Bild, auf welches das Kalendarium entweder aufgedruckt oder als Block befestigt wird. Als Elvgren seine heißblütige blonde Nackte in der Hauptgeschäftsstelle von Brown & Bigelow ablieferte, erhielt sie den Titel *Golden Beauty* (Goldene Schönheit). Bevor das Gemälde an Wards Büro geschickt wurde, wurde es inventarisiert. Danach ward es nie wieder gesehen. In dem vorliegenden Band wird es zum allerersten Mal veröffentlicht (Abb. 252, S. 109). Hinter seinem mysteriösen Verschwinden steht folgende Anekdote: Nachdem das Bild einige Jahre bei Ward zu Hause gehangen hatte, überreichte er es seinem langjährigen Freund Red Rudinski, dem Chef der Wartungsabteilung von Brown & Bigelow (und Autor eines Buches über Techniken zum Knacken eines Safes). Der wiederum schuldete einem Grundstücksmagnaten von St. Paul noch einen Gefallen und schenkte es ihm zu Weihnachten. *Golden Beauty* hing dann 30 Jahre lang im Hinterzimmer einer Immobilienfirma in Downtown St. Paul, wo es zu einer Legende wurde. 1990 schließlich erwarb ein Kunstsammler es für seine Privatsammlung.

Im gleichen Jahr hatte Elvgren seinen Durchbruch als Kultfigur der Pop-Kultur. Denn 1955 wurden zwölf seiner besten Pin-ups auf einem Lampenschirm reproduziert (Abb. 75, S. 35). Der Schirm hing an einer Spindel, so daß er sich drehte, wenn die Hitze durch kleine Schlitze oben auf dem Lampenschirm entwich. Von der Econolite Corporation hergestellt, wurde die Lampe als „Bewegungs"- oder „Hitzeleuchte" bekannt. Sie war aus Zelluloid, der Schirm war überaus zerbrechlich und wegen der Hitze der Glühbirne leicht entflammbar.

1954 wurde einer von Elvgrens Lieblingsillustratoren, Harold Anderson (1894–1973), gebeten, das berühmte „Coppertone Billboard Girl" als Kalenderbild umzusetzen. Zuvor hatte die Coppertone mehrere Illustratoren um Ideen für eine riesige Reklametafel gebeten. Elvgrens Freundin Joyce Ballantyne erhielt schließlich den Zuschlag, und ihr Bild *Don't Be a Paleface!* (Sei kein Bleichgesicht!; Abb. 73, S. 35) wurde zu einer amerikanischen Ikone, die jeden in ihren Bann schlug. Das Bild zeigt ein kleines Mädchen mit Rattenschwänzen, dem ein verspielter kleiner Hund am Badeanzug zupft. Mit diesem Bild etablierte sich Ballantyne als bedeutende Werbegrafikerin und machte gleichzeitig Coppertone (das gleichnamige Sonnenöl) zu einem der bekanntesten Produkte weltweit. Elvgren und Joyce Ballantyne hatten sich an der Chicagoer American Academy of Art kennengelernt, als er dort unterrichtete. Sie war damals eine seiner Studentinnen, aber schon bald wurde sie zu seiner Freundin und Kollegin. Das Gemälde (Abb. 74, S. 35), das Anderson nun für den Kalenderauftrag ausführte, war in einem dicken, reichen, cremigen Sundblom-Elvgren-Stil gehalten, den Elvgren so schätzte, und wurde ein Riesenerfolg.

1956 gelang es Elvgren schließlich, seine Familie zu einem Umzug nach Florida zu überreden. Die Idee dazu war vier Jahre zuvor während eines Urlaubs in Florida geboren worden, und jetzt schien ihm der richtige Zeitpunkt gekommen zu sein, seine Umgebung und seinen Lebensstil zu ändern. Viele

von Elvgrens Freunden hatten sich bereits in Florida niedergelassen. Joyce Ballantyne und seine langjährigen Freunde Arthur Sarnoff, Bill Doyle und Elmore Brown, vor allem aber zwei von seinen und Janets engsten Freunden, Al Buell und Thornton Utz, lebten mit ihren Familien schon seit einigen Jahren dort. Und auch das schöne Wetter steigerte die Lebensqualität. So fühlten sie sich dort vom Tag ihrer Ankunft an mehr zu Hause als im Norden. In seiner neuen Wahlheimat gefiel Elvgren einfach alles.

Ein ideales Heim fanden die Elvgrens in Siesta Key. Gil Elvgren baute sich ein fabelhaftes Studio, das sich über zwei Ebenen erstreckte. In den ersten vier Jahren beschäftigte er einen Lehrling in seinem Studio – Bobby Toombs, der sich zu einem anerkannten Künstler weiterentwickelte. In einem Telefongespräch, das ich 1980 mit Toombs führte, erzählte er mir, was für ein großartiger Lehrer Elvgren war. Elvgren habe ihm nicht nur den Umgang mit Farben und die verschiedenen Tricks beigebracht, eine Arbeit angesichts enger Abgabetermine fertigzustellen, sondern ihn auch in der Kunst unterwiesen, an jeden erdenklichen Auftrag mit einem durchdachten Konzept heranzugehen (eine Arbeitsphilosophie, in der sich die Lehren von Howard Pyle und Harvey Dunn widerspiegelten). Toombs fuhr fort: „Natürlich war die Farblehre das Hauptunterrichtsfach, aber mit Gil Elvgren an meiner Seite hatte ich das Gefühl, alles tun zu können. Elvgren nahm eine Bürste in die Hand und ließ sie über die Leinwand tanzen. Es war wie Zauberei, wenn man ihm in den guten alten Zeiten bei der Arbeit zusah."

Nachdem er sich in Florida niedergelassen hatte, zeichnete Elvgren viele Porträts. Nicht etwa, weil er – wie viele ältere Illustratoren – Ambitionen im Bereich der bildenden Kunst verspürte, sondern weil es ihm einfach Spaß machte, die Gesichter der Menschen, die er in Siesta Key traf, festzuhalten. Viele seiner Models waren berühmt oder sollten es, nachdem er sie gezeichnet hatte, werden. Myrna Loy, Arlene Dahl, Donna Reed, Barbara Hale und Kim Novak waren nur einige von Gils Models. Für eine angehende Schauspielerin war es damals in den 50er und 60er Jahren eine große Karrierechance, wenn ihr Ebenbild auf einer Million Elvgren-Kalendern zu sehen war. Tatsächlich fuhren einmal wöchentlich viele Hollywood Starlets mit dem Zug von Los Angeles nach St. Paul, dem Sitz der Brown & Bigelow Company und dem Geburtsort Elvgrens, nur um sich als Model für Elvgren oder einen der anderen Großen der Branche vorzustellen.

Auch wenn die meisten Künstler Skizzen oder Vorstudien anfertigten, bevor sie ihr Sujet in Öl ausführten, verzichtete Elvgren für gewöhnlich darauf. Manchmal ließ er seinen Assistenten Studien anfertigen, wenn dieser begabt genug war. Nur wenn Elvgren ein besonderes Pin-up-Sujet vor Augen hatte, führte er solche Studien selbst aus. Elvgrens Skizzen waren mit 51 x 41 cm in der Regel recht kleinformatig. Einmal zeichnete er eine bis ins kleinste Detail ausgearbeitete Vorstudie für eines seiner bekanntesten Pin-ups für Brown & Bigelow mit dem Titel *Bear Facts* ([Bären-Tatsachen] oder *Bearback Rider* [Ritt auf dem Rücken eines Bären]; Abb. 414, S. 172). Die Studie unterschied sich im Format (71 x 56 cm) nur geringfügig von dem späteren Ölgemälde (76 x 61 cm). In der unteren linken Ecke dieser sensationellen Studie (Abb. 415, S. 172) stand zu lesen: „Für Toni, die mein bestes Model hätte werden können. ‚Hallo Nachbar!' Gil Elvgren." Über Tonis Identität ist nichts bekannt, aber es ist wahrscheinlich, daß sie sehr wohl ein Model von Elvgren war, insbesondere für einige seiner Werbeaufträge für Schlitz, denn der Slogan des Unternehmens lautete: „Hi Neighbor!" Es ist auch möglich, wenn auch unwahrscheinlich, daß Toni eine Nachbarin der Elvgrens war.

Bei der Auswahl seiner Models beschränkte Elvgren sich nicht auf die bereits erwähnten Starlets und Schauspielerinnen. In den 40er Jahren war er besonders von den beiden Teenagern Dayl Rodney und Pat Varnum angetan. Seit seinem Umzug nach Florida Mitte der 50er Jahre arbeitete er häufig mit Myrna Hansen (die 1954 zur Miss Amerika gewählt wurde) und Janet Rae, der 15jährigen Tochter seiner Nachbarn. In den 60er Jahren waren Rusty Allen und Marjorie Shuttleworth seine Favoritinnen.

Elvgren ersann permanent neue Themen und Situationen, um sie dann in Bilder umzusetzen. Auch wenn ihm seine Kollegen aus Hollywood oft Vorschläge machten, seine wahre Inspirationsquelle war seine Familie, der er am meisten vertraute. Schon in ihrer Chicagoer Zeit hatte Gil Elvgren es sich angewöhnt, Ideen beim Abendessen mit seiner Frau und seinen Kindern zu diskutieren. Das machte das abendliche Beisammensein zu einer unterhaltsamen Angelegenheit.

Im Auftrag von Brown & Bigelow entwarf Elvgren regelmäßig Anzeigen für Napa Auto Parts. Zusätzlich malte er für die Firmen Ditzler und Sylvania pro Jahr ein Pin-up. Für die beiden ersten Aufträge von Ditzler mußte er eine Vorstudie in Farbe abliefern, die fast Originalgröße hatte (76 x 56 cm; Abb. 551, S. 230); bei Sylvania war eine Bleistiftstudie Pflicht. Den Sylvania-Auftrag teilte er sich mit Bill Medcalf, den für Ditzler mit Mayo Olmstead (geb. 1925). 1990 erinnerte sich Olmstead an seine erste Begegnung mit Elvgren in den frühen 50er Jahren, als er gerade begonnen hatte, für Brown & Bigelow zu arbeiten. Er war seit Jahren ein echter Elvgren-Fan und die Aussicht, ihn zu treffen und gemeinsam mit ihm zu arbeiten, machte Olmstead verständlicherweise nervös. Mayo berichtete:

Gil Elvgren war der netteste Kerl, den man sich denken kann. Er war immer bereit, einem Künstlerkollegen aus der Klemme zu helfen. Als ich so um 1950 zu Brown & Bigelow kam, war Elvgren bereits der Star des Unternehmens. Was seine Fähigkeiten und sein Talent anging, so war er eine Klasse für sich. Ich erinnere mich noch lebhaft daran, wie Gil mir damals bei meinem ersten Brown-&-Bigelow-Auftrag half. Für einen Kalender sollte ich ein Pin-up als Cowgirl malen. Ich wußte noch nicht einmal, wie groß mein Original sein sollte. Gil schlug vor, ich solle die gleiche Leinwandgröße wie er benutzen (76 x 61 cm), was ich dann auch tat, obwohl mein Bild ein horizontales Format hatte (Abb. 76, S. 37) – das lag daran, daß es in einem größeren Format als üblich reproduziert werden sollte. Wenn Gil Elvgren mir damals nicht bei meinem ersten Auftrag für Brown & Bigelow geholfen hätte, Sie wissen schon, dieses Cowgirl-Thema, und mich nicht auch bei meinen nächsten Jobs unterstützt hätte, ich glaube nicht, daß ich es je geschafft hätte! Er war ein klasse Typ, wissen Sie, ein echtes Juwel! Ich bin Gil für all seine Hilfe, seine Freundschaft und seine künstlerische Anleitung dankbar, und das seit dem Tag, an dem ich ihn zum ersten Mal getroffen habe.

Die Elvgren-Pin-ups, die die Firma Napa Auto Parts bei Brown & Bigelow orderte, mußten etwas konservativer als gewöhnlich sein. Um Napa diesbezüglich zufriedenzustellen, legte Elvgren den Verantwortlichen bei Napa immer vollständig ausgearbeitete Vorstudien in Öl auf Zeichenkarton vor. Erst wenn diese von der Geschäftsleitung akzeptiert worden waren, malte er das Bild in Öl auf Leinwand. In einer dieser Studien liegt der Fisch, den die Frau an Land gezogen hat, zwischen ihren Beinen (Abb. 573, S. 235). Die Geschäftsleitung von Napa bestand gegenüber Buzz Peck, dem Art Director von Brown & Bigelow, darauf, daß im endgültigen Bild der Fisch auf der anderen Seite liegen sollte.

Auch auf dem Höhepunkt seiner Karriere blieb der Einfluß Haddon Sundbloms auf Elvgren sichtbar. Sundbloms Arbeiten wiederum wiesen Spuren des Einflusses anderer Künstler auf – Howard Pyle, Harvey Dunn, John Singer Sargent, Anders Zorn, Robert Henri, J. C. Leyendecker und Pruett Carter –, aber der wichtigste Einfluß war der von Sorolla. Der sonnige Glanz von Sorollas Werken durchzog auch Sundbloms Arbeiten und wurde über ihn an Elvgren und seinen Kreis weitergegeben: eine Gruppe von Künstlern, mit denen Elvgren in Chicago studiert oder die er unterrichtet hatte und von denen viele zu engen Freunden geworden waren. Sie alle hatten unter den aufmerksamen Augen von „Sunny" gearbeitet. Unter ihnen waren Harry Anderson, Joyce Ballantyne, Al Buell, Matt Clark, Earl Gross, Ed Henry, Charles Kingham, Al Kortner, Al Moore, Walt Richards, James Schucker, Euclid Shook, Bob Skemp, Thornton Utz, Coby Whitmore und Jack Whitrup.

In Siesta Key lernte Elvgren den Schriftsteller John D. MacDonald kennen. Elvgrens Sohn Drake erinnert sich, daß er ihnen direkt gegenüber am Wasser wohnte. Die beiden Männer wurden gute Freunde, sie verbrachten Stunden beim Schachspiel oder besuchten gemeinsam eine der vielen Parties. Im Rampenlicht zu stehen war Elvgrens Sache nicht. Seine Schüchternheit bei großen Zusammenkünften verbarg er, indem er sich, so oft sich ihm die Gelegenheit bot, ans Klavier setzte und spielte – nur um keinen Small talk machen zu müssen. Gelegentlich stieß MacKinlay Cantor, auch er ein berühmter Autor, zu den beiden Männern.

Die Elvgrens trafen sich weiterhin mit den Familien Buell und Utz. Al Buell hatte fast 25 Jahre für Brown & Bigelow gearbeitet. Zunächst malte er Pin-ups, später war er für den erfolgreichen *Artist Sketch Pad* (Künstler-Skizzen-Block)

verantwortlich, einen Kalender (Abb. 77, S. 37). Utz malte hauptsächlich Titelbilder für *The Saturday Evening Post* und übernahm verschiedene nationale Werbeaufträge. Aber genau wie Buell und Elvgren genoß auch er es, schöne Frauen zu malen. Eine seiner Arbeiten aus Florida ist ein Pin-up am Meeresstrand, das perfekt die Stimmung jener Jahre einfängt (Abb. 79, S. 38).

Gil Elvgren lebte aus dem Vollen. Er war ein passionierter „Outdoorsman", er jagte und angelte leidenschaftlich gerne, im nördlichen Minnesota ging er auf Hechtfang, in Florida fuhr er zum Hochseefischen. Auch wenn er sich nichts aus Baden im Meer machte, sah man ihn doch regelmäßig einige Bahnen durch seinen Swimmingpool ziehen oder sich am Rand des Pools entspannen. Mit seinen beiden Söhnen teilte er ein Faible für Rennwagen. Ihm selbst gehörten zwei Rennwagen, und jedes Jahr fuhr er mit seiner Familie nach Sebring, Florida, um sich das Zwölfstundenrennen von Endurance anzusehen.

Mit seinen Söhnen verband ihn noch eine weitere Leidenschaft: das Sammeln alter Waffen, insbesondere Pistolen und Gewehre. Seine erste Bekanntschaft mit Waffen hatte er 1918 im Alter von vier Jahren gemacht, als ihn sein Vater auf die Schultern nahm, so daß er die Waffenauslage in einem Schaufenster sehen konnte. Mit zehn Jahren schenkte ihm sein Vater sein erstes Gewehr zum Geburtstag, der Beginn seiner Sammelleidenschaft. Elvgren war Scharfschütze und hat im Lauf seines Lebens mehrere Wettbewerbe gewonnen. Als er 1956 von Illinois nach Florida zog, nannte er mehr als hundert Feuerwaffen sein eigen, die in drei gläsernen, in die Wand eingelassenen Vitrinen ausgestellt waren. Elvgren war Mitglied des Sarasota Gun Club und der Sarasota Rifle and Pistol Association. Zusätzlich gab er Schießkurse für die Chicagoer Polizei, die Air Patrol, die Civil Defense und die Küstenwache. In seinem Haus in Winnetka hatte er sich sogar einen mehr als 15 Meter großen Schießstand gebaut.

Im Lauf der Jahre beschäftigte Elvgren in seinem Studio etwa ein Dutzend Helfer oder Assistenten, von denen viele hofften, ihr eigenes Talent unter der Anleitung und Hilfe des Künstlers, den sie am meisten bewunderten, entwickeln zu können. Bobby Toombs beispielsweise übernahm bei Brown & Bigelow Elvgrens Napa-Aufträge, nachdem Elvgren die engen Abgabetermine zuviel geworden waren. Unter den Studenten, die Elvgren in Chicago unterrichtet hatte, waren viele, die den Beginn ihrer Karriere auf die Zeit unter der Anleitung Elvgrens datierten. Harry Ekman, der 1953 mit Elvgren in Chicago studiert hatte, machte sich schließlich einen Namen auf dem Gebiet der Pin-up- und Glamour-Kunst.

Wenn er in seinen Jahren in Florida keine Pin-ups malte, war Elvgren mit Illustrationen für Zeitschriftenbeiträge beschäftigt. Allerdings mußte er häufig Angebote ablehnen, weil er einfach keine Zeit dafür hatte. Die Art Directors der Zeitschriften, für die er arbeitete (*McCall's*, *Cosmopolitan*, *Redbook*, *Woman's Home Companion* und *The Saturday Evening Post*) waren in der Regel bereit, bis zu einem Jahr zu warten, wenn sie Elvgren für einen Auftrag buchen wollten.

1963 wurde Elvgren mit der Publikation eines einzigartigen Kartenspiels mit dem Titel *American Beauties* (auch als *Top Hat* bekannt) geehrt. Von Brown & Bigelow lizenziert, enthielt dieses Spiel erstmals Reproduktionen von 53 verschiedenen Elvgren-Pin-ups (auf früheren Kartenspielen war meist nur ein „Elvgren Girl" zu finden). Elvgren war der einzige Künstler bei Brown & Bigelow, dem jemals eine solche Ehre zuteil wurde; der einzige Pin-up-Künstler, der ebenfalls ein Spiel mit 53 Motivkarten veröffentlichte, war Alberto Vargas. Das Elvgren-Kartenspiel übertraf das von Vargas in jeder Hinsicht und erwies sich als durchschlagender Erfolg. Elvgrens Bilder haben ein narratives Element, sind unterhaltsam und lebendig, während die von Vargas nichts zu erzählen haben und somit leblos bleiben.

In der Zeit seiner größten Erfolge erlag Elvgrens Frau Janet 1966 einem Krebsleiden. Nach ihrem Tod stürzte sich Elvgren um so mehr in die Arbeit. In den 60er Jahren erreichte er den absoluten Höhepunkt seines künstlerischen Schaffens. Brown & Bigelow verstanden es, seine Bilder ausgezeichnet zu vermarkten, und die amerikanische Öffentlichkeit reagierte enthusiastisch. Nach 30 Jahren hatte er den Punkt in seiner Karriere erreicht, an dem er sich über nichts zu sorgen brauchte, außer darüber, die bestmöglichen Sujets für seine Arbeiten zu finden. Dementsprechend sind seine Pin-ups aus den 60er Jahren thematisch und zeichnerisch besonders sorgfältig ausgeführt und zählen zu seinen besten überhaupt. Frisch und mit viel Ausstrahlung nahmen diese

„Elvgren Girls" den Betrachter mit ihrem außergewöhnlichen Sexappeal für sich ein. Es waren vollblütige „All-American Glamour Girls" und ihr Erfolg ließ den Vertrieb von Brown & Bigelow glauben, sich im siebten Himmel zu befinden. Es schien, als wenn jedes Unternehmen in Amerika nach den „Elvgren Girls" auf Brown-&-Bigelow-Kalendern verlangte, um sie als Weihnachtspräsente an seine Kunden zu verschenken. Es war sicherlich die beste Zeit in Elvgrens Karriere, überschattet nur von der Trauer über den Tod seiner Frau. Schließlich verbrachte er immer mehr Zeit mit Marjorie Shuttleworth, einem seiner Models aus Sarasota.

Charlie Ward hatte einen Kabinenkreuzer, auf den er in den Sommermonaten in St. Paul oft Kunden von Brown & Bigelow einlud. Elvgren selbst war schon viele Male auf dem Boot gewesen, und als Ward es malen lassen wollte, war es selbstverständlich Elvgren, der den Auftrag erhielt (Abb. 78, S. 38). Später bat ein gewisser Mr. Regal aus Sarasota Elvgren um ein ähnliches Bild seiner Yacht. Elvgren gelangen solche Marine-Sujets genau so gut wie alles andere, das er zeichnete.

Gil Elvgrens Fähigkeit, nicht nur den Körper, sondern auch den Geist und die Sinnlichkeit schöner amerikanischer Frauen einzufangen, war unübertroffen. Seine Pin-ups zeigten Frauen in alltäglichen Situationen. Manchmal waren sie etwas übertrieben, aber letztendlich immer stimmig. Elvgren malte mit einer Palette von 32 Farben zumeist auf Leinwänden im Format 76 x 61 cm, die er auf eine große, hölzerne Staffelei plazierte. Gewöhnlich saß Elvgren beim Malen auf einem Stuhl mit Rollen, so daß er sich hin- und herbewegen konnte, um sein Werk während der Arbeit aus allen Perspektiven zu betrachten. Ein hoher Spiegel an der Wand hinter ihm ermöglichte es ihm, über die Schulter zu schauen und einen Gesamteindruck des Bildes zu bekommen. Während der Jahre in Winnetka und noch in Florida legte der junge Drake Elvgren täglich die Malutensilien seines Vaters bereit.

Als man Elvgren einmal fragte, was ihm bei einem Model am wichtigsten sei, antwortete er: „Ein Mädchen, dessen Gesicht viele verschiedene Stimmungen auszudrücken vermag, ist ein echtes Juwel. Das Gesicht macht die Persönlichkeit aus." Er bevorzuge junge Mädchen zwischen 15 und 20 Jahren, die erst am Anfang ihrer Karriere stünden und sich noch ihre Natürlichkeit und Spontaneität bewahrt hätten. Er schätze Frauen, die sich für ein Projekt begeistern könnten, und Elvgren fügte hinzu, daß solche Frauen schwer zu finden seien. Auf die Frage nach dem Malprozeß erzählte er von den kleinen Abwandlungen: Hier und da vergrößere er die Brust ein wenig, verlängere die Beine, gebe dem Körper verführerische Kurven, male die Taille schmaler und überarbeite den Gesichtsausdruck, so daß die Nasenspitze ein wenig kecker, der Mund voller und sinnlicher und die Augen größer würden. Am Ende des Interviews verriet er, daß es ihm vor allem darum gehe, dem Betrachter die unter der äußeren Schönheit liegende Herzenswärme zu vermitteln.

Elvgren plante jedes seiner Gemälde bis ins kleinste Detail. Von einer Idee ausgehend, arbeitete er ein Konzept aus und suchte dann das passende Model. Als nächstes legte er die Kleidung, den Hintergrund, die Requisiten und das Licht fest. Sogar die Frisur seines Models war wichtig: Da es manchmal bis zu zwei Jahren dauerte, bis das Pin-up veröffentlicht wurde, legte er Wert darauf, daß das Model eine Frisur trug, die nicht so schnell aus der Mode kam. Dann fotografierte er die so entstandene Szene mit einer Rollei-Kamera, um schließlich mit dem Malen zu beginnen.

Elvgrens Pin-ups unterscheiden sich von denen seiner Zeitgenossen dadurch, daß seine „Elvgren Girls" besonders natürlich wirken. Man hat immer das Gefühl, das „Elvgren Girl" könne jeden Moment lebendig werden, einem einen guten Morgen oder einen guten Abend wünschen, eine Tasse Kaffee oder einen Drink anbieten oder einen gar für eine nicht ganz so unschuldige Unterhaltung nach Hause einladen. Elvgrens Pin-ups haben Persönlichkeit und Witz und sind lebendige, freundliche Schönheiten, die optimistischen Enthusiasmus ausstrahlen. Sie haben hübsche Gesichter und sind von der Natur reichlich gesegnet. Sie zaubern bei jedem ein Augenzwinkern hervor, und oft sitzt ihnen selbst der Schalk in den Augen – kurz: Sie verkörpern das „All-American Girl".

In den Anfangsjahren von Elvgrens Karriere mag die Begeisterung für die Mädchen nicht einhellig gewesen sein. Aber sie ertanzten sich einen Weg aus der wirtschaftlichen Depression der 20er, begleiteten die amerikanischen Soldaten während des Zweiten Weltkriegs und schließlich während des Koreakriegs. In diesen Jahren waren sie es, die den Soldaten Hoffnung

gaben und die Erinnerung an ihr Mädchen zu Hause nicht verblassen ließen. Mit ihrem charmanten und gewinnenden Lächeln weckten die „Elvgren Girls" Gefühle und inspirierten die Träume von vielen Männern und Frauen im Goldenen Zeitalter des amerikanischen Pin-ups.

Während seiner Karriere bei Brown & Bigelow hatte Gil Elvgren zwei Signaturen, die sich nur in ihrer Größe, nicht aber im Stil unterschieden. Seine frühe Signatur (1945–1957) war etwa halb so breit und halb so hoch wie seine spätere Signatur (1958–1972), die wesentlich auffälliger war. Der Grund hierfür liegt eindeutig in der wachsenden Reputation. Um 1958 war Elvgren so etwas wie eine Legende unter den Illustratoren. Denn Alberto Vargas' und George Pettys Popularität beschränkte sich auf ihr ganz spezifisches Publikum. Elvgren hingegen wurde auch von den Kollegen gefeiert und beneidet – eine Ehre, die weder Vargas noch Petty zuteil wurde. Hunderte von Illustratoren sehnten sich danach, ein Mädchen so malen zu können wie Elvgren.

Elvgren nahm niemals Aufträge auf dem lukrativen Sektor der Taschenbuchcover an, einem Markt, der in den 50er und 60er Jahren explodierte. Allerdings geht aus seinen Akten (die der Autor von dem Künstler D. H. Rust viele Jahre nach Elvgrens Tod erwarb) hervor, daß er über diese Branche informiert war und die Künstler James Avati (geb. 1912) und James Bama (geb. 1926) favorisierte. Avati malte überaus sensible Sujets, während Bamas Erfolg auf der fotorealistischen Umsetzung aktueller, tendenziell phantastischer Themen beruhte. Beide Künstler waren im Bereich der Coverillustration für Taschenbücher führend. Ed Balcourt, Managerin und Agentin unter anderem von Bama und Ron Lesser, erzählte mir in einem Interview, daß die führenden Taschenbuch-Illustratoren Elvgrens Werke oft diskutierten, wenn sie sich in New York bei ihren Verlegern trafen. Elvgren fand also nicht nur in eigenen, sondern auch in verwandten Anwendungsbereichen Anerkennung.

Weil er sich seiner Position sicher war und wußte, daß sein Talent ausgereift war, fühlte sich Elvgren um 1958 rundum zufrieden. Er führte jeden Auftrag mit wachsender Leichtigkeit und großem Selbstbewußtsein aus und übertraf sich in der letzten Phase seiner Karriere selbst (Abb. 80, S. 39). Tatsächlich führte Elvgren seine späten Pin-ups in einem meisterhaften Stil aus, der in mancherlei Hinsicht an den von John Singer Sargent heranreicht. Mochte er in seinem frühen Werk problematische Stellen hier und da mit Mitteln der Requisite, der Komposition oder des Lichts überspielt haben, so waren sein konzeptueller Ansatz und seine Maltechnik nun vollendet.

Gil Elvgren – der Mann, der sich ganz der Illustration verschrieben hatte – erlag am 29. Februar 1980 im Alter von 65 Jahren einem Krebsleiden. In seinem Studio in der Featherbed Lane in Siesta Key fand Drake das letzte Pin-up für Brown & Bigelow, ein unvollendetes Meisterwerk, das in diesem Buch zum ersten Mal zu sehen ist (Abb. 81, S. 39). Elvgren ist seit nahezu zwei Jahrzehnten tot, aber seine Kunst und sein Esprit stehen lebendig vor uns. Zu genießen, was er geschaffen hat, ist das größte Kompliment und die höchste Ehre, die wir seiner Kunst zollen können. Und zweifelsohne werden die Kunsthistoriker Gil Elvgren als einen der führenden und bedeutendsten Künstler des 20. Jahrhunderts zu schätzen wissen.

## FÜNF GUTE GRÜNDE FÜR EINE ELVGREN-MONOGRAPHIE

**S. 9:** Louis K. Meisel mit Susan und Ari, New York

**1** Mel Ramos: *Peek-a-Boo*, Blond, 1964. Öl auf Leinwand, 67 x 51 cm

**2** Mel Ramos: *Camilla – Königin des Dschungels*, 1963. Öl auf Leinwand, 76 x 66 cm

**3** Die große Betty Page, fotografiert von Elvgrens Freund Art Amsie

**4** Myrna Hansen mit Pete Darrow, Elvgrens Assistenten, posiert für Gil Elvgrens *Sitting Pretty*

**5** Gil Elvgren: *Sitting Pretty*, 1953

**6** John Kacere: *Joelle '89*, 1989. Öl auf Leinen, 102 x 152 cm

## GIL ELVGREN: LEBEN UND WERK

**7** Verschiedene Künstler, unter ihnen Norman Rockwell (links) und Gil Elvgren (zweiter von rechts), bei einem Treffen von Brown-&-Bigelow-Mitarbeitern in St. Paul, Minnesota, 1947

**8** Howard Chandler Christy: *Ein modernes Paar*. Umschlag, *Motor Magazine*, 1912. Aquarellfarben und Gouache auf Karton, 97 x 76 cm

**9** Charles Dana Gibson: *Eine Witwe und ihre Freunde*. Buchcover, 1900 in *Harper's Weekly* veröffentlicht. Bleistift und Tusche auf Papier, 41 x 31 cm

**10** Howard Chandler Christy: *Die Golfverbindung*. Postkarte und Buch- illustrationen, 1902, 1905, 1908 veröffentlicht. Aquarellfarben und Gouache auf Karton, 102 x 76 cm

**11** Howard Chandler Christy: *Amelia Earhart*. Porträt und Magazinumschlag. Öl auf Leinwand, 152 x 102 cm. Datierung: September 1932

**12** Charles Dana Gibson: *Kunst hat einen langen Atem – Letzte Hand anlegen*. Centerfold, *Life*, 1925. Bleistift und Tusche auf Papier, 38 x 31 cm

**13** Harrison Fisher: *Gewinner*. Umschlag, *Cosmopolitan*, 13. Oktober 1913. Aquarellfarben und Gouache, 53 x 23 cm

**14** John Henry Hintermeister: *Eine schöne Melodie*. Kalenderillustration, veröffentlicht 1915–1920. Öl auf Leinwand, 71 x 56 cm

**15** J. C. Leyendecker: *Die Kunst sich zu kleiden – Herbst und Winter*. Umschlag eines Modekataloges, veröffentlicht September 1895. Gouache auf schwerem Papier, 43 x 36 cm

**16** J. C. Leyendecker: *Ostern*. Umschlag für *The Saturday Evening Post*, 27. März 1937. Öl auf Leinwand, 71 x 56 cm

**17** J. C. Leyendecker: Modeanzeige für Hart, Schaffner and Marx. Öl auf Leinwand, 74 x 109 cm

**18** James Montgomery Flagg: *Greta Garbo und Freunde in Hollywood*. Magazinumschlag, veröffentlicht 1930. Bleistift und Tusche auf Karton, 46 x 69 cm

**19** J. C. Leyendecker: Modeanzeige für die Kuppenheimer Clothing Company, gemalt 1919, veröffentlicht 1920. Öl auf Leinwand, 66 x 46 cm

**20** Dean Cornwell: *Marcellus und Diana vor Gericht*. Illustration für das Buch *The Robe* von Lloyd C. Douglas, veröffentlicht bei Houghton Mifflin Co., 1941, und in der Zeitschrift *Life*, 1942

**21** Harvey T. Dunn: *Akt*, gemalt 1939, veröffentlicht am 9. Juni 1941 in *Time*. Öl auf Leinwand, 71 x 102 cm

**22** McClelland Barclay: *Miss America*, 1932. Anzeige für Lucky Strike Cigarettes. Öl auf Karton, 56 x 71 cm

**23** McClelland Barclay: *Paradies für Verliebte*. Doppelseitige Illustration in *Cosmopolitan*, Juni 1932. Öl auf Leinwand, 61 x 127 cm

**24** McClelland Barclay: Anzeige für die General Motors Corp., veröffentlicht 1930. Öl auf Leinwand, 56 x 46 cm

**25** Gil Elvgren: Anzeige für Royal Crown Soda, gezeichnet 1938; 1940 als lebensgroßes, ausgestanztes Display zur Aufstellung in Geschäften reproduziert. Öl auf Leinwand, 76 x 51 cm

**26** Gil Elvgren: Anzeige für Royal Crown Soda. 1940 als ausgestanztes Display zur Aufstellung in Geschäften reproduziert. Karton, 152 x 76 cm

**27** Gil Elvgren: Umschlag eines Modekataloges, veröffentlicht 1936. Öl auf Karton, 61 x 41 cm

**28** Gil Elvgren: *Die Dionne-Fünflinge*. Kunstkalenderdruck, bei Brown & Bigelow erschienen, um 1937/38

**29** Haddon H. Sundblom: *Miss Burd*. Kalenderanzeige für Burd Piston Rings, erschienen bei Brown & Bigelow, um 1957–1960. Öl auf Leinwand, 102 x 76 cm

**30** Haddon H. Sundblom: *Pause machen für die Freundschaft*. Anzeige für die Coca-Cola Company, um 1946–1950. Öl auf Leinwand, auf Karton gespannt, 56 x 74 cm

**31** Haddon H. Sundblom: *Der Traum des Verliebten*, 1949. Anzeige für die Cashmere Bouquet Soap Company. Öl auf Leinwand, 102 x 76 cm

**32** Haddon H. Sundblom: *Miss Sylvania*. Kalenderanzeige, erschienen bei Brown & Bigelow, um 1955–1958. Öl auf Leinwand, 102 x 76 cm

**33** Haddon H. Sundblom: *Überrascht in einem Hauch von Nichts*. Kalender, bei der Louis F. Dow Company unter dem Pseudonym „Showalter", erschienen, um 1958–1960. Öl auf Leinwand, 76 x 56 cm

**34** Andrew Loomis: *Atemberaubend*. Kalender-Glamour-Pin-up, erschienen bei Brown & Bigelow. Öl auf Leinwand, 86 x 61 cm

**35** Andrew Loomis: *Das erste Auto*. Illustration für *Ladies' Home Journal*, April 1952. Öl auf Leinwand, 71 x 102 cm

**36** Gil Elvgren: *Nimm eine Cola!* Anzeige für die Coca-Cola Company, veröffentlicht um 1937. Öl auf Leinwand, 46 x 58 cm. Als ausgestanztes Schaufensterdisplay reproduziert

**37** Gil Elvgren: *So erfrischt man sich richtig*. Anzeige für die Coca-Cola Company. Öl auf Karton, 61 x 86 cm. Als 24teilige Werbetafel reprodu- ziert, um 1945–1950

**38** Gil Elvgren: *Mehr braucht man nicht, um den Durst zu löschen*. Anzeige für die Coca-Cola Company, um 1950. Öl auf Leinwand, 56 x 71 cm

**39** Gil Elvgren: *Coca-Cola sollte man reichlich mit nach Hause nehmen*. Anzeigentafel für die Coca-Cola Company

**40** Gil Elvgren: Eine besonderes Pin-up-Buch, Serie Nr. 1, veröffentlicht von der Louis F. Dow Company, um 1937

**41** Gil Elvgren: *Einen Blick auf die Knie erhaschen*. Illustration für ein Glamour-Girl-Puzzle, 1940

**42** Gil Elvgren: *Ein unübersehbares Zeichen*. Das Motiv wurde als Kalender, Notizblock und Kunstdruck von der Louis F. Dow Company veröffentlicht, 1937–1943

**43** Gil Elvgren: *Ein tolles Paar*. Kalenderzeichnung, veröffentlicht von der Louis F. Dow Company, 1943. Öl auf Leinwand, 71 x 56 cm

**44** Gil Elvgren: *Sie weiß, was Freiheit wirklich heißt*. Anzeige für General Electric in *Good Housekeeping*, Juni 1942. Öl auf Leinwand, 56 x 71 cm

**45** Gil Elvgren: Anzeige für General Electric in *Good Housekeeping*, Juni 1942

**46** Gil Elvgren: Anzeige für Four Roses Liquor, um 1947. Öl auf Karton, 41 x 36 cm. Veröffentlicht als Schaufenster- und Ladentischdisplay

**47** Pruett Carter: Illustration für die Geschichte „Tut mir leid, daß ich überhaupt existiere!" von Adelaide Gerstley in *The Saturday Evening Post*, um 1950–1955. Öl auf Leinwand und Karton, 53 x 56 cm

**48** Charles E. Chambers: Illustration für *The Saturday Evening Post*, um 1937. Öl auf Leinwand, 84 x 64 cm

**49** John LaGatta: Illustration für eine Geschichte in *Cosmopolitan*, um 1935. Öl auf Leinwand, 69 x 71 cm

**50** Gil Elvgren: Doppelseitige Illustration zu „Also Träume sind es, was du willst" von Ware Torrey Budlong in *McCall's*, März 1946. Öl auf Leinwand, 61 x 86 cm

**51** Gil Elvgren: Doppelseitige Magazin-Illustration in *McCall's*, März 1946

**52** Gil Elvgren: *Zurückgelehnte orientalische Nackte im Studio*, um 1947. Öl auf Leinwand, 41 x 69 cm

**53** Verpackung für den *Ballyhoo Calendar*, 1953 von Brown & Bigelow veröffentlicht

**54** Gil Elvgren: *Zwei-Stunden-Skizze*, um 1940–1945. Öl auf Leinwand, 74 x 58 cm

**55** Al Dorne: Anzeige für Wurlitzer (Juke Box) in *The Saturday Evening Post*, 1946. Öl auf Karton, 41 x 51 cm

**56** Walter Baumhofer: Doppelseitige Magazin-Illustration, um 1950. Öl auf Leinwand, 43 x 86 cm

**57** Tom Lovell: Doppelseitige Magazin-Illustration, um 1950. Öl auf Leinwand, 61 x 91 cm

**58** Robert G. Harris: *Die richtige Nummer*. Kalender, um 1950 von Brown & Bigelow veröffentlicht. Öl auf Leinwand, 61 x 51 cm

**59** Gil Elvgren: *Ellen öffnet einem die Augen*. Brieföffner, um 1958–1960 von Brown & Bigelow hergestellt. Plastik, 25 x 4 cm

**60** Walt Otto: Cover, Umschlag für *The Saturday Evening Post*, 28. Januar 1939. Öl auf Leinwand, 46 x 36 cm

**61** George Hughes: Umschlag für *The Saturday Evening Post*, 28. August,1954. Öl auf Masonit, 79 x 64 cm

**62** Thornton Utz: Umschlag für *The Saturday Evening Post*, 19. April, 1952. Öl auf Karton, 48 x 46 cm

**63** Walt Otto: Anzeige für Alka-Seltzer, um 1950 als Poster veröffentlicht. Öl auf Leinwand, 76 x 61 cm

**64** Gil Elvgren, um 1950

**65** Gil Elvgren: *Spaß am Schwimmbecken*. Universal-Werbetafel für die Schmidt Lithograph Corp., um 1950. Öl auf Karton, 41 x 51 cm

**66** Gil Elvgren: *Räum das Picknick weg!* Universal-Werbetafel für die Schmidt Lithograph Corp., um 1950. Öl auf Karton, 46 x 76 cm

**67** Gil Elvgren: Detail einer Universal-Werbetafel für die Schmidt Lithograph Corp. mit einer Anzeige für A-1 Pilsner Beer – Jumbo Quart, um 1950

**68/69** Gil Elvgren: *Auf Nummer Sicher gehen* und *Auf Zehenspitzen*. Beide Bilder fanden Verwendung in einer Anzeigenkampagne für Pangburn's Chocolates

**70** Gil Elvgren: Ausgestanzte Universal-Werbetafel für die Schmidt Lithograph Corp. Öl auf Karton, 46 x 41 cm

**71** Jon Whitcomb: Illustration zu der Geschichte „Ich glaube, ich liebe dich". Öl auf Leinwand, 41 x 51 cm

**72** Edwin Georgi: Illustration zu der Geschichte „Rendezvous mit Bo" in *Redbook*, Juni 1953. Öl auf Karton, 69 x 56 cm

**73** Joyce Ballantyne: *Sei kein Bleichgesicht!* Ein Werbetafeldisplay aus Karton für die Firma Coppertone. Diese Tafel wurde seit 1950 immer wieder aufgelegt

**74** Harold Anderson: *Das Coppertone Girl*. Als Kalendermotiv veröffentlicht, um 1955

**75** Eine rotierende Elektrolampe mit zwölf Elvgren-Pin-ups auf dem Lampenschirm, der um 1955 von der Econolite Corporation hergestellt wurde

**76** Mayo Olmstead: *Im Herzen immer noch ein Baby*. Einblättriger Kalender, von Brown & Bigelow veröffentlicht, um 1950. Öl auf Leinwand, 61 x 76 cm

**77** Al Buell: *Top Date*. Kalender, 1962 von Brown & Bigelow veröffentlicht. Öl auf Leinwand, 76 x 61 cm

**78** Gil Elvgren: *CrisCraft Kabinenkreuzer*, um 1955–1960. Öl auf Leinwand, 51 x 71 cm

**79** Thornton Utz: *Ohne Titel*. Öl auf Leinwand, 76 x 61 cm

**80** Gil Elvgren, um 1970

**81** Gil Elvgren: Ein unvollendetes und bislang unveröffentlichtes Gemälde

# GIL ELVGREN

## Les Pin-Up américaines du maître glamour

**POURQUOI UNE MONOGRAPHIE D'ELVGREN ?**
*Louis K. Meisel*

1. C'est le meilleur artiste de pin-up dans l'histoire de l'illustration américaine.
2. Il a connu une carrière suffisamment prolifique et importante pour alimenter un grand album à lui seul.
3. Il a exercé une vaste influence en tant qu'artiste et enseignant.
4. Après la publication de *L'Age d'or de la pin up américaine*, nous avons été submergés de demandes le concernant.
5. Notre ami Art Amsie l'avait promis à l'artiste.

1. Je crois que l'on peut affirmer sans crainte que Gil Elvgren fut et continue d'être le plus grand créateur de pin-up au monde. Près d'un quart de million de gens ont déjà admiré les œuvres des soixante-dix-sept illustrateurs présentés dans *L'Age d'or de la pin up américaine*, écrit par Charles Martignette et moi-même. Je suis sûr que si on leur demandait de voter pour le meilleur d'entre eux, Elvgren serait élu haut la main.

2. Du milieu des années 30 à 1972, Elvgren a créé plus de cinq cents images de jolies filles. Presque toutes furent peintes à l'huile sur toile et étaient des œuvres d'art à part entière. Dès le début, ses images étaient remarquables, et elles n'ont cessé de s'améliorer au fil des ans. Elvgren s'est toujours surpassé, peaufinant chaque fois ses idées, ses compositions, ses couleurs et sa technique.

3. Au fil des ans, Elvgren a influencé des dizaines de jeunes artistes qui ont été ses assistants, ont étudié ses œuvres ou ont cherché à suivre l'exemple du « maître ». Son influence ne s'est pas exercée uniquement sur les autres illustrateurs de pin-up et d'autres domaines de l'illustration, mais également sur d'autres artistes comme le peintre de Pop Art, Mel Ramos (ill. 1 et 2, p. 10). Le peintre photoréaliste John Kacere le connaissait et reconnaît lui aussi s'en être inspiré (ill. 6, p. 11). Comme il le dit lui-même : « Lorsque j'ai demandé à Gil si je pouvais travailler dans son atelier, il m'a répondu que je devais me consacrer à la peinture et non me cantonner dans le domaine des pin-up. »

4. Lorsque *L'Age d'or de la pin up américaine* a été publié, Elvgren a déclenché une vague d'enthousiasme. Nous avons reçu de nombreuses lettres nous demandant de présenter plus de ses œuvres. Nous avions toujours eu l'intention de rendre hommage à ce grand artiste, ce mouvement d'admiration n'a fait que nous encourager davantage.

5. Art Amsie, que Charles et moi connaissons bien, a été proche d'Elvgren pendant de longues années. Il nous a aidés à mieux connaître son œuvre et nous a fourni de ses peintures. Art était également un ami du célèbre modèle de pin-up Betty Page, qu'il a photographiée dans les années 50 (ill. 3, p. 10). Dans les années 60 et 70, il a tenu une galerie, « The Girl Whirl», alors la seule à être consacrée à l'art de la pin-up. Au moment où Elvgren s'éteignait du cancer, Art lui a promis de faire tout son possible pour réaliser son rêve : publier un jour un livre sur son œuvre. Lorsque j'ai rencontré Art il y a de nombreuses années, je lui ai annoncé qu'avec son aide, je me chargerais de rendre ce rêve réalité. Ce volume est donc l'accomplissement d'une promesse, faite à Gil Elvgren, à Art et au monde.

Il a fallu près de dix ans pour rassembler ces images. Elles représentent pratiquement quatre-vingt-dix-huit pour cent de la production de pin-up et d'art glamour de Gil Elvgren. Avec l'aide d'Art Amsie, j'ai commencé par les listes et les informations de droits d'auteur qu'il avait collectées. J'ai également bénéficié des listes de titres et des descriptions compilées par Earl Beecher et Michael Stapleton. J'ai obtenu des informations de source directe en m'entretenant avec Joyce Ballantyne, une consœur d'Elvgren, et avec ses anciens modèles Myrna Hansen et Janet Rae. Myrna Hansen a posé pour de nombreuses images d'Elvgren, dont *Sitting Pretty* (ill. 4 et 5, p. 11) à Glamourcon à Los Angeles. Janet Rae, la fille des voisins d'Elvgren, a posé pour bon nombre des meilleures peintures d'Elvgren, y compris *Inside Story*, *Well Built*, *Puppy Love* et *Sheer Comfort*. Elle a longuement répondu aux questions de notre amie Marianne Phillips. Marianne est une antiquaire spécialisée dans les pin-up mais, surtout, elle a passé des années à faire des recherches sur les artistes de pin-up et leurs œuvres. C'est une source inépuisable d'informations sur Zoë Mozert, Joyce Ballantyne et, naturellement, Gil Elvgren. Nous lui sommes particulièrement reconnaissants d'avoir accepté de partager son savoir avec nous.

Bien sûr, notre principale source d'informations et de matériaux a été Brown & Bigelow, le plus grand éditeur de calendriers de tous les temps. William Smith Sr. et William Smith Jr. les propriétaires actuels, ainsi que Teresa Roussin, archiviste et responsable des droits, ont répondu à notre avalanche de questions, nous donnant les autorisations nécessaires, leurs encouragements et un soutien généreux. Elvgren ayant consacré le plus gros de sa carrière à créer des images pour leurs collections de calendrier, il était naturel qu'ils soient associés à ce projet pour immortaliser son œuvre. Compte tenu de la demande incessante en pin-up d'Elvgren, nous espérons qu'il y aura de plus en plus de rééditions d'images puisées dans les archives de Brown & Bigelow.

Nous avons choisi de présenter d'abord la vie d'Elvgren, suivie de ses œuvres. Contrairement à d'autres artistes dont les peintures sont présentées et vendues dans des galeries, et sont donc datées, intitulées et documentées, celles d'Elvgren étaient destinées à être reproduites. Par conséquent, une peinture achevée en 1948 n'était parfois enregistrée qu'en 1948 ou 49, et imprimée en 1950, voire plus tard. Les peintures d'Elvgren étant rarement datées, les dates indiquées sont approximatives, établies en fonction du style, du modèle, de la situation, de l'enregistrement des droits ou de la date indiquée sur le produit portant l'image. La plupart du temps, ces indices nous ont permis de retrouver la date exacte et notre marge d'erreur ne devrait pas excéder un ou deux ans. Les illustrations ont été classées dans l'ordre suivant : Les années Louis F. Dow (1937–1944) ; trois chapitres consacrés aux images pour Brown & Bigelow : Les années 40, les années 50, de 1960 à 1972 ; et enfin, les travaux publicitaires, dont les images pour NAPA et Sylvania (également produites par Brown & Bigelow) qui étaient généralement réalisées un an avant la date apparaissant sur les calendriers, ainsi que divers travaux datés en fonction des rares informations dont nous disposons.

Les titres sont eux aussi problématiques. Il arrivait à Elvgren de suggérer un titre, mais la plupart étaient inventés par les rédacteurs travaillant chez les éditeurs de calendriers. Une peinture paraissait parfois sur un calendrier sous un titre, puis était rééditée en couverture de bloc-notes sous un autre, puis sous forme de buvard avec un autre encore. Lorsqu'un seul titre apparaît dans une légende, il s'agit soit du titre enregistré soit du seul que nous ayons retrouvé (certaines images ont été rebaptisées plusieurs fois à mesure qu'elles changeaient de propriétaire). Les titres secondaires figurent entre parenthèses à la suite du titre principal.

Pratiquement tous les travaux d'Elvgren pour Brown & Bigelow furent réalisés à l'huile sur des toiles de 76 x 61 cm. Ceux pour Louis F. Dow faisaient 71 x 56 cm.

Nous avons tenté d'utiliser la meilleure source possible pour chaque illustration. Malheureusement, nous n'avons disposé parfois que d'une mauvaise photocopie d'une mauvaise photo de calendrier. Toutefois, nous avons pu photographier deux cents originaux, dont la plupart nous appartiennent ou nous ont appartenu. A mesure que d'autres originaux referont surface, nous essaierons de fournir de meilleures reproductions dans les rééditions suivantes. Naturellement, nous espérons que toutes les nouvelles découvertes nous serons signalées.

## LA VIE ET L'ŒUVRE DE GIL ELVGREN
*Charles G. Martignette*

Gil Elvgren (1914–1980) fut le plus grand dessinateur de pin-up et d'art glamour du XXe siècle. Au cours de sa carrière, qui a débuté au milieu des années 30 et s'est étalée sur plus de quarante ans, il est devenu l'artiste de prédilection des collectionneurs et des admirateurs de pin-up dans le monde entier. Bien qu'il ait surtout travaillé sur commande pour des sociétés commerciales, il est de plus en plus reconnu comme un artiste à part entière par un nombre croissant de collectionneurs privés, de galeristes, de marchands d'art et de conservateurs de musée. Si, pendant près de trois quarts de siècle, le grand public l'a surtout associé aux pin-up, Elvgren mérite d'être reconnu pour ce qu'il est : un illustrateur américain de formation classique ayant touché à de nombreux domaines de l'art commercial. Même s'il était passé maître dans l'art de dépeindre la beauté féminine, son œuvre est loin de se confiner à l'industrie des calendriers de pin-up.

Elvgren doit indubitablement une grande partie de sa célébrité aux séries de pin-up devenues légendaires réalisées pour l'éditeur de calendriers Brown & Bigelow de St. Paul (Minnesota) pendant trente ans. Ses campagnes publicitaires pour Coca-Cola, qui ont duré vingt-cinq ans, ont également contribué à établir sa réputation comme l'un des plus grands illustrateurs de son temps. Si ses affiches pour Coca-Cola incluaient des pin-up typiquement « Elvgren », un grand nombre des autres images pour la célèbre marque représentait des familles américaines moyennes, des enfants, des adolescents, en somme, des gens ordinaires menant une existence ordinaire. Pendant la Seconde Guerre mondiale et la guerre de Corée, il peignit également des scènes militaires pour la même firme. Comme ses célèbres pin-up pour Brown & Bigelow, les campagnes pour Coca-Cola devinrent des images emblématiques de la vie américaine.

Ces dernières représentaient le rêve américain d'une vie saine et confortable, alors que ses célèbres illustrations d'articles de magazines saisissaient souvent des moments hors du temps : elles reflétaient les espoirs, les craintes et les joies des lecteurs. Il réalisa ces commandes éditoriales pendant les années 40 et 50 pour des magazines américains « grand public » tels que *McCall's*, *Cosmopolitan*, *Good Houskeeping* et *Woman's Home Companion*.

Dans le domaine de la publicité, outre ses travaux pour Coca-Cola, il réalisa des campagnes pour de célèbres marques américaines comme Orange Crush, Schlitz Beer, Sealy Mattress, General Electric, Sylvania et Napa Auto Parts. Entre ses images pour Brown & Bigelow, Coca-Cola, d'autres annonceurs nationaux et ses illustrations éditoriales, Elvgren était très demandé. Il fallait généralement lui passer commande plus d'une année à l'avance.

Elvgren était également photographe professionnel, maniant l'objectif avec la même dextérité que ses pinceaux. Son talent et son énergie hors du commun ne s'arrêtaient pas là : il était aussi le professeur respecté, voire adulé, de nombreux élèves qui devinrent célèbres à leur tour, notamment grâce à son enseignement et ses encouragements.

Bien avant de s'inscrire à son premier cours d'art en 1933, Elvgren avait été fortement impressionné par les premiers illustrateurs de « jolies filles » tels que Charles Dana Gibson, Howard Chandler Christy, Harrison Fisher et James Montgomery Flagg, ainsi que par leurs successeurs, les artistes de « glamour and romance », dont McClelland Barclay, Haddon H. Sundblom, Andrew Loomis, Charles E. Chambers et Pruett Carter. Dès ses débuts, il prit l'habitude de tenir à jour un système de fichiers très détaillé et de collectionner des pages et des couvertures de magazine présentant les œuvres des illustrateurs qu'il admirait ou qui l'intéressaient. Semaine après semaine, mois après mois, il se tint à ce rituel. Ces illustrations devaient plus tard influencer non seulement sa technique de peinture mais également la manière dont il abordait certaines commandes.

Pour mieux comprendre l'importance de l'œuvre d'Elvgren, il me paraît nécessaire de commencer par examiner brièvement deux groupes d'artistes qui l'ont influencé au début de sa carrière. De même, à mesure que nous progresserons dans l'étude chronologique de sa vie et de son œuvre, nous nous pencherons sur le travail d'autres artistes qui l'ont inspiré tout au long de sa carrière. Nous mentionnerons également ceux qui n'ont cessé de l'imiter. Certains avaient été ses élèves, d'autres ses amis, d'autres encore ne l'avaient jamais rencontré mais, comme il le faisait lui-même, connaissaient son travail grâce aux pages qu'ils arrachaient dans les magazines. En examinant ainsi le contexte dans lequel Elvgren travaillait, nous brosserons un portrait complet, détaillé, et, espérons-le, divertissant, de l'homme et de l'artiste, le « Norman Rockwell » de la pin-up et de l'art glamour.

De nombreux historiens d'art considèrent Felix Octavius Carr Darley (1822–1888) comme le premier illustrateur américain digne de ce nom. Il eut une carrière prolifique, travaillant à la fois pour des éditeurs, illustrant les œuvres des grands auteurs de son temps (Poe, Hawthorne et Longfellow, entre autres), et pour des magazines, contribuant régulièrement au *Harper's Weekly*. Plus important encore, Darley fut le premier illustrateur américain à concurrencer avec succès les écoles européennes et britanniques qui avaient jusque-là monopolisé l'art commercial américain.

Darley devint membre de la National Academy en 1853. Cette même année naissait à Wilmington (Delaware) celui qui, vingt-cinq ans plus tard, deviendrait le véritable père de l'illustration américaine. Howard Pyle (1853–1911) fut un artiste à la productivité impressionnante, l'auteur de nombreux livres et, enfin, le fondateur de la Brandywine School, qui allait influencer l'illustration américaine pendant les cent années à venir. Presque tous les illustrateurs du XXe siècle qui travaillèrent en utilisant des techniques de peintre, Elvgren y compris, furent directement influencés par l'enseignement de Pyle et de ses meilleurs élèves : Harvey T. Dunn (1884–1952) et Frank Schoonover (1877–1972).

Comme nous le verrons plus tard, Elvgren partageait une grande admiration pour la philosophie de l'école de Brandywine avec son ami Norman Rockwell (1894–1978). Les deux hommes se lièrent d'amitié en 1947, alors qu'ils assistaient à un congrès des directeurs de Brown & Bigelow à St. Paul (ill. 7, p. 15). Elvgren et Rockwell étaient de la même trempe : tous deux avait le don de croquer des gens ordinaires dans des situations parfaitement crédibles. La seule différence était que Rockwell disposait d'un éventail de sujets illimité dans ses commandes, alors que les pin-up d'Elvgren lui laissaient moins de liberté. Rockwell eut rapidement l'occasion de confier à son cadet ce que ce dernier avait déjà souvent entendu dire ses amis artistes : il admirait son travail et l'enviait de pouvoir peindre les plus belles femmes du monde. Leur rencontre marqua le début d'une longue amitié et, lorsqu'ils se retrouvaient chaque année, ils échangeaient même leurs petits secrets artistiques.

L'apparition de l'art glamour au XXe siècle fut une des conséquences naturelles de l'épanouissement plus général de l'illustration américaine, celle-ci bénéficiant des progrès en matière d'impression. A la fin du XIXe siècle, la production d'art commercial s'accéléra considérablement pour faire face aux demandes en illustrations des nouveaux magazines hebdomadaires et mensuels. L'une des premières leçons qu'apprirent les éditeurs fut qu'une revue se vendait mieux lorsqu'elle comportait des illustrations, tant en accompagnement des articles qu'en couverture. En outre, à la même époque, les

Etats-Unis connurent une explosion démographique qui ne fit qu'alimenter la demande en journaux et l'exigence de qualité.

Dix ans après la première illustration publiée de Pyle, le public fit connaissance avec sa première vraie pin-up américaine. Cette beauté idéalisée, à mi-chemin entre « la fille d'à côté » et « la créature de rêve », vit le jour sous les pinceaux de Charles Dana Gibson (1867–1944), à Boston, dans le Massachusetts, vers 1887. Promue rapidement « la chérie de l'Amérique », la « Gibson Girl » était principalement représentée au crayon et à la plume. Son image fut publiée dans tous les premiers périodiques, y compris *Scribner's*, *Century* et *Harper's Weekly*. Elle remporta un tel succès que les « Gibson Girls » apparurent bientôt dans les revues populaires telles que *Life* et *Collier's*, d'abord en couverture, puis sous forme de poster central de deux pages. La jeune fille seule des premiers dessins laissa bientôt la place à des groupes de femmes, puis à une femme et un homme ou à des groupes mixtes. Les hommes devinrent bientôt connus sous le nom de « Gibson Man » et furent accueillis avec enthousiasme par les admirateurs de la « Gibson Girl ».

Vers 1900, la « Gibson Girl » (et le « Gibson Man ») avait atteint un niveau de popularité internationale sans précédent. On en retrouvait des copies partout en Amérique et en Europe. Les dessins de Gibson étaient publiés et reproduits sous forme de gravures, de lithographies, de calendriers, d'affiches et de couvertures de magazine ainsi que dans d'innombrables produits publicitaires tels que des cartes à jouer, des blocs-notes, des tampons buvards et des éventails. Il y eut même des papiers peints, de la vaisselle en porcelaine, des boîtes à bijoux et des parapluies portant son effigie. Entre 1898 et 1900, *Harper's* et *Scribner's* publièrent quatre albums luxueux contenant des sélections de dessins de Gibson. Le dernier en date, intitulé *A Widow and Her Friends* (Une veuve et ses amies), arborait en couverture un dessin que Gibson qualifia lui-même d'épitomé de la « Gibson Girl » (ill. 9, p. 15).

La « Gibson Girl » a enchanté plus d'une génération d'Américains. Elle vit le jour pendant la période de l'Art nouveau et poursuivit sa carrière pendant les Années folles sous la forme d'une jeune femme émancipée dansant le Jitterbug et le Charleston dans les Speakeasy. Afin d'élargir son public durant la période Art déco, Gibson en intégra le style et la mode dans ses dessins (ill. 12, p. 15).

La pin-up suivante à faire son entrée sur la scène fut la « Christy Girl ». Créée par Howard Chandler Christy (1873–1952), elle devint presque aussi célèbre que la « Gibson Girl ». Le « Christy Man » suivit dans la foulée, l'artiste peignant de nombreuses scènes d'amoureux romantiques.

Christy commença sa carrière en réalisant des couvertures pour de grands magazines (ill. 8, p. 15), puis des illustrations de livres (ill. 10, p. 15). Mêmes des romans tels que *Le Dernier des Mohicans* furent illustrés avec des scènes incluant une « Christy Girl ». Christy vivait à New York, où il avait un atelier à l'Hôtel des Artistes. Il peignit les fameux nus sensuels de la salle de restaurant qui, aujourd'hui encore, attirent des touristes venus du monde entier. En 1921, alors à l'apogée de sa carrière, il cessa de faire des illustrations pour se consacrer au portrait. Sa commande la plus célèbre, un portrait d'Amelia Earhart, fut achevée en 1932. Cette huile sur toile (ill. 11, p. 15) fut plus tard reproduite en couverture du numéro de février 1933 de *Town & Country*. Ce fut la seule exception à la décision de Christy de ne plus laisser ses œuvres être utilisées à des fins commerciales. Ce joyau de l'art américain fut exposé lors d'une exposition de Christy intitulée « Portraits de célébrités » au musée d'art de Baltimore en janvier 1936. Il était accroché entre les portraits de Will Rogers et de William Randolph Hearst. Peu de temps après, il disparut et ne fut retrouvé que récemment. Il est reproduit ici pour la première fois en plus de soixante ans.

Harrison Fisher (1875–1934) fut l'un des autres artistes glamour dont les créations portaient son nom. La « Fisher Girl », qui rivalisait avec les beautés de Gibson et de Christy, apparut pour la première fois dans *Puck* vers 1898. Pendant les années 10 et 20, Fisher eut la prestigieuse responsabilité de réaliser toutes les couvertures de *Cosmopolitan* (ill. 13, p. 16). Finalement, à l'instar de Christy, il décida de se consacrer exclusivement au portrait. De fait, cette tendance finit presque par devenir une tradition pour les générations d'illustrateurs qui leur succédèrent. Après avoir atteint des sommets dans le domaine de l'art commercial, ils voulaient être reconnus dans celui des « beaux-arts ». Pour ces artistes, le portrait était la meilleure route à suivre pour obtenir la reconnaissance qu'ils cherchaient auprès des musées,

des critiques et de la communauté des beaux-arts. Malheureusement, au moment où leur carrière commerciale s'achevait, un grand nombre d'entre eux n'étaient plus au sommet de leurs capacités artistiques et physiques.

Gil Elvgren étudia minutieusement le travail de ces premiers artistes classiques, car le clan Gibson-Fisher-Christy avait établi la base à partir de laquelle toutes les autres images glamour (et les pin-up) furent créées. John Henry Hintermeister (1870–1945) fut un autre des artistes qui influencèrent Elvgren. Bien qu'il se soit surtout concentré sur des sujets liés au folklore américain, il réalisa un certain nombre de pin-up sensuelles et d'images glamour pour des calendriers (ill. 14, p. 16).

Le dernier grand précurseur de l'illustration américaine à influencer à la fois Gil Elvgren et Norman Rockwell fut J.C. (Joseph Christian) Leyendecker (1874–1951). Rockwell le vénérait et, dans son autobiographie, parle de lui comme son idole, son mentor et sa principale source d'inspiration. Il se rendait souvent à la gare de New Rochelle en début de soirée pour le regarder descendre du train alors qu'il rentrait de son atelier de Manhattan. Des années plus tard, lorsque la carrière de Rockwell eut pris des proportions semblables à la sienne, ils devinrent amis. L'admiration d'Elvgren pour Leyendecker remontait à l'époque où il commença à suivre des cours à l'Academy of Art de Chicago. Il visitait souvent l'Art Institute afin d'y voir les dessins réalisés par Leyendecker quand il était étudiant et conservés dans les collections du musée.

La carrière de Leyendecker prit un essor considérable en 1895 quand il reçut commande d'une couverture pour un catalogue de mode. Sa peinture, *Art in Dress – Fall and Winter* (L'Art du vêtement – Automne et hiver ; ill. 15, p. 16) est un exemple rare et superbe de l'intégration du style Art nouveau dans la représentation d'un jeune couple beau et élégant. En 1899, Leyendecker réalisa sa première couverture pour *The Saturday Evening Post*. Elle marqua le début d'une relation de presque toute une vie entre l'artiste et la Curtis Publishing Company. Parmi ses quelque trois cents couvertures pour le *Post*, les plus belles sont celles réalisées entre le milieu et la fin des années 30, qui ont toutes un côté ludique et espiègle (ill. 16, p. 16).

L'image la plus célèbre de Leyendecker, l'homme des chemises Arrow, fut créée pour le fabricant de vêtements masculins Cluett Peabody pendant les années 20 et 30. Le séduisant modèle qui apparaissait dans ces campagnes rencontrait un tel succès que, chaque semaine, l'artiste et l'agence de publicité de la compagnie recevaient des centaines de lettres d'admiratrices le demandant en mariage. Bien que Leyendecker ait surtout réalisé des publicités pour la mode masculine (ill. 19, p. 17), il ne dédaignait pas d'inclure une jolie fille dans ses images. Sa campagne publicitaire légendaire pour Hart, Schaffner and Marx (ill. 17, p. 17) remporta un succès similaire à celle de l'homme des chemises Arrow auprès du public et fit considérablement grimper les ventes.

Ce qu'Elvgren et Rockwell admiraient surtout chez Leyendecker, c'était son double talent virtuellement inégalé par aucun autre artiste ou illustrateur avant lui. Il avait une manière unique d'intégrer la toile nue dans sa composition de sorte à ce qu'elle serve à la fois de couleur de fond et d'élément pictural dans l'image finale. De nombreux autres illustrateurs s'y essayèrent sans succès. D'autre part, Leyendecker était un excellent dessinateur qui construisait ses dessins comme un architecte dessine un bâtiment. A cet égard également, il eut peu de rivaux. Pratiquement tous les illustrateurs du XX$^e$ siècle tentèrent d'obtenir le même effet, mais Elvgren et Rockwell furent parmi ceux qui réussirent le mieux à l'imiter.

James Montgomery Flagg (1877–1960) était un autre membre du club glamour Gibson-Christy-Fisher. Comme les autres membres du groupe, il peignit de nombreuses scènes de la vie quotidienne, mais le centre d'intérêt principal de son œuvre étaient les images de jolies Américaines. Flagg, comme Christy, était le chouchou des médias. Tous deux faisaient souvent l'objet d'articles de journaux et de magazines et apparaissaient dans les nouvelles présentées avant les films dans les cinémas. Bien qu'il soit surtout connu pour sa célèbre affiche de mobilisation dans l'armée pendant la Première Guerre mondiale (*Uncle Sam – I Want You*), ses « Flagg Girls » avaient leurs propres admirateurs, dont Elvgren. (Ils se rencontrèrent brièvement à New York vers le milieu des années 50.) Elvgren était très impressionné par la maîtrise de Flagg au crayon et à l'encre, comme on peut le constater dans *Garbo and Friends* (Garbo et des amis ; ill. 18, p. 17). Cette illustration servit de page de garde au livre de Susan Mayer *James Montgomery Flagg* (New York, Watson-Guptill, 1974). Bien qu'Elvgren n'ait

jamais travaillé avec ce médium, il admirait les superbes dessins au trait de Flagg (et de Gibson).

Un grand nombre des illustrateurs qui influencèrent Elvgren au début de sa carrière étaient des élèves de la Brandywine School d'Howard Pyle. Parmi ces derniers et non des moindres : Harvey T. Dunn, le protégé de Pyle et son élève le plus accompli. Dunn devint lui aussi un professeur influent, transmettant une combinaison de sa propre philosophie et de celle de Pyle à des centaines d'artistes. Dean Cornwell (1892–1960) fut sans doute le plus célèbre de ses élèves (ill. 20, p. 18) et son influence sur la génération d'Elvgren fut si marquante qu'ils le baptisèrent le « Dean » (le doyen) des illustrateurs.

Le rôle crucial que joua Dunn dans l'évolution d'Elvgren est démontré par l'immense archive que le jeune artiste avait constitué en découpant les images de son aîné dans des revues. Faisant huit centimètres d'épaisseur, il s'agissait surtout d'illustrations de magazines et d'images publicitaires. Le dossier contenait également un fascinant article paru dans *Time Magazine*, daté du 9 juin 1941, sur Dunn et l'une de ses plus célèbres peintures. On y voyait un nu de face très sensuel (et, pour l'époque, très osé) que Dunn avait peint en 1939 (ill. 21, p. 18), accompagné d'une photo de l'artiste se tenant fièrement devant son œuvre. L'article racontait comment, lorsque le nu de Dunn avait été exposé en mai 1941 au Guild Artists Bureau à New York (dans une exposition intitulée « Sexhibition »), George Baker, le directeur de la galerie, avait invité le public a voter dans cinq catégories : meilleure œuvre à emporter sur une île déserte ; meilleure œuvre à emporter dans le désert ; meilleure œuvre à avoir chez soi ; meilleur tout court, et Waow ! La légende révélait que le tableau de Dunn avait remporté les cinq catégories.

Enfin, McClelland Barclay (1891–1943) fut également un modèle pour Elvgren et ses confrères dans les années 30. Ses tableaux Art déco très stylisés représentaient le « gratin » de l'époque, et plus particulièrement les femmes du monde. Ses célèbres campagnes pour les cigarettes Lucky Strike montraient, entre autres, Miss America 1932 fumant sa marque préférée (ill. 22, p. 18). Ses illustrations de nouvelles pour *Cosmopolitan* (ill. 23, p. 18) impressionnèrent beaucoup le jeune Elvgren. Puissantes, elles étaient peintes dans un style sec et assuré, avec un recours inhabituel à la perspective. Sa campagne pour Fisher Body (General Motors ; ill. 24, p. 18) acheva d'établir sa réputation. Malheureusement, Barclay mourut pendant la Seconde Guerre mondiale alors qu'il peignait des scènes de bataille sur un bateau qui fut torpillé.

Ayant à l'esprit ses différentes influences artistiques, nous pouvons à présent nous pencher sur l'histoire de Gil Elvgren et suivre l'évolution de sa remarquable carrière.

En 1933, alors que la Grande Dépression tenait l'Amérique entre ses griffes, un jeune idéaliste de dix-neuf ans s'enfuit avec la lycéenne de son cœur. C'était par un jour froid à St. Paul, dans le Minnesota, mais pour Gillette A. Elvgren et Janet Cummins, l'air était chargé de promesses, d'aventure et de défis à venir. Ce n'était pas le froid qui aurait fait peur à Elvgren. Il était né par un jour glacial, le 15 mars 1914, et en avait connu bien d'autres pendant son enfance dans la région de St. Paul – Minneapolis. Ses parents, Alex et Goldie Elvgren, possédaient un magasin de peinture et de papiers peints au centre de St. Paul, surmonté d'une enseigne au néon indiquant leur patronyme avec des lettres très semblables à celles de la première signature artistique de leur fils.

Après avoir achevé ses études secondaires, Elvgren décida de devenir architecte. Ses parents l'encouragèrent car ils avaient déjà remarqué le don naturel de leur fils pour le dessin dès l'âge de huit ans. Il avait été expulsé de classe plusieurs fois pour avoir dessiné dans les marges de ses manuels scolaires. Elvgren alla à l'université du Minnesota pour y étudier l'architecture et le design. Il suivit également des cours au Minneapolis Art Institute et, lors de cours d'été dans cet établissement en 1933, décida qu'il préférait créer des œuvres d'art plutôt que de dessiner des bâtiments ou des parkings.

Au cours de l'automne de cette même année, il prit une autre décision importante qui allait enrichir sa vie pendant les trente années qui allaient suivre : celle d'épouser Janet Cummins. Le couple attendit près de deux mois avant d'annoncer la nouvelle de leur mariage à leurs familles respectives, ce qui ajouta une réjouissance supplémentaire aux fêtes de Thanksgiving et de Noël de cette année. Pour la nouvelle année, le couple décida de s'installer à Chicago, qui offrait plus de possibilités pour une carrière artistique. Ils auraient pu choisir New York, mais Chicago était plus près de

chez eux et convenait bien pour parfaire l'éducation artistique de Gil. Elle était également plus petite que New York et moins menaçante.

Dès son arrivée à Chicago, le jeune artiste s'attela à la tâche. Prudent, il décida d'absorber et d'apprendre le plus possible et le plus vite possible afin de pouvoir travailler au plus tôt. Il s'inscrivit à la prestigieuse American Academy of Art, située au centre ville. Là, il se lia d'amitié avec Bill Mosby, un artiste et un professeur accompli qui veilla jalousement sur l'évolution de son talentueux élève. Au cours d'un entretien, aujourd'hui conservé dans les archives de Brown & Bigelow, Mosby se remémora cette période :

Enseigner l'art est comme enseigner les mathématiques ou n'importe quelle autre discipline. Il y a certains principes de base que tout le monde peut apprendre. On peut enseigner à dessiner et à peindre à n'importe qui, mais on ne peut pas en faire des artistes.

Lorsque Gil est arrivé à l'American Academy, il avait du talent, certes, mais pas plus que la plupart des autres étudiants. Ce qui le distinguait, c'était sa détermination. Beaucoup d'étudiants n'ont pas une idée bien définie de ce qu'ils veulent faire. Gil le savait dès le début. Il voulait avant tout être un bon peintre. En deux ans, il a emmagasiné l'équivalent de trois ans et demi de travail. Il suivait des cours du jour, des cours du soir et des cours d'été. Pendant ses heures libres et les week-ends, il peignait.

C'était un bon élève et je n'ai jamais vu un étudiant travailler avec autant d'acharnement. Il suivait tous les cours susceptibles de lui apprendre quelque chose sur la peinture. On tenta de lui expliquer qu'il n'était pas bon de mettre tous ses œufs dans le même panier et qu'il devait suivre des cours de mise en page et de calligraphie qui lui apporteraient une formation plus souple pour travailler dans le domaine de l'illustration. Il reconnaissait que c'était logique et appréciait qu'on s'intéresse à son sort, mais il refusait toujours. En deux ans, il a fait des progrès phénoménaux. C'est sans conteste celui de nos élèves qui a le mieux réussi.

C'est un bon peintre et, en tant que de dessinateur, il n'a pas son pareil. Il a des mains extraordinaires. Il est bâti comme un footballeur et a des paluches si grandes que le crayon y paraît tout petit. Pourtant, la légèreté de son coup de crayon et les variations subtiles dont il est capable rappellent la dextérité d'un grand chirurgien.

Outre son talent et sa maîtrise technique, c'est également un des types les plus sympas du métier. Son succès ne lui a pas donné la grosse tête.

Lors de son séjour de deux ans et demi à l'Academy, Elvgren ne s'accorda pas une seconde de répit et décrocha son diplôme deux fois plus vite que la normale. Ses travaux d'étudiants étaient si bons que l'école les utilisait souvent pour illustrer ses brochures et ses catalogues. A l'Academy, Elvgren rencontra également bon nombre d'autres étudiants qui devinrent ses amis. Il forma avec certains un réseau d'entraide professionnel qui perdura toute sa carrière. Parmi eux, Harold Anderson, Joyce Ballantyne, Al Buell, Thornton Utz et Coby Whitmore qui, comme nous le verrons plus tard, furent très influencés par son art. Déjà à cette époque, ses confrères étaient frappés par son talent, par la magie de ses mains sur la toile.

Toutefois, il n'avait encore jamais vendu une œuvre ni reçu une commande. Le jeune couple avait du mal à joindre les deux bouts à Chicago, mais ils furent récompensés par les incroyables progrès réalisés par Gil.

En 1936, ils décidèrent de revenir s'installer à St. Paul, où Gil ouvrit fièrement un atelier. Heureusement, sa première commande suivit presque aussitôt : la couverture d'un catalogue de mode, un beau jeune homme vêtu d'une veste croisée et d'un léger pantalon blanc à pinces (ill. 27, p. 20). Conformément aux instructions du directeur artistique de la maison commanditaire, l'œuvre originale fut réalisée à l'huile sur planche d'illustrateur et non signée. Dès qu'il eut reçu la commande, le président de la compagnie téléphona à Elvgren pour le féliciter et lui commander une demi-douzaine d'autres couvertures de catalogues. Le jeune artiste était lancé !

Quelques semaines plus tard, il reçut un autre appel déterminant, cette fois, au sujet d'une éventuelle campagne publicitaire pour laquelle on lui demandait de présenter son portfolio. Il s'agissait de peindre un portrait des quintuplées Dionne, qui faisaient sensation dans les médias. Elvgren avait pensé qu'il lui faudrait travailler pendant des années avant de bénéficier d'une occasion pareille. Outre le fait qu'il s'agissait de peindre de jolies jeunes filles,

la commande avait un autre intérêt : elle émanait de Brown & Bigelow, le plus important éditeur de calendriers du monde. Les deux portraits des quintuplées Dionne par Elvgren parurent dans les calendriers de 1937 (ill. 28, p. 20) et 1938 et remportèrent un immense succès. Brown & Bigelow reversèrent 58 097,17 dollars de royalties aux célèbres sœurs, ce qui témoigne du succès de ces deux images. Tout le monde chez l'éditeur était ravi du travail d'Elvgren. Ayant commencé sa carrière en peignant les jeunes filles les plus célèbres, aimées et admirées d'Amérique, il était devenu lui-même un phénomène : un illustrateur rencontrant le succès du jour au lendemain.

Au début de 1937, Elvgren fut contacté par le plus grand rival de Brown & Bigelow, la Louis F. Dow Calendar Company, dont le siège se trouvait également à St. Paul. Son directeur artistique lui commanda une série de pin-up. Le jeune artiste n'en croyait pas ses oreilles : non seulement il avait la chance inouïe de recevoir deux commandes exceptionnelles dès le début de sa carrière mais on lui demandait de peindre des jolies filles que tout le monde verrait sur des calendriers. Elvgren ignorait alors que la Dow Company reproduirait ses œuvres sous toutes sortes de format, y compris des blocs-notes, des buvards, des cartes postales, des boîtes d'allumettes et des jeux de cartes. Elle édita même des petits livres de 20 x 25 cm, avec une pin-up d'Elvgren en couverture et une douzaine de reproductions à l'intérieur.

En 1944, quand Elvgren quitta Dow pour travailler pour Brown & Bigelow, l'éditeur engagea un artiste pour repeindre certaines parties des pin-up réalisées par Elvgren pour la maison. Ainsi, elle pouvait à nouveau utiliser les images sans avoir à payer Elvgren ni à lui reverser de royalties. Heureusement, l'artiste choisi pour accomplir cette tâche était le très talentueux Vaughan Alden Bass, qui avait un grand respect pour le travail d'Elvgren, Le plus souvent, il se contenta de retoucher les fonds et les vêtements en laissant les visages, les mains et les jambes intactes. La version retouchée de A Perfect Pair (Une paire parfaite ; ill. 151, p. 64) en est un bon exemple, que l'on peut comparer avec l'original d'Elvgren, publié d'abord par Dow sous divers formats, dont un calendrier, un petit livre de douze images, une carte postale et une boîte d'allumettes (ill. 152, p. 64).

En 1938, Elvgren reçut sa première commande pour plusieurs grandes silhouettes féminines et masculines en carton. Plus de 6 500 de ces pin-up presque grandeur nature exécutées pour Royal Crown Soda (ill. 25 et 26, p. 20) furent distribuées dans les supermarchés américains. Il créa des présentoirs représentant un grand-père, aujourd'hui connu comme le « Toasting Scotsman », pour les Distilleries Frankfort de Louisville (Kentucky) et produits par la Mattingly and Moore Company. L'année 1938 vit un autre événement important dans la vie de Gil et Janet Elvgren : la naissance de leur premier enfant, une petite fille baptisée Karen.

Pendant les deux années qui suivirent, Elvgren fut accaparé par diverses commandes publicitaires, des travaux éditoriaux et, naturellement, ses pin-up pour Louis F. Dow. Devant cet incroyable succès professionnel et la joie d'être parents pour la première fois, le couple commença à revoir ses plans d'avenir. La plupart des commandes d'Elvgren venaient de Chicago et de New York. Il ne faisait aucun doute pour lui qu'il aurait encore plus de travail s'il habitait l'un de ces deux grands centres artistiques. Une fois de plus, ils choisirent Chicago.

Peu après leur arrivée en 1940, Elvgren trouva un poste dans l'important atelier Stevens/Gross. Il y rencontra un homme qui allait devenir son mentor : Haddon H. Sundblom (1899–1976). Les deux hommes devinrent d'excellents amis et Sundblom exerça une influence énorme sur le développement artistique d'Elvgren. Sundbloom était déjà une sorte d'idole pour Elvgren et le jeune homme avait assemblé une série de ses images collectées dans des revues avant qu'ils ne se rencontrent. Parmi elles se trouvaient les célèbres publicités pour Coca-Cola (ill. 30, p. 21). (Plus tard, Sundblom présenta Elvgren à la compagnie Coca-Cola et les publicités du jeune artistes côtoyèrent celles de son aîné dans les kiosques à journaux, sur les affiches et les calendriers.)

Sundblom et Howard Stevens avaient ouvert l'atelier qui devint plus tard Stevens/Gross en 1925 avec leur ami Edwin Henry. Si Elvgren admirait le style de chacun des trois artistes, c'était celui de Sundblom qui l'impressionnait le plus. Lorsqu'il arriva à Chicago, Sundblom était en train de peindre une série de publicités nationales pour la compagnie Cashmere Bouquet Soap (ill. 31, p. 21). Sundblom n'avait alors fait que quelques pin-up et images glamour, mais

exclusivement pour ce marché, mais elles étaient superbes. La plupart du temps, il les signait de son vrai nom (ill. 29 et 32, p. 21). Toutefois, lorsque la pin-up était intentionnellement provocante (par exemple un modèle portant de la lingerie fine ou une tenue transparente ; ill. 33, p. 22), l'éditeur y apposait le nom de plume de Sundblom, Showalter.

Sundblom présenta Elvgren à Andrew Loomis (1892–1959), un autre des héros du jeune artiste. Elvgren l'admirait pour ses pin-up glamour (ill. 34, p. 22) ainsi que pour ses illustrations d'articles de magazines (ill. 35, p. 22), superbement dessinées et construites, et pour lesquelles il avait été plusieurs fois primé. Loomis enseignait également à l'ancienne école d'Elvgren, l'American Academy of Art, ce qui contribua à les rapprocher. De fait, au cours de l'automne 1940, Elvgren accepta de donner des cours du soir dans cette même académie.

Earl Gross et Howard Stevens convinrent avec Sundblom qu'Elvgren était le candidat idéal pour reprendre une grande partie de la campagne publicitaire pour Coca-Cola dont leur atelier était chargé. C'est ainsi que commença l'une des étapes les plus importantes de la carrière d'Elvgren : la première d'une série de campagnes publicitaires pour Coca-Cola étalées sur vingt-cinq ans et qui constituent aujourd'hui un des repères de l'histoire de l'illustration américaine. Sa première mission fut de peindre une silhouette en pied pour un présentoir en carton distribué dans tous les supermarchés (ill. 36, p. 23). La réaction du directeur artistique et des administrateurs de la grande firme d'Atlanta fut enthousiaste.

Après avoir achevé la maquette de son premier grand panneau publicitaire pour Coca-Cola (ill. 37, p. 23), Elvgren apporta son œuvre dans sa classe à l'académie pour illustrer l'une des facettes du métier de l'illustrateur publicitaire. Il espérait impressionner ses élèves en leur montrant une image qui serait bientôt exposée en format géant sur le bord des autoroutes. Pour des questions de reproduction, l'image devait être divisée en vingt-quatre sections, qui seraient reproduites sur des bandes de papiers indépendantes avant d'être assemblées et collées sur les panneaux d'affichage. Il était particulièrement fier d'une de ses Coca-Cola Girls créée pour une publicité pleine page destinée aux magazines. Il demanda à ce que l'original lui soit restitué (ill. 38, p. 23) et l'offrit plus tard à son ami Al Buell.

Peu après le bombardement de Pearl Harbor, General Electric lui demanda de réaliser une œuvre publicitaire d'envergure nationale pour leur campagne d'effort de guerre. Sa première image (ill. 44, p. 24), publiée en juin 1942 en pleine page dans Good Housekeeping (ill. 45, p. 24), était accompagnée de la légende « She Knows What Freedom Really Means » (Elle sait ce que signifie réellement le mot liberté). Il s'agissait d'une « Elvgren Girl » portant fièrement l'uniforme d'officier des unités motorisées de la Croix-Rouge. Lorsque les Etats-Unis entrèrent finalement en guerre, les pin-up d'Elvgren étaient déjà publiées et reproduites sur des millions de produits publicitaires et, naturellement, dans des calendriers de toutes formes et toutes tailles. Pour encourager les troupes, la Louis F. Dow Company réédita ingénieusement ses petits livres d' « Elvgren Girls » sous un nouveau format (ill. 40, p. 24) qui pouvait être envoyé sans enveloppe par la poste aux G.I. sur le front. Ils remportèrent un immense succès et accrurent encore le public d'Elvgren.

Aux Etats-Unis, la notoriété des pin-up d'Elvgren pour Dow ne cessait de croître également. Ses images de calendriers étaient souvent vendues lors de collectes de fonds. Hommes et femmes aimaient se détendre pendant leur temps libre en assemblant des puzzles représentant une « Elvgren Girl » (ill. 41, p. 24). Jusque-là, l'image qu'il avait réalisée pour Louis F. Dow qui avait rencontré le plus de succès et avait été la plus vendue avait été A Perfect Pair, suivie de près par The High Sign (Les Souliers neufs ; ill. 42, p. 24). Ce dernier sujet était si demandé que ce fut la seconde œuvre que Louis F. Dow demanda à Vaughan Alden Bass de retoucher (ill. 43, p. 24) lorsqu'il l'engagea pendant les années de guerre.

Les quotidiens et les magazines de cette époque regorgeaient de récits sur les soldats partis au front en Europe. Pratiquement tous les Américains avaient un parent ou un voisin mobilisé. Se concentrant souvent sur le moral des troupes, ces histoires étaient illustrées de photos de soldats dans leurs baraquements ou sous leurs tentes, voire même dans une tranchée lorsqu'il y avait une accalmie sur le champ de bataille. Très souvent, on aperçoit une image ou un petit livre de pin-up d'Elvgren édité par Louis F. Dow collé sur un mur, accroché à un sac à dos ou dans la main d'un jeune soldat ayant

visiblement le mal du pays. Le seul autre artiste de pin-up dont les œuvres étaient aussi présentes était Alberto Vargas, qui était le protégé du magazine *Esquire* et bénéficiait de ses stratégies de marketing. Le succès d'Elvgren est d'autant plus étonnant quand on songe qu'il atteignit une telle notoriété cinq ans seulement après avoir ouvert son premier atelier. Il ne fait aucun doute que ses images séduisirent le public américain d'abord parce qu'elles lui permettaient d'échapper un moment à la dure réalité pendant cette période sombre de la guerre.

En 1942, la famille Elvgren s'agrandit encore grâce à la naissance de Gil junior. A la même époque, Elvgren se lança dans une série de campagnes publicitaires nationales pour le whisky Four Roses, que ses fabricants voulaient voir présenté dans un environnement récréatif. La première image à paraître (ill. 46, p. 25) montrait un groupe d'hommes pêchant en haute mer tout en buvant leur boisson préférée. La seconde présentait des couples buvant devant une cheminée dans un chalet en montagne. Les peintures originales pour la série Four Roses, réalisées sur planche d'illustrateur plutôt que sur toile, étaient les premières à être exécutées de cette manière depuis 1936.

Al Buell, un collègue et ami d'Elvgren à Chicago, travaillait lui aussi dans l'atelier Stevens/Gross à la même époque. Je l'ai interviewé plusieurs fois en 1980 pour un article sur l'histoire de la pin-up américaine et l'art glamour que m'avait commandé le magazine *Antique Trader*. Au cours de nos conversations, il m'a raconté qu'Elvgren lui parlait sans arrêt de trois artistes dont les illustrations éditoriales l'intéressaient particulièrement : Charles E. Chambers, Pruett Carter et John LaGatta. Chambers (1883–1941 ; ill. 48, p. 25) avait étudié avec George Bridgman (le père du dessin anatomique moderne) qu'Elvgren considérait comme l'un des plus grands artistes des années 30.

Carter (1891–1955) travaillait dans un style pictural qu'Elvgren aimait imiter. D'après Buell, Elvgren avait toujours espéré étudier un jour auprès de Carter à la Grand School of Art (où enseignait également Harvey Dunn), mais l'occasion ne se présenta jamais, la carrière prolifique d'Elvgren ne lui en laissant pas le temps. Carter était surtout connu pour ses illustrations romantiques d'articles de magazines (ill. 47, p. 25). Buell m'envoya également une page de journal venant du dossier d'Elvgren sur LaGatta (1894–1977), autre artiste important qui se spécialisa dans les scènes romantiques (ill. 49, p. 25). Selon Buell, Elvgren considérait LaGatta comme l'un des meilleurs artistes travaillant dans le circuit commercial et admirait particulièrement la manière dont il représentait la beauté féminine. Les illustrations de magazines de LaGatta et ses travaux publicitaires étaient souvent conçus pour mettre en valeur les aspects sensuels de la beauté.

1943 fut une autre grande année pour Gil Elvgren. Il croulait sous les commandes, ses enfants s'épanouissaient et Janet était de nouveau enceinte. Louis F. Dow commercialisait massivement les pin-up qu'il avait réalisées pour la société plusieurs années auparavant. Tout semblait sourire à l'artiste talentueux et au père de famille. Pourtant, au cours des années qui allaient suivre, il allait connaître un succès plus grand encore.

Tout commença en 1944 lorsque Brown & Bigelow proposa à Elvgren de se joindre à leur équipe d'artistes maison. Cette invitation signifiait que son travail serait plus ou moins en concurrence directe avec celui des autres artistes de pin-up et d'art glamour de la compagnie, à savoir la crème de la crème dans ce domaine. Rolf Armstrong, Earl Moran et Zoë Mozert étaient déjà établis chez l'éditeur et lui rapportaient beaucoup d'argent, alors que la seule collaboration d'Elvgren avec cette maison datait déjà de quelques années, lorsqu'il avait peint les quintuplées Dionne pour deux séries de calendriers.

Pendant qu'Elvgren se tâtait pour savoir s'il accepterait ou non l'offre de Brown & Bigelow, Janet mit au monde leur troisième enfant, un autre garçon, Drake. Cette nouvelle arrivée décida Elvgren : l'éditeur proposait un salaire d'environ 1 000 dollars par peinture, avec un revenu prévu autour de 24 000 dollars pour la première année. C'était une somme non négligeable en 1944 et faisait d'Elvgren l'illustrateur le mieux payé des Etats-Unis, une position sans précédent chez Brown & Bigelow.

Toutefois, avant de s'engager à travailler exclusivement pour Brown & Bigelow, Elvgren accepta une commande de Joseph C. Hoover and Sons de Philadelphie, sa première (et unique) commande de sujet glamour. Pour ne pas s'attirer d'ennuis avec Brown & Bigelow, il accepta à condition de ne pas signer son œuvre. Il reçut 2 500 dollars pour une toile qui mesurait 102 x 76 cm, la plus grande pin-up qu'il ait jamais créée. Ses pin-up pour

Louis F. Dow faisaient toutes 71 x 56 cm, à l'exception de *Help Wanted !* (Au secours ! ; ill. 116, p. 52), réalisée dans l'ancien format de 84 x 69 cm.

La pin-up de 1945 réalisée pour la maison Hoover était en fait plus qu'un sujet glamour. Intitulée *Dream Girl* (Créature de rêve ; ill. 210, p. 90), elle devint la pin-up en robe du soir la plus vendue de Hoover. Elle fut maintenue dans la ligne « haut de gamme » de l'éditeur pendant plus de dix ans et fut reproduite en présentoir de boutique pour le Campana Balm Home Dispenser Gift Package en 1945. Après le premier succès de *Dream Girl*, le président de Hoover demanda à Elvgren de lui faire une série de peintures pour des calendriers mais, à cette époque, Elvgren avait déjà accepté l'offre de Brown & Bigelow.

Le contrat d'Elvgren auprès de Brown & Bigelow l'autorisait à continuer à illustrer des articles de revues et à réaliser ses campagnes publicitaires pour Coca-Cola. De fait, il pouvait accepter n'importe quelle commande publicitaire à condition que cela n'entraîne pas de conflit avec son travail pour Brown & Bigelow. 1945 marqua donc un grand virage dans la carrière d'Elvgren : son contrat avec Brown & Bigelow marquait le début de son chapitre le plus important, un chapitre qui allait durer jusqu'à sa retraite en 1972 et même plus tard, quand il continua à réaliser des commandes spéciales pour l'éditeur.

Charlie Ward, le président de Brown & Bigelow qui avait convaincu Elvgren d'entrer dans la compagnie, était un bon vivant. Les deux hommes s'entendirent à merveille et Ward lui annonça bientôt qu'il comptait commercialiser son nom et son travail comme il ne l'avait jamais fait auparavant. Il tint sa promesse et le présenta à son équipe de commerciaux et à ses clients nationaux avec toute la pompe réservée à une star. Lorsque Ward annonça qu'il était l'artiste derrière les campagnes très populaires de Coca-Cola qui fleurissaient au bord des routes, tout le monde reconnut immédiatement son nom et son style.

Elvgren commença ses séries de pin-up pour Brown & Bigelow sur des toiles plus grandes qu'à l'accoutumée (76 x 61 cm). C'était nettement supérieur au format utilisé jusqu'alors pour ses pin-up destinées à Dow (71 x 53 cm). A l'exception de plusieurs commandes particulières, pour lesquelles il travailla sur un format plus grand encore, il conserva pendant trente ans ce même format pour presque toutes ses toiles pour Brown & Bigelow.

Dès son premier mois dans la compagnie, Ward lui demanda de réaliser une pin-up nue pour la ligne de 1946 (ils travaillaient avec un an d'avance). Elvgren accepta avec enthousiasme, car il voulait faire plaisir à Ward en produisant une image de calendrier qui batte des records de vente. Son œuvre mesurait 91 x 76 cm, le plus grand nu qu'il ait jamais réalisé. *Gay Nymph* (Nymphe joyeuse ; ill. 238, p. 101) présentait une belle blonde nue allongée sur une plage au clair de lune et entourée de lilas. Elle devint si populaire que Brown & Bigelow sortit un double jeu de cartes avec cette image et un autre nu réalisé par une autre artiste vedette de la maison, Zoë Mozert. Le jeu, baptisé *Yeux Doux* et accompagné de la légende « Une traduction moderne de Gil Elvgren et Zoë Mozert » était proposé à des annonceurs qui pouvaient faire inscrire le nom de leur compagnie sur le paquet. La qualité de la présentation était impeccable et les annonceurs l'offrirent en cadeau de Noël 1946 à leurs clients.

L'année suivante, Ward demanda à nouveau un nu à Elvgren. Cette fois, il parut sur un double jeu de cartes sur lequel ne figureraient que le nom et des pin-up d'Elvgren. *Vision of Beauty* (Vision de beauté ; ill. 236, p. 100) fut présentée au public dans la ligne de 1947 et connut un succès immédiat, réalisant des ventes égales à celles de *Gay Nymph*, qui avait elle-même battu un record de vente pour un nu. *Vision of Beauty* était plus conventionnel, traité comme un nu artistique en intérieur. Le paquet du jeu de cartes portait le titre « Mais Oui ! par Gil Elvgren ».

Dès le début de sa carrière chez Brown & Bigelow, Elvgren ne peignit qu'un nu par an. Il arrivait aussi que l'éditeur ne désire pas de nu dans ses collections de l'année. Comme il aimait en peindre, Elvgren en réalisait parfois pour son propre plaisir. Il ne reste aujourd'hui que quelques-unes de ces huiles, dont un superbe modèle asiatique faisant la sieste sur le sofa de l'atelier d'Elvgren entre deux séances de pose (ill. 52, p. 27). Cette peinture fut réalisée sur une planche d'illustrateur de 41 x 69 cm, et date de 1947 environ.

Un autre de ces nus, qu'il avait accroché dans son atelier au côté de celui précédemment cité, fut peint en moins de deux heures (ill. 54, p. 27). Il montre un des modèles qu'Elvgren utilisait fréquemment dans les années

40 assise dans un gros fauteuil confortable dans son atelier. Signé « croqué en deux heures » et « Elvgren », il est peint sur toile et mesure 74 x 58 cm. Cette œuvre, réalisée entre 1940 et 1945, montre l'extraordinaire dextérité d'Elvgren. Peu d'artistes peuvent créer une huile de cette qualité, avec un tel éclat impressionniste, en si peu de temps.

Le numéro de mars 1946 de *McCall's* contenait la première illustration d'Elvgren à être reproduite en double page. L'œuvre (ill. 50, p. 26) est également remarquable en ce qu'elle dépeint le premier vrai « Elvgren Man », représenté dans une pose romantique avec une des plus belles « Elvgren Girls ». Bien que, une fois reproduite, cette image ait rencontré un immense succès (ill. 51, p. 26), Elvgren dut refuser toutes les autres offres de magazines qui lui demandaient d'illustrer leurs articles. Il n'avait pas assez de vingt-quatre heures dans une journée pour réaliser ne serait-ce qu'une fraction de ce qu'on lui proposait.

Les trois premières pin-up qu'Elvgren livra à Brown & Bigelow en 1948 battirent des records de vente en quelques semaines. L'une d'elles, *He Thinks I'm Too Good to Be True* (Il me trouve trop bien pour être vraie ; ill. 190, p. 80), fut la première pin-up non nue d'Elvgren pour Brown & Bigelow a être éditée sous forme de calendrier cintre géant (76 x 51 cm). Elle remporta un tel succès qu'elle fut rapidement rééditée en jeu de cartes puis, en 1952, dans un calendrier hors série de douze pages, *Ballyhoo*. La directrice artistique de Brown & Bigelow, Clair Fry, la choisit pour figurer sur la pochette (ill. 53, p. 27), accompagnée de la légende « Edition limitée – 12 vues aguichantes en couleur ! ». Une fois de plus, un produit Elvgren, le premier du genre qu'il réalisait pour Brown & Bigelow, fit un tabac.

Pendant que les nus et les pin-up d'Elvgren pour Brown & Bigelow étaient acclamés partout et se vendaient comme des petits pains, un autre artiste dont il suivait de près la carrière jouissait lui aussi des faveurs du public. Albert Dorne (1904–1965) réalisait les publicités des très populaires 1015 Wurlitzer Juke Box (ill. 55, p. 27). Depuis 1946, ces dernières paraissaient tous les mois en format pleine page dans tous les grands magazines du pays. Elvgren les conservait toutes dans ses dossiers, car il trouvait leur composition très novatrice pour l'époque. Les couleurs de Dorne étaient également très enviées de ses confrères, y compris Elvgren. Dorne fut ensuite élu président de la Society of Illustrators et devint le fondateur-directeur de la Famous Artists Schools à Westport, dans le Connecticut.

Entre 1948 et 1949, Elvgren se lança dans une nouvelle aventure en sculptant une « Elvgren Girl » qui fut ensuite commercialisée sous forme de coupe-papier. Brown & Bigelow la fit mouler en plastique beige et l'emballa dans un étui pliable. Les annonceurs qui achetaient ce produit pouvaient faire inscrire un message publicitaire sur le ballon de plage que l' « Elvgren Girl » tenait au-dessus de sa tête (ill. 59, p. 29). Brown & Bigelow avait imprimé un message à l'intérieur de la boîte que l'on pouvait lire en sortant le coupe-papier : « Toujours prêts à vous servir ! Un travail à faire, un service à rendre, un besoin à satisfaire ? Nous sommes là pour ça ! Et si vous avez besoin d'un sourire pour effacer les petits tracas de la journée, voici Ellen, votre ouvreuse de lettres. Traitez-la bien, c'est une fille chouette. Dessinée par Elvgren. »

A la fin de la décennie, Elvgren était devenu le dessinateur le plus important de Brown & Bigelow. En deux ans de service, il avait déjà peint une demi-douzaine d'images que l'on s'arrachait et avait créé un nouveau produit innovateur. En outre, ses dessins touchaient un public toujours plus vaste grâce à l'assistance enthousiaste des médias. En mars 1948, le magazine *See* publia un article de cinq pages intitulé « Des calendriers qui attirent le regard » sur Elvgren et ses œuvres. On le voyait dans son atelier avec son assistant Ewen Lotten plaçant un de ses modèles, Pat Varnum, âgée de dix-huit ans, dans un décor qu'il avait conçu spécialement pour photographier ses sujets avant de les transformer en pin-up de calendrier.

En mars 1949, le magazine *U. S. Camera* publia un article similaire entièrement consacré au travail d'Elvgren pour des calendriers et à sa manière de réaliser des pin-up. Intitulé « Un artiste éclaire son modèle », on y traitait des préférences d'Elvgren en matière d'éclairage de studio lorsqu'il photographiait un modèle. Cinq mois plus tard, en août 1949, Elvgren et son travail firent la couverture d'un troisième magazine, *Pix*. L'article, « les jambes sont une industrie », avait pour sous-titre « les chefs-d'œuvre sexy de l'artiste Elvgren sont des best-sellers ». On y voyait le modèle Candy Montgomery posant pour *Keeping Posted* (Courrier du cœur ; ill. 193, p. 81).

Le succès phénoménal des pin-up d'Elvgren attirait sans cesse de nouveaux clients vers Brown & Bigelow. En 1950, l'éditeur comptait une centaine de nouveaux annonceurs venus chercher des produits portant les images d'Elvgren pour servir de supports à leurs marques. De son côté, l'artiste était constamment contacté par d'autres compagnies ou de grandes agences de publicité voulant lui passer commande. Naturellement, il lui était matériellement impossible de répondre à toutes ces demandes. Parmi les compagnies pour lesquelles il parvint à trouver le temps de travailler se trouvaient : Coca-Cola, Orange Crush, Schlitz, Red Top Beer, Ovaltine, Royal Crown Soda, Campana Balm, General Tire, Sealy Mattress, Serta Perfect Sleep, Napa Auto Parts, Ditzler Automotive Finishes, Frankfort Distilleries, Four Roses Blended Whisky, General Electric Appliance et Pangburn's Chocolates.

Confronté à une telle demande, Elvgren envisagea de monter son propre atelier avec une équipe d'artistes puisés parmi ses anciens camarades, ses propres élèves et d'autres talentueux aspirants illustrateurs. Ils étaient nombreux à admirer son travail et ce qu'ils appelaient l'école « mayonnaise » (un style développé par l'atelier de Sundblom à Chicago et surnommé ainsi du fait de l'aspect « crémeux et soyeux » des peintures). Après avoir pesé le pour et le contre (en tenant compte des maux de tête et de la responsabilité de diriger une affaire de grande envergure, sans parler de la perte de temps que cela aurait représenté pour sa propre carrière), il laissa tomber cette idée.

Dans les années de l'immédiate après-guerre, l'Amérique était devenue un nouveau pays. Le phénomène des baby-boomers battait son plein et le marché de l'illustration entamait la décennie la plus marquante et productive de son histoire. Entre 1950 et 1960, l'illustration américaine devait connaître son âge d'or tandis que la demande des magazines, des publicistes, des maisons d'édition et des éditeurs de calendriers atteignait des records. Dans les années 50, tout comme au début de sa carrière, Elvgren admirait certains artistes dont il suivait le travail et dont il gardait des exemples dans ses dossiers en guise de référence.

Parmi eux se trouvait Tom Lovell (1909–1997), qui avait droit à la plus grosse chemise dans les dossiers d'Elvgren. Elle faisait près de dix centimètres d'épaisseur et contenait pratiquement tout ce que Lovell avait publié. Une des illustrations, qui présentait un sujet romantique proche des pin-up (ill. 57, p. 28), était annotée en marge et accompagnée d'une petite note destinée à Al Buell. De fait, Elvgren et Lovell se téléphonaient régulièrement pour se complimenter.

Le même respect mutuel unissait Elvgren à l'illustrateur américain Walter Baumhofer (1904–1985). Tous deux travaillèrent avec le directeur artistique de *McCall's* de 1946 au milieu des années 50. Elvgren admirait les éclairages savants de Baumhofer qui lui permettaient de créer l'atmosphère idéale pour ses images (ill. 56, p. 28). A l'instar de Sundblom, Baumhofer utilisait lui aussi des effets de lumière pour renforcer la tension dramatique lorsqu'il illustrait des histoires. Il était particulièrement doué pour traduire l'essence d'une scène en une image efficace. Elvgren suivit sa carrière depuis les années 30. A l'époque, Baumhofer peignait des couvertures de revues pulp pour Street and Smith, aux côtés de Robert G. Harris (né en 1911). Harris peignait dans un style quasi photoréaliste qui lui valait l'admiration de ses confrères. Elvgren le recommanda auprès de Brown & Bigelow, qui lui commanda le seul calendrier de pin-up qu'il réalisa pour l'éditeur. Bien qu'il s'agisse d'un sujet glamour en robe du soir (ill. 58, p. 29), ce calendrier lui attira le respect de ses confrères et des cadres de la maison.

Il y a quelques années, lors d'un entretien téléphonique, Harris m'a confié que la plupart des illustrateurs de l'époque enviaient Elvgren, surtout ceux qu'il rencontrait à la Society of Illustrators de New York. Bien que tout le monde respectât son talent, sa carrière « idéale » suscitait aussi des jalousies. Il passait ses journées à peindre de jolies femmes alors qu'ils devaient tous accepter régulièrement les corvées inhérentes à leur métier.

Du milieu des années 40 au milieu des années 50, Elvgren fut également inspiré par le travail de Walt Otto. Comme Elvgren, Otto était un illustrateur de revue « grand public », ainsi qu'un artiste d'art glamour et de pin-up. Tous deux avaient étudié à Chicago et y avaient commencé leur carrière, et chacun aimait le travail de l'autre. On retrouve des similitudes avec le travail d'Elvgren dans la skieuse réalisée par Otto pour la couverture du *Saturday Evening Post* (ill. 60, p. 30) et dans sa publicité pour Alka-Seltzer (ill. 63, p. 30).

Du fait de la grande popularité d'Elvgren, Brown & Bigelow avaient souvent recours à lui pour les commandes spéciales. Il passait beaucoup de temps avec les directeurs des ventes nationales de la compagnie car, avec les représentants régionaux, ces derniers étaient chargés de placer chaque année les nouveaux produits. Il faisait également des tournées pour rencontrer la presse et le public lors de divers événements promotionnels. Lors de ces déplacements, il rencontra beaucoup de monde, dont des célébrités qui devinrent des amis. Il se lia notamment avec le célèbre acteur Harold Lloyd qui, vers 1950, lui fit connaître la photographie stéréo en couleurs 35 mm. Passionné de photographie, Elvgren s'y consacrait dès qu'il avait du temps.

Lloyd appréciait surtout Elvgren en tant qu'ami, plus qu'en tant qu'illustrateur connu entouré de beauté et de glamour. Ceci dit, c'était également un admirateur inconditionnel et Elvgren lui offrit l'un de ses plus beaux nus réalisé pour Brown & Bigelow en 1951 (ill. 251, p. 108). Il s'agit de la première pin-up (et également du premier nu) que Clair Fry lui avait commandé pour un jeu de cartes. L'original, une huile sur planche d'illustrateur de 69 x 48 cm, s'intitulait *To Have* (Avoir). L'autre image du jeu de cartes fut baptisée *To Hold* (Tenir). Le double jeu de cartes était présenté dans un étui à rabat ajouré qui ne laissait voir que les visages des modèles. A l'intérieur du rabat, on lisait : « Quelles soient blondes, brunes ou rousses, les hommes préfèrent les GIRLS…. Surtout quand elles sont peintes par Gil Elvgren. Quelles que soient vos préférences en matière de jeux de cartes, nous espérons que votre plaisir sera plus grand encore grâce à ces deux beautés. » Lorsqu'on soulevait complètement le rabat, on découvrait les deux pin-up nues.

Elvgren pouvait désormais se permettre d'offrir ses peintures car, en 1951, son contrat avec Brown & Bigelow avait changé. Il était passé de 1 000 à 2 500 dollars par toile, avec une production annuelle de vingt-quatre sujets. Ses revenus étaient également complétés par les commandes pour illustrer des articles de journaux et ses nombreuses campagnes publicitaires. Bientôt, la famille Elvgren put quitter Chicago pour s'installer dans la banlieue de Winnetka. Sitôt dans leur nouvelle maison, Elvgren fit construire un atelier dans le grenier. Equipé d'une verrière pour laisser entrer la lumière du nord, l'atelier fut achevé en quelques mois. Drake, le fils d'Elvgren, m'a raconté que son père avait commencé par y travailler seul mais qu'il avait vite dû engager un assistant à temps plein pour l'aider à éclairer et à photographier les modèles, construire des décors avec divers accessoires, et lui préparer ses peintures et ses pinceaux. Travailler chez lui accrut encore son efficacité, car il ne perdait plus de temps dans les transports et pouvait s'isoler sans être dérangé dans son travail.

Elvgren était constamment obnubilé par le besoin de trouver de nouveaux sujets. Comme de nombreux autres artistes de pin-up et d'art glamour, il avait souvent l'impression que tout avait déjà été fait. Lorsqu'il travaillait dans l'atelier Stevens/Gross avec une dizaine d'autres illustrateurs, il les consultait régulièrement sur ses projets et, eux, lui demandaient conseil en retour. Joyce Ballantyne m'a raconté un jour au téléphone (vers 1982) qu'elle et Elvgren échangeaient souvent des idées. Le réseau d'entraide entre elle, Gil, et les autres artistes de l'atelier ne s'arrêtait pas là : quand l'un d'entre eux était mal en point, était soumis à une trop forte pression de la part d'un client ou sentait qu'il n'arriverait pas à finir une peinture dans les délais, il appelait un collègue à la rescousse. Chez lui, Elvgren n'avait pas ce luxe, mais il lui arrivait de décrocher le téléphone et de demander conseil à d'autres amis artistes.

Elvgren offrait aussi généreusement des idées à des amis tels que George Hughes, qui peignit plus de 125 couvertures pour *The Saturday Evening Post*. Il lui décrivit un jour une scène qu'il avait vue sur la plage et Hughes en fit une image grand public proche de la pin-up pour la couverture du numéro du 28 août 1954 du *Saturday Evening Post* (ill. 61, p. 30). Son ami Thornton Utz (né en 1914) m'a confié dans un entretien il y a de longues années : « Gil débordait d'idées. Un jour où j'étais à sec pour une couverture du *Saturday Evening Post*, il m'a décrit un magasin de disques où il s'était rendu la veille, avec la tête des gens enfermés dans chaque box pour écouter les disques qu'ils envisageaient d'acheter. Ça m'a aussitôt inspiré quelques croquis. Finalement, son idée est devenue le sujet de la couverture » (du numéro du 19 avril 1952 ; ill. 62, p. 30).

En 1951, la revue *Modern Man* publia un article sur Elvgren. En couverture, on le voyait photographiant le modèle Candy Montgomery pour l'image qui devait s'intituler *Keeping Posted*. Dans l'article, Elvgren est décrit

comme « le plus grand peintre de genre d'Amérique ». Interrogé sur sa vision de la femme américaine, il répondit : « Aujourd'hui, elle est devenue infiniment plus maligne. Elle est plus belle que jamais et plus naturelle. Elle n'est plus harnachée comme autrefois et elle n'essaie plus de ressembler à un garçon, Dieu merci ! » Il déclara également à la revue que : « Le cinéma, la télévision et les magazines ont considérablement aidé à faire évoluer les conceptions vieillottes, mais l'art des calendriers a eu encore plus d'influence que tous les autres réunis. »

Au cours des années 50, le magazine *Figure Quarterly* interviewa plusieurs fois Clair Fry au sujet d'Elvgren (ill. 64, p. 30). Sa perception de l'illustrateur à cette époque est assez révélatrice :

Gil est avant tout l'un des dessinateurs et des peintres les plus habiles travaillant aujourd'hui dans le domaine de l'illustration, mais ce n'est pas tout. Il y a de nombreux illustrateurs très doués qui ne sortent jamais de l'anonymat. C'est comme de prendre deux charpentiers équipés du même jeu d'outils. Le premier a déjà dans sa tête un plan précis de la maison qu'il s'apprête à construire, alors que le second travaille sans avoir vraiment d'objectif prédéfini.

Gil a un goût très sûr. C'est un bien précieux et rare. De nombreux artistes très doués n'arrivent jamais à se faire reconnaître car leurs lignes et leurs compositions, bien qu'excellentes d'un point de vue littéral, aboutissent à un effet brouillon et terne. Ils n'ont pas ce petit plus essentiel qui, dans la vie réelle, permet à une fille de sortir du lot.

Gil a également de l'esprit. Non seulement il ajoute toujours une touche d'humour dans ses scènes, mais il sait se montrer ingénieux et inventif dans le choix de ses couleurs, de ses poses, de ses mouvements, créant une image vivante qui retient l'attention. Son travail est sincère. Lorsqu'on regarde une de ces images, on pense tout de suite que la fille représentée existe réellement. Les attitudes et les expressions sont réalisées avec une telle maîtrise qu'elles transmettent exactement le sens qu'Elvgren a voulu leur donner sans avoir cet effet artificiel qu'ont tant d'autres illustrations. Gil suit toujours de près le renouvellement des canons de la beauté féminine. C'est un facteur important. Si l'on regarde les images de belles femmes depuis Rubens, on remarque que chaque époque détermine ce qui est beau pour elle et ce qui ne l'est pas. Gil sait exactement quels sont les ingrédients nécessaires pour satisfaire aux critères du moment. Tout compte fait, ce savoir, et cette faculté à le traduire, est sans doute le facteur le plus important dans l'incroyable succès de Gil.

Le reconnaissance de ce grand talent dont parle Fry attirait sans cesse de nouveaux clients qui se bousculaient à la porte d'Elvgren. Ces derniers allaient de ceux qui l'imploraient d'accepter une « seule commande » à ceux qui voulaient qu'il prenne en charge la totalité de l'image et des produits de leur compagnie. Au début des années 50, la Schmidt Lithograph Company of Chicago and San Francisco parvint à le convaincre de peindre une série d'affiches « universelles » pour divers clients. Ces affiches étaient qualifiées d'universelles car leur format et leurs sujets pouvaient facilement être adaptés pour vendre pratiquement n'importe quel produit. La plupart de ces images étaient des portraits traités dans le style « glamour », généralement sans fond ni accessoires. Toutefois, les deux premières commandes d'Elvgren dans ce genre sont des exceptions à la règle. La première, intitulée *Poolside Fun* (Au bord de la piscine ; ill. 65, p. 32), montrait une belle « Elvgren Girl » se séchant les cheveux après avoir plongé dans la piscine, tandis qu'en arrière-plan, on apercevait un couple buvant des bières apportées par un majordome. Dans le coin en haut à gauche, une autre « Elvgren Girl » se tenait sur le plongeoir, s'apprêtant à sauter. Les différents éléments de la scène sont assemblés avec un sens brillant de la perspective et de la composition.

Le second travail d'Elvgren pour Schmidt était le portrait d'une beauté souriante tenant un plateau de bouteilles de bière (ill. 66, p. 32). L'artiste intégra lui-même le titre *The Pick of the Picnic !* (Le clou du pique-nique !) dans l'original. La plupart des images d'Elvgren pour Schmidt furent réalisées sur des planches d'illustrateur faisant plus ou moins 38 x 76 cm. Le plus souvent, il n'utilisait qu'un tiers de la planche (la partie gauche), laissant le reste vide pour que l'annonceur puisse y placer son message. Ces peintures originales ont parfois été coupées par des acquéreurs pour les encadrer. Toutefois, d'autres collectionneurs puristes ont tenu à les conserver telles qu'elles avaient été conçues à l'origine.

Dans une autre version de *The Pick of the Picnic !* (ill. 67, p. 32), les bouteilles ont été remplacées par une seule bouteille de bière Pilsner A-1. Le modèle de la « Elvgren Girl » qui sourit et pointe le doigt (ill. 70, p. 33) était Myrna Hansen, qui commença à poser pour Elvgren en 1951 alors qu'elle n'avait que quinze ans. Elle devint l'un de ses modèles favoris. Un autre portrait d'une jeune femme portant un rang de perles (ill. 585, p. 238) fut utilisé sous deux versions par Schmidt, qui vendit la même image à deux annonceurs différents. De même, les images d'Elvgren furent altérées pour les adapter à des situations spécifiques lorsqu'elles furent reproduites dans des publicités pour les chocolats Pangburn (ill. 68 et 69, p. 33).

Pendant les années 50 et 60, Elvgren prit grand plaisir à suivre les carrières de certains artistes dont il admirait le travail. Comme il travaillait toujours pour des magazines, bon nombre de ces derniers venaient de ce secteur. Son dossier sur Jon Whitcomb (né en 1906 ; ill. 71, p. 34) était massif et semblait inclure pratiquement tout ce que Whitcomb avait publié tout au long de sa carrière prolifique. Contrairement à Elvgren, il peignait principalement sur planche d'illustrateur mais il lui arrivait néanmoins de réaliser des huiles sur toile pour illustrer des articles de revue.

Edwin Georgi (1896–1964) était respecté par tous les illustrateurs ayant travaillé du milieu des années 30 à la fin des années 50, dont Elvgren. Utilisant des pastels iridescents (longtemps avant qu'ils ne soient à la mode), Georgi développa une approche spectaculaire de la couleur qui devint son image de marque. Il ne peignait presque que des jolies femmes (et des beaux hommes) et son travail était publié par tous les grands magazines américains (ill. 72, p. 34).

En 1953, après s'être installés dans leur nouvelle maison de Winnetka, Elvgren et sa famille partirent en vacances en Floride. Dès leur arrivée, l'artiste tomba amoureux de ce lieu de villégiature. Après avoir vécu toute sa vie avec la neige et le froid, il ne pouvait se lasser du ciel bleu et des vents tropicaux faisant doucement osciller les palmiers. Bien qu'il vienne juste de s'installer dans une nouvelle maison à Winnetka, il envisagea de déménager en Floride.

En janvier 1955, Charlie Ward demanda un nouveau nu à Elvgren pour la collection de calendriers de 1957 de Brown & Bigelow. Il s'agissait d'un calendrier à image unique de 51 x 76 cm ou de 56 x 71 cm, avec les mois imprimés directement sur l'image ou attachés dessous. Lorsque la blonde incendiaire d'Elvgren fut livrée au quartier général de la compagnie, elle fut intitulée *Golden Beauty* (Beauté dorée), puis inventoriée avant d'être acheminée jusqu'au bureau de Ward. A la surprise générale, la peinture ne fut plus jamais revue. Elle est publiée ici pour la première fois (ill. 252, p. 109). En fait, après avoir gardé l'image chez lui pendant de longues années pour son propre plaisir, Ward l'offrit à Red Rudinski, du service de maintenance de Brown & Bigelow et ami de longue date. Plus tard, Rudinski (l'auteur d'un livre sur les techniques d'ouverture de coffres-forts) la donna à un magnat de l'immobilier de St. Paul auprès duquel il était très endetté. Au cours des trente années suivantes, *Golden Beauty* resta dans l'arrière-boutique d'une agence immobilière au centre de St. Paul, où elle devint une sorte de légende, jusqu'à ce qu'elle soit rachetée par un collectionneur privé en 1990.

1955 fut également l'année où Elvgren accéda au statut de vedette de la culture pop : douze de ses pin-up réalisées pour Brown & Bigelow furent reproduites sur un abat-jour rotatif (ill. 75, p. 35). Les images étaient accrochées à une broche qui les faisait tourner grâce à la chaleur qui se dégageait des fentes situées en haut de l'abat-jour. Commercialisé par la Econolite Corporation, on l'appelait « lampe à chaleur » ou « lampe tournante ». Réalisé en celluloïd, l'abat-jour était extrêmement fragile et menaçait sans cesse de brûler en raison de la chaleur de l'ampoule.

En 1954, l'un des illustrateurs préférés d'Elvgren, Harold Anderson (1894–1973) fut chargé de reproduire pour un calendrier l'affiche géante de Coppertone. L'amie d'Elvgren, Joyce Ballantyne, avait peint la publicité originale pour les panneaux d'affichage géant à vingt-cinq feuillets (ill. 73, p. 35). *Don't Be a Paleface !* (Bronzage intégral) devint rapidement une icône américaine. Montrant un petit chien tirant sur le maillot de bain d'une fillette, l'image établit la réputation de Ballantyne en tant qu'illustratrice grand public tout en faisant connaître les produits Coppertone dans le monde entier. (Elvgren avait rencontré Ballantyne à l'American Academy of Art de Chicago, où il enseignait. Elle était son élève mais devint rapidement son amie et sa collègue.) Le tableau d'Anderson pour le calendrier fut réalisé dans le style riche et crémeux de l'école de Sundblom. Elvgren l'accueillit avec enthousiasme et l'image remporta un grand succès dès sa publication (ill. 74, p. 35).

En 1956, Elvgren parvint enfin à convaincre sa famille de s'installer en Floride. Il y pensait depuis quatre ans et le moment semblait propice à un changement de vie et d'environnement. Il avait déjà de nombreux amis en Floride. Joyce Ballantyne y vivait depuis un certain temps, tout comme de vieux amis tels qu'Arthur Sarnoff, Bill Doyle et Elmore Brown. En outre, deux des amis les plus proches du couple Elvgren, Al Buell et Thornton Utz y habitaient avec leur famille. Aussi, dès leur arrivée, ils se sentirent chez eux, et plus à l'aise que dans le nord de Chicago. En outre, pendant le plus gros de l'année, le climat de l'Illinois n'était guère propice aux visites et aux mondanités, ce qui n'était pas le cas de la Floride. Elvgren découvrit bientôt que tout dans sa nouvelle région lui plaisait.

Les Elvgren trouvèrent la maison de leurs rêves à Siesta Key, où Gil construisit un superbe atelier sur plusieurs niveaux. Pendant les quatre premières années, il eut un apprenti du nom de Bobby Toombs, qui devint ensuite un artiste à part entière. Lors d'une conversation téléphonique avec Toombs en 1980, il m'a raconté qu'Elvgren avait été un professeur formidable. Non seulement il lui avait appris à utiliser les peintures et plusieurs trucs pour finir ses commandes à temps, mais il l'avait aussi guidé dans la manière d'aborder de façon réfléchie n'importe quelle commande (une philosophie qui reflétait les enseignements d'Howard Pyle et d'Harvey Dunn). Toombs observa également : « Naturellement, il s'agissait surtout d'apprendre la valeur des couleurs mais, avec Gil Elvgren à mes côtés, j'avais l'impression que rien n'était impossible. Il saisissait un pinceau et le faisait danser sur la toile. Le regarder faire était comme assister à de la magie. »

Une fois installé en Floride, Elvgren se mit à peindre un grand nombre de portraits, mais pas pour les mêmes raisons que la plupart des autres anciens illustrateurs ou illustrateurs en semi-retraite. N'ayant aucune aspiration à être reconnu comme un artiste classique, il aimait simplement la compagnie des gens de sa nouvelle communauté de Siesta Key. Un grand nombre de ses modèles étaient célèbres ou le devinrent après avoir posé pour lui, dont Myrna Loy, Arlene Dahl, Donna Reed, Barbara Hale et Kim Novak. Dans les années 50 et 60, pour une starlette ou une aspirante actrice, avoir son visage reproduit sur des millions de calendriers d'Elvgren était une formidable promotion. De fait, chaque semaine, des starlettes venues tout droit de Hollywood faisaient la queue devant le quartier général de Brown & Bigelow à St. Paul pour se proposer comme modèles à Elvgren et aux autres illustrateurs vedettes de la maison.

Contrairement à la plupart des autres artistes, Elvgren effectuait rarement des esquisses préliminaires avant d'attaquer une huile. Il arrivait cependant qu'il demande à son apprenti de s'en charger, si celui-ci savait y faire. Lorsqu'Elvgren décidait de réaliser une pin-up un peu spéciale, il faisait d'abord une étude, généralement assez petite, d'environ 51 x 41 cm. Ce fut le cas pour *Bear Facts* (ou *Bearback Rider* [La Dompteuse d'ours ; ill. 414, p. 172]), une de ses images les plus célèbres pour Brown & Bigelow. Le dessin (ill. 415, p. 172) est à peine plus petit que des huiles habituelles et fut offert à « Toni », avec une inscription disant « à Toni, qui aurait pu être mon modèle favori ! ‹ Salut, voisine › ! Gil Elvgren. » On ignore qui est Toni. Elle a peut-être posé pour Elvgren et, si ce fut le cas, sans doute pour une des affiches publicitaires de Schlitz dans la mesure où le slogan de cette compagnie était « Salut Voisin ! ». Il se peut aussi que Toni ait simplement été une voisine d'Elvgren.

Dans le choix de ses modèles, Elvgren ne se limitait pas aux starlettes et aux actrices mentionnées plus haut. Dans les années 40, il avait un faible pour Dayl Rodney et Pat Varnum, toutes deux âgées de moins de vingt ans. Au début des années 50, après s'être installée en Floride, Myrna Hansen (qui devint plus tard Miss Amérique 1954) et sa voisine Janet Rae, âgée de quinze ans, posèrent pour lui. Dans les années 60, ses modèles préférés étaient Rusty Allen et Marjorie Shuttleworth.

Elvgren était toujours à la recherche de nouvelles situations originales à utiliser dans ses compositions. Si ses collègues habitant en Floride lui faisaient souvent des suggestions, il avait aussi souvent recours aux membres de sa famille. Tous les soirs, à la table du dîner, il discutait de ses nouvelles idées avec sa femme et ses enfants. Cela donnait des repas animés où chacun pouvait apporter sa contribution.

Outre ses commandes spéciales pour Napa Auto Parts chaque année, Brown & Bigelow lui demanda de réaliser une pin-up par an pour Ditzler et Sylvania. Pour les deux premières livraisons, il dut présenter une peinture préliminaire de 76 x 56 cm à Ditzler (ill. 551, p. 230) et une étude au crayon à Sylvania. Il partageait cette dernière commande avec Bill Medcalf et le projet Ditzler avec Mayo Olmstead (né en 1925). Dans un entretien de 1990, Olmstead me parla de sa rencontre avec Elvgren au début des années 50, à l'époque où il réalisait ses premiers dessins pour Brown & Bigelow. Il était un fan d'Elvgren depuis des années et l'idée de travailler à ses côtés le rendait très nerveux, ce qui était compréhensible. Selon Mayo :

Gil Elvgren était le type le plus sympa du monde. Il se pliait en quatre pour vous rendre service. Lorsque je suis entré chez Brown & Bigelow, il était déjà une vedette de la maison. Tout le monde respectait son talent et son professionnalisme. Je me souviens très clairement de la première fois où il m'a aidé. Ma première tâche pour Brown & Bigelow consistait à peindre une cow-girl pour un calendrier cintre. Je ne savais même pas quelle devait être la taille de l'original. Gil m'a suggéré d'utiliser le même format que lui, soit une toile de 76 x 61 cm, ce que j'ai fait, bien que mon image soit horizontale (ill. 76, p. 37) car elle devait être agrandie pour répondre au format imposant des « cintres ». Si Gil n'était pas venu à mon secours pour cette première commande et celles qui ont suivi, je ne crois pas que je m'en serais sorti ! Gil était un être précieux, hors pair. Je lui suis éternellement reconnaissant de son amitié, de son aide et de ses conseils artistiques.

Les pin-up Napa qu'Elvgren réalisait pour Brown & Bigelow devaient être un peu plus conservatrices qu'à l'accoutumée. Pour s'assurer qu'il ne dépassait pas les bornes, il présentait toujours une étude préliminaire, réalisée à l'huile sur planche d'illustrateur. L'éditeur la soumettait ensuite aux dirigeants de Napa pour approbation. Après avoir reçu leur feu vert, Elvgren se mettait alors à la toile définitive. Dans une de ces études (ill. 573, p. 235), le poisson que la femme vient de pêcher est placé entre ses cuisses écartées. Les dirigeants de Napa demandèrent à Buzz Peck, directeur artistique de Brown & Bigelow, de suggérer à l'artiste de déplacer le poisson d'un côté ou de l'autre de ses jambes, ce qu'il fit pour la version finale.

Au sommet de sa carrière, Elvgren continuait d'être influencé par son grand ami Haddon Sundblom. Les peintures de ce dernier portaient les traces de plusieurs autres artistes, dont Howard Pyle, Harvey Dunn, John Singer Sargent, Anders Zorn, Robert Henri, J. C. Leyendecker et Pruett Carter, mais sa plus grande influence était Sorolla. La lumière dorée de Sorolla illuminait les œuvres de Sundblom et se transmit à celles d'Elvgren et de son « cercle ». Parmi ce groupe d'artistes avec lesquels Elvgren travaillait, s'amusait et enseignait à Chicago, beaucoup devinrent des amis proches, ayant tous étudié et travaillé sous le regard vigilant de « Sunny », comme ils appelaient affectueusement Sundblom. Parmi eux se trouvaient Harry Anderson, Joyce Ballantyne, Al Buell, Matt Clark, Earl Gross, Ed Henry, Charles Kingham, Al Kortner, Al Moore, Walt Richards, James Schucker, Euclid Shook, Bob Skemp, Thornton Utz, Coby Whitmore et Jack Whitrup.

A Siesta Key, Elvgren rencontra le célèbre écrivain John D. MacDonald qui habitait juste en face, de l'autre côté de la baie. Les deux hommes devinrent de grands amis, jouant aux échecs et se rendant souvent aux mêmes réceptions au sein de leur communauté. Elvgren, qui n'aimait pas trop se retrouver sous le feu des projecteurs, parvenait à surmonter sa timidité en s'asseyant au piano, ce qui lui permettait d'éviter d'avoir à entretenir la conversation. De temps à autre, Elvgren et MacDonald étaient rejoints par un autre auteur célèbre, MacKinlay Cantor.

Les Elvgren continuaient également à fréquenter assidûment les Buell et les Utz. Al Buell avait travaillé pour Brown & Bigelow pendant près de vingt-cinq ans, d'abord comme peintre de pin-up, comme Elvgren, puis en tant que responsable du *Artist Sketch Pad*, une ligne de calendriers à douze feuillets (ill. 77, p. 37). Utz peignait principalement des couvertures pour *The Saturday Evening Post* et avait réalisé différentes campagnes publicitaires nationales, mais, tout comme Elvgren et Buell, il aimait peindre des jolies femmes dès que l'occasion s'en présentait. L'une de ses œuvres réalisées en Floride est une pin-up sur la plage qui capte parfaitement l'esprit du temps (ill. 79, p. 38).

Gil Elvgren vivait intensément. Il adorait la vie au grand air, la chasse, les randonnées dans le sud du Minnesota, la pêche en eaux profondes au large des côtes de Floride. Il n'aimait pas nager en pleine mer mais passait beaucoup de temps au bord de sa piscine. Il aimait également les voitures de course (il en possédait deux) et, chaque année, emmenait sa famille assister au grand prix d'endurance de Sebring, qui durait douze heures.

Il partageait une autre passion avec ses deux fils : les armes anciennes, notamment les pistolets et les fusils. Il y avait été initié dès l'âge de quatre ans, quand, lors d'une kermesse pour rassembler des fonds de guerre, son père l'avait hissé sur ses épaules pour admirer des armes exposées dans une vitrine. Pour ses dix ans, son père lui avait offert son premier fusil. Après quoi, il s'était mis à les collectionner et était devenu fin tireur, remportant de nombreuses compétitions. A l'époque de son installation en Floride, il possédait plus de cent armes, qu'il gardait dans trois vitrines. Il était membre du club de tir de Sarasota et de l'association Rifle and Pistol. Il donnait également des cours de tir au département de police de Chicago, à la patrouille aérienne, à la défense passive et aux gardes-côtes. Il s'était même construit un stand de tir de quinze mètres de long dans sa maison de Winnetka.

Au fil des ans, Elvgren eut une douzaine d'assistants dans son atelier. La plupart étaient des artistes talentueux qui espéraient développer leur art grâce aux conseils et aux instructions de l'artiste qu'ils admiraient le plus. Bobby Toombs, notamment, reprit la place d'Elvgren chez Brown & Bigelow une fois qu'Elvgren décida qu'il en avait assez des délais de livraison. De nombreux étudiants auxquels Elvgren avait enseigné à Chicago virent leur carrière s'envoler après avoir assimilé les leçons du maître. Harry Ekman, qui avait étudié avec Elvgren à Chicago en 1953, fit une carrière brillante dans le domaine de la pin-up et de l'art glamour.

Lorsqu'il ne peignait pas des pin-up en Floride, Elvgren illustrait des articles de magazine. Les directeurs artistiques des revues pour lesquelles il travaillait (*McCall's*, *Cosmopolitan*, *Redbook*, *Woman's Home Companion* et *The Saturday Evening Post*) devaient souvent patienter une année entière avant de recevoir leur commande.

En 1963, Brown & Bigelow édita un jeu de cartes unique en son genre. Intitulé *American Beauties* (ou parfois *Top Hat*), c'était le premier à présenter cinquante-trois pin-up différentes d'Elvgren, une distinction que seul Alberto Vargas avait connue jusqu'alors. Toutefois, le jeu d'Elvgren était infiniment supérieur à celui de Vargas et remporta un grand succès. Ses images racontaient une histoire. Elles étaient drôles et pleines de couleurs, alors que les pin-up de Vargas étaient présentées sans contexte ni vie.

En 1966, la mort de Janet des suites d'un cancer porta un coup terrible à Elvgren. Pour se consoler, il se mit à travailler avec plus d'ardeur encore. A la fin des années 60, sa popularité était plus grande que jamais, aussi bien auprès du public américain que chez Brown & Bigelow. Après trente ans de carrière, il avait atteint un sommet et n'avait plus à se soucier que de produire la meilleure image possible. De ce fait, ses pin-up des années 60 sont les mieux conçues, les mieux peintes et les plus belles de toutes. Fraîches et magnétiques, ces « Elvgren Girls » envoûtaient le spectateur avec leur sex-appeal. Elles étaient des glamour girls typiquement américaines et leur succès faisait le bonheur des directeurs des ventes de Brown & Bigelow. Toutes les entreprises réclamaient à corps et à cris des « Elvgren Girls » sur les calendriers qu'elles offraient à leurs meilleurs clients pour Noël. Ce fut sans doute le meilleur moment de la carrière d'Elvgren, tristement assombri par la disparition de son épouse. Au fil des années qui suivirent, il passa de plus en plus de temps en compagnie de Marjorie Shuttleworth, un de ses modèles de Sarasota.

Charlie Ward possédait un petit yacht sur lequel il emmenait parfois des clients de Brown & Bigelow pendant l'été à St. Paul. Elvgren y avait été de nombreuses fois et, lorsque Ward eu besoin d'une peinture de son bateau, Elvgren la lui réalisa de bon gré (ill. 78, p. 38). (Plus tard, à Sarasota, un certain M. Regal lui commanda un tableau similaire avec un bateau presque identique.) Les sujets nautiques d'Elvgren étaient aussi réussis que tout ce qu'il entreprenait d'autre.

L'aptitude d'Elvgren à saisir l'esprit et la sensualité de la beauté féminine américaine était sans égale. Ses pin-up étaient de vraies jeunes filles surprises dans des situations de la vie quotidienne. Les situations étaient parfois un peu exagérées mais fonctionnaient toujours. Il travaillait sur un chevalet, avec une palette de trente-deux couleurs, le plus souvent sur des toiles de 76 x 61 cm.

Il peignait généralement sur une chaise équipée de roulettes, ce qui lui permettait d'observer son modèle et l'œuvre en cours sous tous les angles possibles. Grâce à un grand miroir accroché au mur derrière lui, il pouvait, en lançant un regard par-dessus son épaule, avoir une vue d'ensemble du tableau. A Winnetka puis pendant les premières années en Floride, le jeune Drake préparait tous les jours les pinceaux et les tubes de peinture de son père.

Lorsqu'on demanda à Elvgren ce qui l'intéressait le plus chez un modèle, il répondit : « J'aime les filles aux traits très mobiles, capables d'une grande variété d'expressions. Le visage, c'est la personnalité. » Il déclara également que le choix du modèle était un facteur essentiel pour obtenir une image forte. Il les préférait jeunes, entre quinze et vingt ans, au tout début de leur carrière, car elles avaient encore une fraîcheur et une spontanéité qu'elles perdaient souvent à mesure qu'elles acquéraient de l'expérience. Il aimait que les modèles s'intéressent au projet et ajouta qu'elles étaient difficiles à trouver. Lorsqu'on l'interrogea sur sa méthode pour créer des pin-up, il expliqua qu'il appliquait certaines « touches » à chaque peinture, mettait le buste en valeur, allongeait les jambes, rétrécissait la taille, donnait au corps des courbes plus généreuses et séduisantes, travaillait sur les traits du visage et les expressions, rallongeait et retroussait le nez, rendait les lèvres plus charnues et agrandissait les yeux. Il conclut en disant que, outre ses charmes apparents, les yeux du modèle devaient refléter une chaleur et une espièglerie délicieuses.

Elvgren préparait soigneusement chaque image. Une fois qu'il avait l'idée, il réfléchissait à l'effet visuel qu'il voulait obtenir puis choisissait un modèle qui convienne bien à la situation choisie. Ensuite, il sélectionnait une tenue, un fond, des accessoires et l'éclairage. Même la coiffure du modèle avait son importance. Comme certaines images ne seraient pas publiées avant deux ans, il essayait de faire coiffer le modèle dans un style qui ne se démoderait pas facilement. Il utilisait un appareil Rollei 2¼. Une fois les prises de vues achevées, il s'asseyait devant son chevalet et se mettait enfin à peindre.

Ce qui distinguait les pin-up d'Elvgren de celles des autres artistes de l'époque était que les « Elvgren Girls » avaient toujours l'air de vraies filles en chair et en os. On aurait dit qu'à tout moment, elles allaient vous faire un signe, vous offrir un verre ou vous inviter à des jeux pas si innocents que ça. Elles avaient de la personnalité et du piquant. C'était des beautés vivantes, amicales et débordantes d'enthousiasme. Elles avaient des visages doux et étaient généreusement pourvues par la nature. Leur regard espiègle allumait une étincelle dans celui du spectateur. Pendant plus de trente ans, des années 40 aux années 60, elles ont incarné la jeune beauté américaine.

Les « Elvgren Girls » firent leur apparition au cours de la Grande Dépression et traversèrent la Seconde Guerre mondiale avant d'accompagner les soldats jusque dans la guerre de Corée. Elles leur donnèrent du courage et de l'espoir, leur rappelant les petites amies qu'ils avaient laissées à la maison. Armées de leur sourire charmant et engageant, elles s'attirèrent l'affection et inspirèrent les rêves de nombreux hommes et femmes tout au long de l'âge d'or de la pin-up américaine.

Au cours de sa carrière chez Brown & Bigelow, Elvgren utilisa deux signatures, qui différaient en taille mais non en style. Sa première signature (1945–1957) mesurait la moitié en hauteur et en longueur de la seconde (1958–1972), qui était plus marquée et plus imposante. Cette différence est proportionnelle au développement de sa carrière et de sa réputation. En 1958, il était devenu une sorte de légende vivante dans le domaine du calendrier. Bien que Vargas et Petty aient été très admirés par leurs confrères, Elvgren, lui, fut imité par tous les illustrateurs de son temps. Tout le monde voulait peindre comme lui.

Elvgren n'entra jamais sur le marché lucratif des couvertures de romans, un marché qui explosa dans les années 50 et 60. Toutefois, à en juger par ses dossiers (que l'auteur a racheté à l'artiste D. H. Rust de nombreuses années après la mort d'Elvgren), il suivait cette branche de l'illustration de très près et ses artistes favoris dans ce domaine étaient James Avati (né en 1912) et James Bama (né en 1926), deux maîtres du genre. Avati peignait des sujets très sensuels alors que Bama était surtout connu pour ses images photoréalistes, traitées avec un angle moderne mais légèrement fantastique. Ed Balcourt, qui gérait les carrières de Bama et de Ron Lesser, m'a raconté lors d'un entretien que les principaux illustrateurs de romans discutaient souvent des œuvres d'Elvgren lorsqu'ils se rencontraient à New York chez leurs éditeurs. Il était ainsi reconnu non seulement dans son propre domaine d'activité mais également par ses confrères travaillant dans des secteurs annexes de l'illustration.

Du fait de cette admiration, et parce que sa technique avait atteint un tel niveau de supériorité, Elvgren était très à l'aise avec son talent et sa réussite. Peignant chaque nouvelle commande avec une aisance et une assurance croissantes, il créa ses pin-up les plus belles et les plus sophistiquées à la fin de sa carrière, à partir de 1958 (ill. 80, p. 39). Comme en témoignent les images de ce livre, ses premières œuvres étaient plus nerveuses alors que ses dernières sont, structurellement, plus détendues et moins académiques (du moins en apparence). En réalité, à la fin de sa vie, il peignait ses pin-up dans un style qui rappelle, à certains égards, John Singer Sargent. Il n'avait plus de problèmes de composition ni d'éclairage, son art s'exprimait naturellement. Il avait atteint une maîtrise totale, tant dans l'approche conceptuelle de ses sujets que dans sa technique picturale.

Gil Elvgren, un homme qui avait passé une grande partie de sa vie à enrichir celles des autres, mourut d'un cancer le 29 février 1980, à l'âge de soixante-cinq ans. Dans son atelier de Featherbed Lane à Siesta Key, Drake découvrit sa dernière pin-up destinée à Brown & Bigelow, une peinture inachevée mais néanmoins superbe, reproduite et publiée ici pour la première fois (ill. 81, p. 39). Elvgren nous a quittés il y a bientôt deux décennies, mais son art, son esprit et son talent lui ont survécu. Le meilleur compliment et honneur que nous pouvons lui faire est encore de célébrer et d'apprécier son œuvre. Il ne fait aucun doute que les historiens d'art du XXIe siècle reconnaîtront en lui un artiste qui a fortement influencé l'art américain du XXe siècle et y a apporté une contribution majeure.

# LÉGENDES

## POURQUOI UNE MONOGRAPHIE D'ELVGREN ?

**P. 9 :** Louis K. Meisel avec Susan et Ari, New York

**1** Mel Ramos : *Par le petit trou de la serrure*, Blond, 1964. Huile sur toile, 67 x 51 cm

**2** Mel Ramos : *Camilla – Reine de la jungle*, 1963. Huile sur toile, 76 x 66 cm

**3** La célèbre Betty Page, photographiée par l'ami d'Elvgren, Art Amsie

**4** Myrna Hansen avec Pete Darrow, l'assistant d'Elvgren, posant pour *Sitting Pretty* de Gil Elvgren

**5** Gil Elvgren : *Sitting Pretty*, 1953

**6** John Kacere : *Joelle '89*, 1989. Huile sur toile, 102 x 152 cm

## LA VIE ET L'ŒUVRE DE GIL ELVGREN

**7** Des artistes, dont Norman Rockwell (à gauche) et Gil Elvgren (le deuxième en partant de la droite), lors d'une convention Brown & Bigelow à St. Paul, Minnesota, 1947

**8** Howard Chandler Christy : *Un couple moderne*. Couverture de *Motor Magazine*, 1912. Aquarelle et gouache sur carton, 97 x 76 cm

**9** Charles Dana Gibson : *Une veuve et ses amies*. Couverture de *Harper's Weekly*, publiée en 1900. Crayon et encre sur papier, 41 x 31 cm

**10** Howard Chandler Christy : *Les Liens de golf*. Carte postale et illustration, publiées en 1902, 1905, 1908. Aquarelle et gouache sur carton, 102 x 76 cm

**11** Howard Chandler Christy : *Amelia Earhart*. Portrait et couverture de revue. Huile sur toile, 152 x 102 cm. Daté de septembre 1932

**12** Charles Dana Gibson : *L'Art prend du temps – La touche finale*. Poster central, *Life*, 1925. Crayon et encre sur papier, 38 x 31 cm

**13** Harrison Fisher : *Prix de beauté*. Couverture de *Cosmopolitan*, 13 octobre 1913. Aquarelle et gouache, 53 x 23 cm

**14** John Henry Hintermeister : *Une jolie mélodie*. Illustration de calendrier, publiée en 1915–1920. Huile sur toile, 71 x 56 cm

**15** J. C. Leyendecker : *L'Art du vêtement – Automne et hiver*. Couverture de catalogue de mode, publié en septembre 1895. Gouache sur papier épais, 43 x 36 cm

**16** J. C. Leyendecker : *Pâques*. Couverture pour *The Saturday Evening Post*, 27 mars 1937. Huile sur toile, 71 x 56 cm

**17** J. C. Leyendecker : Publicité de mode pour Hart, Schaffner and Marx. Huile sur toile, 74 x 109 cm

**18** James Montgomery Flagg : *Greta Garbo et des amis à Hollywood*. Couverture de magazine, publiée en 1930. Crayon et encre sur carton, 46 x 69 cm

**19** J. C. Leyendecker : Publicité de mode pour la Kuppenheimer Clothing Company. Peint en 1919, publié en 1920. Huile sur toile, 66 x 46 cm

**20** Dean Cornwell : *Marcellus et Diane au procès*. Illustration du livre *La Tunique*, de Lloyd C. Douglas. Publié par Houghton Mifflin Co., 1941 ; et dans *Life*, 1942

**21** Harvey T. Dunn : *Nu*. Peint en 1939, publié dans *Time* le 9 juin 1941. Huile sur toile, 71 x 102 cm

**22** McClelland Barclay : *Miss Amérique*, 1932. Publicité pour les cigarettes Lucky Strike. Huile sur carton, 56 x 71 cm

**23** McClelland Barclay : *Le Paradis des amoureux*. Illustration double page parue dans *Cosmopolitan*, juin 1932. Huile sur toile, 61 x 127 cm

**24** McClelland Barclay : Publicité pour General Motors Corp., publiée en 1930. Huile sur toile, 56 x 46 cm

**25** Gil Elvgren : Publicité pour Royal Crown Soda. Peinte en 1938, reproduite en 1940 sous forme de présentoir en carton grandeur nature. Huile sur toile, 76 x 51 cm

**26** Gil Elvgren : Publicité pour Royal Crown Soda. Reproduite en 1940 sous forme de présentoir en carton. Carton, 152 x 76 cm

**27** Gil Elvgren : Couverture de catalogue de mode, publiée en 1936. Huile sur carton, 61 x 41 cm

**28** Gil Elvgren : *Les Quintuplées Dionne*. Reproduction de calendrier, publié par Brown & Bigelow vers 1937/38

**29** Haddon H. Sundblom : *Miss Burd*. Publicité de calendrier, publié pour Burd Piston Rings par Brown & Bigelow, vers 1957–1960. Huile sur toile, 102 x 76 cm

**30** Haddon H. Sundblom : *Petite pause entre amis*. Publicité pour Coca-Cola Company, vers 1946–1950. Huile sur toile, montée sur carton, 56 x 74 cm

**31** Haddon H. Sundblom : *Le Rêve des amoureux*, 1949. Publicité pour Cashmere Bouquet Soap Co. Huile sur toile, 102 x 76 cm

**32** Haddon H. Sundblom : *Miss Sylvania*. Publicité de calendrier, publié par Brown & Bigelow, vers 1955–1958. Huile sur toile, 102 x 76 cm

**33** Haddon H. Sundblom : *Tombée des nues*. Calendrier, publié par Louis F. Dow Company sous le pseudonyme « Showalter », vers 1958–1960. Huile sur toile, 76 x 56 cm

**34** Andrew Loomis : *Une vraie beauté*. Pin-up glamour de calendrier, publié par Brown & Bigelow. Huile sur toile, 86 x 61 cm

**35** Andrew Loomis : *La Première Voiture*. Illustration pour *Ladies' Home Journal*, avril 1952. Huile sur toile, 71 x 102 cm

**36** Gil Elvgren : *Un Coca ?* Publicité pour Coca-Cola Company, publiée vers 1937. Huile sur toile, 46 x 58 cm. Reproduite sous forme de présentoir de vitrine en carton

**37** Gil Elvgren : *La Pause fraîcheur*. Publicité pour Coca-Cola Company. Huile sur carton, 61 x 86 cm. Reproduite sous forme d'affiche géante de vingt-quatre lés, vers 1945–1950

**38** Gil Elvgren : *Le Meilleur Moyen d'étancher sa soif*. Publicité pour Coca-Cola Company, vers 1950. Huile sur toile, 56 x 71 cm

**39** Gil Elvgren : *Faites le plein de Coca-Cola*. Panneau publicitaire, Coca-Cola Company

**40** Gil Elvgren : Album de pin-up hors collection, série numéro 1, publié par Louis F. Dow Company, vers 1937

# INDEX
## of Elvgren illustrations

The illustrations in this volume are drawn principally from the archives of Brown & Bigelow. However, some of the Elvgren originals can no longer be traced, and in these cases we have had to reproduce from the print versions. We chose to do this because we thought it desirable to collect the complete Elvgren.

Die Abbildungen in diesem Buch stammen vorwiegend aus den Beständen des Archivs von Brown & Bigelow. Da die Originale von Elvgren zum Teil nicht mehr auffindbar sind, waren wir leider gezwungen, auf alte Vorlagen zur Reproduktion zurückzugreifen. Dennoch wollten wir nicht darauf verzichten, Elvgrens Werk in seiner Vollständigkeit zu zeigen.

Les illustrations de cet ouvrage provient dans sa plus grande partie des archives de Brown & Bigelow. Certaines photographies originales d'Elvgren sont introuvables, mais comme nous tenions à représenter son œuvre dans son intégralité, nous avons dû nous résoudre à utiliser d'anciens positifs, ce qui explique la qualité médiocre de certaines reproductions.

Page 2: *A Knockout*, 1939
Page 3: *Foil Proof*, undated
Page 4: *Thar She Blows*, 1939
Page 5: *Knee-ding a Lift*, 1940

**ACKNOWLEDGMENTS:**

The authors are grateful to the following for their help in making this book possible: at Brown & Bigelow, Bill Smith, Sr., Bill Smith, Jr., and Teresa Roussin; for research assistance, Drake Elvgren, Earl Beecher, Michael Stapleton, Tom Skemp, John Dillard, and Bill Doyle; for supplying photographs, Ray Warkel, Pierre Lescure, Pierre Bogaertz, Clarke and Janice Smith, and Max Allan Collins; for photography, Steve Lopez and Aaron Miller; for editing, Margaret Donovan, Yvonne Havertz, Burkhard Riemschneider and Nina Schmidt. Our warmest thanks to them all.

The authors would like to encourage anyone with additional material on Elvgren to submit such information or photographs of any original artwork to our Archives of Pin-Up and Glamour Art. Such material will be used for historical documentation. Material should be sent to Charles G. Martignette, P.O. Box 293, Hallandale, Florida 33008, or to Louis K. Meisel, Meisel Gallery, 141 Prince Street, New York, New York 10012.

**DANKSAGUNG:**

Der Dank der Autoren gilt denjenigen, die dieses Buch überhaupt erst ermöglicht haben: Bill Smith, Sr; Bill Smith, Jr., und Teresa Roussin von Brown & Bigelow; Drake Elvgren, Earl Beecher, Michael Stapleton, Tom Skemp, John Dillard und Bill Doyle für ihre Unterstützung bei der Recherche; Ray Warkel, Pierre Lescure, Pierre Bogaertz, Clarke und Janice Smith sowie Max Allan Collins, die bereitwillig ihr Fotomaterial zur Verfügung gestellt haben; Steve Lopez und Aaron Miller, die unser Material fotografiert haben; Margaret Donovan, Yvonne Havertz, Burkhard Riemschneider und Nina Schmidt für Redaktion und Lektorat. Unser herzlicher Dank gilt ihnen allen.

Die Autoren bitten darum, jeden, der über weiteres Material zu Gil Elvgren verfügt, diese Informationen oder Fotos von Originalen an unser Archiv für Pin-up- und Glamour-Kunst zu senden. Das Material dient der historischen Dokumentation. Bitte senden Sie Ihr Material entweder an: Charles G. Martignette, P.O. Box 293, Hallandale, Florida 33008, oder an Louis K. Meisel, Meisel Gallery, 141 Prince Street, New York, New York 10012.

**REMERCIEMENTS :**

Les auteurs souhaitent remercier les personnes suivantes pour avoir rendu ce livre possible : chez Brown & Bigelow, Bill Smith Sr., Bill Smith Jr., Teresa Roussin ; pour nous avoir assistés dans nos recherches, Drake Elvgren, Earl Beecher, Michael Stapleton, Tom Skemp, John Dillard, Bill Doyle ; pour avoir fourni des photographies, Ray Warkel, Pierre Lescure, Pierre Bogaertz, Clarke et Janice Smith, Max Allan Collins ; pour la photographie, Steve Lopez et Aaron Miller ; pour la mise en page, Margaret Donovan, Yvonne Havertz, Burkhard Riemschneider et Nina Schmidt. Notre plus sincère gratitude à tous.

Les auteurs encouragent toute personne possédant des documents, des photographies ou des œuvres originales d'Elvgren à les soumettre aux Archives of Pin-up and Glamour Art. Ils serviront à la documentation historique. Les documents peuvent être adressés à Charles G. Martignette, P.O. Box 293, Hallandale, Florida 33008, ou à Louis K. Meisel, Meisel Gallery, 141 Prince Street, New York, New York 10012.

To stay informed about upcoming TASCHEN titles, please request our magazine at www.taschen.com/magazine or write to TASCHEN, Hohenzollernring 53, D–50672 Cologne, Germany, contact@taschen.com, Fax: +49–221–254919. We will be happy to send you a free copy of our magazine which is filled with information about all of our books.

© 2008 TASCHEN GmbH
Hohenzollernring 53, D–50672 Köln
**www.taschen.com**
Original edition: © 1999 Benedikt Taschen Verlag GmbH
© 1999 Charles G. Martignette and Louis K. Meisel,
for the illustrations and text
Design by Armando Chitolina, Milan
Layout by Giorgio Martinoli, Milan
Cover design by Sense/Net, Andy Disl and Birgit Reber, Cologne
Text edited by Nina Schmidt, Cologne
German translation by Raingard Eßer, Alten-Buseck
French translation by Philippe Safavi, Paris

Printed in China
ISBN 978–3–8365–0305–1